harry benson: fifty years *in pictures*

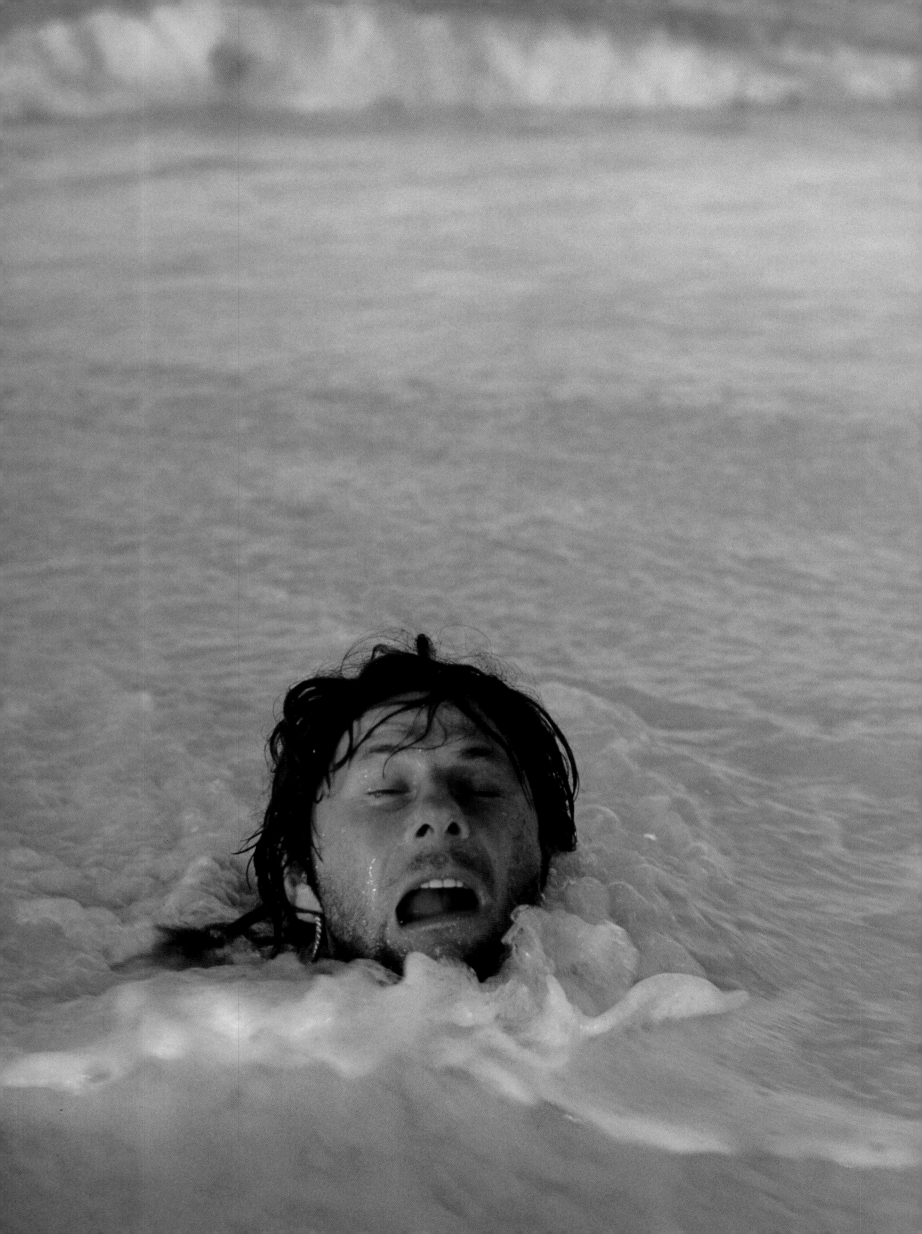

harry benson: fifty years *in pictures*

Harry N. Abrams, Inc., Publishers

Each a glimpse and gone for ever!

—ROBERT LOUIS STEVENSON, *"From a Railway Carriage"*

Table of Contents

starting out

I left school at thirteen. I couldn't pass French, Latin, or Greek and my most pressing ambition was to play goalie for Scotland in soccer.

One day my father asked me how school was going. I proceeded to give him a detailed recounting of all my classes. Then he showed me

the sports page of the Glasgow *Evening Times*. The headline was something like "Glasgow Rangers' First Day of Training Camp," and there

was a photo of the team working out with a group of young boys watching from the sidelines. There I was front and center, having skipped

school to watch them practice. I was punished not only for skipping school but for lying. ¶ Even then, though, soccer wasn't my only pas-

sion. I was an amateur photographer, inspired by Churchill's radio speeches during World War II to imagine myself a photojournalist in

the center of the world's great events. I was too young to enlist, but I remember that the head prefect—student—at my school in Glas-

gow came back to talk to us before being shipped out. A month later the headmaster announced over the school's loudspeaker that he

had been killed in action. I never forgot how I felt that day. ¶ I was sixteen when I took my first published picture in the Calder Park Zoo

in Glasgow, which had been founded by my father. It was of a small roe deer, taken with a Thornton Pickard 4 x 5" plate camera. I sent

the photo to the Glasgow *Evening Times*. Several months later, I was riding on a train and glanced over to the open paper of a man sitting

next to me, and there it was. I was so proud. I can't even remember if they paid me for it, but that wasn't what mattered. Seeing the pic-

ture in print was what mattered. That feeling has never left me. ¶ After attending the Glasgow School of Art for two years and a few odd

jobs, I was drafted into the Royal Air Force. I would tell everyone I was in radar, but actually I was a cook. On maneuvers, I had to para-

chute out of planes with the pots and pans. Ironically, I tried to join the barrack's camera club and they turned me down, saying my work

wasn't up to their standards. After I came out of the R.A.F., I would get up every Saturday at 4:30 A.M., take the bus to photograph early

ROE DEER / GLASGOW / 1946 – My first published picture was taken when I was sixteen in the Calder Park Zoo founded by my father.

morning Catholic weddings around Glasgow, hurry home to develop and print the film, and rush back with the wet prints to sell at the receptions. ¶ I tried to get a job at the Glasgow *Evening Citizen,* and the picture editor told me I should be feeding animals in my father's zoo. It made me all the more determined, and I kept thinking, "I'll show the bastards." I still feel that way today. I was then hired by Leddy & Glen, a wedding photography studio, for something like three pounds a week. That summer (around 1951) I was staff photographer at Butlin's holiday camp, sort of a Scottish mini-version of Club Med, photographing sack races and knobby-knee contests. Not exactly the center of world events, but a good place to meet girls. ¶ A job on the *Hamilton Advertiser,* the largest Scottish weekly newspaper, was next. It is the paper to which the Scottish missionary David Livingston sent his dispatches from Africa. Now I knew my pictures were going to be published. I did up to ten jobs a day—the only way to really learn your trade. It was an unwritten rule that you had to come back from an assignment with a picture; you couldn't say there was nothing in the story, as I later learned it was common to do in America. My four years there under editor Tom Murray was the equivalent of a university education. I learned discipline and my life had a purpose. ¶ Charlie McBain, still my friend today, was the other staff photographer, and he would cover for me when I took the overnight train to London to show my portfolio to the picture editors of the national newspapers on legendary Fleet Street. Working there was like being in a privileged club, yet there was intense competition among the papers, to a degree that does not exist in America. I've yet to see as much secrecy surrounding an assignment as there was on Fleet Street. To scoop the other papers was your everyday goal. It was the best training ground for a photojournalist. I loved it. ¶ I had no formal training, however. I learned the hard way to have a plan before getting to an assignment. I was told to go to Balmoral Castle, as the Queen had requested to be photographed. I was about twenty-three years old and off I went

GLASGOW SCHOOLBOYS / KELVIN GROVE PARK / 1956 — One afternoon I was walking around the park and happened upon a group of schoolboys up to some mischief, going for a dip in the fountain. The newspapers called it a "Glasgow heat wave," but the temperature was only around 75 degrees. Looking back I now realize there were no outdoor swimming pools available for the children at the time.

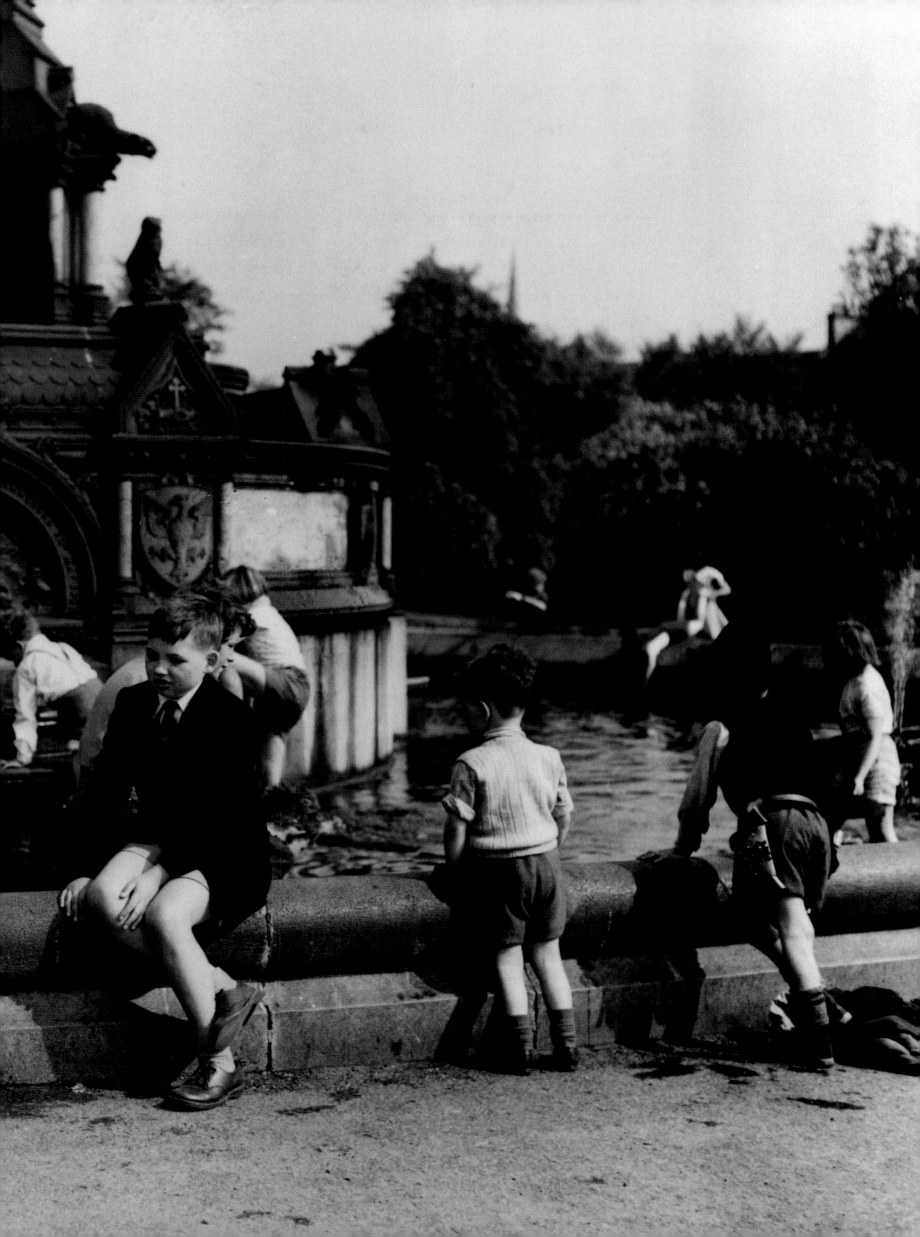

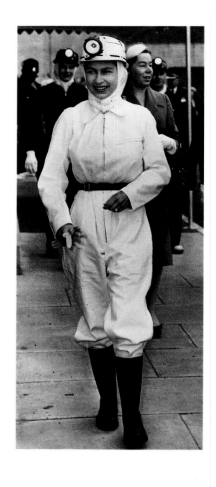

QUEEN ELIZABETH II OF ENGLAND / SCOTLAND / 1957 – The Queen had come to Scotland to open a new coal mine and she dressed for the occasion. It was one of the first times I had photographed her and to this day, I have never seen her looking that good again. They discovered after the grand opening that there wasn't much coal in the pit. That embarrassing mistake cost Scotland millions of pounds.

with my Speed Graphic camera. When she came out laughing, with her dogs jumping about her, I was completely overawed. She asked what she could do for me that day and I just stammered and melted. She sat down primly and that was that. A missed opportunity. ¶ It was on my seventh trip to London's Fleet Street that I saw the assistant picture editor of the London *Daily Sketch,* Freddy Wackett. As I left, I asked if I had a chance, and the way he looked up and smiled gave me an inkling of hope. After several days I got a call from the *Sketch* with an assignment, and that was really the start. As a freelance living at home, I covered Scotland for the *Sketch,* and the first year I placed second as "photographer of the year," the first person out of Scotland ever to attain that distinction. This win, along with my exclusive interviews with mass murderer Peter Manuel, got me to London. ¶ Manuel, who killed eight people in Glasgow in the late 1950s, took a long time to catch because he was very clever and would move his victims into recently plowed fields that had already been searched. When I encountered him, he was in Glasgow's Barlinnie Prison, but had not yet confessed. I knew Sammy Doherty, the biggest boxing promoter in Scotland, who also ran an illegal betting parlor. Sammy knew some people who had been in prison with Manuel, and he introduced me to Wee Willie Gourley, the best safe cracker in Scotland. During World War II, Wee Willie had been flown behind the lines to work with the French Resistance, to open German safes and retrieve information that might help the Allied forces. A decorated war hero, he could blow a safe without a terrible mess, very clean. It was Wee Willie who got me into the prison. Neeley O'Donnell, a prisoner on good behavior, was assigned to monitor who got to see Manuel, and he let me cross out all the names of other journalists who had asked for interviews because I was a friend of Sammy's. The outcome was that Manuel wrote to me and let me interview him, although no photographs were allowed by the prison. He said I was the only one who came to see him besides his priest and his mother and thanked

H.R.H. PRINCE PHILIP / SCOTLAND / 1957 – Prince Philip had just been made chancellor of Edinburgh University. Students in the gallery became raucous and celebrated the occasion by throwing toilet paper and flour down at the prince.

me. For legal reasons, the paper couldn't use everything he said until the trial was over, but it was enough for my first big exclusive and I never even took a picture. At the time my mother was appalled that I was receiving letters from a murderer. When she got to the mail first, she burned Manuel's letters, so I had to have them sent to my friend Carlo Pediani's house. ¶ My first day on the job in London, I was sent to cover some event and all of Fleet Street was there. I was the new kid on the block and didn't know that this relegated me to the second row behind the barricade. I pushed in front of some veteran photojournalist, who was annoyed at the upstart from Scotland and gave me a shove. Of course, I belted him one and broke a bone on the top of my hand. I tried to keep it a secret, but when the office found out they were not impressed, to say the least. ¶ Once I was told by the *Sketch* to go down to Brighton to see what I could find out about a doctor who had been accused of murdering some of his patients. I arrived about lunchtime and went to the house. A woman answered the door and asked where I was from, meaning what newspaper. I replied, "I'm from Glasgow," which avoided the issue. She handed me a package, saying, "Oh, you've come for the pictures." I took them, and I later found out she had intended them for a rival paper, the *Daily Mirror.* I felt that I had only taken what the woman handed me, never pretending to be from the *Mirror.* ¶ I gatecrashed a party given by Lord Beaverbrook's son, Sir Max Aitken, for Stanhope Joel, a racehorse owner and friend of his. I was the only photographer there and began taking pictures. Someone came over and said Sir Max would like to speak with me. He gave me a drink at the bar and suggested that I work for his father's paper, the London *Daily Express.* He said he liked me because I had managed to be uncouth enough to crash his party and still be unobtrusive enough not to disturb the guests. I answered, "One is always trying to better oneself." To this day that doesn't sound like me talking, but that's what I said. ¶ Six months later, there was still no call from the *Express* and I was on a job outside the

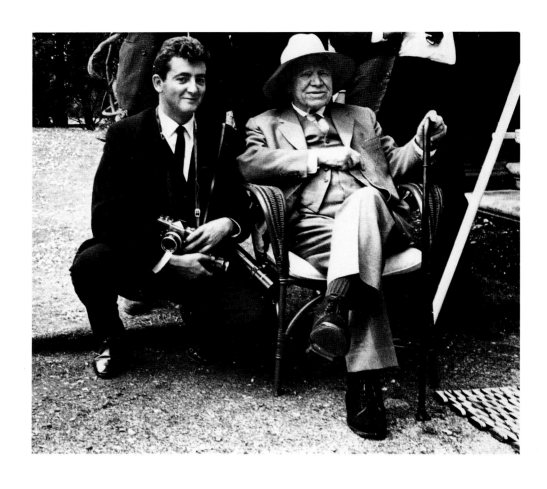

Caprice Restaurant, which was next to Lord Beaverbrook's apartment, waiting for some movie star to emerge (the *Sketch* did these pictures better than most). Out came Aitken. I walked over and said, "Sir Max, do you remember me. I've been waiting for a telephone call and I was wondering what happened." He said, "You'll get one tomorrow." Sure enough, picture editor Frank Spooner called, saying, "My dear boy, we would like you to come work for us." Years later, after I got to know Frank, he told me he hadn't called the first time because he had asked around about me and heard, "He's good but he's trouble." ¶ I had a tremendous grounding in photography working for the *Express* when Lord Beaverbrook owned the paper. It was the best training I could ever have. Spooner, Derek Marks, David English, Andy Fyall, Harold Keeble—all were great journalists who each taught me something, but Beaverbrook was to my mind the greatest journalist I have ever met. I think of him as a mentor. He was Minister of Aircraft Production in Churchill's cabinet during World War II, and listening to Churchill's radio addresses during the war had been part of what made me want to become a photographer and to be at the center of what was happening in the world. The *Express* when Beaverbrook owned it in the 1950s and 1960s was the best of British journalism. Beaverbrook's advice to me was, "Flattery, put it on with a shovel." It actually works. I photographed Lord Beaverbrook at his home, Cherkley, outside of London shortly before he died. His letter of thanks, calling me "a photographer of the first order," pleased me more than I can say. ¶ I worked with a reporter called Jeremy Banks on the *Express* off and on for about a year and a half. He was a wild and crazy man who would go to any lengths to be the first to get a story. Charming, but with an attitude, he had no qualms about wearing whatever old school tie would be the most influential on a given day. We'd have big rows. Before we got into one of J. Paul Getty's parties in the early 1960s, we flipped a coin to see who would be the driver and who would be the guest. We fought over my winning the toss. He

HARRY BENSON WITH LORD BEAVERBROOK / SUSSEX, ENGLAND / 1963 – Several editors and I were invited for lunch at his home, Cherkley, outside London. Lord Beaverbrook, proprietor of the *Daily Express* when I worked there, was the greatest journalist I have ever met.

told me I looked more like a chauffeur, but I made him drive because he lost. He said, "Well you do the talking then, you little worm." Actually I didn't do so badly. I walked up to Mr. Getty and congratulated him on the party and started taking pictures. Everything was fine after that. ¶ Banks and I went to do a story on President Gamal Abdel-Nasser of Egypt in 1961. When we got there, Nasser wouldn't see us. Banks huffed and puffed like a mad man, his eyes popping out of his head, as he told Nasser's aide-de-camp, "Do you know who we are going to photograph next week in the United States of America? Do you have any idea who you are talking to? We are going to photograph Elvis Presley." He emphasized the name slowly and with reverence, E-L-V-I-S P-R-E-S-L-E-Y. I was mortified and wouldn't speak to him on the way back to the hotel. I got into the bath and the phone rang. It was Jeremy, who said, "Be downstairs with your camera in ten minutes, old boy, or I'll go without you." His pomposity had worked, and we saw Nasser that afternoon. He did not let me live that one down for a long time. ¶ Frank Spooner was the picture editor who sent me to America with the Beatles in February 1964, so I owe him a lot. On my first assignment to cover them in Paris, at a hall outside of town, I was in a bad mood because I had been pulled off a job to go to Kenya for an independence anniversary celebration. But then I heard them play and that was it. I knew they were going straight to the top. What happened after that is the subject of this book. ¶ In 1971, when I published my first book, I made a list of qualities that I feel are essential to a photojournalist, and I think the list remains valid today: an inherent love of photography, a strong determination to succeed, a willingness to put everything else second to your work, a sense of history, an awareness of human behavior, physical stamina, a fascination with gossip, a survival instinct, a naive belief in yourself, and a bit of luck. I feel sorry for people who don't do what they like in their lives. I'm lucky in that I don't even have to keep a diary. My photos are my diary. ¶

— *Harry Benson*

SIR WINSTON CHURCHILL / HARROW SCHOOL, ENGLAND / DECEMBER 1964 – This was Sir Winston's last visit to his old school, Harrow. The boys added a chorus to the school song, "And Churchill's name shall win acclaim through each new generation." As a child, I listened to Churchill's speeches during the war, and I remember the inspiration he gave the British people during those very hard times.

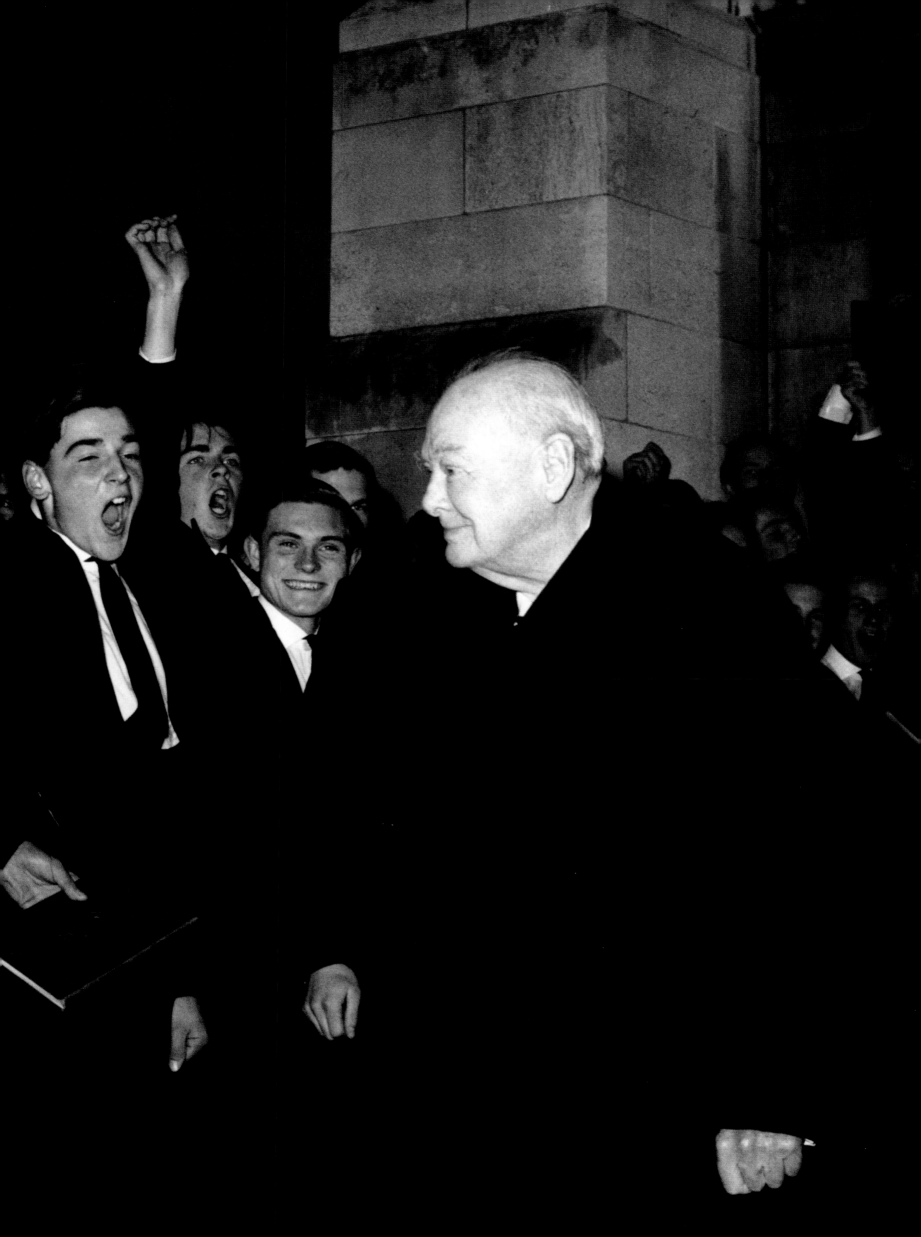

CHRISTIAN DIOR COMES TO GLASGOW / 1957 – Daly's department store held a fashion show with versions of the first collection St. Laurent did for Dior—the trapeze. It caused a sensation in the world of fashion and the Glasgow women were curious to see what it was like.

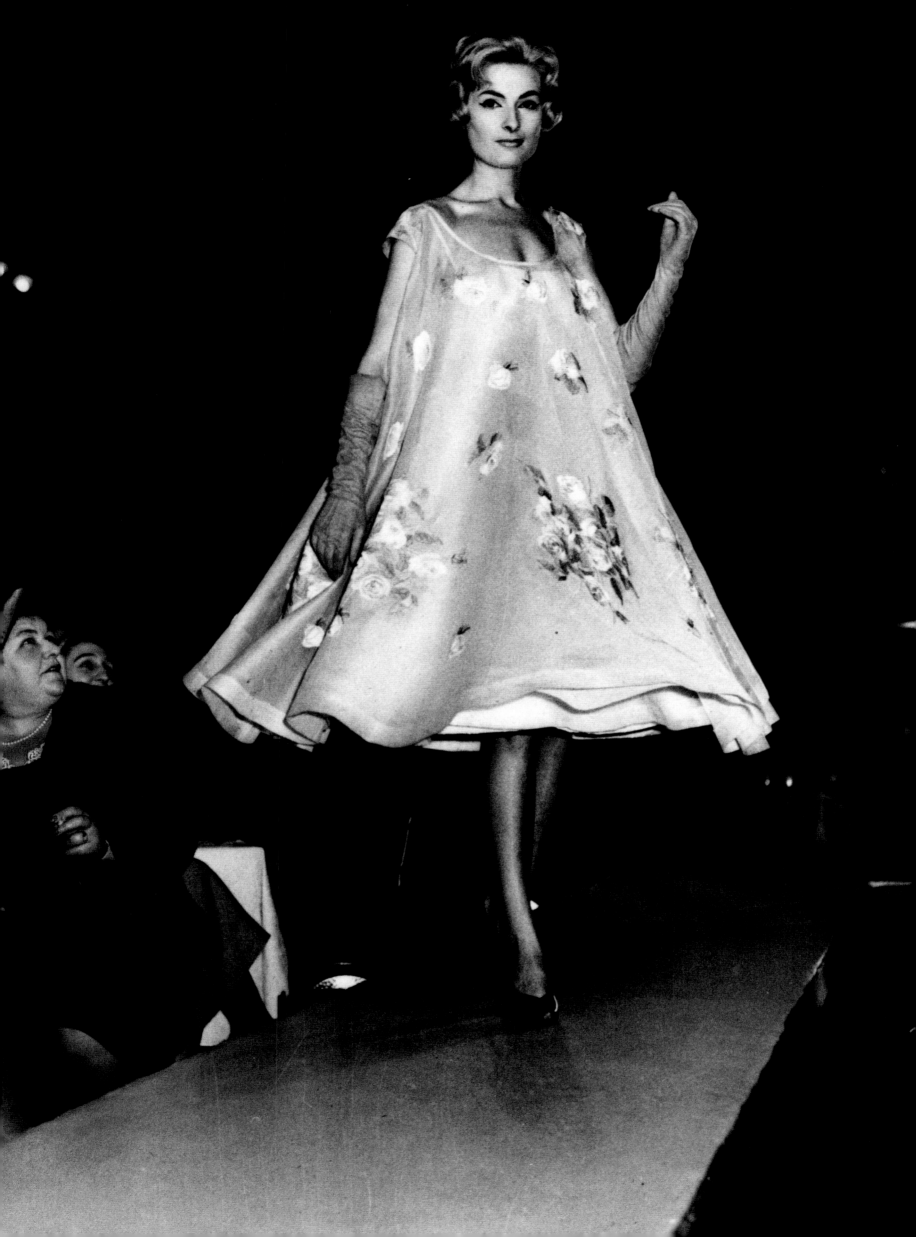

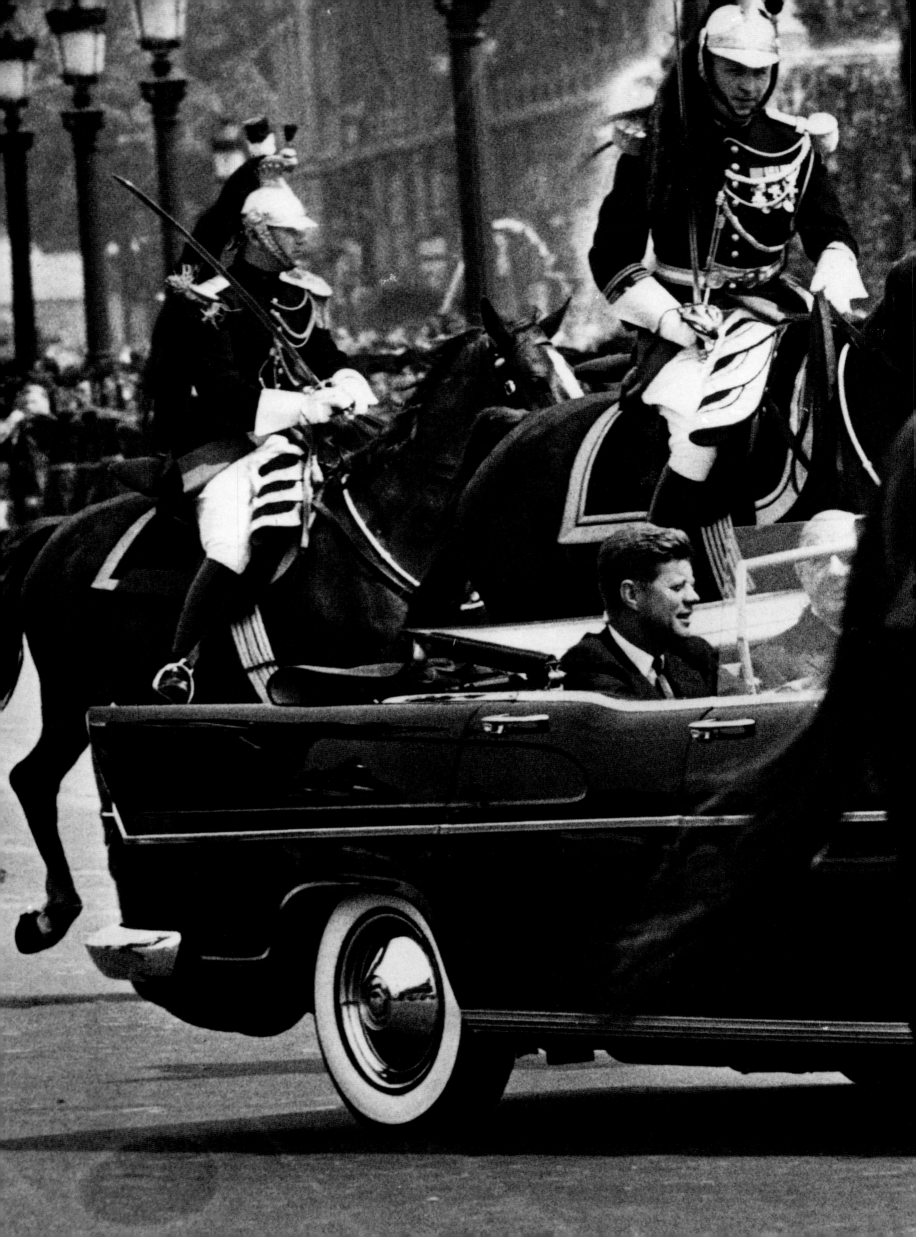

PRESIDENT JOHN F. KENNEDY AND PRESIDENT CHARLES DE GAULLE / PARIS / 1961 — Kennedy visited Paris in the summer of his first year as president, and Parisians lined the streets cheering and craning for a glimpse of him with the French president riding in an open car. Honor guards in their plumed helmets and gold epaulets on their galloping horses surrounded the procession. It was what an official state visit should be: full of pomp and circumstance. John Kennedy, Jr. asked me for a copy of this photograph for his office at *George* magazine. He thanked me with a note saying, "this was when politics was fun."

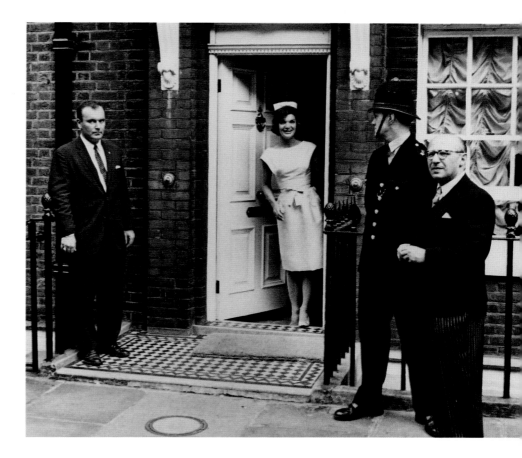

JACQUELINE KENNEDY / LONDON / 1961 — It was late afternoon when Mrs. Kennedy stepped out of her sister Lee Radziwill's home to wave to the Fleet Street photographers who had been waiting the good part of a day to photograph her. Needless to say, she was the toast of London and Paris, which led the president to make his now famous remark, "I am the man who accompanied Jackie Kennedy to Paris."

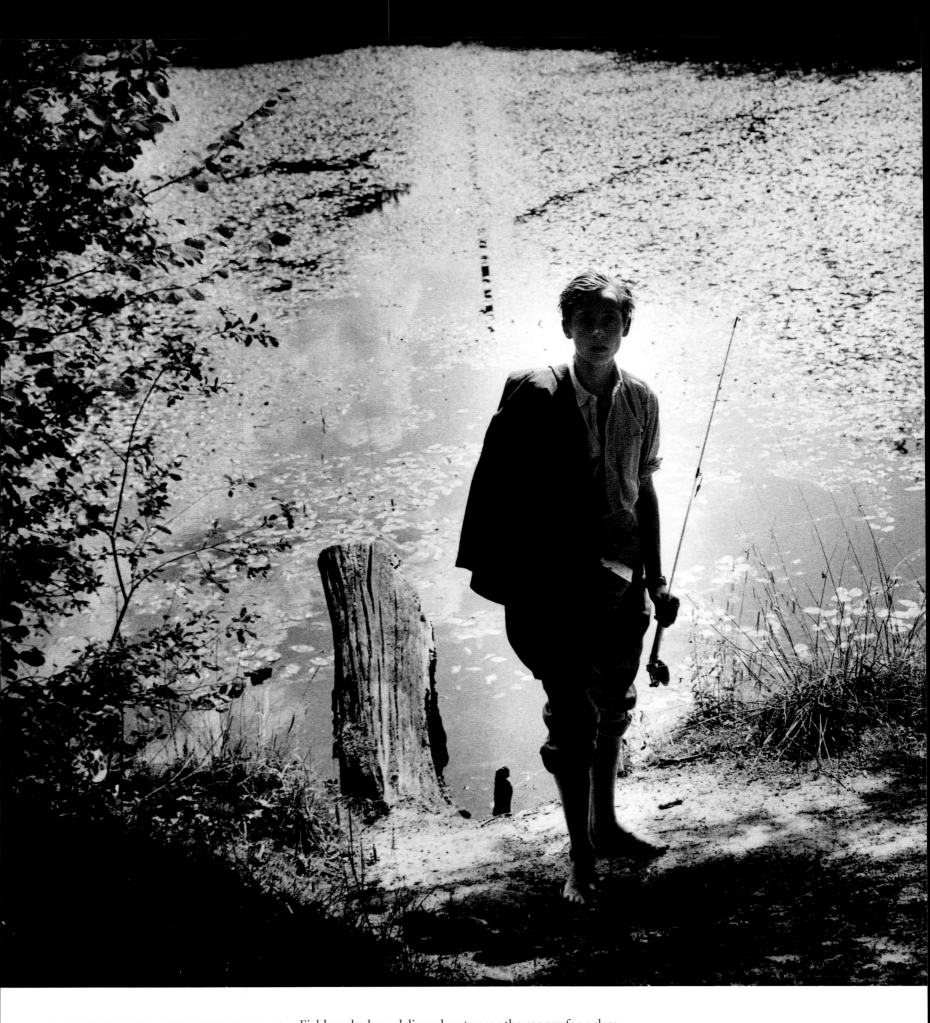

SCHOOLBOY DAVID FIELD / ENGLAND / 1962 – Field worked as a delivery boy to earn the money for a class trip to Norway. At the last minute he stayed behind, giving the money to his mother, who was very ill. The plane crashed, killing all his classmates. I went to his house the next day. His mother told me she had sent him fishing near their home. Self-serving as this may seem, I'll never forget editor-in-chief Ted Pickering saying this was the best photo on the picture page that the *Daily Express* had ever published.

HOUSEWIVES WITH AMERICAN SAILORS / GLASGOW / 1961 – American submarines carrying Polaris nuclear missiles had just docked at the Holy Loch near Glasgow. There was a controversy over whether to allow the submarines to stay in Scotland, but the Glasgow housewives had no qualms about welcoming the sailors to their shores.

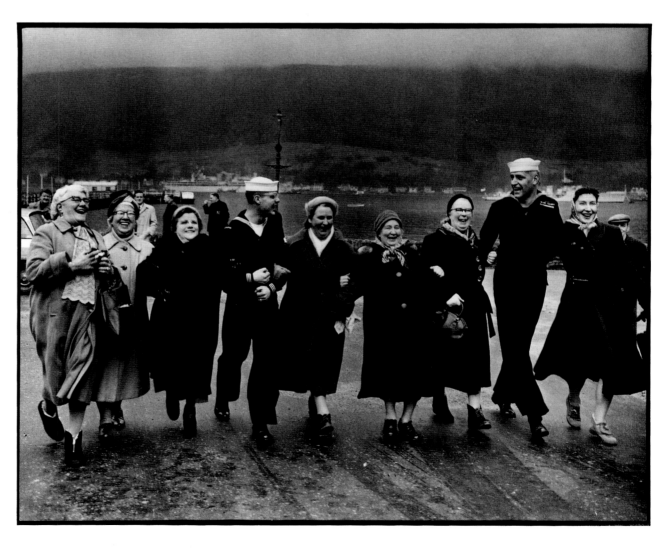

TEDDY BOYS / LONDON / MARCH 1963 – Young cockney boys from the suburbs worked as messengers in the City, as the London Stock Exchange is known. Known as Mods by some, they took pride in dressing in the latest fashions. Don't get me wrong, they were tough kids who could take care of themselves, but they wanted to be dandys at work.

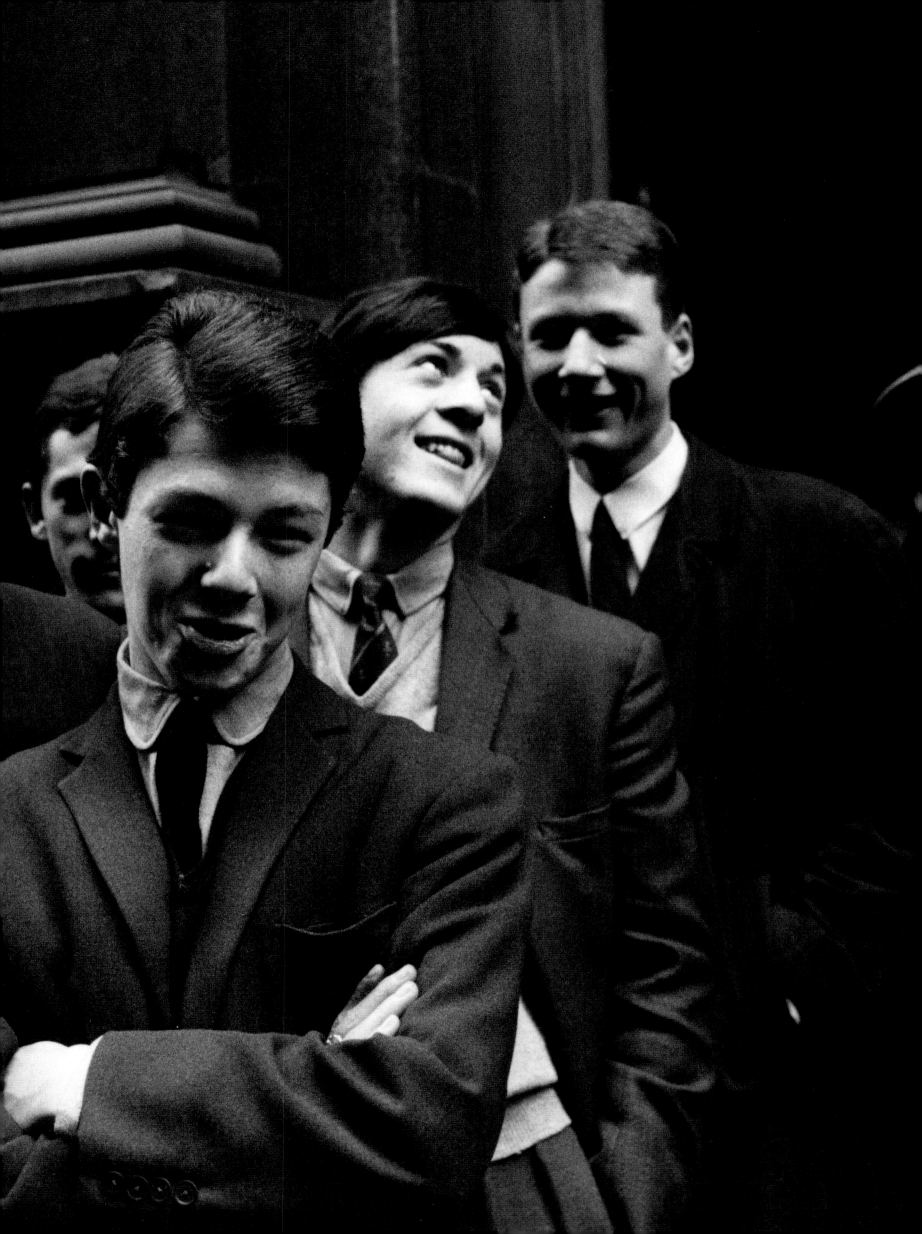

good times

THE BEATLES ARRIVING IN NEW YORK / FEBRUARY 7, 1964 – As they stepped off the plane I asked them to turn around for a picture. I didn't develop this film until years later because the crowds had been kept back by the police barricades.

There are a lot of stories I would like to go back and do over again, but the Beatles isn't one of them. I spent a lot of time with the Beatles in the mid-1960s and took hundreds of photographs of them. My favorite is the pillow fight, photographed at the Hotel George V in Paris in 1964, when they were still not world weary and tired of the pace. I also like the shot of them writing music, taken in the same hotel. There are not many pictures of the Beatles composing, and yet that's what they were, composers. They'd do it whenever there was a free moment. It's not like they said, let's compose now. It could happen anytime. In their pajamas. In their hotel rooms. One would wander over to the piano and start tinkering, then another would walk over, most of the time it was either John and then Paul or Paul and then John, but it wasn't like, yeah, we've gotta do this. ¶ I was on the plane with them for their first trip to America. Before we landed in New York, I said I wanted a picture of them actually arriving. Mind you, when the time came, Ringo helped me because the other three forgot to turn around to look at me. They were distracted with people shouting at them. I called out and Ringo told them to turn around for Harry. ¶ When I phoned the *Daily Express* office in London and told them the crowds were nothing like what we'd seen in Amsterdam or Paris, they said not to bother sending the picture over. There were fewer crowds because the New York Port Authority hadn't allowed people to run all over the tarmac. The crowds were nothing like they were in Europe, where the fans could stand on the top deck and watch them arrive. About fifteen years ago, going through some old boxes, photographer Jonathan Delano came across the undeveloped roll. It's not that it's such a great picture, but it is historic. It's the Beatles arriving in America for the first

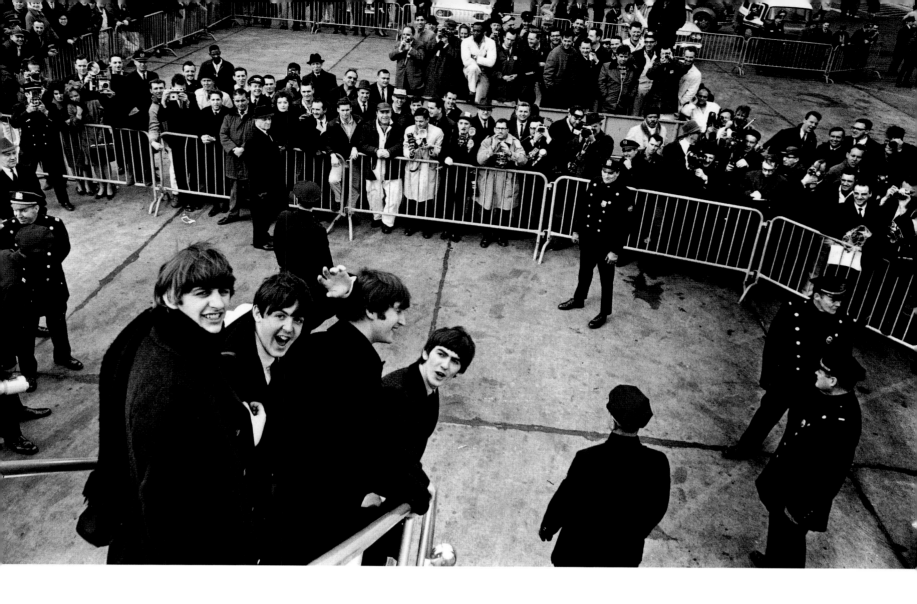

time. And when you think about it, they had a tremendous impact— on the music, on the way people dressed, and on the way they thought. ¶ One of the secrets of the Beatles' success was that in each hotel in each city we traveled to, there was a suite next to their rooms packed with reporters from all over. Everyone was allowed in to speak with the Beatles for five to ten minutes and be photographed with them. These reporters then went back to wherever they came from and wrote "I was the fifth Beatle." The publicity was staggering. Every newspaper—large or small—could get five minutes with the Beatles. Their manager, Brian Epstein, saw to that. Today, a rock star gives an exclusive to one publication, orchestrated by his public relations person. Then the celebrity goes off to the Caribbean and buys a yacht and when he comes back no one knows who he is. ¶ I was in Miami with the Beatles later in 1964 for their second appearance on the Ed Sullivan show at the same time Cassius Clay was preparing to fight Sonny Liston for the world heavyweight title. I had the idea to take the Beatles to meet Clay for a photo. They said they wanted to meet the champ, Sonny Liston, not the loudmouth challenger who was going to get beaten. I went to Liston's training gym. He never looked up at me, just kept tying his shoes as I asked if he wanted to meet the Beatles. His answer— "I don't want to meet those bums." ¶ So I got the Beatles in a limousine and off we went to meet Clay, who they think is going to be Liston. Clay had them jumping up, lying down, shouting, "Who's the most beautiful man in the world, who is the greatest." Clay, who was to become Muhammad Ali the day after he defeated Liston, had outdone them at their own game. Afterward the Beatles wouldn't speak to me for several weeks, telling me Clay embarrassed them and it was all my fault. ¶

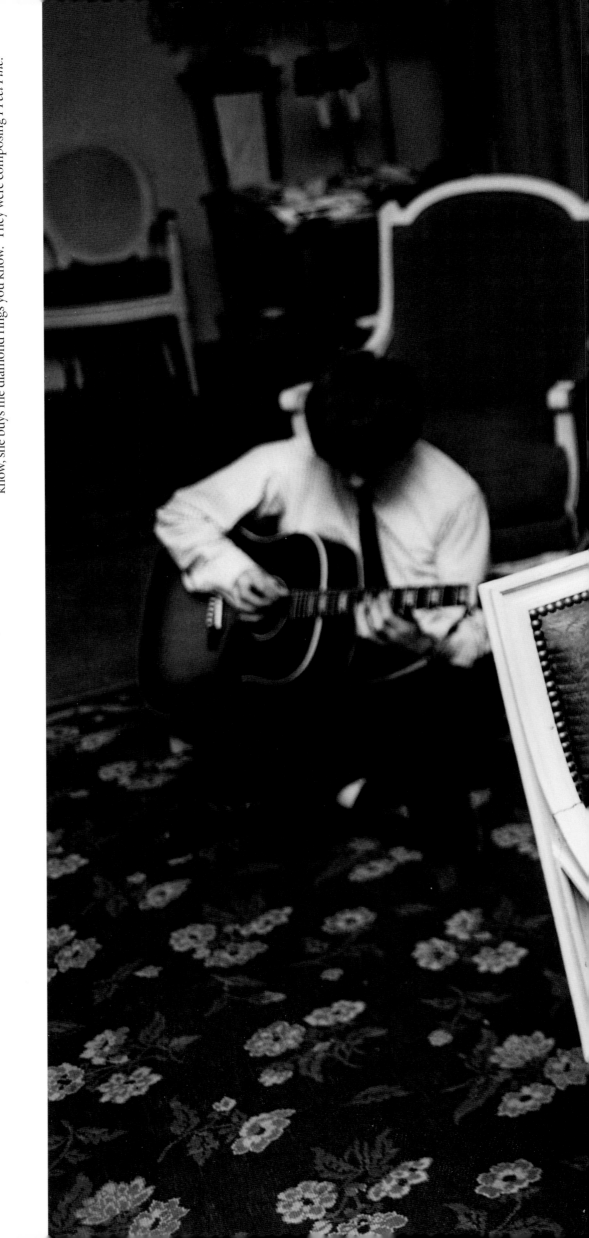

THE BEATLES COMPOSING / HOTEL GEORGE V, PARIS / 1964 — At first nothing much was making sense, but John and Paul quickly became completely engrossed, oblivious to my presence. First the melody, then the words, "My baby's good to me you know, she buys me diamond rings you know." They were composing *I Feel Fine.*

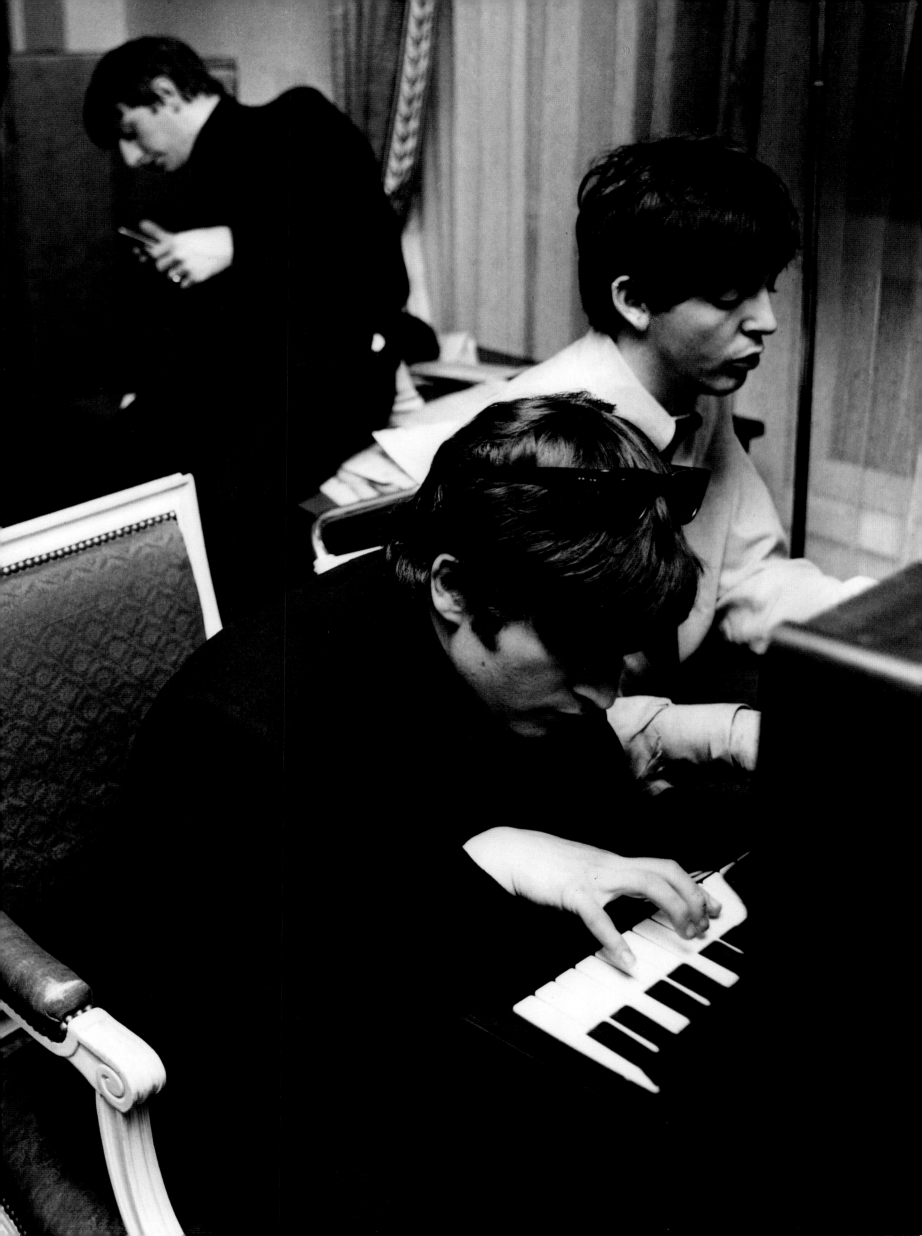

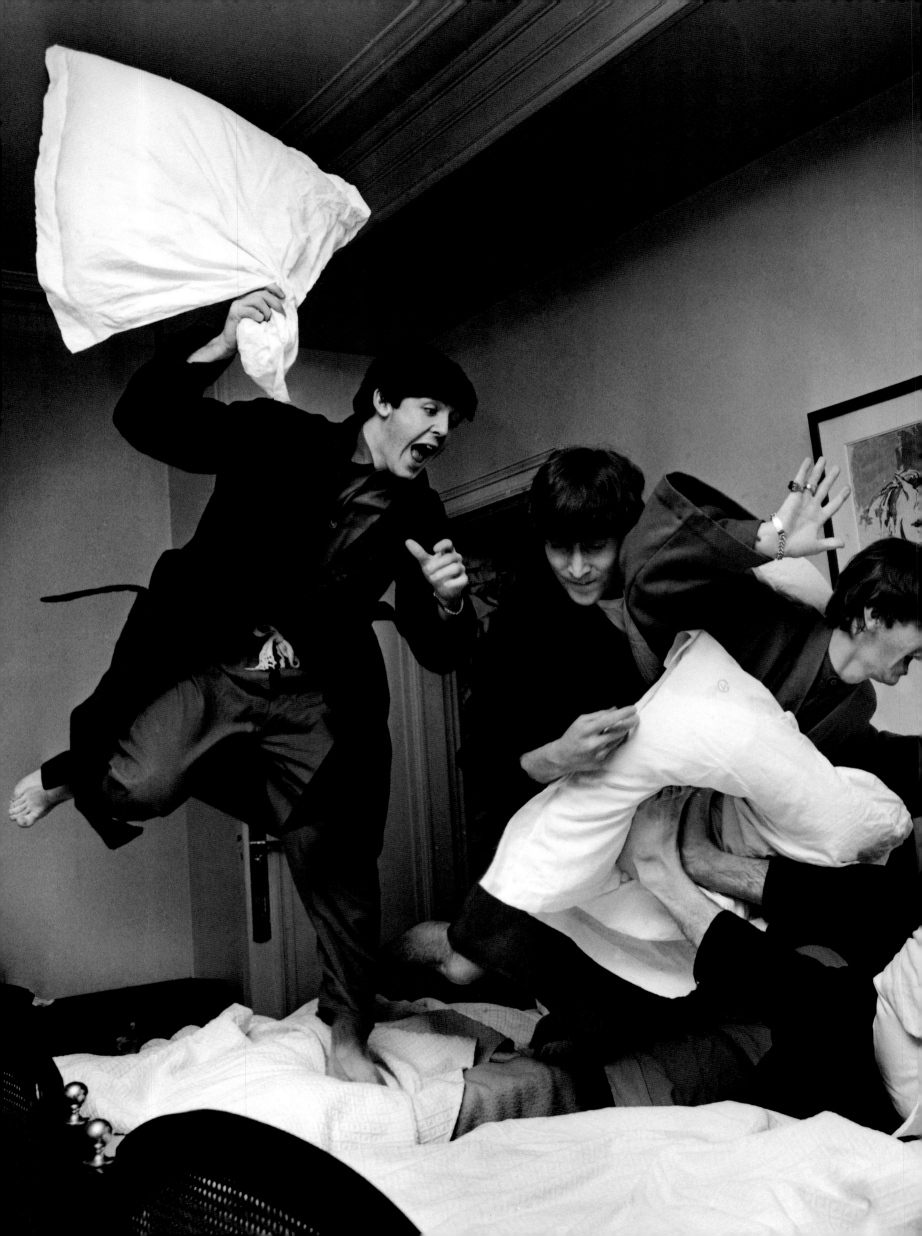

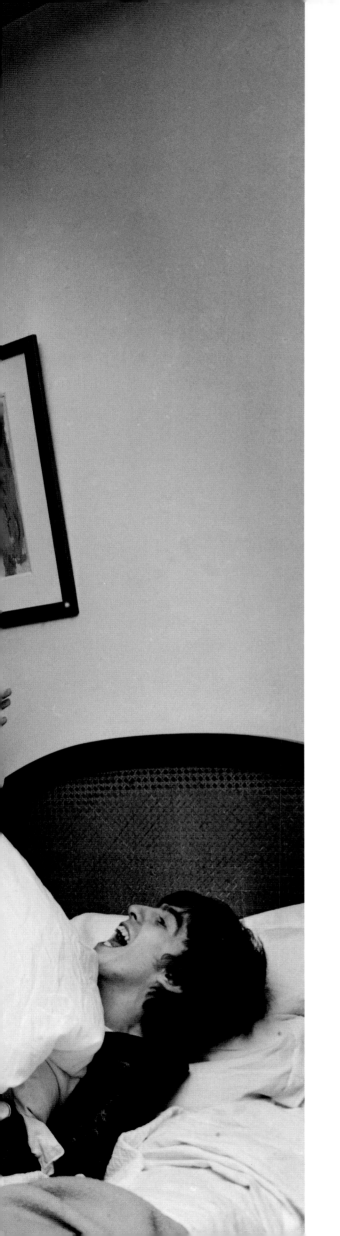

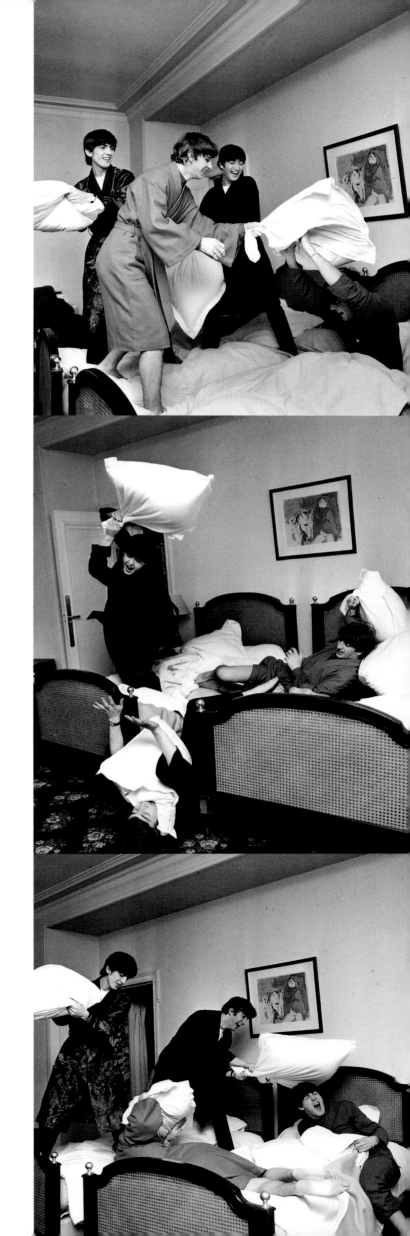

BEATLES PILLOW FIGHT / HOTEL GEORGE V, PARIS / 1964 – At about 3:00 A.M. after a performance, the Beatles' manager, Brian Epstein, came in to tell them "I Want to Hold Your Hand" was number one on the U.S. charts, which meant they would be going to America to perform on the Ed Sullivan Show. They were elated with the news. I had seen them have pillow fights before and when I suggested it, they all said it was a silly idea. Then John sneaked up and hit Paul in the head and the fun began.

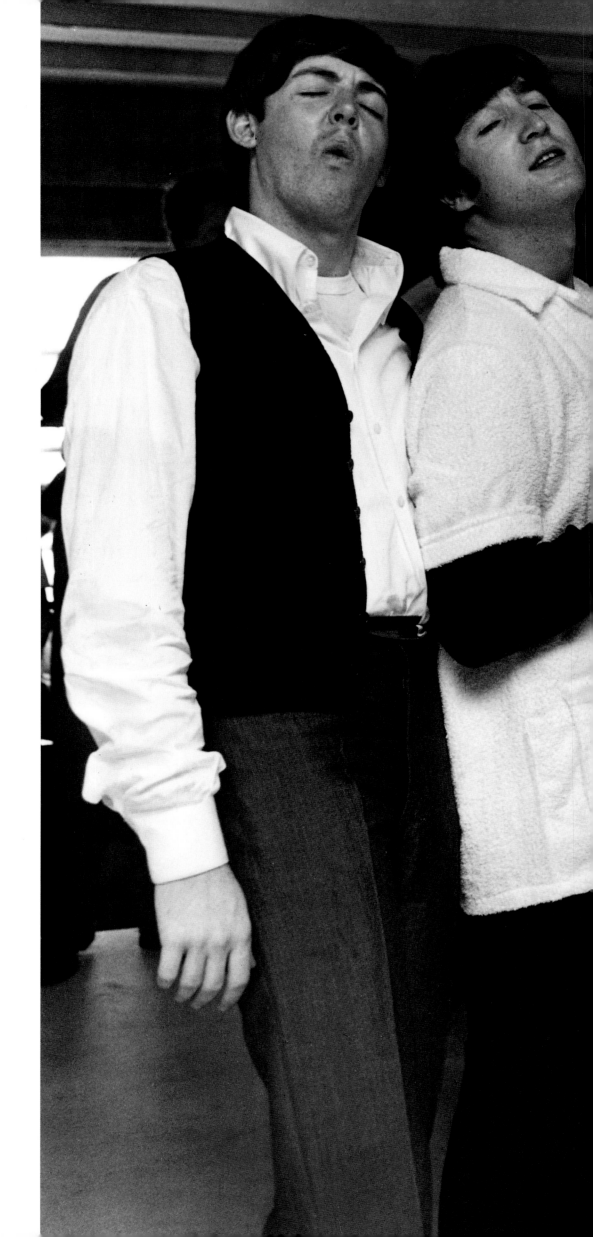

THE BEATLES WITH CASSIUS CLAY / MIAMI / 1964 – Before their second Ed Sullivan Show appearance, I took the Beatles to meet Clay, who was training for his upcoming title fight against Liston. Clay ordered them around, shouting, "Who's the most beautiful?" and "I'm the greatest," and literally beat them at their own game. They were annoyed with me, to say the least.

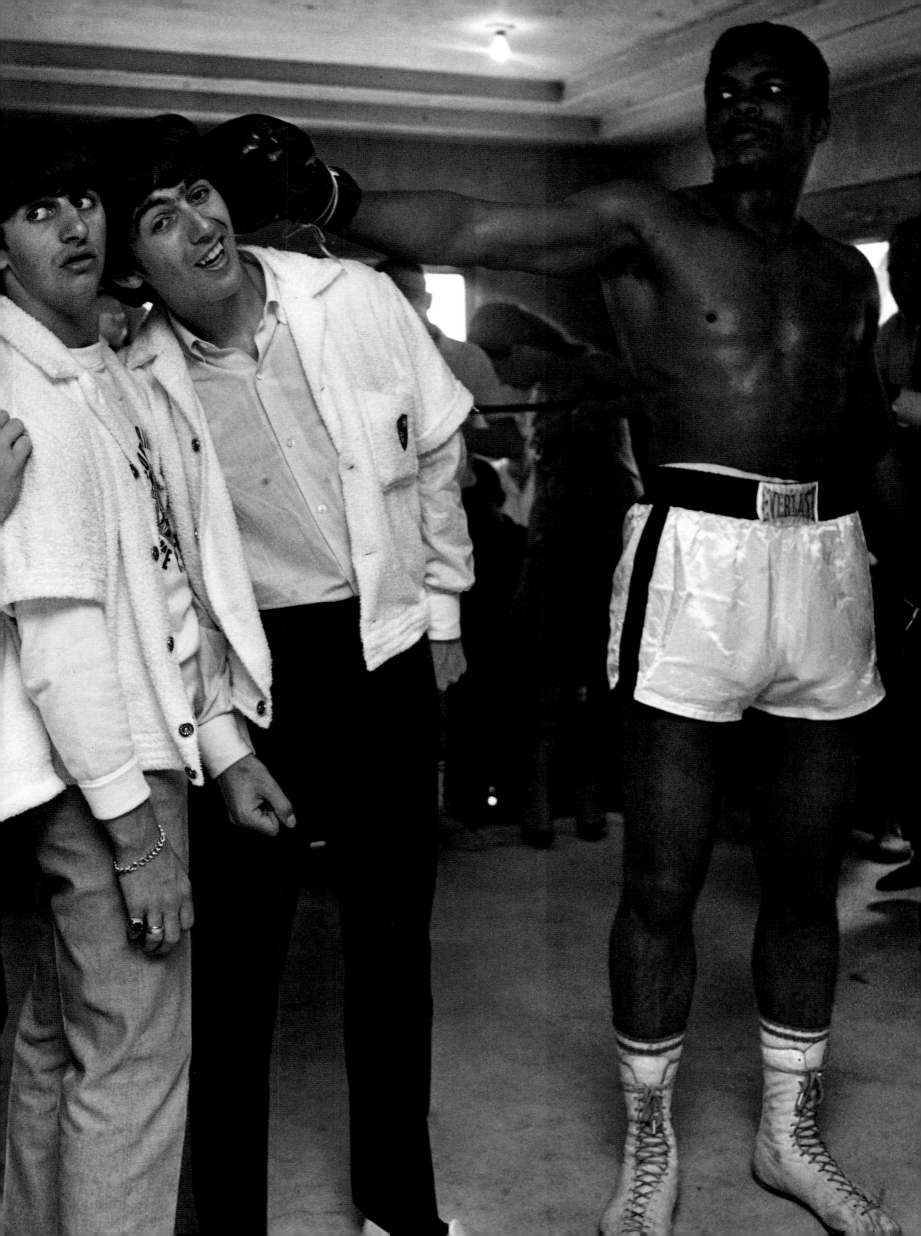

SONNY LISTON / MIAMI / FEBRUARY 1964 — World heavyweight boxing champion Sonny Liston sits in defeat in his corner after failing to come out for the seventh round in his first title fight against Cassius Clay. Legendary boxer Joe Louis can be seen directly behind Liston's head. Clay performed as he predicted he would: "Float like a butterfly and sting like a bee."

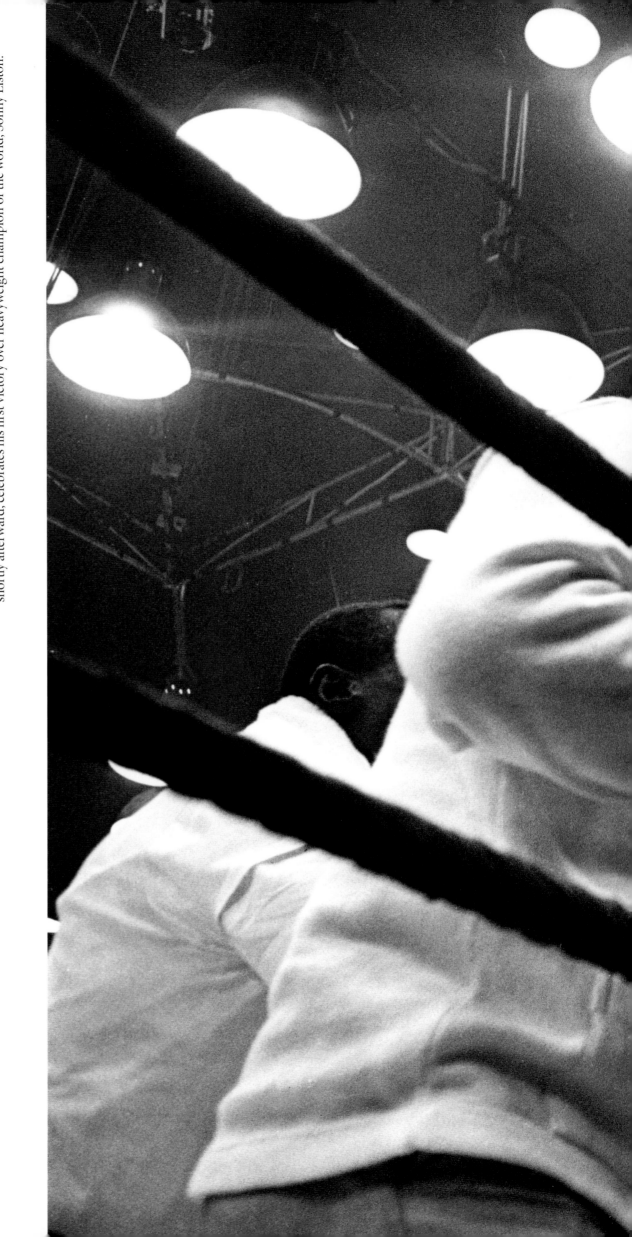

CASSIUS CLAY / MIAMI / FEBRUARY 1964 – Cassius Clay, who would change his name to Muhammad Ali shortly afterward, celebrates his first victory over heavyweight champion of the world, Sonny Liston.

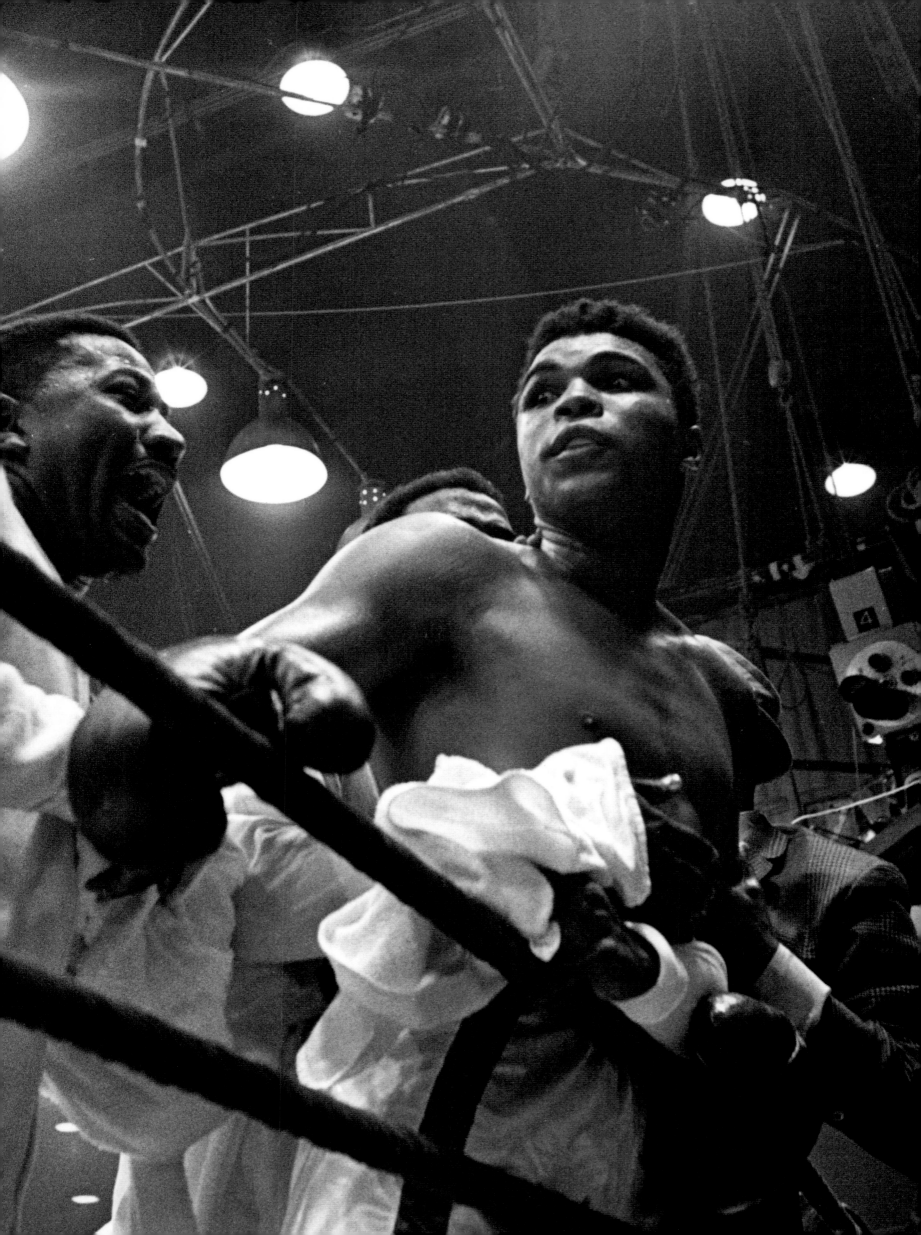

IAN FLEMING / JAMAICA / FEBRUARY 1964 – Author of the James Bond novels, Fleming was at his home "Golden Eye" in Oro Cabeso. The first James Bond film was becoming the rage. Fleming told me Sean Connery was too coarse and unsophisticated to be James Bond. The nearest he could envision was David Niven in the part. Fleming, an ex-journalist, had been in British intelligence during World War II.

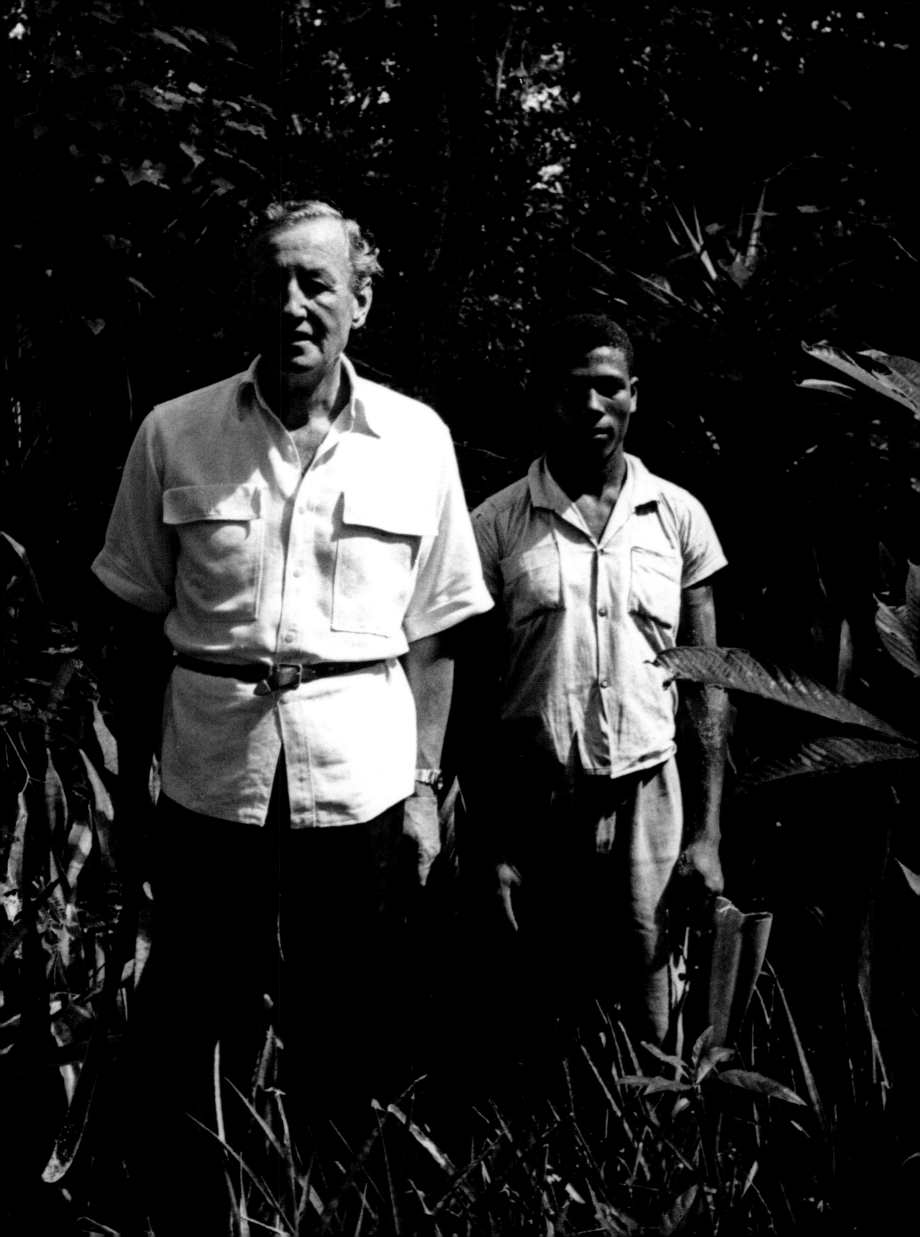

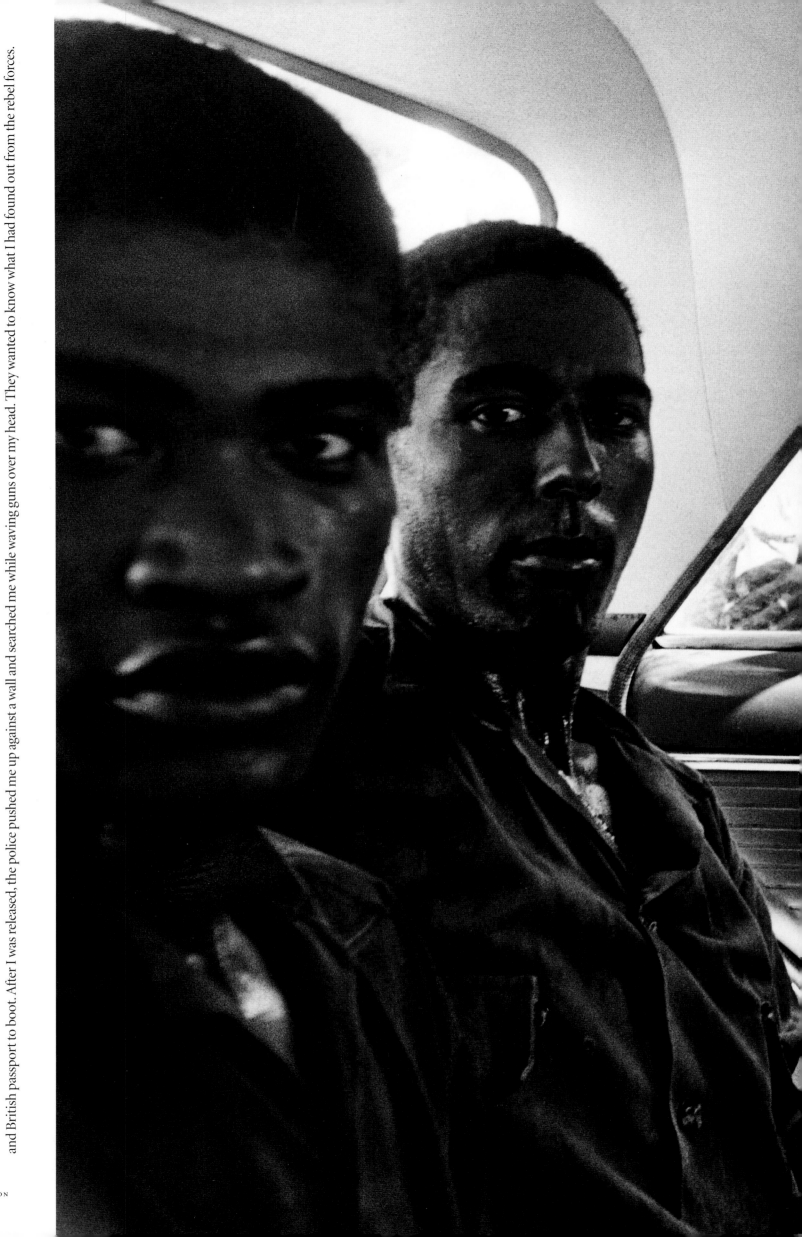

DOMINICAN REPUBLIC / MAY 1965 – During the civil war in the Dominican Republic, which led to the island becoming an internally self-governing state in 1967, I was captured by both sides in one day. Rebel guns were pointed into the car in which I was riding and I was marched away amid cries of "American spy." My Scottish accent got thicker and thicker as I explained who I was, flashing my press pass and British passport to boot. After I was released, the police pushed me up against a wall and searched me while waving guns over my head. They wanted to know what I had found out from the rebel forces.

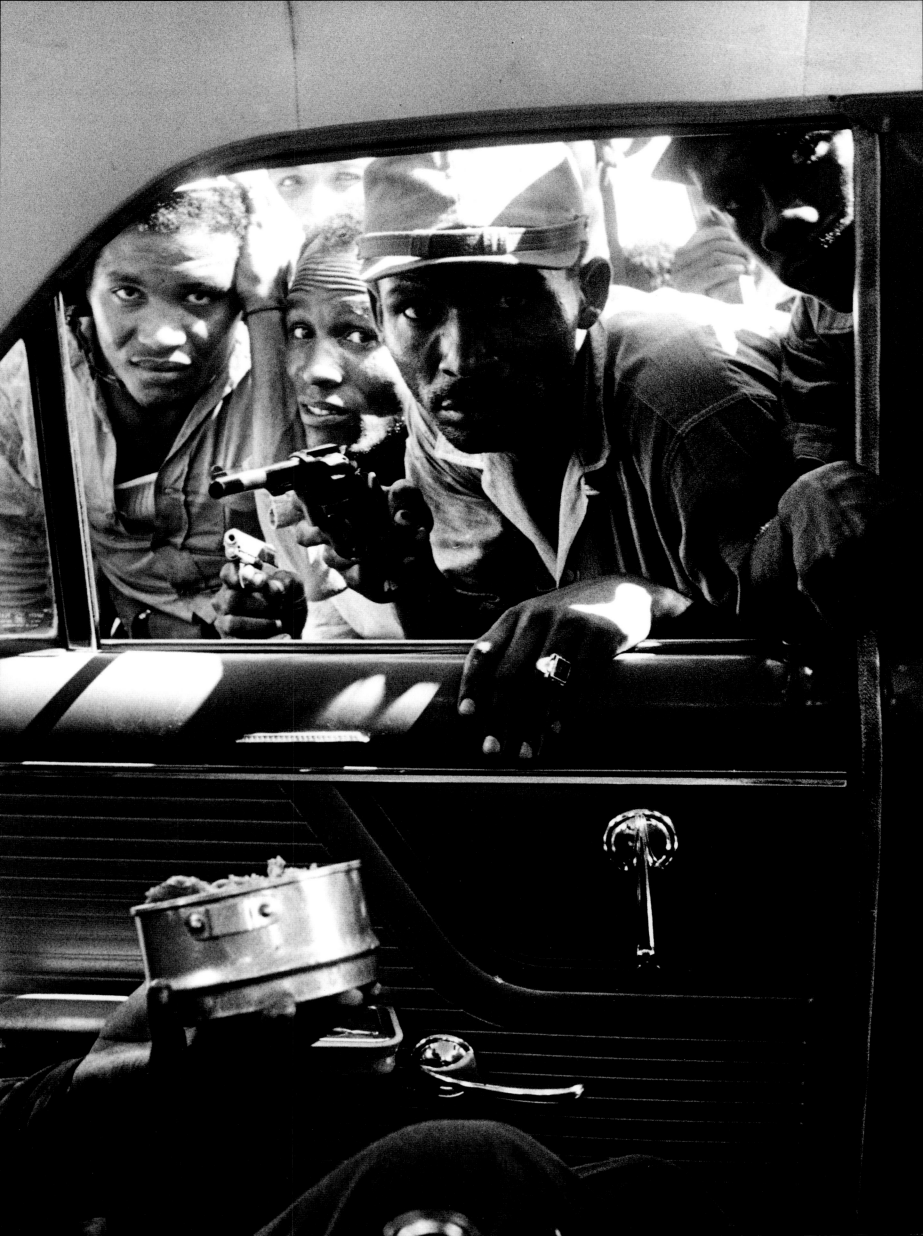

a dangerous job

The terrible Watts riots . . . six scary days in the summer of August 1965. I picked Harry up at the Los Angeles airport. Although it was almost sundown Harry insisted on heading straight to where the action was. It was a war zone, a surrealistic scene: shops were raging infernos; looters ran wild in the streets, racing out of stores carrying armchairs and TV sets. Snipers were all over the place firing at anyone and anything that moved. ¶ Harry had to make a picture. The editors in London had their deadlines. I was crawling on my hands and knees in some of the most dangerous areas. Gunfire came from rooftops, smashing into the sidewalk and shop windows. But Harry must have thought he was encased in bulletproof armor from head to toe. I thought he'd gone mad. It was almost as if he had willed that no mere sniper would stand in the way of his getting his pictures. ¶ Raw and novice young National Guardsmen had been flown in to keep the peace and stop the violence, and one, seeing this fellow with his hair flying and his camera clicking away, warned him, "Get the fuck out of here." In the early hours of the morning I dropped Harry at his hotel. I was exhausted and in shock; he was exhilarated. Harry had delivered and his London editor was thrilled.

—Ivor Davis, West Coast correspondent, *Daily Express,* 1964–77

WATTS RIOTS / LOS ANGELES / 1965 – Prowling the streets with police sirens wailing and buildings smoldering around me, I came across this scene in the early hours of the morning.

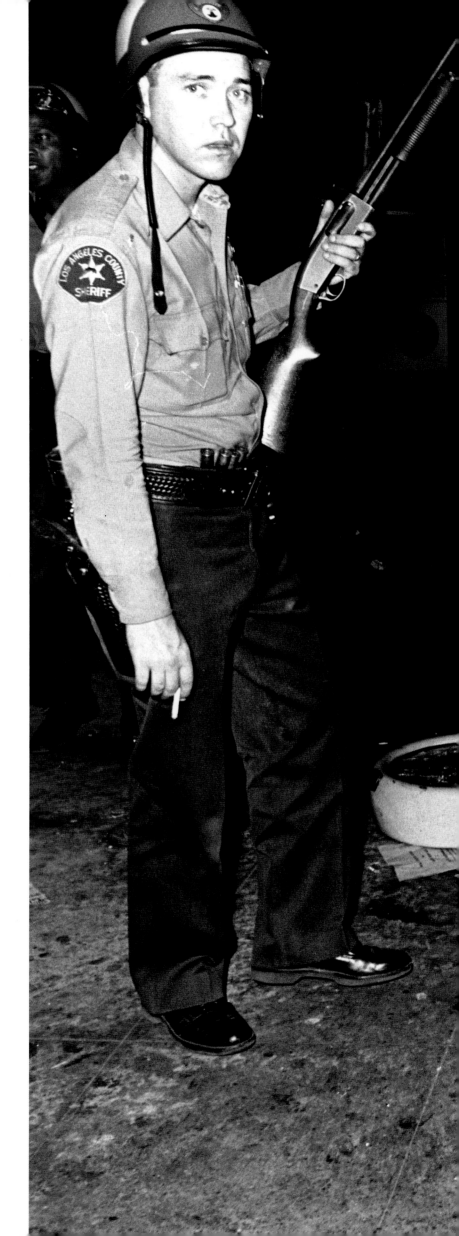

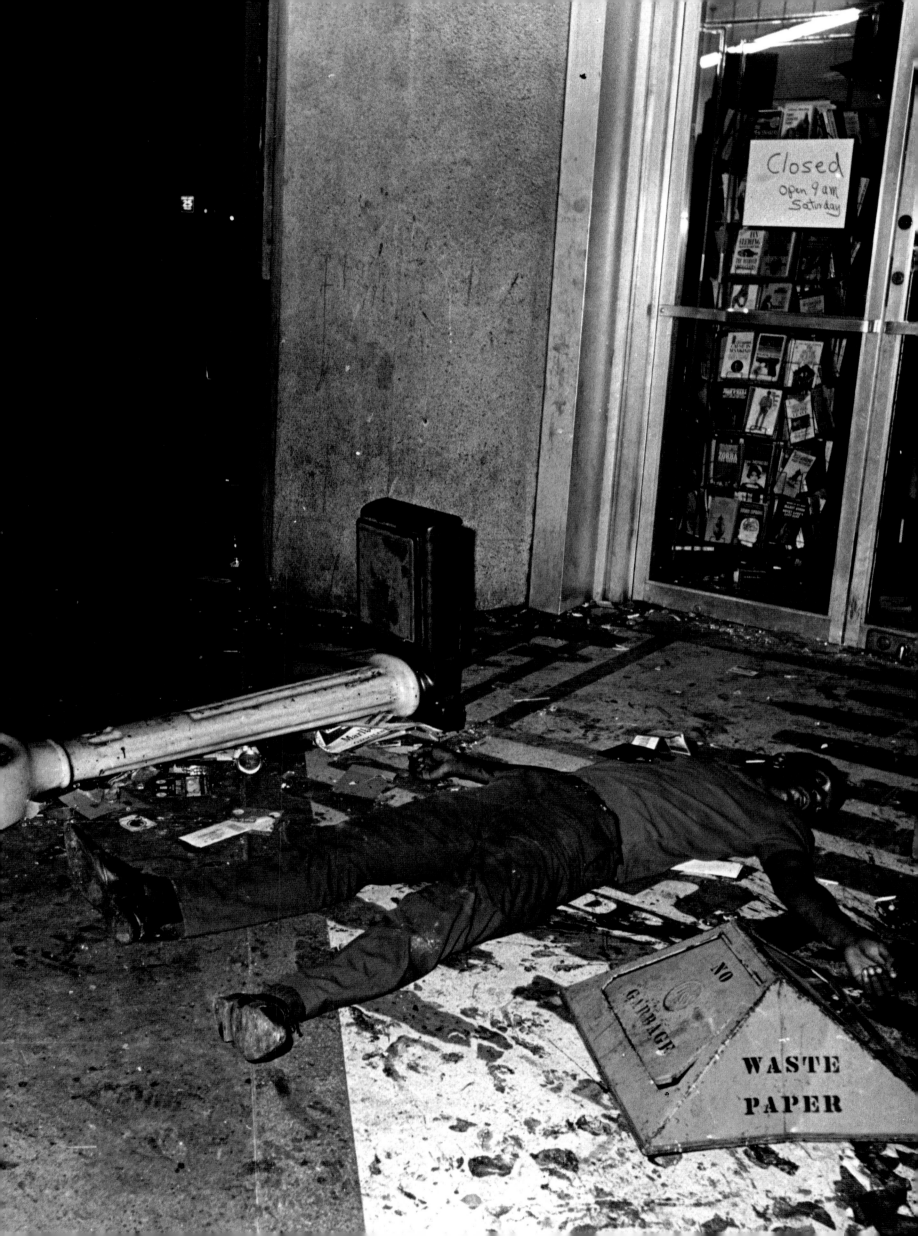

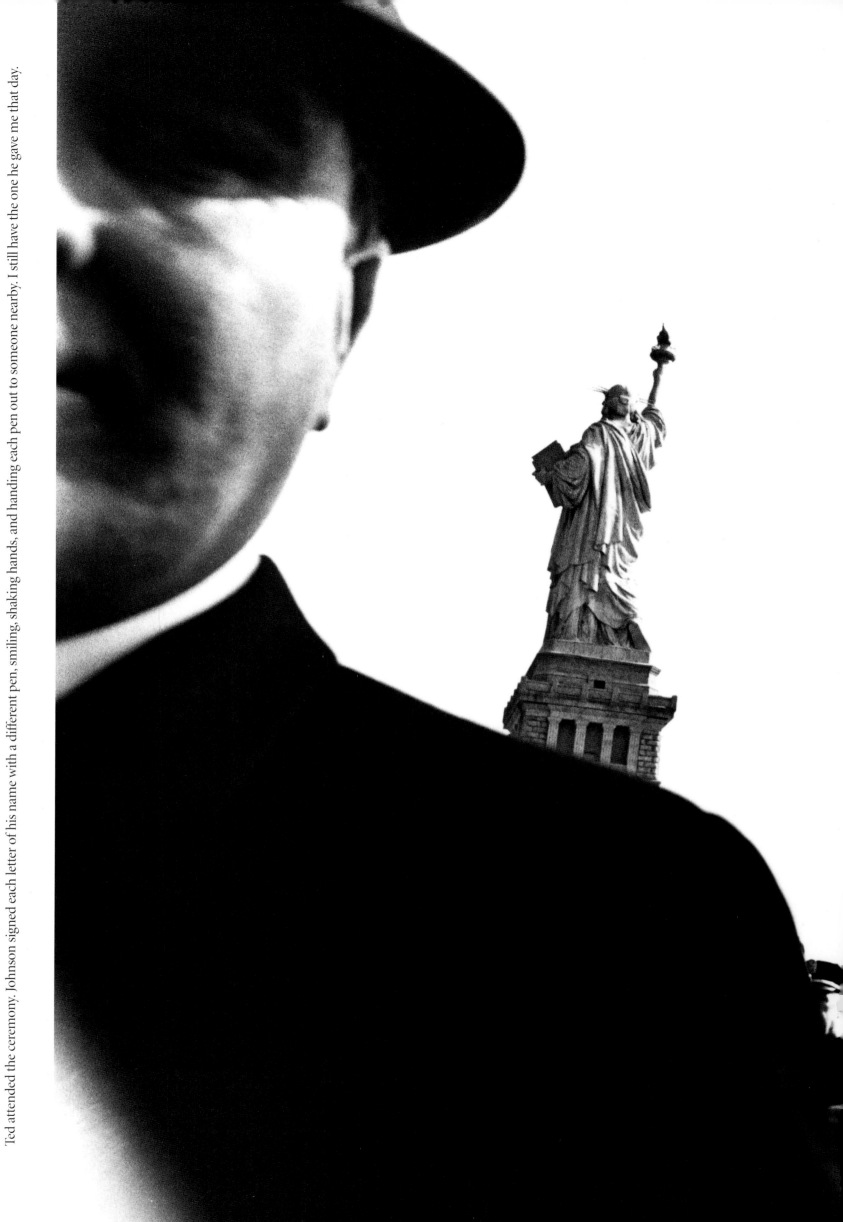

PRESIDENT AND MRS. LYNDON BAINES JOHNSON / NEW YORK / OCTOBER 1965 — President Johnson had just signed a new immigration bill at the foot of the Statue of Liberty. Robert Kennedy and his brother Ted attended the ceremony. Johnson signed each letter of his name with a different pen, smiling, shaking hands, and handing each pen out to someone nearby. I still have the one he gave me that day.

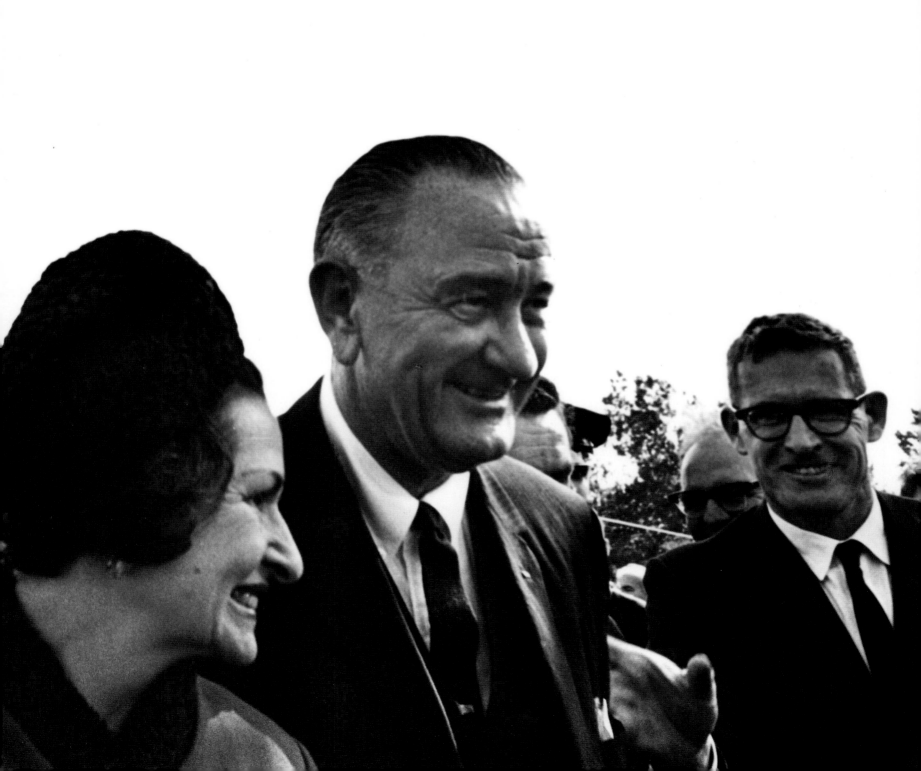

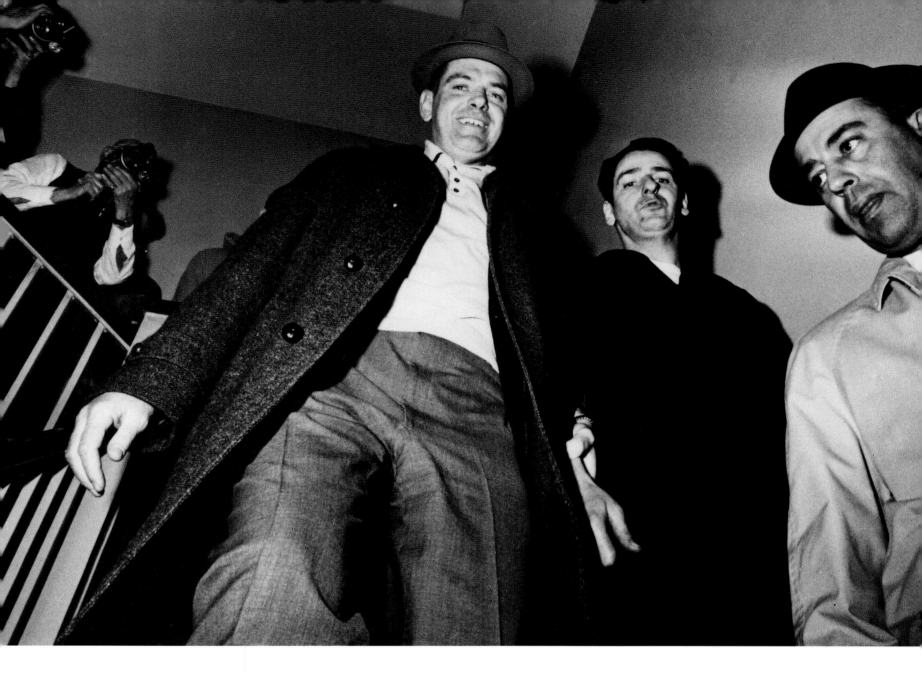

on assignment in america

Working with Harry was a roller-coaster of a ride. Our assignments went from the sublime to the ridiculous, and some of them nearly ended in disaster. One such occasion was when Jim Clark, a Scot like us, won the famous Indianapolis 500 car race in 1965. I wrote the words, Harry got the shots he wanted and wired them to London to await further instructions. ¶ Clark planned an evening celebration and we expected to be there but, to our surprise, the acting Bureau Chief in New York at that time instructed us to return to base immediately. The planes were full and I suggested the overnight train. Not a good idea. It was a miserable, long journey but worse was to follow. We were met at Penn Station by our rotund and excitable office assistant, George Valinotti, and I can still hear his words: "You guys are in trouble. You should have stayed in Indianapolis. London wants you back there . . . NOW." ¶ A rented limousine rushed us to LaGuardia just in time to catch the connection. We decided not to call London to check in; we knew temperatures would be running high. We got a message from Foreign Editor David English (later Sir David, who became editor of the *Daily Mail*) that we should compose a photo montage to illustrate all the

THE BOSTON STRANGLER / LYNN, MASSACHUSETTS / 1966 – Albert De Salvo, known as the Boston Strangler, had escaped from a mental institution near Boston. After several days a report that he had been seen was broadcast. It was a Saturday morning and I got on the first flight to Boston, rented a car, and started out. I got lucky: I was lost and caught in horrendous traffic, but when I asked someone on the street what was wrong, I learned that the police had just caught him in a nearby shoe store dressed as a sailor. When I eventually arrived at the Lynn police station, De Salvo was being led to a cell by the policemen who had captured him.

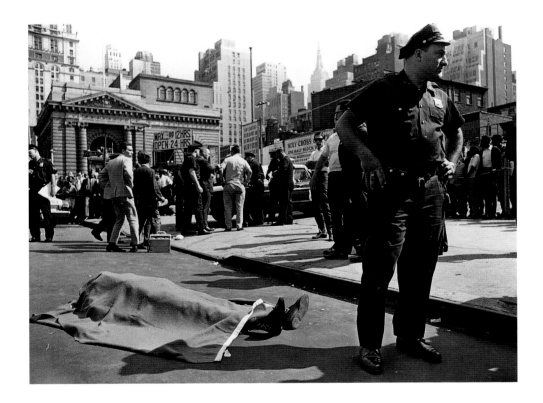

CORPSE / NEW YORK CITY / AUGUST 1965 – As my colleague Andy Fyall and I left our office in the old Herald Tribune building for lunch on a hot New York summer's day, we happened upon this scene on West 42nd Street near Seventh Avenue.

goods that Clark had won, apart from the money and the race. These ranged from a car and new suits to shoes, free petrol for a year, and a whole lot more. Even a year's supply of milk. ¶ Harry and I, with the support of the local tradesmen, assembled all the goods in a supermarket car park on the banks of the Wabash, and Harry even persuaded a local farmer to lend us a cow to represent the gift of milk. ¶ That was when the fun began. ¶ Unfortunately, or perhaps it was just as well, Jim Clark declined to take part, but we went ahead without him. The picture was all set up, Harry perched high on a stepladder, when the cow went berserk. The farmer couldn't hold it as it broke free and stampeded through our carefully planned set. ¶ When peace was finally restored and the air no longer blue, Harry got his picture. Unfortunately, the *Express* didn't: the news agency wiring the pictures sent ones of the pop group Herman's Hermits instead.¶ The following year, as the *Express* reduced the size of its foreign offices, I returned to London. Harry resolutely refused to go back. He knew where his future lay. ¶ It was the best decision he ever made.

—Andrew Fyall, chief American correspondent, *Daily Express,* 1960–66

JOHN LENNON / CHICAGO / 1966 — After an interview with British journalist Maureen Cleave in which Lennon said the Beatles were more popular than Jesus, an uproar ensued. People burned Beatles' records in the Bible belt, D.J.'s refused to play their records, and stores stopped selling them. I was told to get to Chicago as quick as I could. Lennon was very upset and tears welled up when he said, "Why did I open my big mouth, why did I do it? I didn't mean it." The other Beatles were quite annoyed. He made a formal apology. Later he was much more cocky about it. And, of course, some people think he was right.

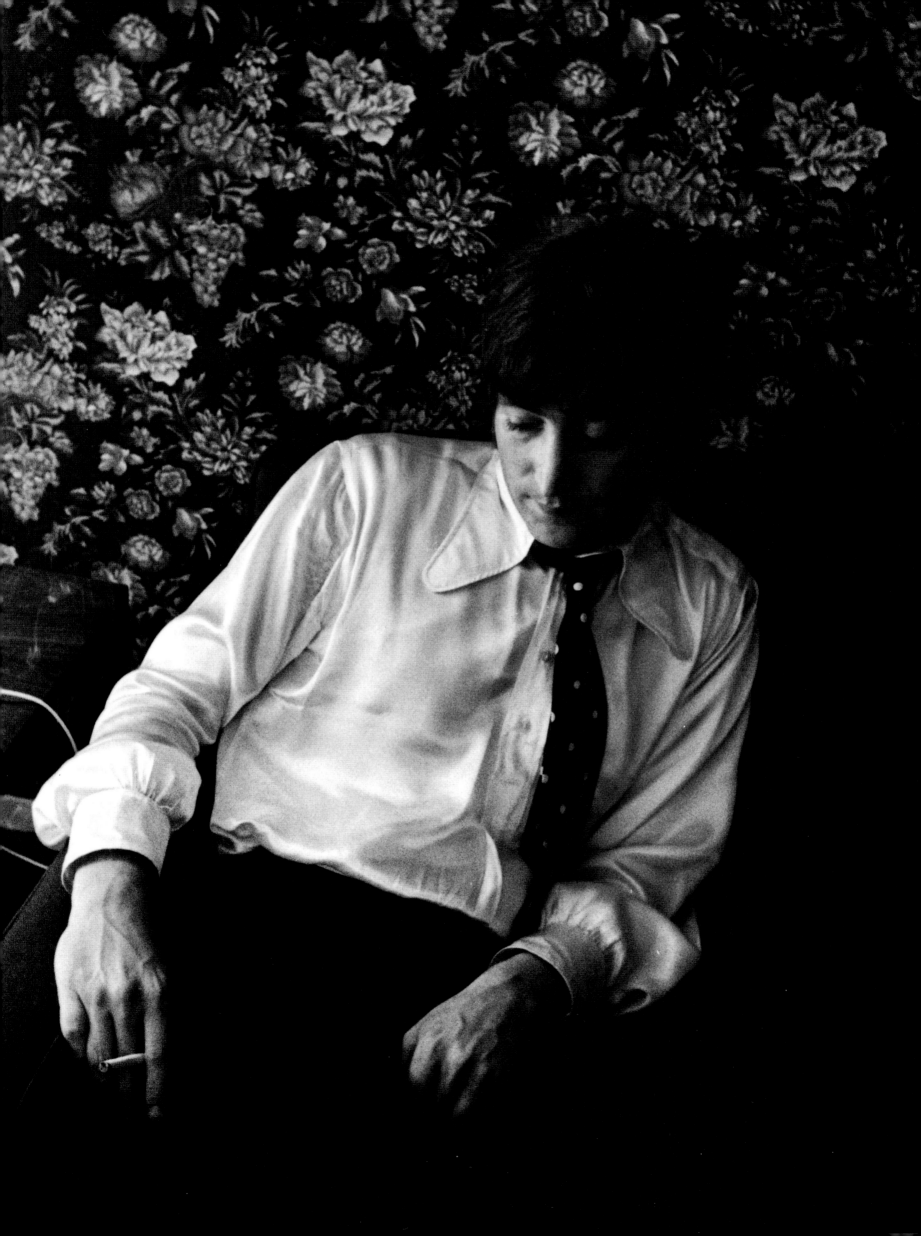

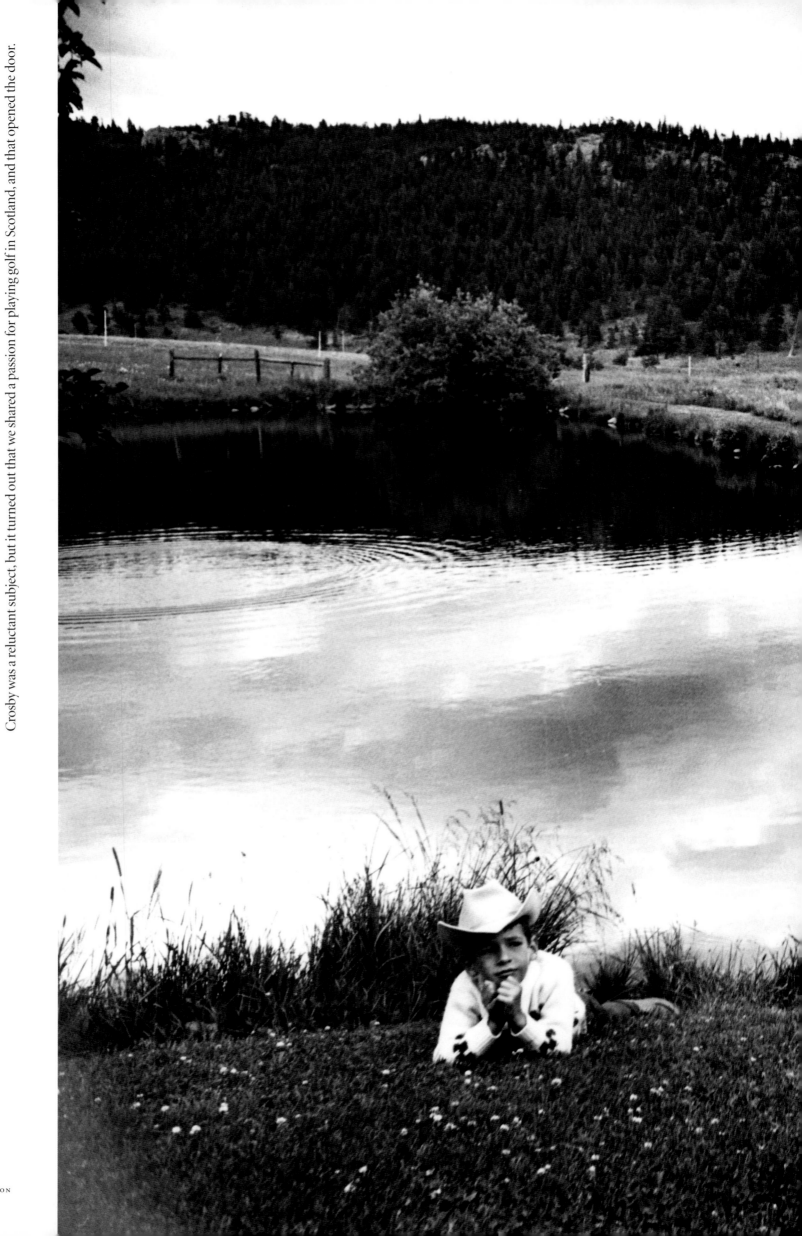

BING AND HARRY CROSBY / COLORADO / APRIL 1965 – Bing Crosby was in Colorado to star in a remake of the film *Stagecoach.*

Crosby was a reluctant subject, but it turned out that we shared a passion for playing golf in Scotland, and that opened the door.

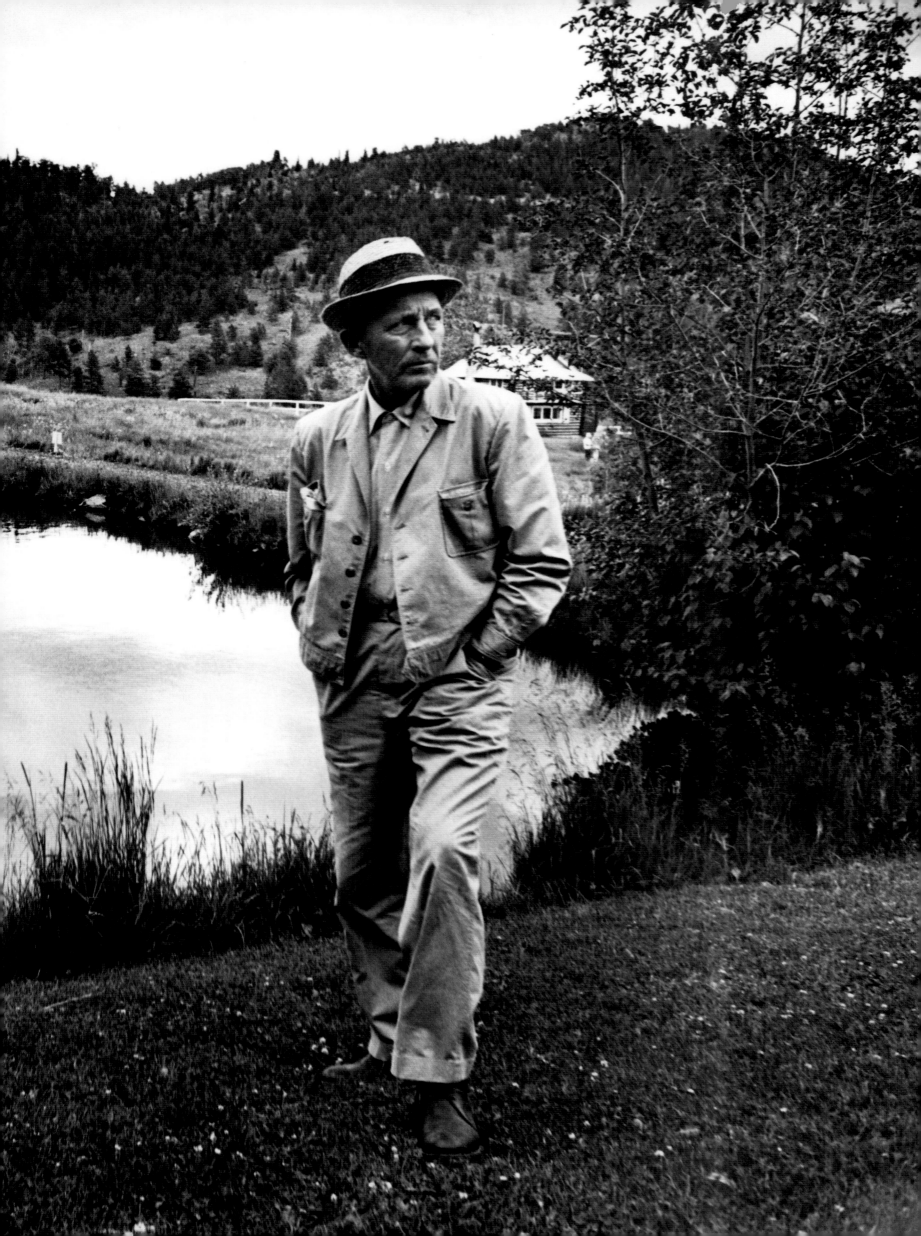

RONALD REAGAN / LAKE MALIBU, CALIFORNIA / NOVEMBER 1966 – Reagan had just announced he was running for governor of California. With him for a barbecue at his ranch to launch his campaign were his wife, Nancy, and several of his actor friends, including Andy Devine, Slim Pickens, Walter Brennan, and Robert Taylor. It was the first time I photographed the future President of the United States.

JAYNE MANSFIELD / TAMPA, FLORIDA / 1965 – Some photographs happen in a round about way. I was in Florida for actor Jordan Christopher. He had recently married Richard Burton's ex-wife, Sybil, whom I had known from London and who owned the private club of the moment in New York, called Arthur. Anyway, Jayne Mansfield was there to make a film with Christopher. No press agents or managers to negotiate with, no hassle, just a simple photograph of a major sex symbol who was happy to oblige.

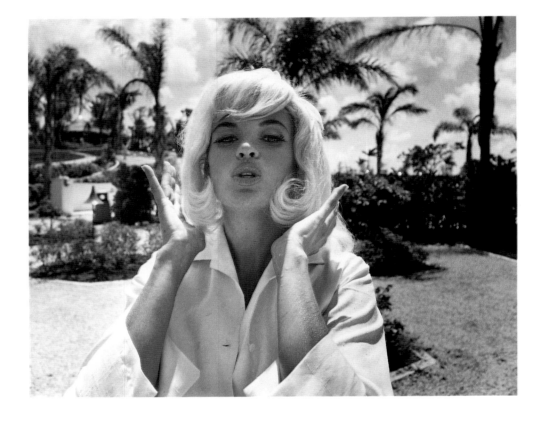

TEDDY KENNEDY / NEW YORK CITY / CIRCA 1966 – I was at a new club in New York one night. Several well-known New Yorkers were there and I noticed Ted Kennedy sit down for a chat after leaving the dance floor.

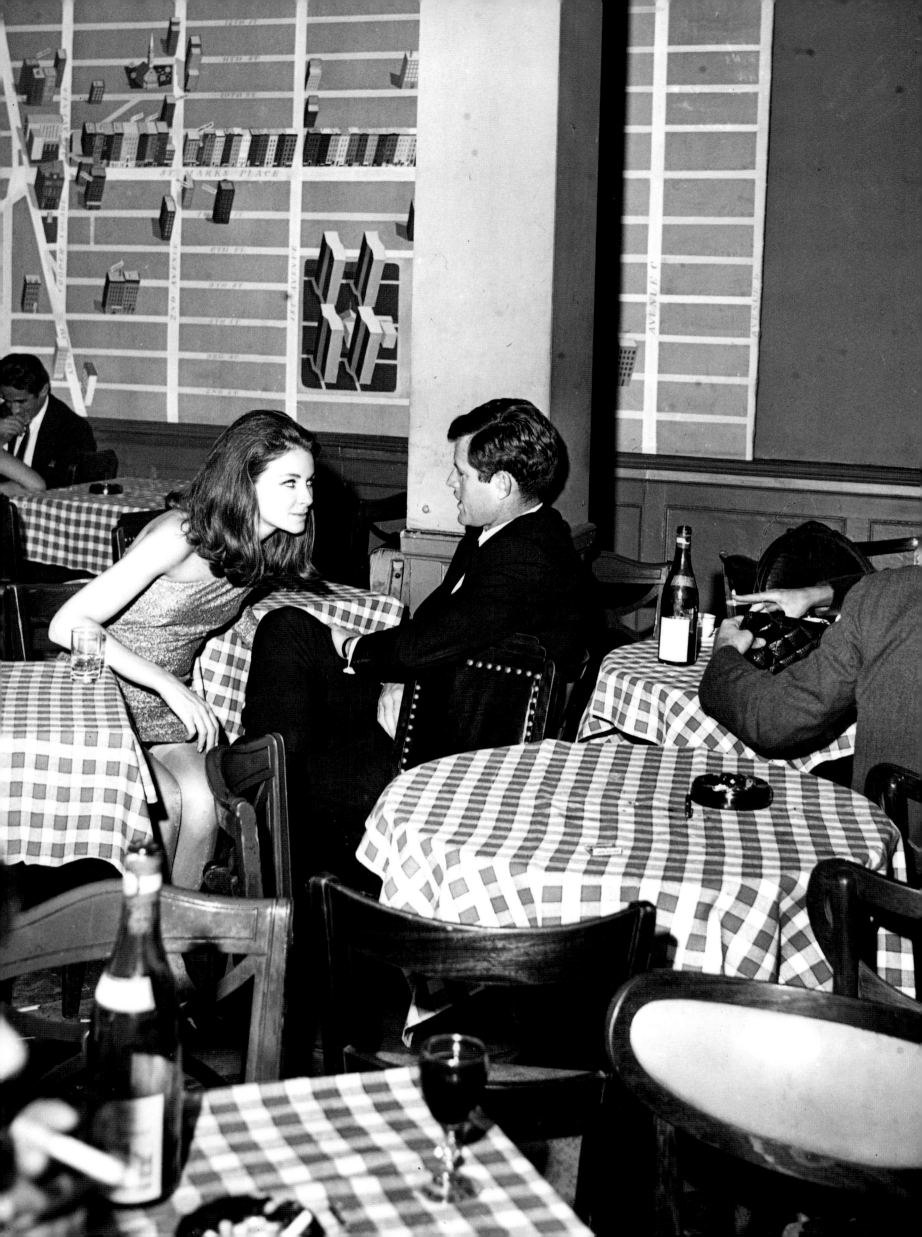

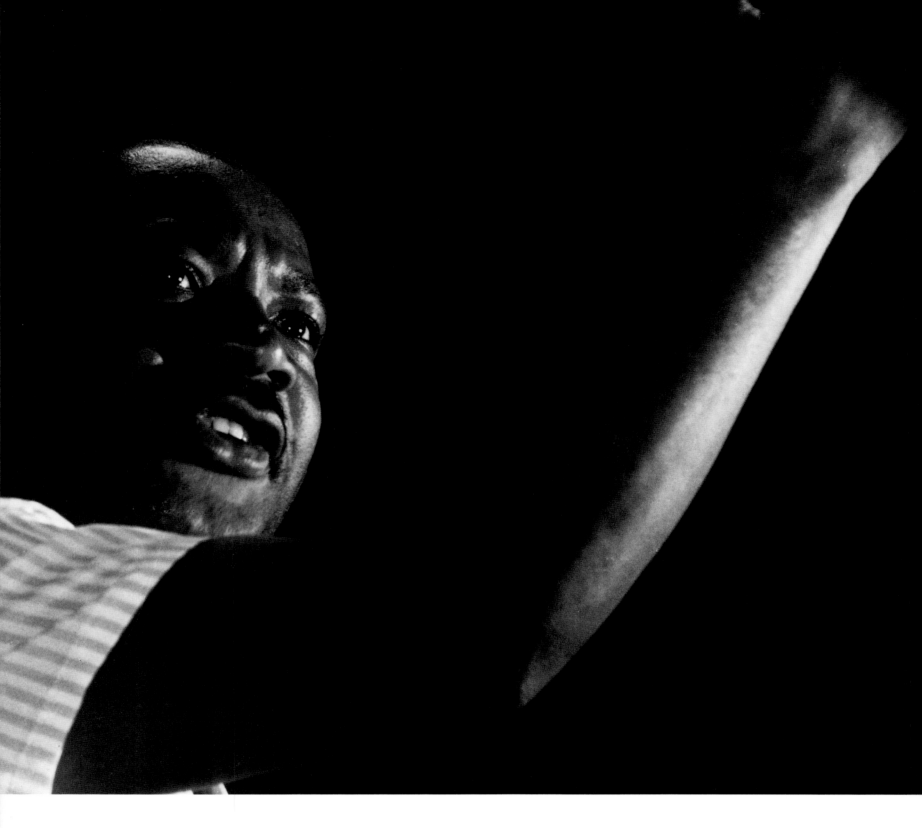

on the march

James Meredith's Freedom March in Mississippi in 1966 was one of the things I am glad I covered. I think the reporters who marched

alongside must feel the same. When we were marching there were no more than eight or ten from the press. That is nothing. Think of

what it would be like today . . . hundreds would be there. ¶ At night the marchers would stop and pitch tents to sleep in. One night Stok-

ley Carmichael of the Student Nonviolent Coordinating Committee, the more aggressive arm of the Civil Rights movement, came

round. He gathered a bunch of kids around him and said, "When I say 'What do you want,' I want you to answer, 'Black power.' " It became

the anthem of the Civil Rights movement, and it was in that circle that it started. I remember Carmichael telling the men and women at

one rally not to go to work the next day, to boycott work as a show of power. Martin Luther King, Jr. jumped up and interrupted, putting his hands in the air and telling them, "No, go to work. You've got to live, but what you've got to do is register to vote. That's where your real power is." ¶ Each night I would go to some dingy motel and develop the day's take in the bathroom, shut in there with an enlarger. I had to blackout the room and put on a red light I had brought with me. The heat was stifling. Outside it was over one hundred degrees, inside it was a virtual sauna. I splashed about with the chemicals and would come out with a few prints that I would transmit on a portable machine I hooked up to the telephone in my room. It went beep-be-be-be-beep over and over. If Vic Davis, the reporter on the march with me, called in the middle of a transmission with a "hello, old boy," I'd have to start over. That part of the job was maddening. It took hours, sometimes all night. And we thought we were on the cutting edge. It was definitely not instantaneous e-mail. ¶ One morning about 6:00 A.M. the sun was just coming up and there was a knock on my door. The woman who owned the motel was standing there with two highway patrolmen who wanted to know what I was doing. They thought I was a spy from Russia or something. I showed them. They had never seen anything like it in their life. I let them see my press pass and they left. ¶

MARTIN LUTHER KING, JR. / CANTON, MISSISSIPPI / 1966 – There is one thing I learned about covering demonstrations and protests. When the police throw tear gas, it does disburse the crowd but the protesters always become enraged. In a church about an hour after we were all teargassed, Dr. King had never seemed so angry. I was sitting at his feet as he stood on the stage, and he said to me, "It's really terrible being black in this country."

KU KLUX KLAN MEETING / BEAUFORT, SOUTH CAROLINA / MAY 1965 – I had an appointment to meet the Imperial Wizard of the KKK, Bobby Shelton, in a diner in Tuscaloosa, Alabama. I was sitting at an empty table, the place was crowded, and people were looking at me in a strange way. In walked Shelton, greeting everyone. Later, in his hotel room, he showed me a gun that he claimed had been used to kill Viola Liuzzo, a white civil rights worker who had come down from Detroit, and he invited me to a rally that I attended later that week. In those situations you should not overstay your welcome, to say the least. I made it known that I was from Scotland, and that seemed to be a plus. What surprised me is that women with their infants were there. I couldn't believe that this type of pagan ritual with burning crosses could go on in a civilized society.

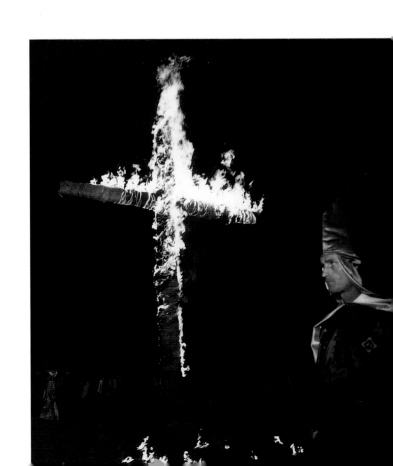

MEREDITH MARCH / MISSISSIPPI / 1966 — A regular scene on the Meredith march: onlookers would mock the marchers, waving Confederate flags and playing the anthem "Dixie." The marchers were told to ignore the heckling. Actually it is quite amazing that no one was killed when a Klansman drove his car straight into the group—sending them diving to either side of the road.

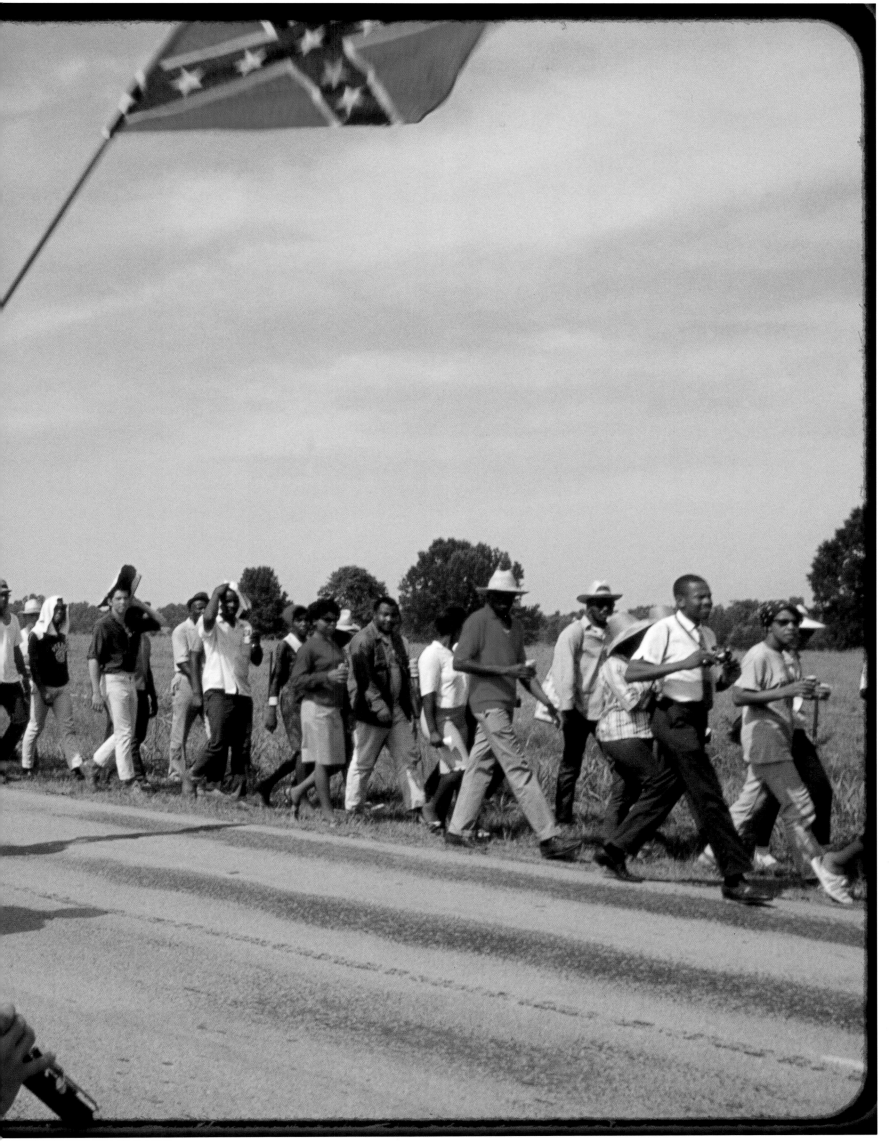

infamy

We came to the little town of Canton, Mississippi, where sweet music played from speakers in the main square. It seemed a nice place—for five minutes. Here, the white governing board of a black college had refused permission for the marchers to sleep that night in two tents on the school grounds. ⁋ The town attorney called in the National Guard to prevent this infamy from taking place. We British journalists went to see an official and said, "Look, what harm will it do? You don't want your nice town besmirching its name, placing itself alongside Selma and Little Rock." ⁋ "Nope. We're gonna do it," he said. "They try to sleep there, they're gonna get driven off." ⁋ And he was as good as his obdurate word. The cloud from the Guardsman's tear-gas grenades enveloped men, women, and children, including babes in arms, without distinction. I got upwind and suffered only a whiff of the disgusting stuff—manufactured at a Federal arsenal—that chokes and burns wherever on your body you sweat. ⁋ Harry, who'd plunged in close to the panicking marchers to get his pictures, disappeared. I looked everywhere in the chaos. Eventually, two schoolteachers found him collapsed in a garden, retching and choking. Around us, distinguished American journalists from New York were literally crying not only from the tear gas but from the shame that these events were heaping upon their country. ⁋

—Victor Davis, roving American correspondent,
Daily Express, 1966–69

TEARGASSED CIVIL RIGHTS MARCHERS / CANTON, MISSISSIPPI / 1966–
I was luckier than most of the marchers: A young policeman looked me in the eyes and just tapped me lightly with his baton. Afterward two schoolteachers helped me into their home and gave me some water.

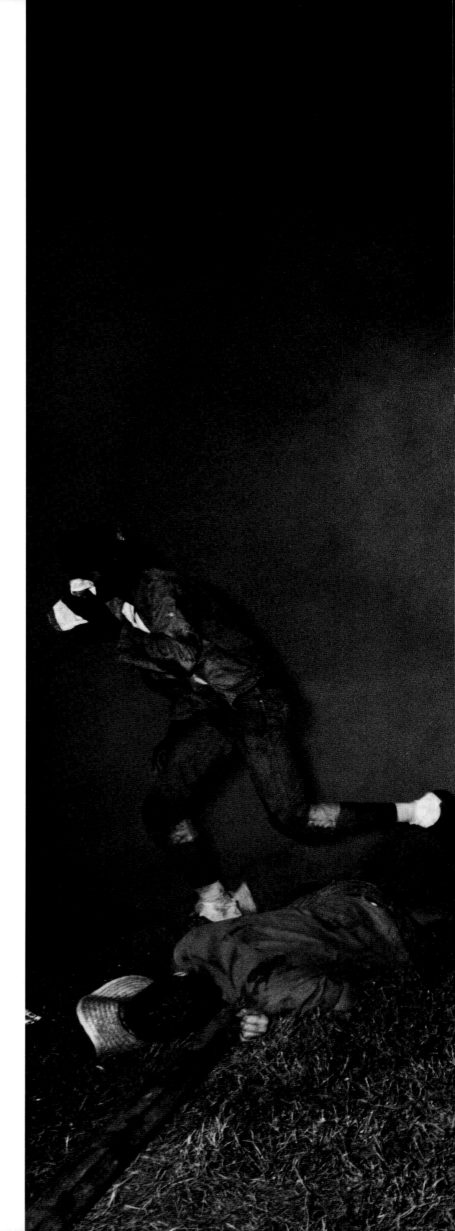

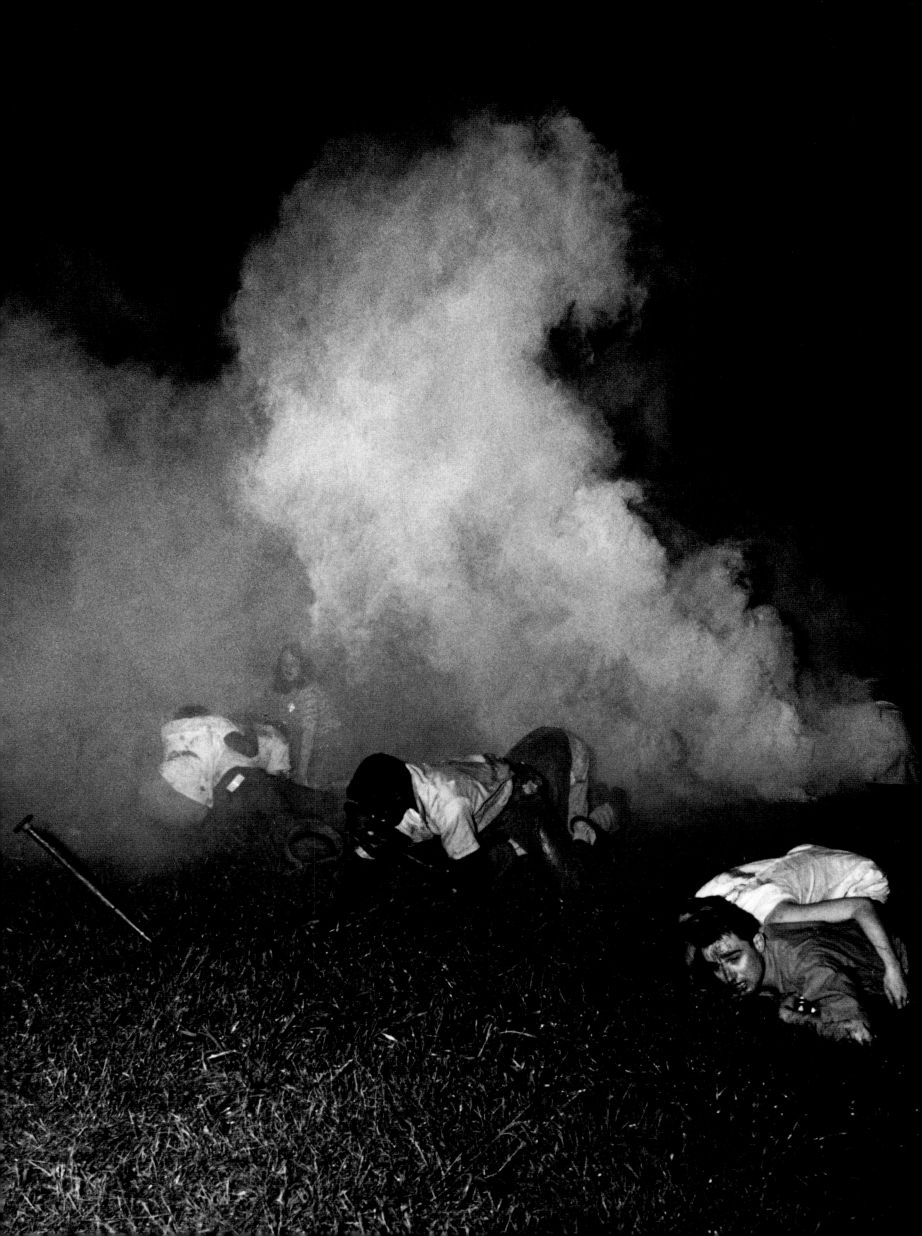

BOBBY KENNEDY AT THE ST. PATRICK'S DAY PARADE / NEW YORK CITY / 1968 – Bobby Kennedy announced he was running for President on St. Patrick's Day in 1968, and he marched up Fifth Avenue in the parade. People wanted to touch him and he would dive into the crowd and shake hands. At one point, he looked up, pointed his finger, and smiled. I followed his gaze and saw Jackie and John John with their heads out a window on Fifth Avenue. Bobby knew they would be there. I photographed him that day and was on the campaign trail for the duration. There was a camaraderie among the press corps traveling with Bobby. You always got a photograph before the end of the day. I know it was manipulative, but he made you feel like one of the inner circle, and it worked. The press and the people loved Bobby.

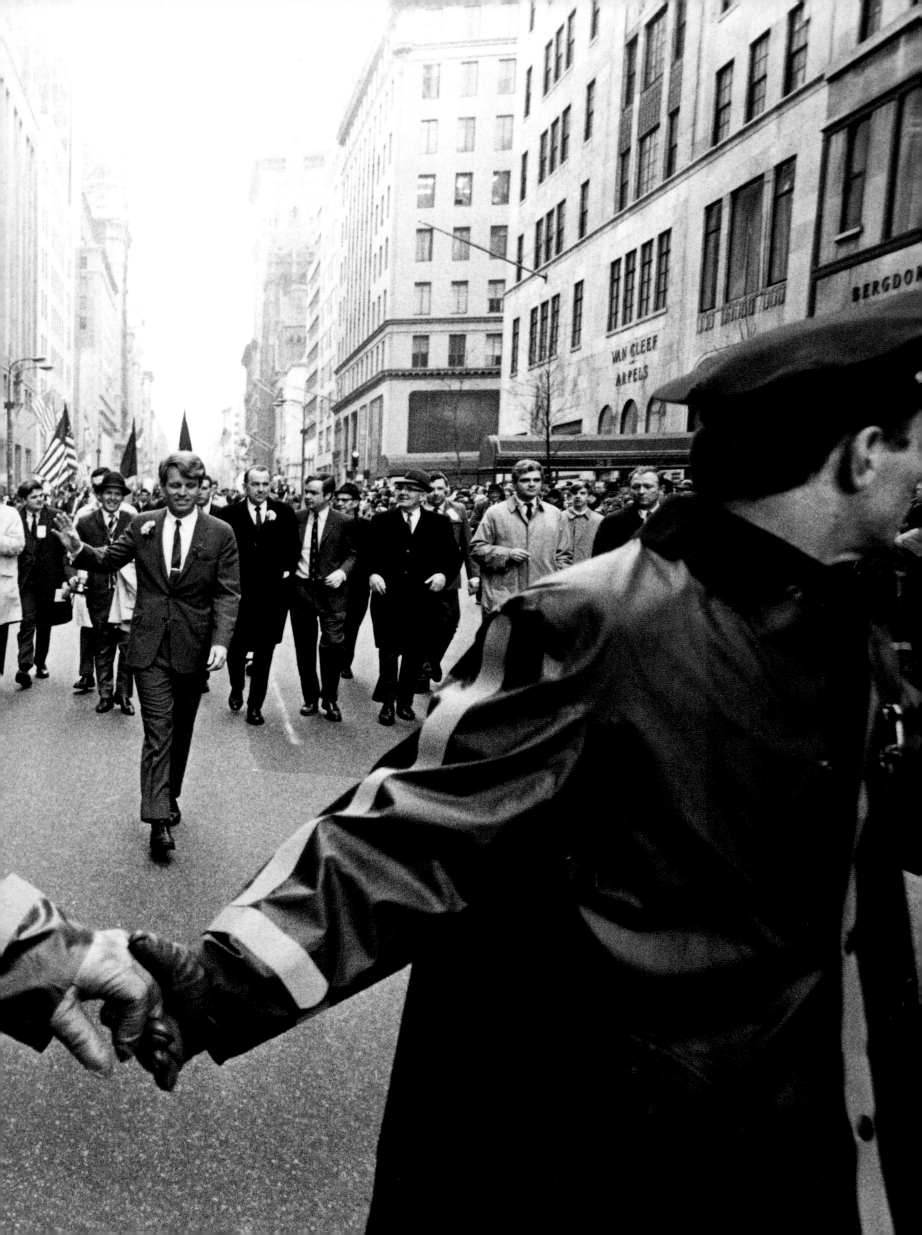

the biggest story

ROBERT F. KENNEDY ASSASSINATION / AMBASSADOR HOTEL, LOS ANGELES / 1968 — In the midst of the bedlam Bobby lay on the kitchen floor of the Ambassador Hotel after being shot in the head by Sirhan Sirhan.

I don't know why I covered Bobby's victory speech in the California primary at the Ambassador Hotel in Los Angeles on June 4, 1968. I hadn't planned to go, but something told me not to miss it. I stood on a chair to get some photographs as his "on to Chicago" brought a roar from the crowd. He started to work his way toward the kitchen exit. I started out the other way, but it was so crowded I decided to follow Bobby. As I neared the kitchen door I heard a horrifying scream. Sometimes I think I heard the shots, but I don't think I did . . . the scream told me everything. I'd covered much of the Civil Rights violence, I'd been to the Congo and Nigeria and Cyprus for the uprising. There's something about violence, you can feel it, there is no mistaking it. So I knew at once he'd been shot. We had walked out of happiness into hell. ¶ In the kitchen I kept saying, "Please, god, don't let me mess this up. This is for history. This is what I've come into the business for." The whole room started to move. People were screaming, crying, beating their heads against the wall, yelling "fuck this country—not again—not again." ¶ Bobby was lying on the floor with blood coming out of the back of his head. Ethel was well behind me, but she was brought over to him somehow. I was standing on a stove two feet away from his body, but Jesse Unruh threw me off. I saw her bend down and say, "I'm with you, Bobby." His eyes glazed over and a rosary was placed in his hand. He did not say anything. Ethel turned around and yelled, "Give him air, give him air." ¶ The writers Bud Schulberg and Jimmy Breslin were trying to take charge and stop the hysteria in the room, but everyone was shouting. No one even thought to wrap Bobby's head to try and stop the bleeding. Off on the edge, I saw Rosey Grier and George Plimpton grabbing at Sirhan, but no one could stop this tiny guy from emptying his revolver. It was only when the agonizing melee subsided that I realized that others around me had been shot. ¶ I was stuffing the exposed rolls of film into my

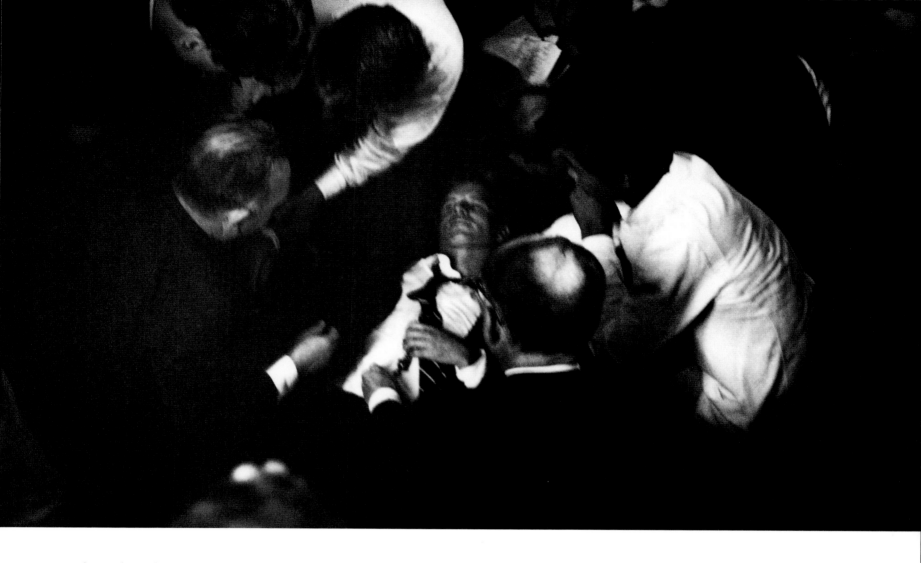

socks so the police wouldn't find them and take them away. That had happened to me in Chicago during the riots. I was thinking about

Dallas the whole time. I kept thinking that everything in the room was important. And I kept talking to myself: "Pull yourself together,

don't blow it. Don't fail. Stay at the center. This is for history. Bobby will understand my doing this, doing my job." ¶ It seemed like a very

long time before an ambulance arrived and later everyone blamed each other for the delay. I think the Kennedy aides could have handled

it better, but they were inexperienced in the midst of such unexpected tragedy. When it was all over I was one of the last to leave the kitchen.

On the floor was a pool of blood. A young woman placed her straw boater beside it. That was all that was left. ¶ Bruised all over from being

shoved around, I felt like I had been in a fight. I was black and blue and had a bump on my head from having the camera bang into it. Wan-

dering around for a while afterward, wanting to be alone, I felt a sort of numbness; I was shaken but not shattered. There is a feeling you

get, a very strong feeling, when you come through violence, a sense of strength. That's what I felt. ¶ George Gale, the *Daily Express* reporter,

a grand, dapper sort, did not get into the kitchen. His attitude was always, "I'm not here to help photographers," but I gave him his story

as he had nothing. I kept the details for myself and dictated them to the *Express* in the first person. ¶ I went to the A.P. office to wire the

photos to the paper in London and told the darkroom technicians to be careful because the film had been exposed without much light.

You don't really work with exposure meters under duress, you know. They developed the film by inspection. That's the only way we got

anything. David English called from London and wanted me to dictate a story for the paper. He said, "I hope you've been at the hospital

all night." I told him I'd been through an horrific event and standing outside a hospital would be useless. I never did go to the hospital. I

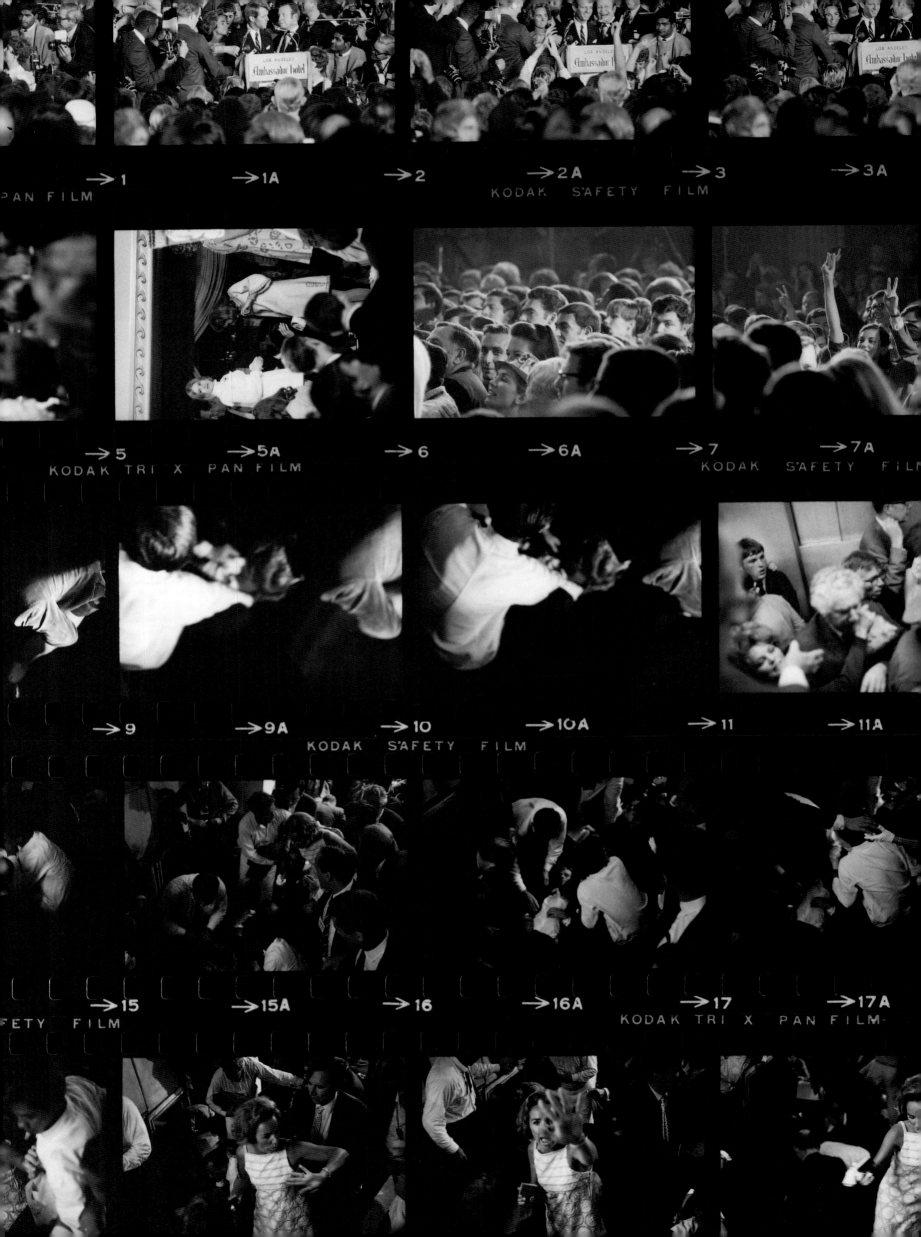

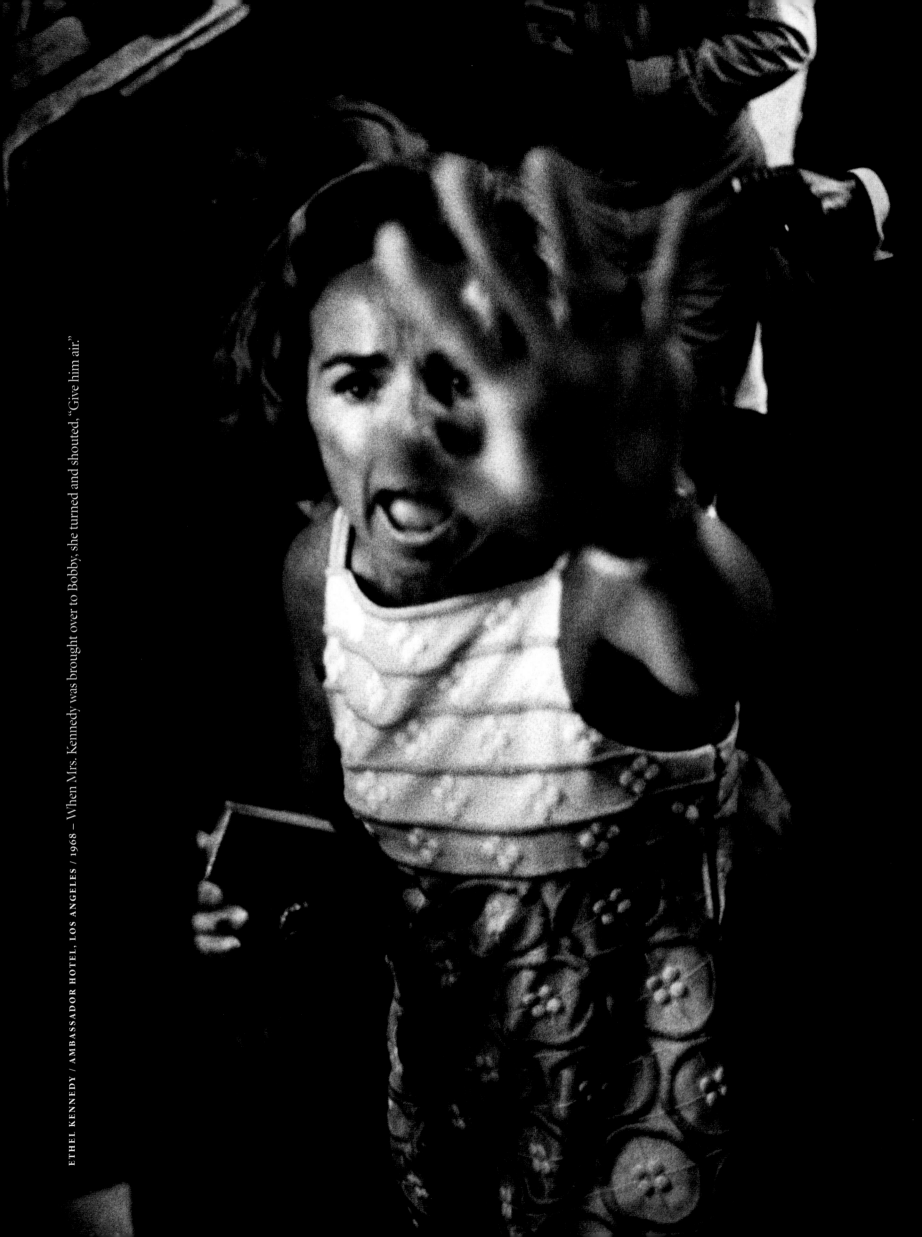

ETHEL KENNEDY / AMBASSADOR HOTEL, LOS ANGELES / 1968 – When Mrs. Kennedy was brought over to Bobby, she turned and shouted, "Give him air."

had had enough emotionally. Enough drama. I couldn't do any better. Let someone else hang around a hospital waiting room for a doctor. I knew Bobby was gone when he left the kitchen. ¶ I called the F.B.I. and told them I had these pictures. Even one of a girl in a polka dot blouse (they had been looking for someone in a polka dot dress to question), but they never came to look at all. It was really amazing. ¶ Sometimes I wake up and go through the whole event, reliving the tragedy. It will stay with me forever. The senseless horror of it all. The sadness. ¶ It was a terrible night. ¶ I went back to New York to get ready for the funeral, to bury him in Arlington Cemetery. I rode the funeral train to Washington, D.C., after the St. Patrick's Cathedral service. The train was crawling because so many people cluttered the tracks, coming to pay their respects. Crying, waving flags, standing somberly all along the train route. Martin Luther King, Jr. had been shot just three months before. And it was only about five years since John Kennedy had been killed in Dallas. These memories were very much in people's minds.¶

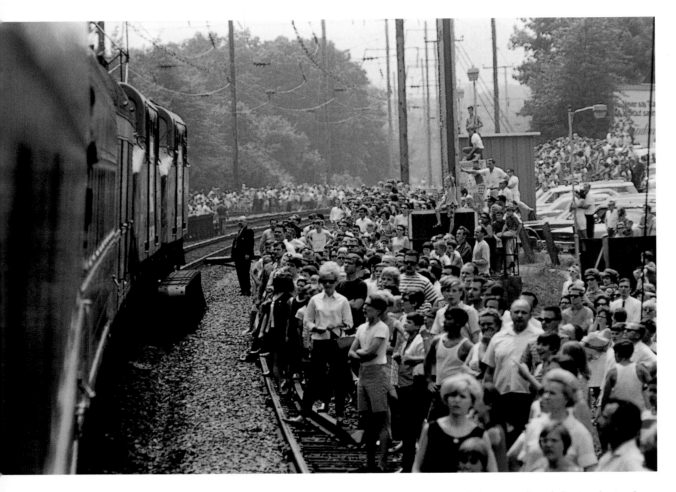

RFK FUNERAL TRAIN / BETWEEN NEW YORK AND WASHINGTON, D.C. / 1968 – Mourners lined the tracks to show their respect as the train carrying the body of the slain Robert Kennedy slowly passed. He was to be buried in Arlington Cemetery near his brother John.

BLOOD ON THE FLOOR / AMBASSADOR HOTEL, LOS ANGELES / 1968 – One of the campaign workers put her boater hat on the pool of Robert Kennedy's blood after the ambulance had taken him to the hospital.

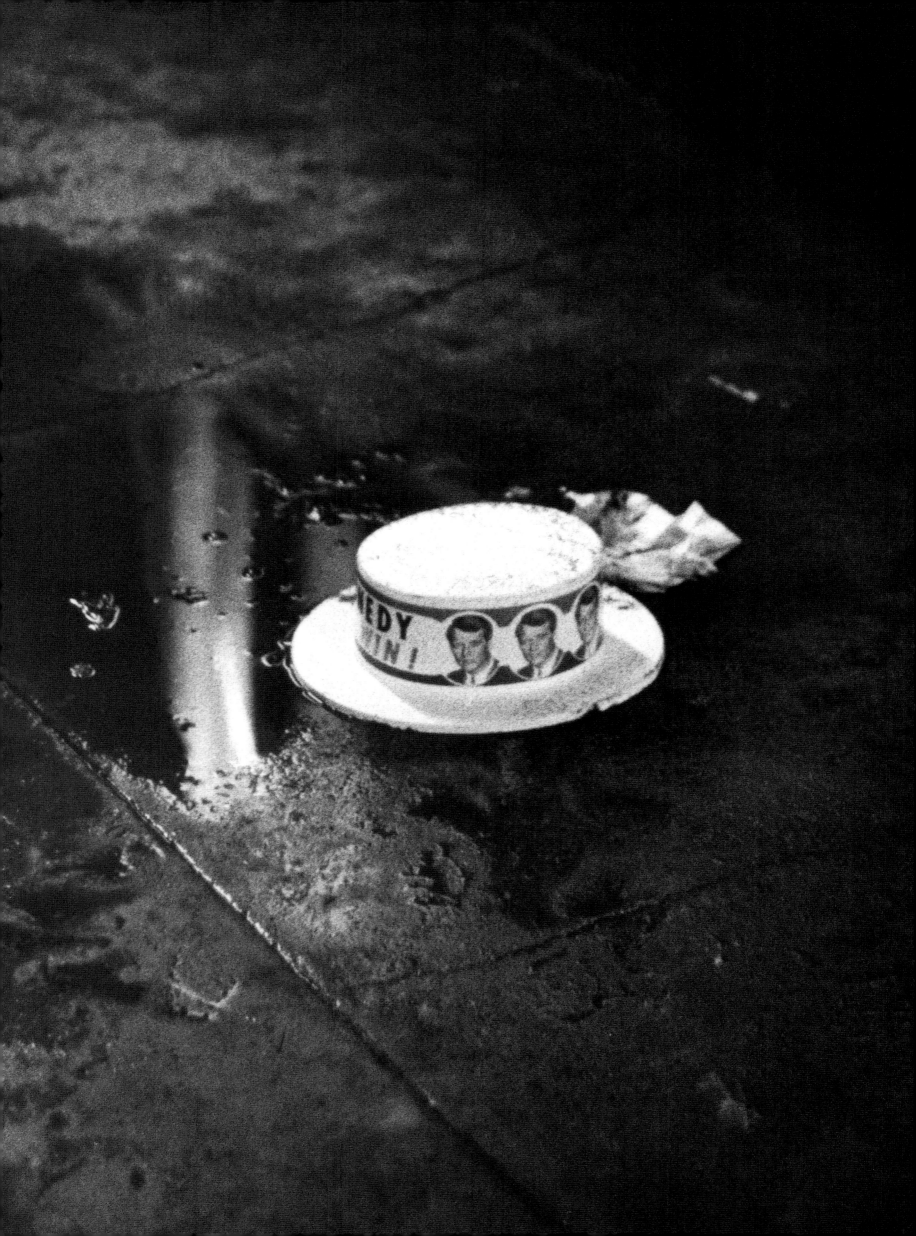

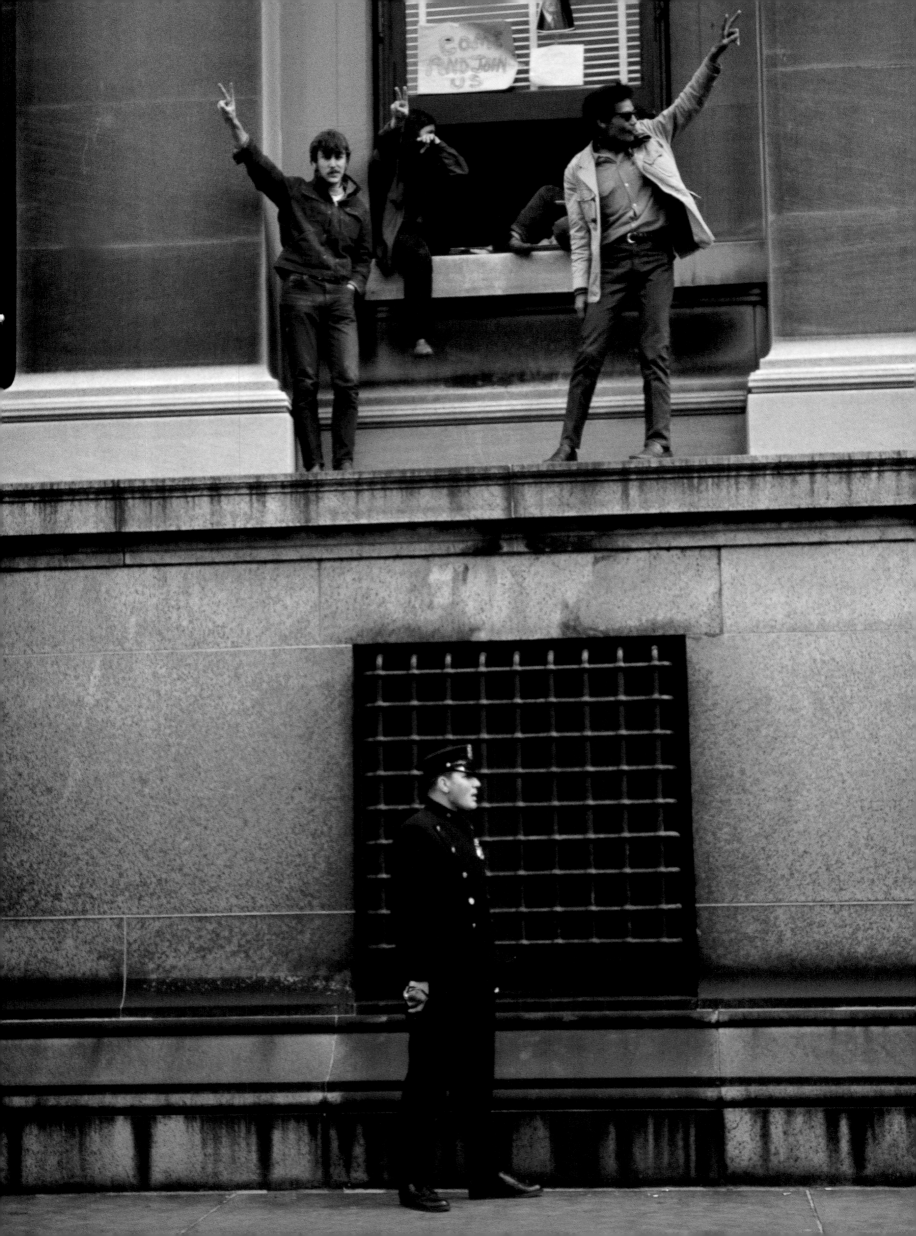

COLUMBIA UNIVERSITY / NEW YORK CITY / 1967 – It was right in the middle of the Vietnam War. Students had taken over the Columbia University campus. It started off quite good naturedly. Then students started wrecking the dean's office and the class rooms. The police moved in, and it became quite nasty.

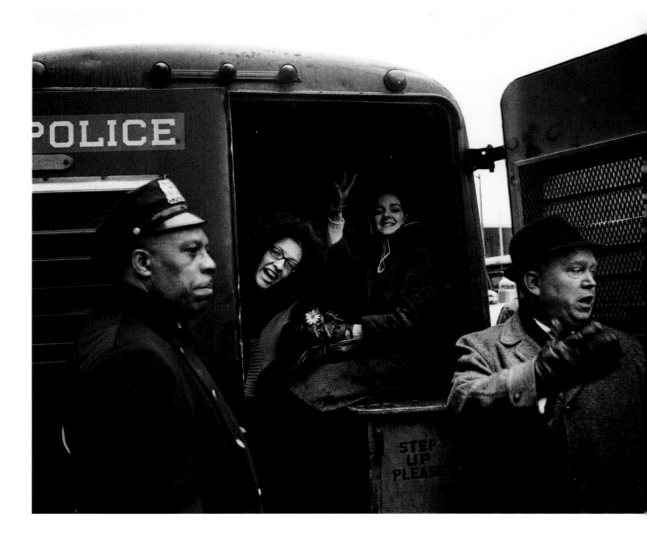

ANTIWAR DEMONSTRATION AT CITY HALL / NEW YORK CITY / 1967 – Plainclothes policemen began grabbing the press photographers' cameras and smashing them on the ground. I could see a dangerous situation getting worse. I took some photographs but didn't hang around. All kinds of people, young and old, were demonstrating against the American involvement in the Vietnam War.

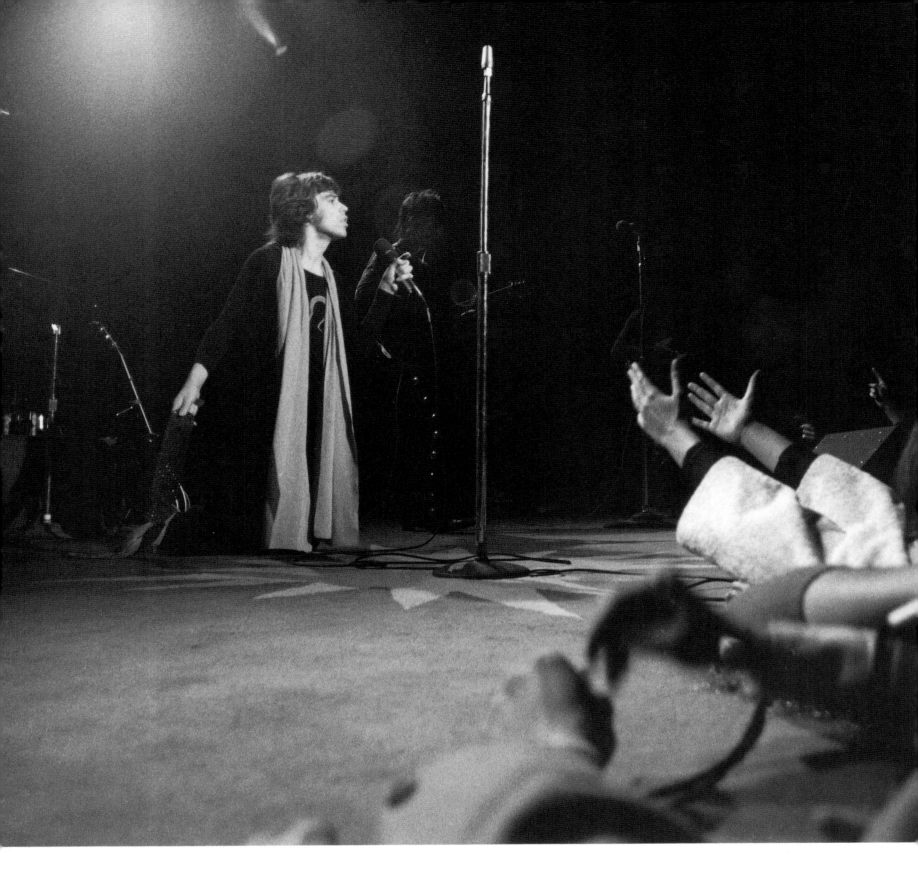

MICK JAGGER / NEW YORK CITY / 1968 – The Rolling Stones concert at Madison Square Garden was so different from what concerts are like today. It was just the band on stage, no pyrotechnics, no huge projection screens, but the crowd was as wildly enthusiastic as ever. Tina Turner, also on the bill, was astonished when Janis Joplin unexpectedly jumped on stage from the audience to sing with her.

R. CRUMB / NEW YORK CITY / 1968 – An early assignment for *Life* magazine was on underground cartoonist R. Crumb. The office liked the pictures but the story never saw the light of day after they found out Crumb's cartoons were somewhat pornographic.

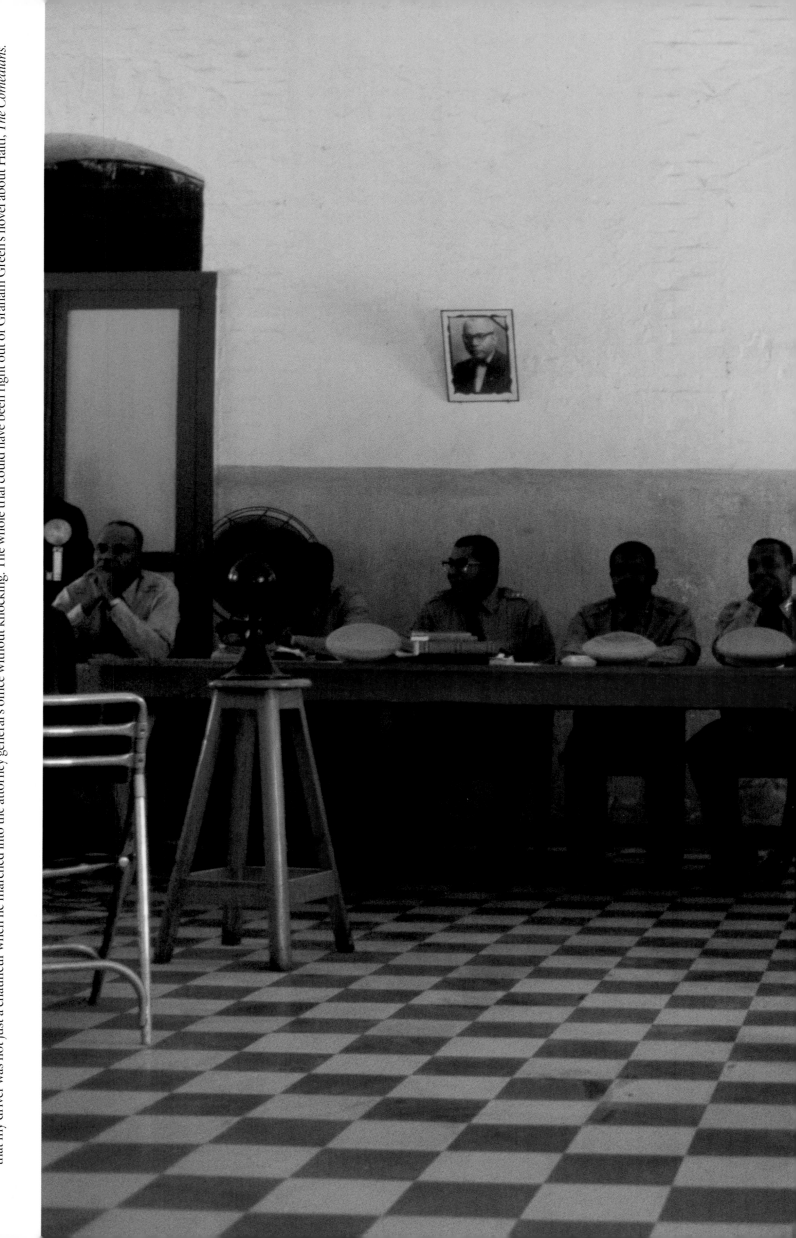

ESPIONAGE TRIAL / PORT-AU-PRINCE, HAITI / 1968 — British subject John Knox had been accused of spying by Haitian dictator "Papa Doc" Duvalier and was on trial for his life. His weak defense that he was there for plastic surgery notwithstanding, he was convicted and later pardoned by Duvalier. The irony of it all is that they would let me photograph inside the courtroom but not outside of it. I got the idea that my driver was not just a chauffeur when he marched into the attorney general's office without knocking. The whole trial could have been right out of Graham Green's novel about Haiti, *The Comedians*.

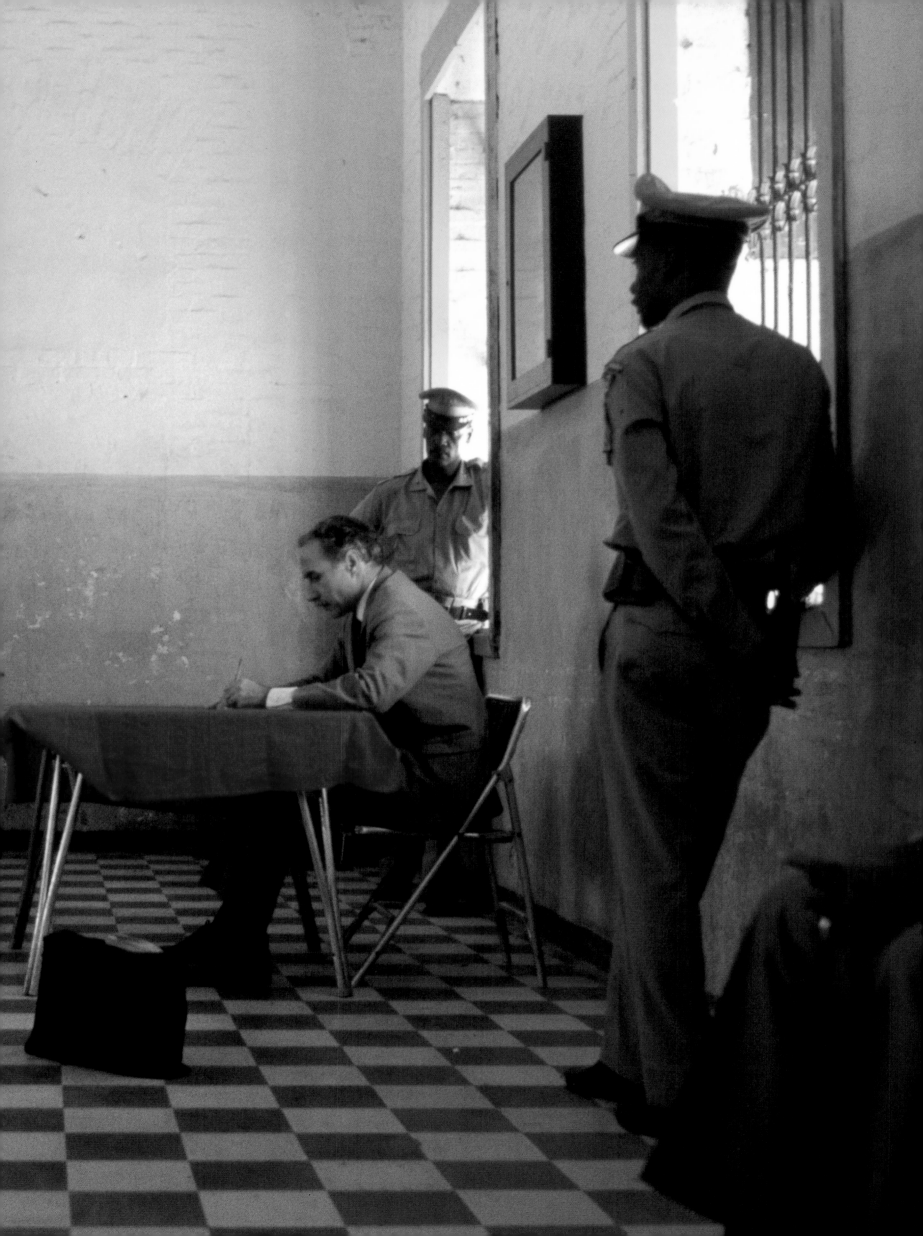

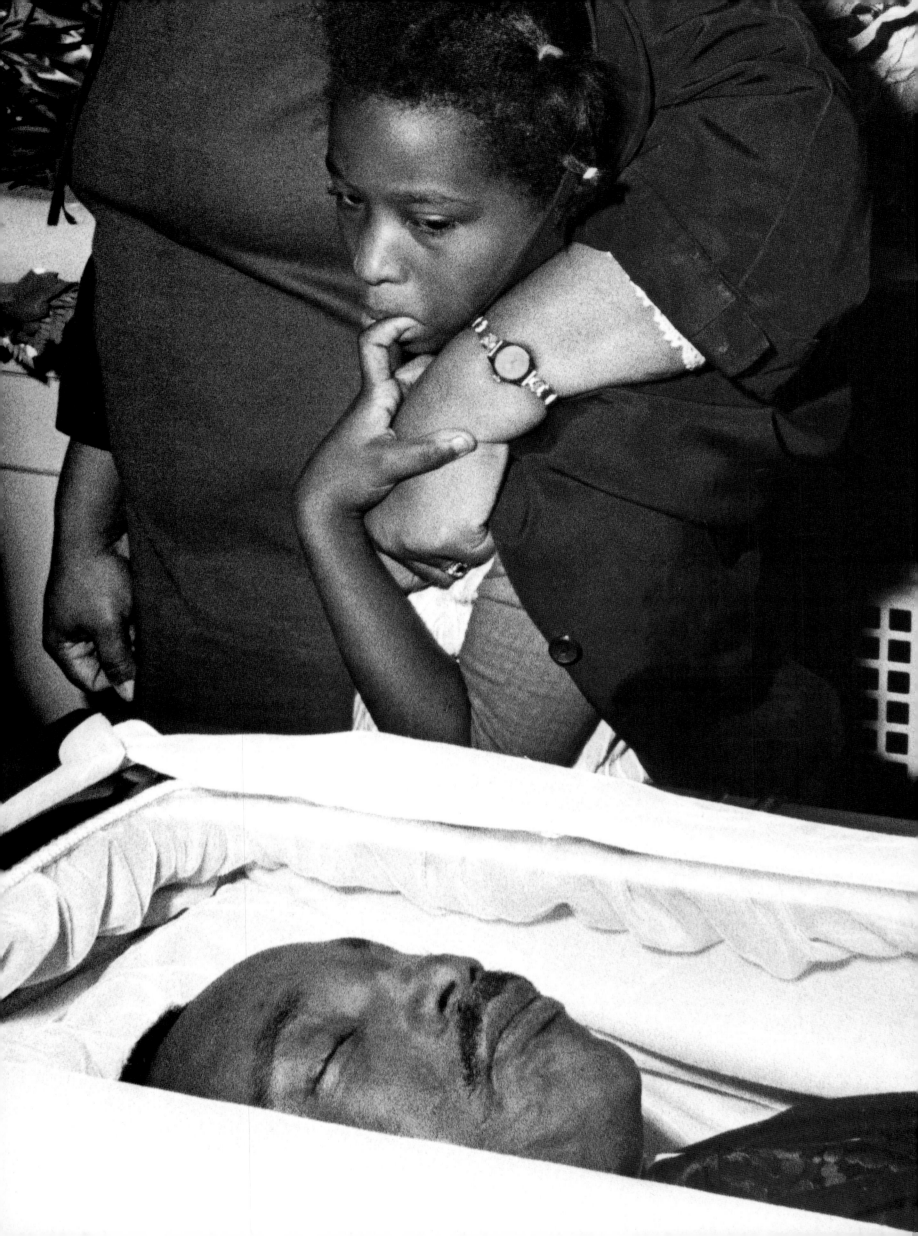

MARTIN LUTHER KING'S FUNERAL / ATLANTA / 1968 – After his assassination, Martin Luther King, Jr.'s body was laid in state in Atlanta. Inside the Ebenezer Baptist Church, the heat was stifling as people cried and mourners passed by the open casket.

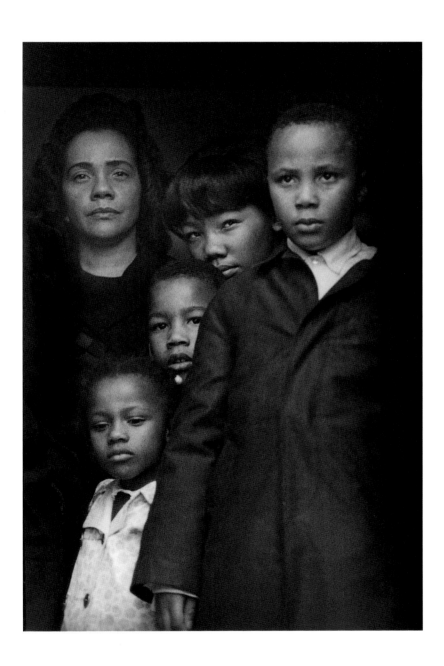

CORETTA SCOTT KING WITH HER CHILDREN / ATLANTA / 1968 – Mrs. King and her four children flew from Memphis back to Atlanta with Dr. King's body for burial. As Dr. King's body was being taken from the plane, there was just a moment when the family came together in the doorway.

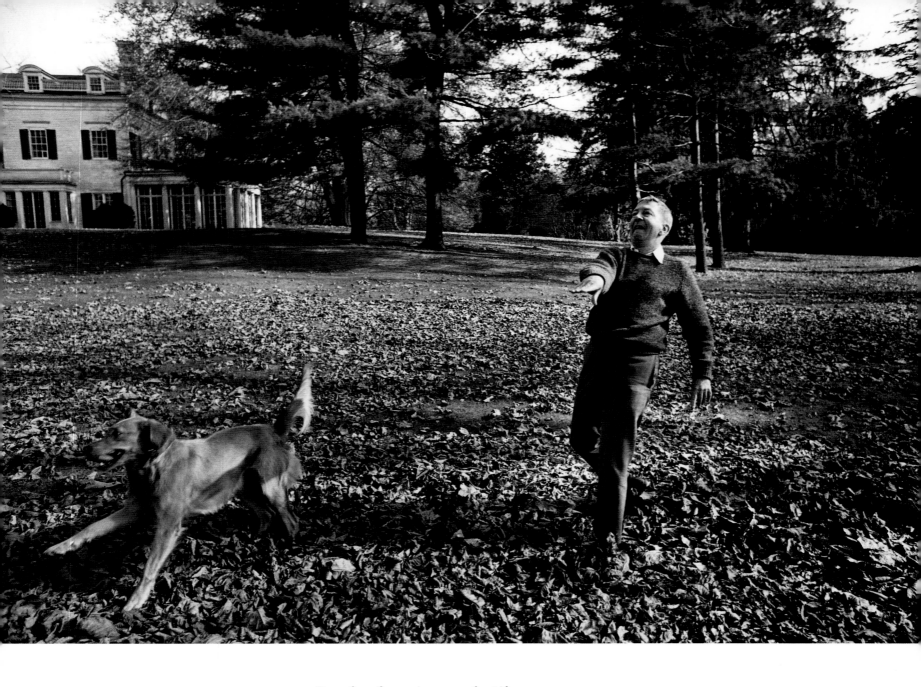

JOHN CHEEVER / OSSINING / NEW YORK / 1969 – One of my first assignments for *Life* was to photograph the esteemed American author with his family. A rather shy man in person, he enjoyed playing ball games with his daughter's golden retriever outside his home.

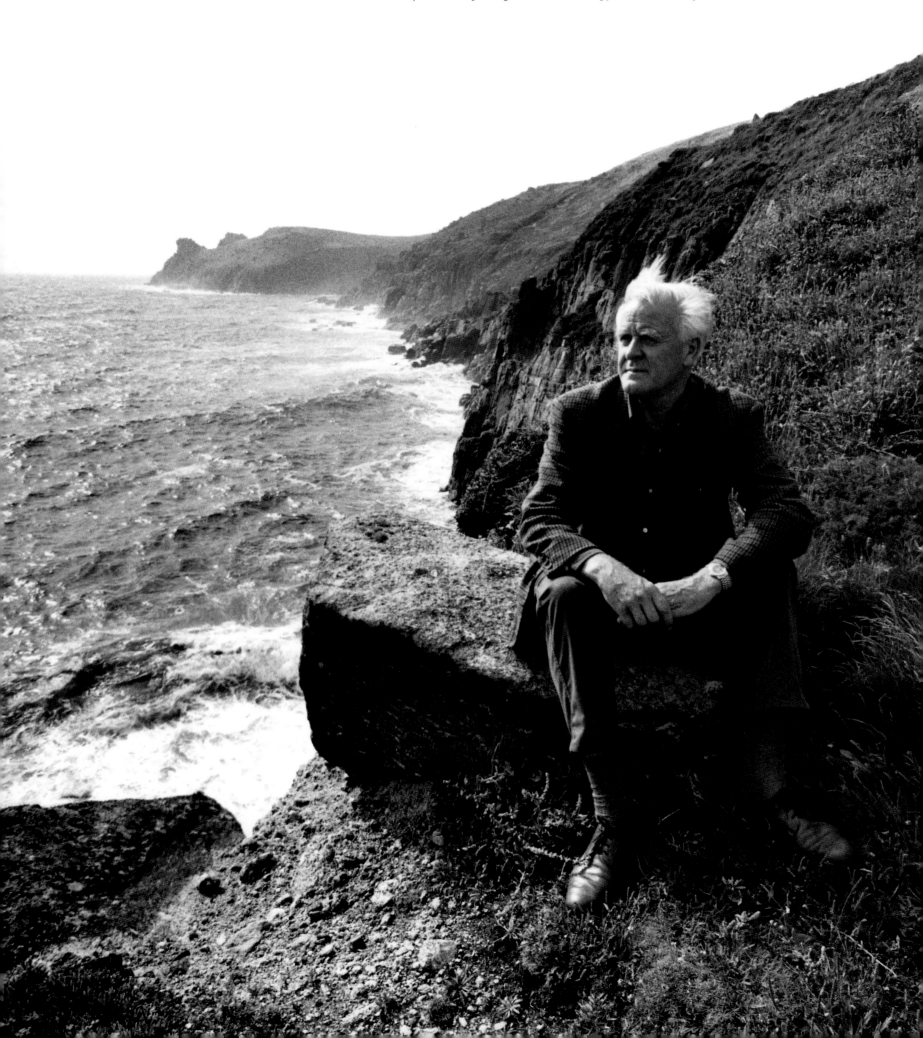

JOHN LE CARRE / CORNWALL, ENGLAND / AUGUST 1993 – Le Carre was unassuming, rather like a country gentleman farmer. He didn't look like someone who could write such intricately woven espionage novels as *The Spy Who Came in from the Cold*.

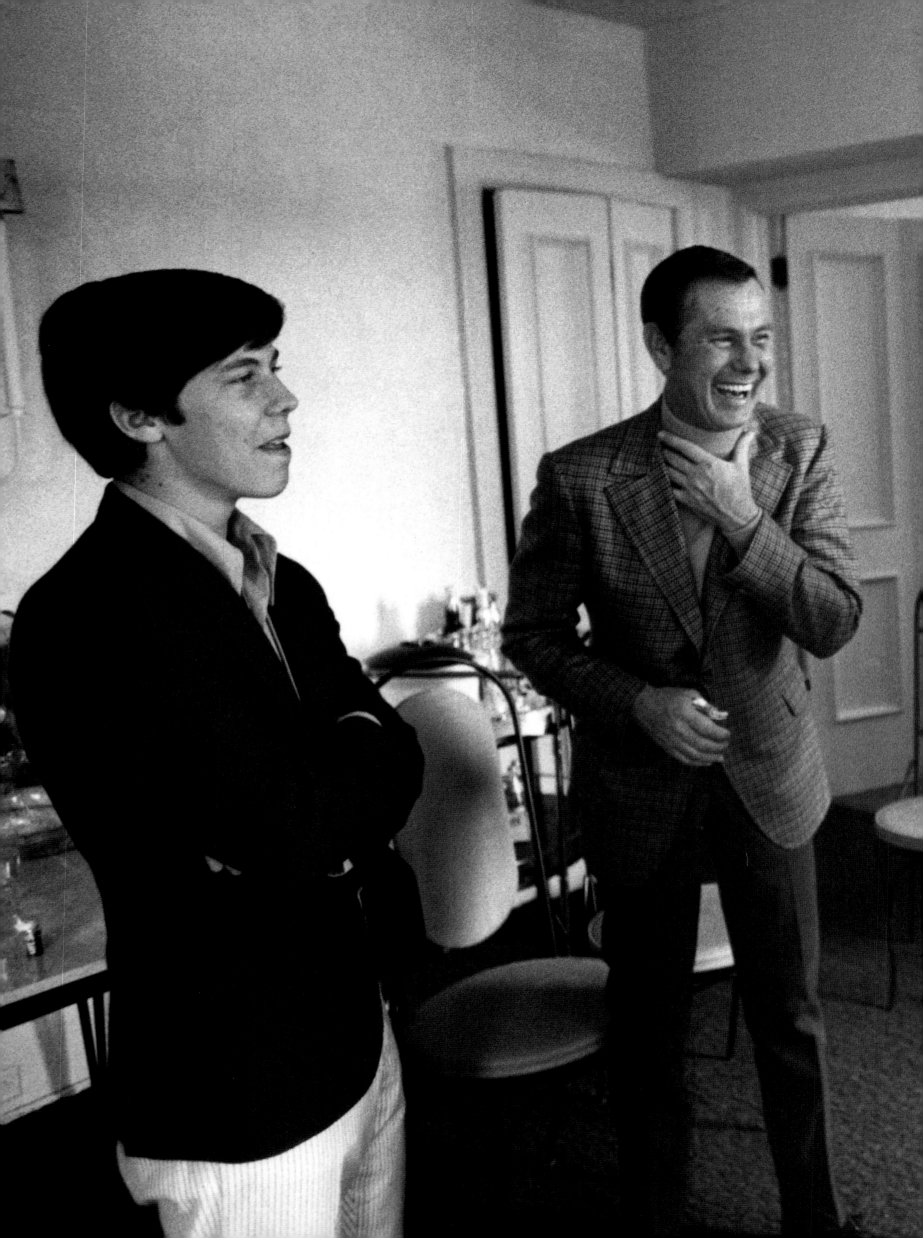

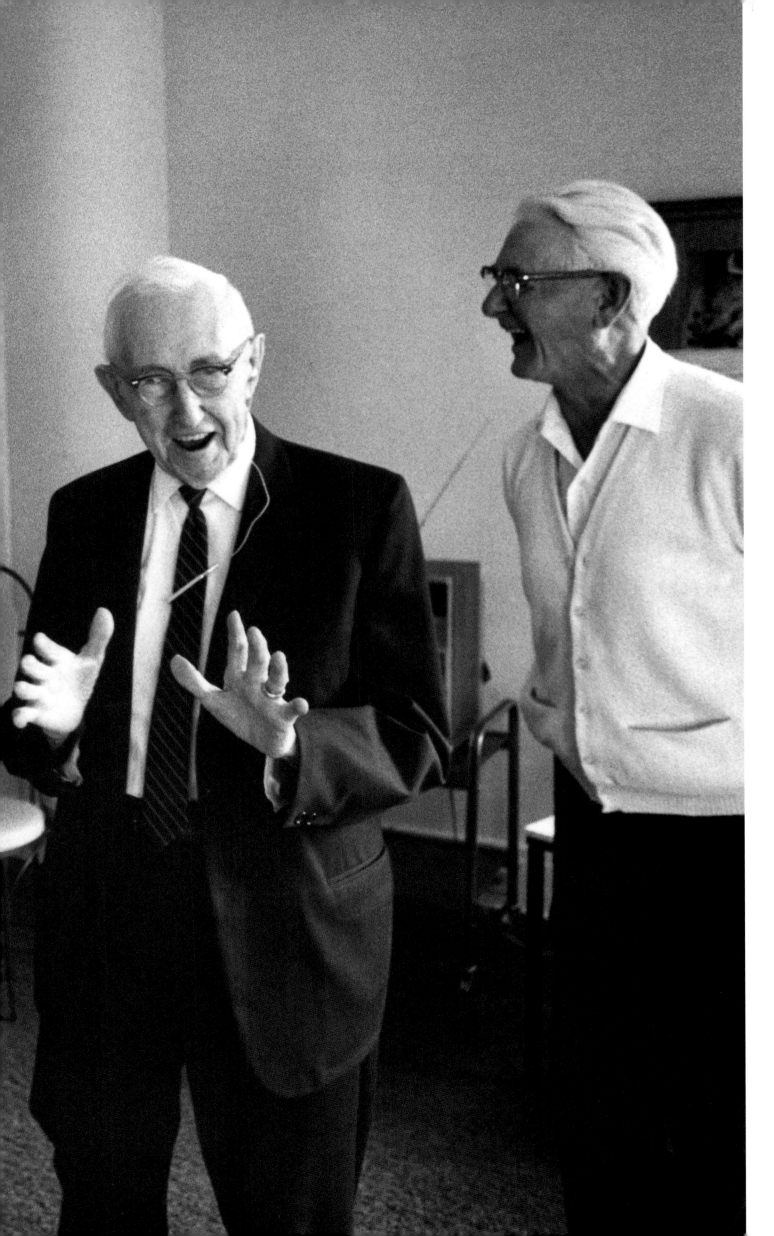

FOUR GENERATIONS OF CARSONS / OMAHA, NEBRASKA / 1969 – Johnny Carson came from Omaha, the middle of America, and he was visiting his parents' home there. He told me that the four generations of his family had never been photographed together before. Here they are: his son, Ricky; himself; his grandfather, Christopher (then ninety-five); and his father H.L. "Kit." He was one of the shyest celebrities I have ever met; really uncomfortable with people away from the set. Once he finished hosting *The Tonight Show*, he barely said goodnight, he was just away. The longer I worked with him the more I liked him.

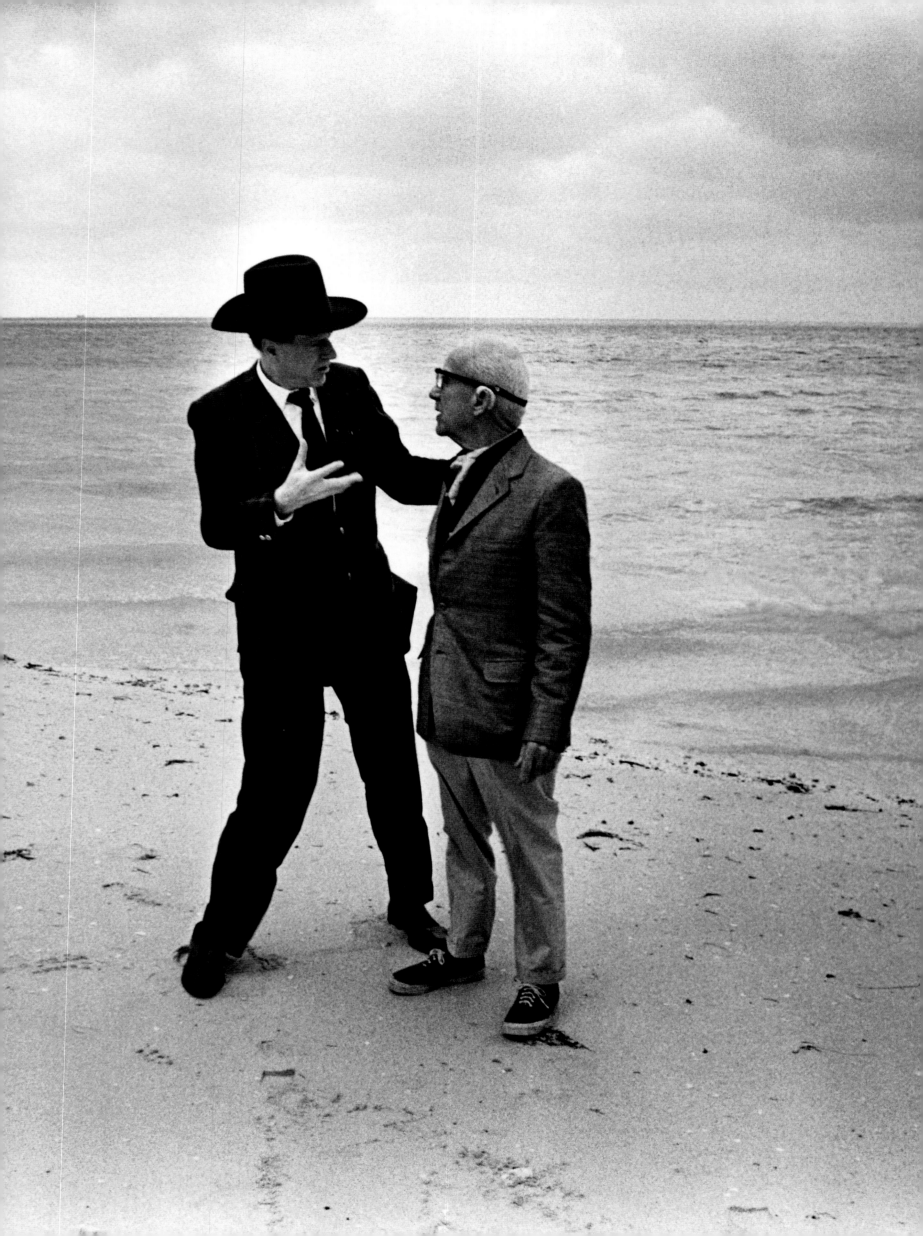

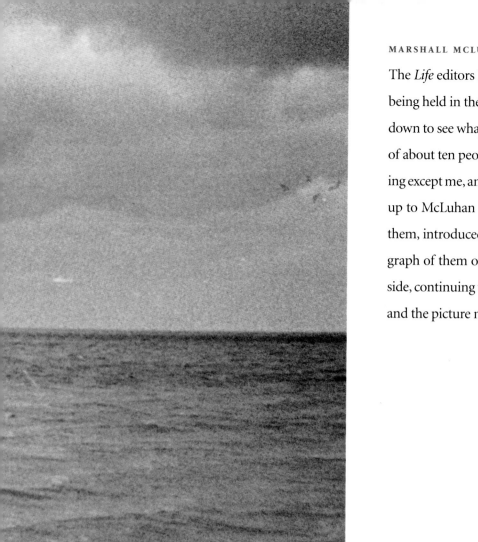

MARSHALL MCLUHAN AND BUCKMINSTER FULLER / FREEPORT, THE BAHAMAS / 1970 —
The *Life* editors heard about an exclusive Marshall McLuhan Executive Seminar that was being held in the Bahamas, with no press allowed. Writer Tommy Thompson and I went down to see what we could get. Tommy told me to quietly join one of the seminar groups of about ten people. It was very embarrassing trying to hide a camera: everyone was talking except me, and I was afraid I would be asked a question. During a coffee break, I walked up to McLuhan and Buckminster Fuller, who were engrossed in discussion, interrupted them, introduced myself as a photographer from *Life,* and asked if I could take a photograph of them on the beach. They got up without saying a word to me and walked outside, continuing their animated conversation. I hadn't a clue what they were talking about, and the picture never saw the light of day—*Life* didn't run the story.

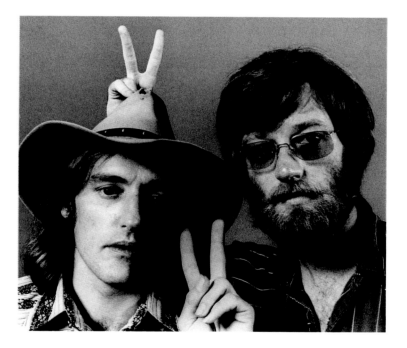

DENNIS HOPPER AND PETER FONDA / NEW YORK CITY / 1969 – The pair had written, produced, directed, and starred in the film *Easy Rider,* which was to become the definitive motion picture of the hippie, antiwar generation. I photographed them for *Vogue,* and I got the idea they had not expected all the hullabaloo that erupted after the film was released. They turned up in full regalia; they were covered with bells, trinkets, and suede pouches, and very laid back.

GERMAINE GREER / NEW YORK CITY / APRIL 1971 – Feminist Greer was in New York to promote her book *The Female Eunuch* when I photographed her for *Life* in her room in the Chelsea Hotel. Hippie-chic, the forerunner of grunge, is the best way to describe her ambiance and no-airs manner. Later we traveled to Washington, D.C., where she participated in a Vietnam peace rally.

GERMAINE GREER / NEW YORK CITY / APRIL 1971 – Greer loved American TV. Sitting with a friend, she watched her appearance on a television talk show she had taped earlier in the day.

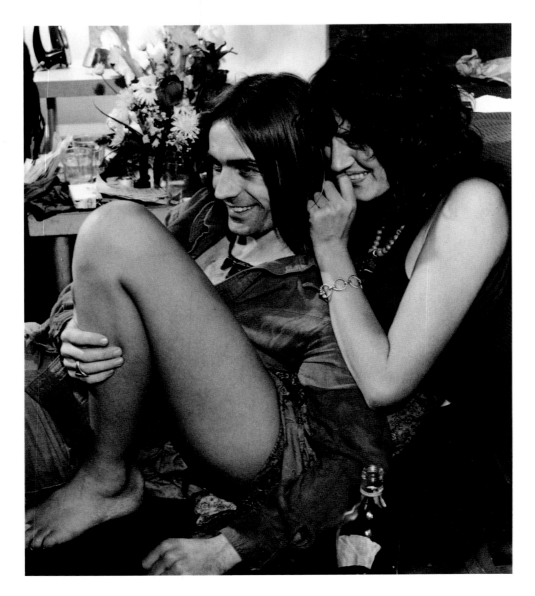

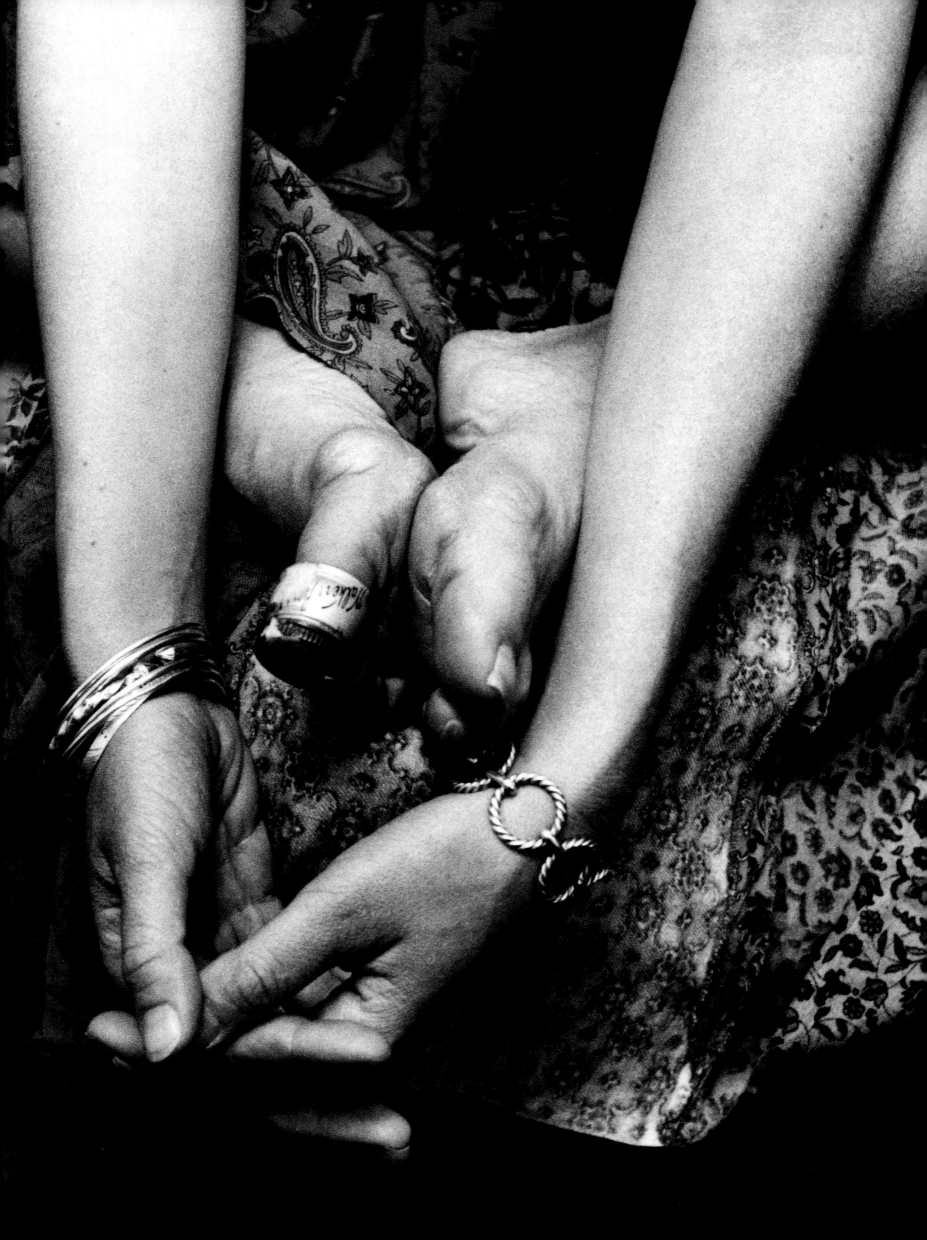

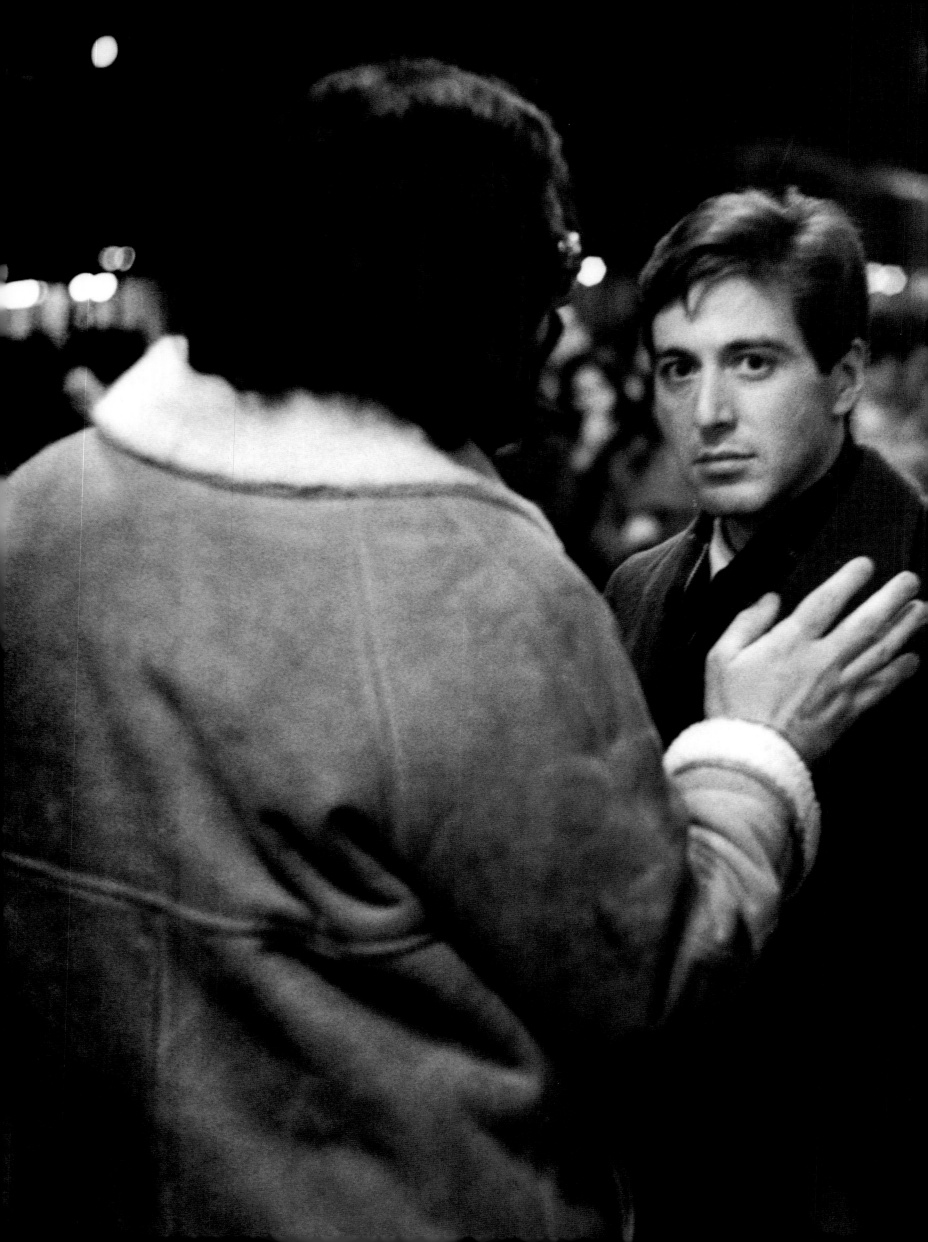

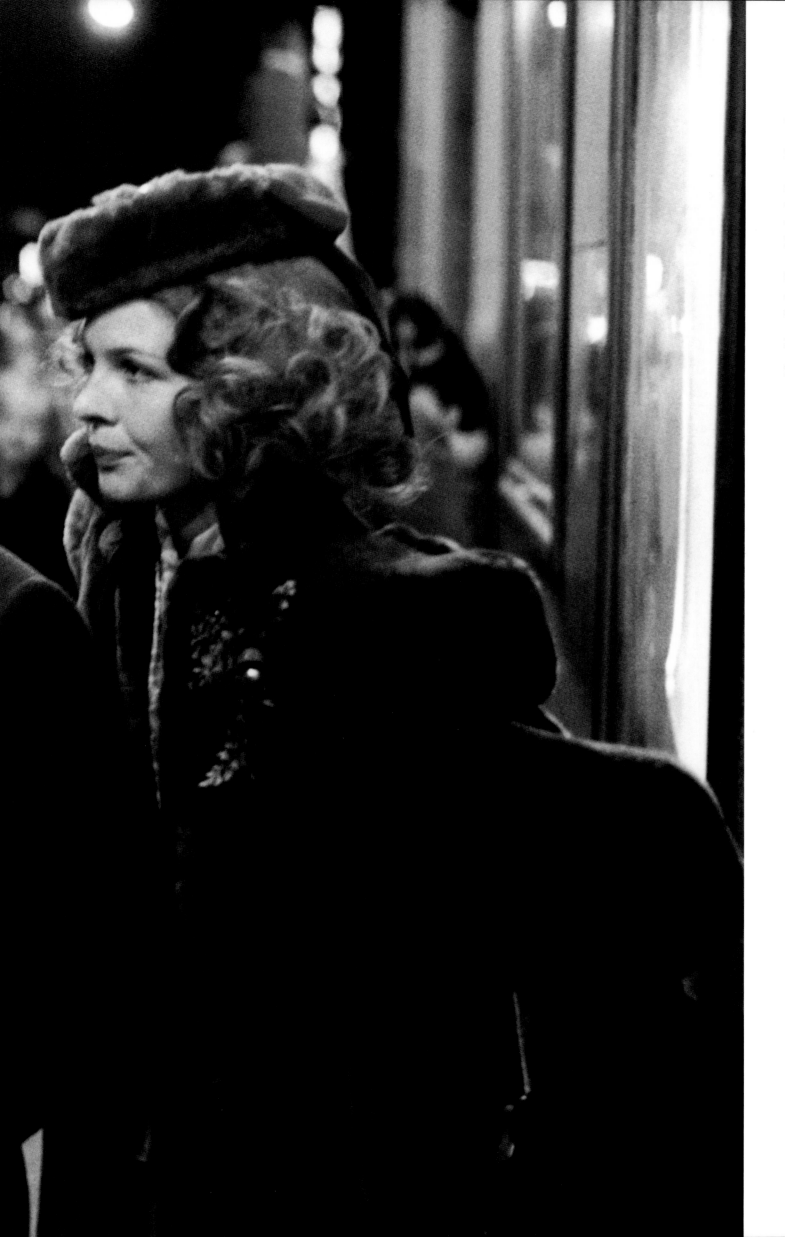

FRANCIS FORD COPPOLA, AL PACINO, AND DIANE KEATON / NEW YORK CITY / 1971 — The sidewalks had been blocked off outside Radio City Music Hall and it was late at night and very cold as Coppola directed a scene from *The Godfather*. In the scene, Pacino learns his father has been shot.

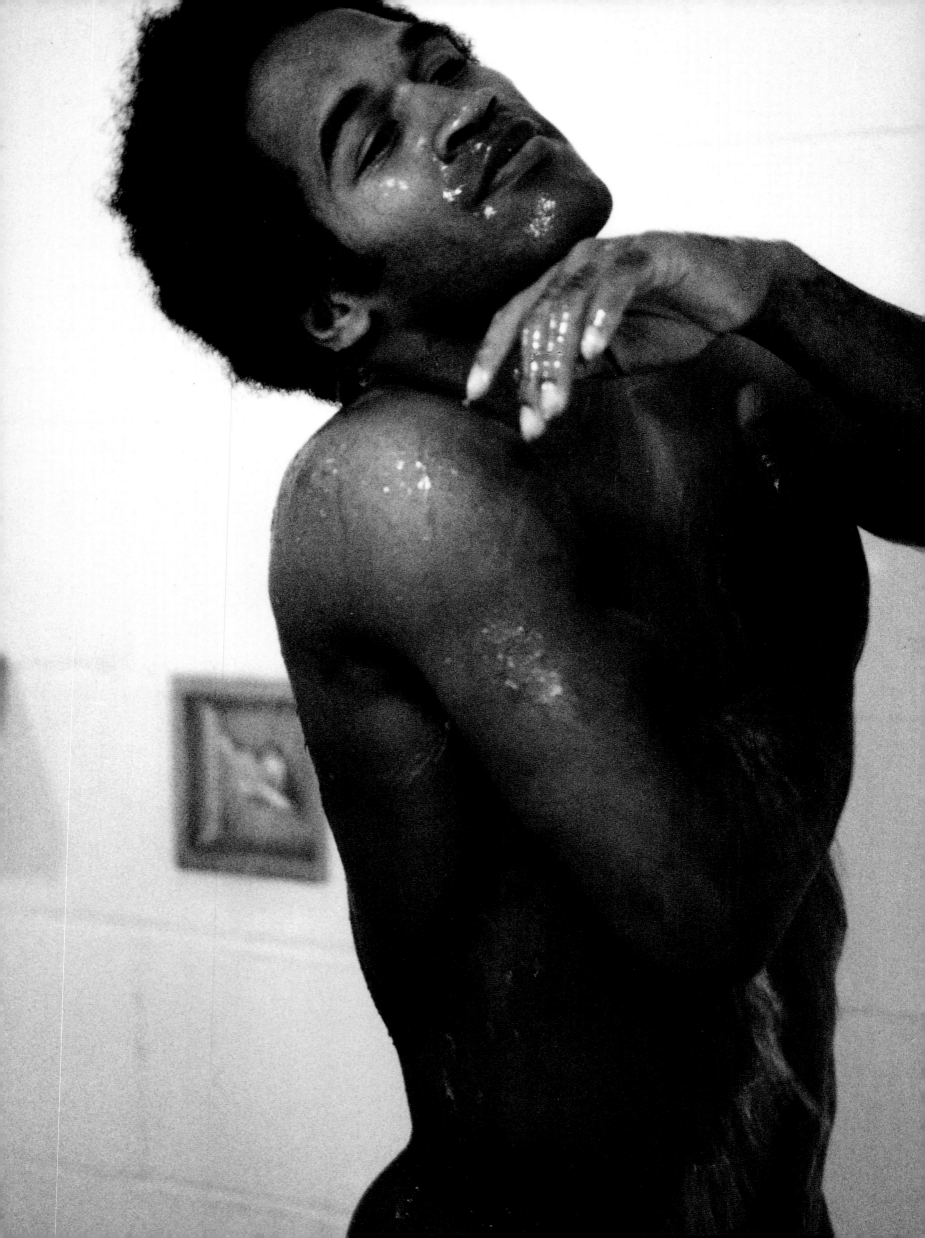

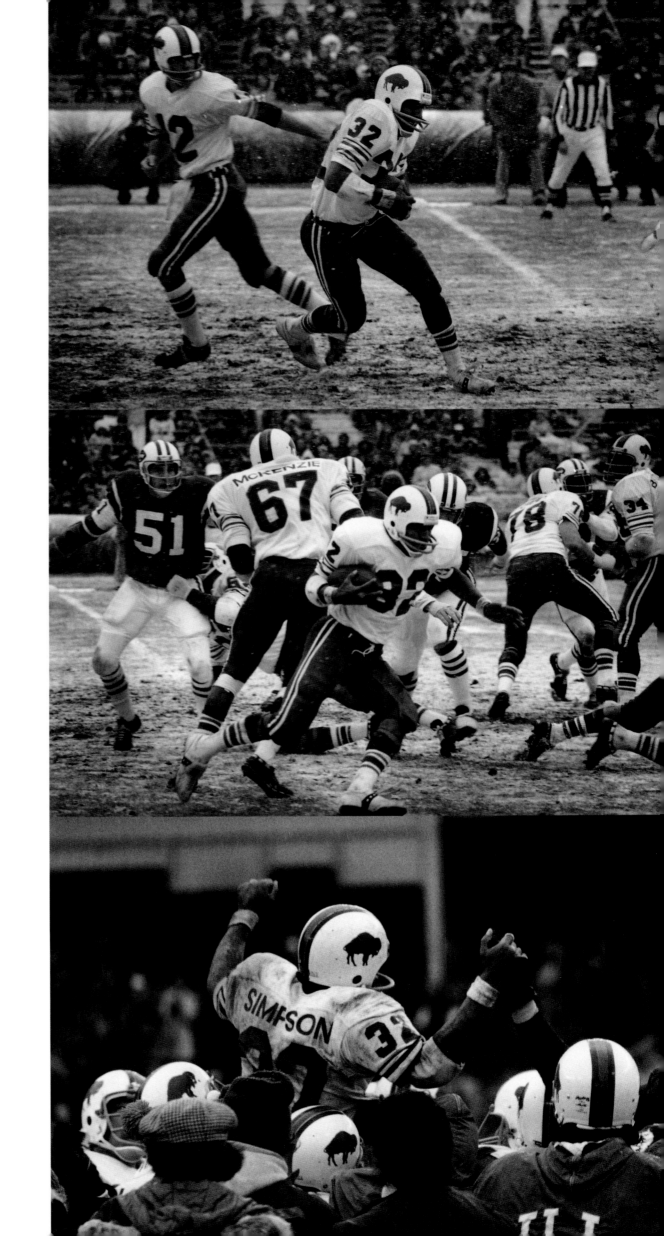

O. J. SIMPSON / SHEA STADIUM, NEW YORK CITY / 1972 — Simpson, running back for the Buffalo Bills, is breaking the N.F.L. record of two thousand yards rushing in one season in these photos. After giving numerous interviews, O. J. remained alone in the locker room while the team waited on the bus.

JOE NAMATH / BALTIMORE / 1974 – Namath was hit hard and taken off the field during a game with the Baltimore Colts. I was standing on the edge of the field and didn't pay much attention. Someone came over to me and said Joe's got a D.S. I didn't want to show my ignorance, so I went up to another photographer and asked what a D.S. was. Dislocated shoulder was the reply. The hand you see in the photograph is that of his brother. Joe called his mother from the locker room. He knew she would be worried since she had been watching the game on television at home.

JOE NAMATH / NEW YORK CITY / 1971 — Broadway Joe was the toast of New York because he had promised the underdog Jets would win the Super Bowl in 1969 and they had. When I tried to do a story on the quarterback for *Life,* he wouldn't cooperate. Johnny Carson phoned and told Namath that I was okay, and the story was on. I photographed him quite a bit after that—on fishing trips, at his camp for kids. The funniest was when he made a panty-hose commercial. At first he wouldn't do it, but I suggested to his manager, Jimmy Walsh, that if they put a beautiful girl in the picture Joe would look much more macho. Here, the New York Jets were playing the Buffalo Bills at Shea stadium. It was the day O. J. Simpson would break the season rushing record.

ARNOLD PALMER / LATROBE, PENNSYLVANIA / OCTOBER 1974 — Palmer was walking toward the fairway on his home course, the Latrobe County Club, when a fan called out to him and he waved back. When I told him I was from Scotland, he let me walk around the course with him. He reminisced about the Royal Troon Golf Club, where he won his first British Open—one of the great successes of his career.

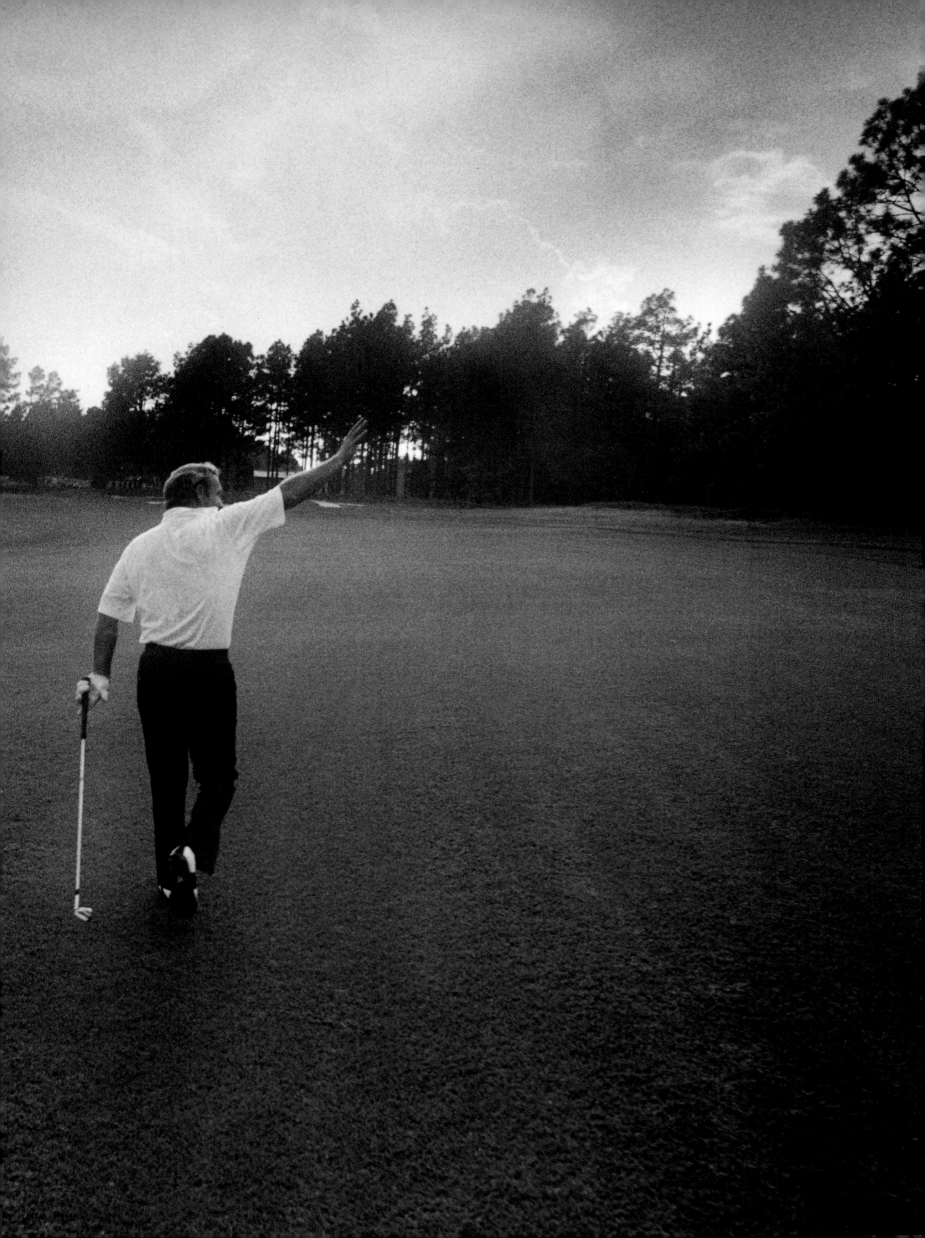

genius at work

We learned what a resource Harry was when we sent him to Iceland in 1972 to shoot the World Chess Championships. The *enfant terrible* Bobby Fischer was challenging the Russian Boris Spassky in what was one of those occasional symbolic East vs. West show-downs of the Cold War. Harry had shot Fischer at a run up to this match with some success so he got to spend the summer in Reykjavik with Bobby. And a large contingent of the world press. ¶ Photographing an international chess match is about as visual as a UN treaty debate. Perhaps less. All aspects of the venue down to the chairs and lighting are the result of laborious negotiations. The participants, brooding eccentrics, are held in isolation by their handlers. And when they finally meet in a nondescript audi-

torium, the photographers are in an isolated gallery where they are presented with the same dreary pic-ture of two men staring at a game board for hours on end. ¶ Matches last days and a tournament for weeks. Within these stultifying confines was where *Life* first saw Harry's genius. ¶ Since I had produced a photo essay on Iceland the previous year, my con-tacts were still fresh so I became Harry's point per-son in New York. The network we set up included using Icelandic Airlines flight personnel to carry unexposed and exposed film back and forth in their

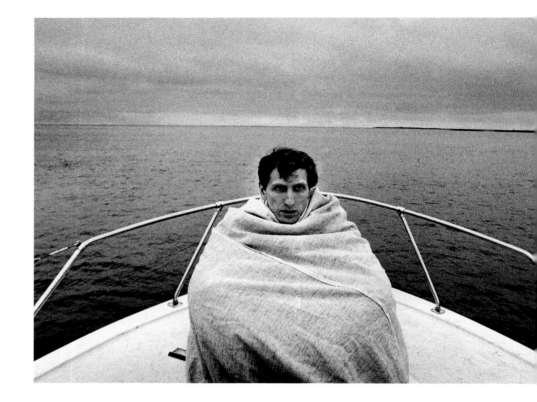

personal effects and a guide who, unlike his usually formal and diffident countrymen, would be able to react quickly to a running international news event. As the pictures would show, Harry made Kristjan earn his keep. ¶ We had expected Harry to have some access based on his and staff writer Brad Darrach's previous exposure to Fischer, but as the film came in—after days in which very little was happening at the match itself—his contact sheets showed Bobby in his private quarters. Bobby getting fitted for a new suit. Bobby brooding on the foredeck of a private cruiser. Bobby in a pasture being nuzzled by ponies! ¶ And then, in came the rolls of Spassky including one improbable picture of him working out chess moves with a pocket-size chess set on top of a rock in the middle of a field of barren, moss covered lava boulders. ¶ In an event that was a non-event photographically, Harry had not only gotten behind the scenes but had successfully invaded both warring camps and produced lively, telling, and *exclusive* pictures.

The depth of his involvement is best illustrated by the fact that after visiting with Spassky, Harry returned to Fischer's quarters to give him the news that Spassky would concede the tournament that day. ¶ Harry's journalistic achievement was more considerable than what is seen by the casual observer. The combat was not just between the principals at the chess board. With a laboriously drawn-out story, where little scraps of news are being doled out daily, if at all, the press corps becomes ravenous. They hound their subjects, who retreat further into their bunkers, making it all the more difficult a story for everyone to cover. ¶ Reflecting on this situation years later Harry said, "In situations like this, there's usually one friend in the enemy camp. I thought, it might as well

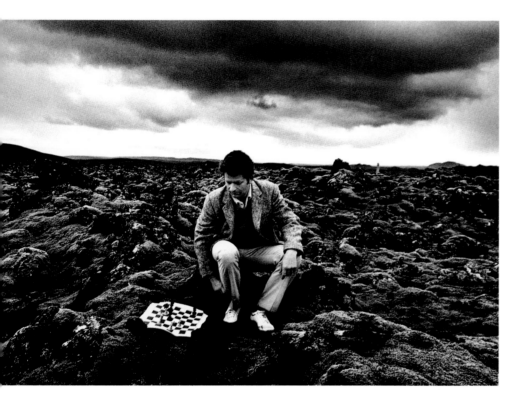

be me." ¶ How does he do this when many other photographers have the same (if not better) command of their equipment, dramatic use of light, quick reflexes, an eye for composition? I think it's his uncanny ability to quickly size up any individual and then use his wits to get them into a situation where they reveal themselves in a story-telling photograph. ¶ Until the emergence of Harry Benson's pictures in American magazines, first at the weekly *Life* in its waning days, and then at *People, New York,* and *Vanity Fair,* among others, in the 1970s and

1980s, this style of imagery had been largely absent from mainstream photojournalism in this country. ¶ What had pervaded at *Life* and other "serious" picture magazines since the 1950s was a kind of reverential approach to subject matter typified by the work of W. Eugene Smith, where the story was told in a series of dramatic images artfully arranged over several spreads with text blocks and captions in what was known as the picture essay. Many of its practitioners thought photography could change the world and the term "concerned photography" was in vogue. ¶ By comparison, Benson's pictures were irreverent, gritty, casual, and stagy, sometimes outrageously so. They told the story in a single image, usually used large in the opening spread, where it dictated the headline, thereby bending the writer's narrative around Harry's photo. ¶

—Sean Callahan, deputy director of photography, *Life* magazine, 1969–72

PRESIDENT RICHARD M. NIXON / LAREDO, TEXAS / 1972 — It was a hot day and the crowds were enthusiastic. Nixon was ahead of George McGovern in the polls in his campaign for reelection. Against the wishes of the Secret Service agents, he decided to ride in an open car down the streets of Laredo.

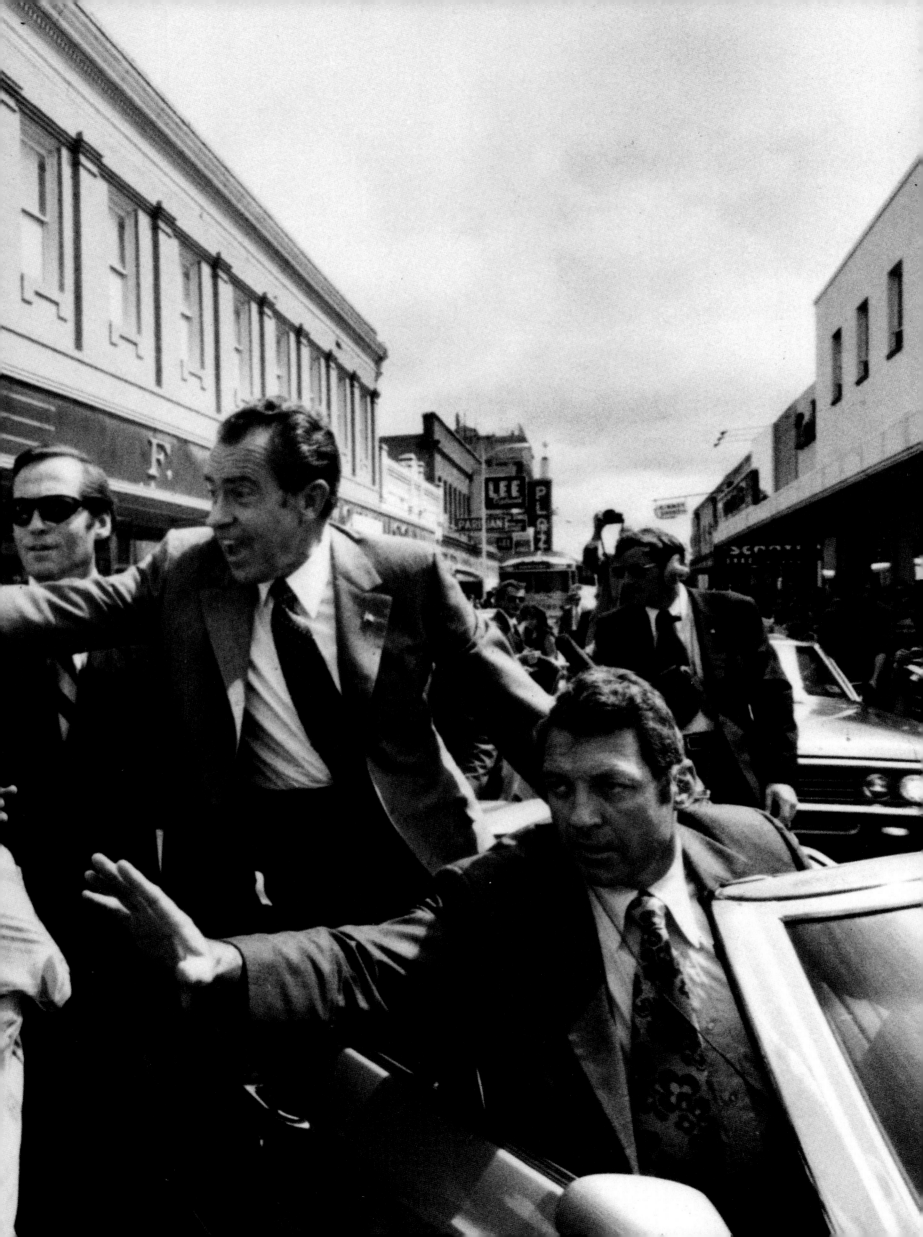

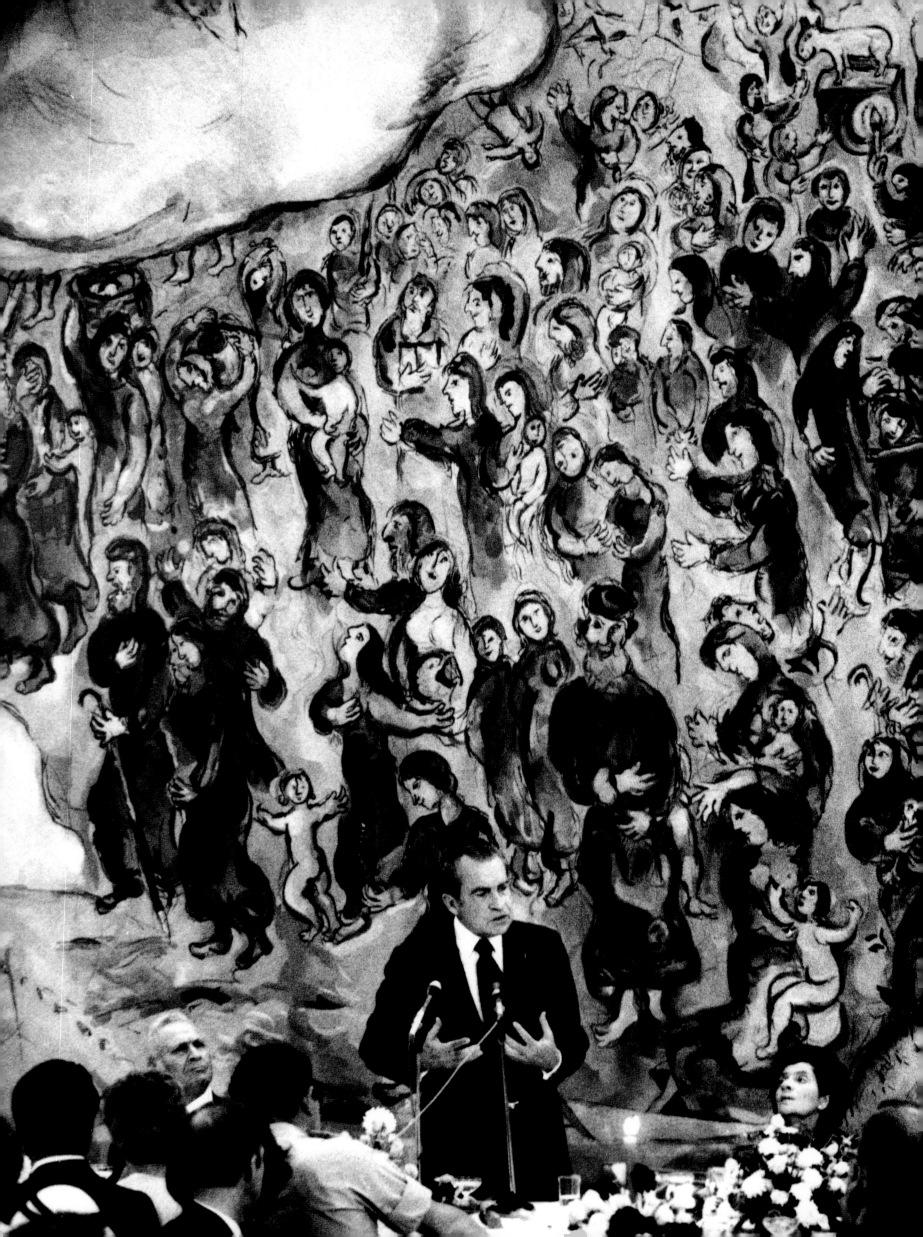

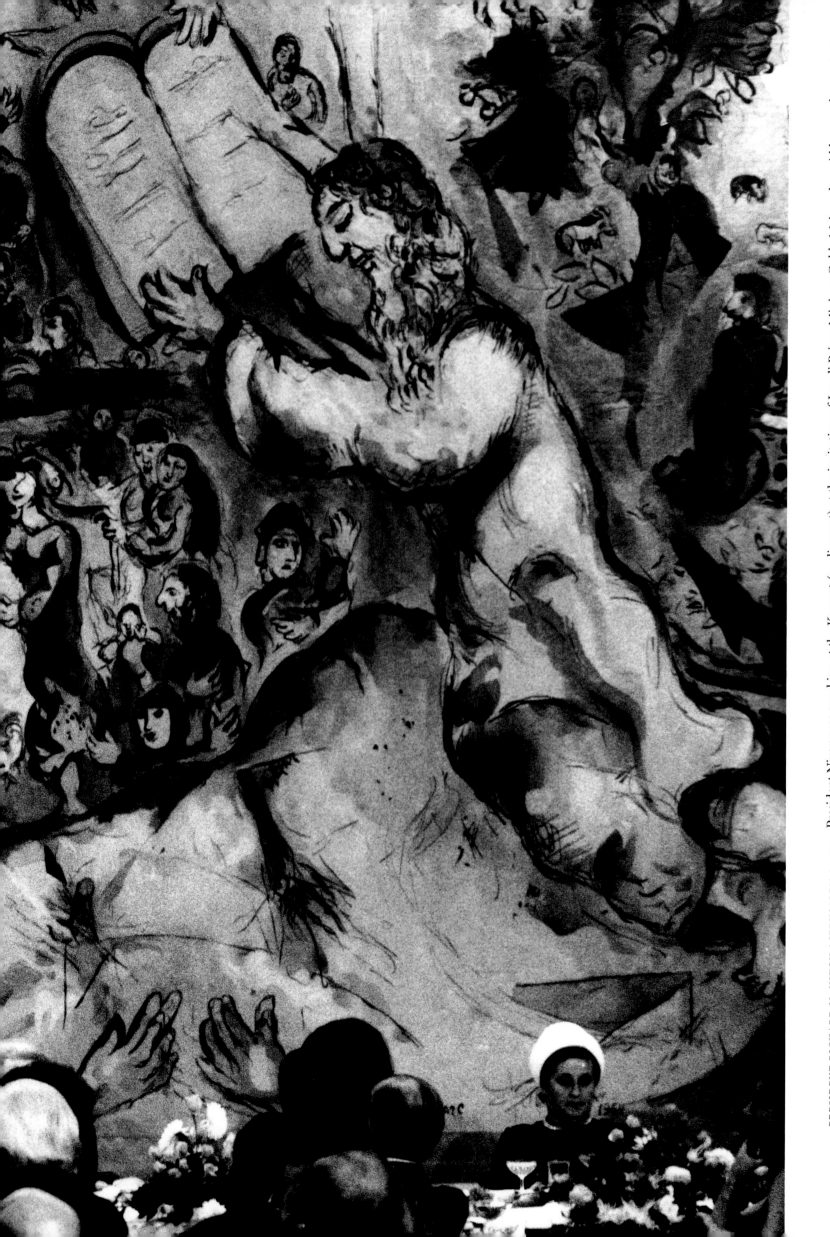

PRESIDENT RICHARD M. NIXON / JERUSALEM / 1974 — President Nixon was speaking at the Knesset (parliament) at the invitation of Israeli Prime Minister Golda Meier, who said he was the greatest American president Israel had ever had. Behind him loomed a massive Chagall mural of Moses with the Ten Commandments. What struck me was the way he held his hands, just like those in the mural.

stakeout

The wiliest stakeout I've seen involved not taking pictures. I asked Harry Benson to cover former Attorney General John Mitchell's trial in

New York City. While the jury was deliberating, Benson went to Mitchell's hotel at 6:00 A.M. simply to stand on the sidewalk and say "good

morning." Every day Mitchell would come out to walk in Central Park and Benson was there with a cheerful greeting. He did not take any

pictures. He wanted Mitchell to see that he was hardworking, but considerate; doing his job, but friendly. "I want him to recognize me. See

me around," Harry explained. "When the verdict's in, I'll go for the kill." Benson felt he had to give me some explanation—I was paying

BOB WOODWARD AND CARL BERNSTEIN / WASHINGTON, D.C. / 1973 – I tried to talk the star reporters who did so much to break the Watergate scandal into posing in front of the Watergate apartment complex where the Democratic headquarters had been burgled, but they wouldn't. Here they are in the stacks at the *Washington Post* office, during the height of the investigation.

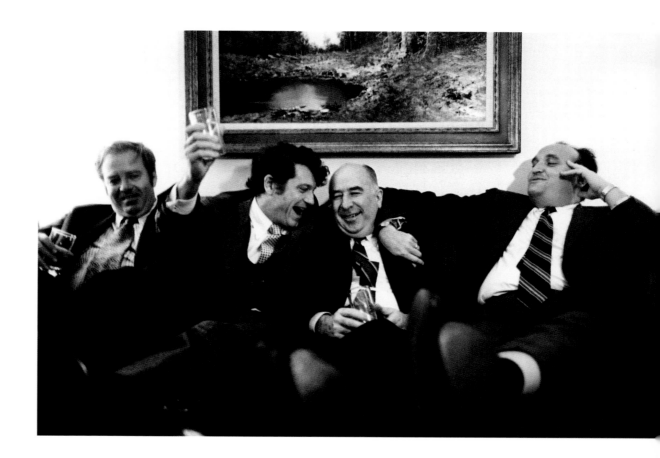

JOHN MITCHELL AND LAWYERS / NEW YORK CITY / 1974 – Nixon's Attorney General John Mitchell had been indicted in the Watergate scandal and was happy to be acquitted in his first trial. His lawyers kept saying, "I knew you could do it, I knew you could do it," and they kept pouring themselves glasses of Scotch. There was something sad about it all. And yet Mitchell was one of the few who never bad-mouthed his boss. That says something about him. I stayed until the other press had left. When the men heard I was from Scotland, they raised their glasses and sang songs by Scottish vaudevillian Harry Lauder.

him, but I wasn't getting any pictures. After three days, the jury's verdict was "not guilty," and that night the press crowded into Mitchell's suite for pictures and interviews. Benson stayed in the back of the room. Only when the last photographers had left did he greet his now exuberant early-morning acquaintance. Soon Benson was sitting on the floor, leading Mitchell and three of the lawyers in Harry Lauder songs. The lawyers and Mitchell relaxed on a couch, drinks in hand. Benson stayed a few minutes. They sang a few tunes from the music hall. They told a few jokes. Harry made a few exposures, and then wished them a happy goodnight.

—John Loengard, picture editor, *Life* and *People* magazines, 1973–74

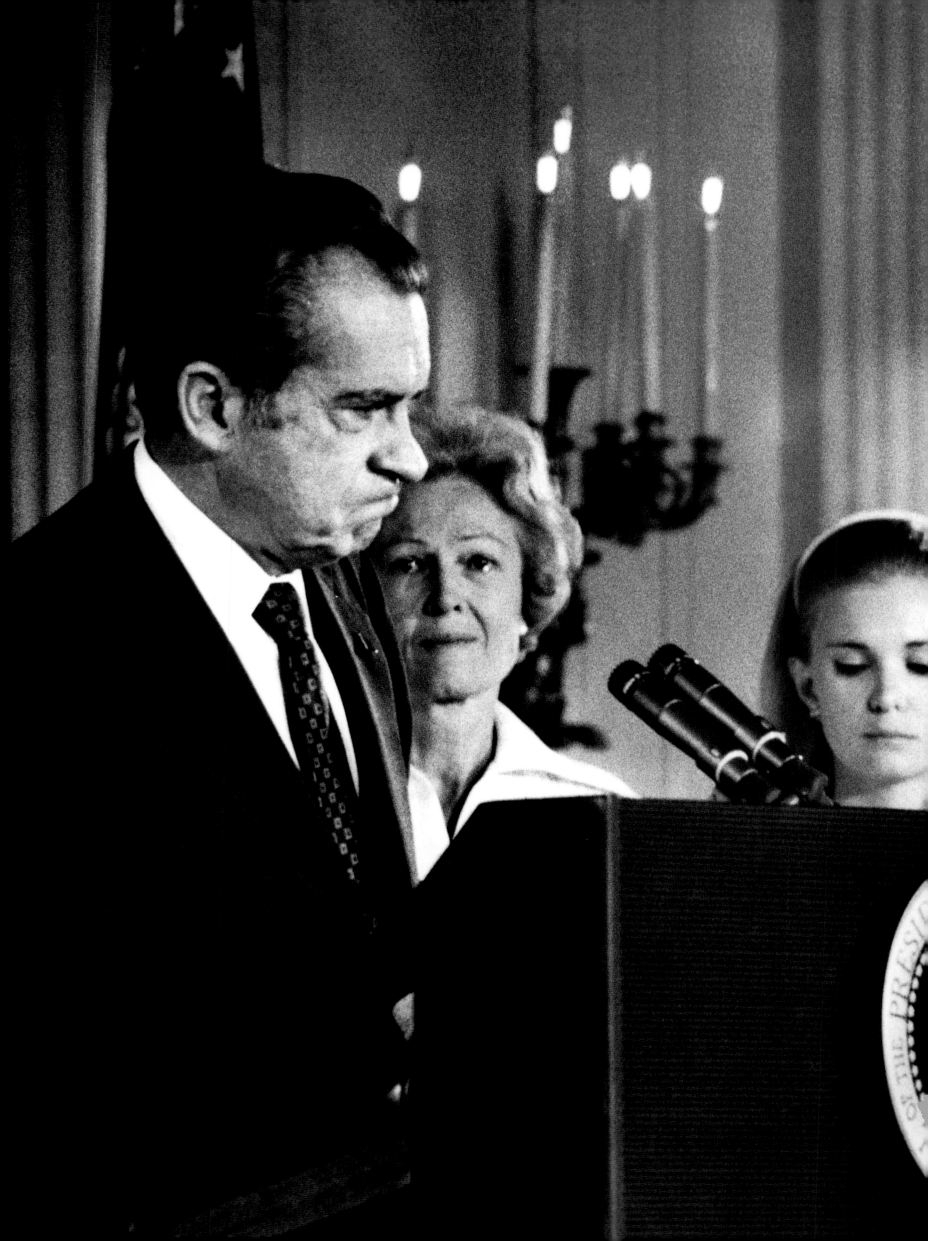

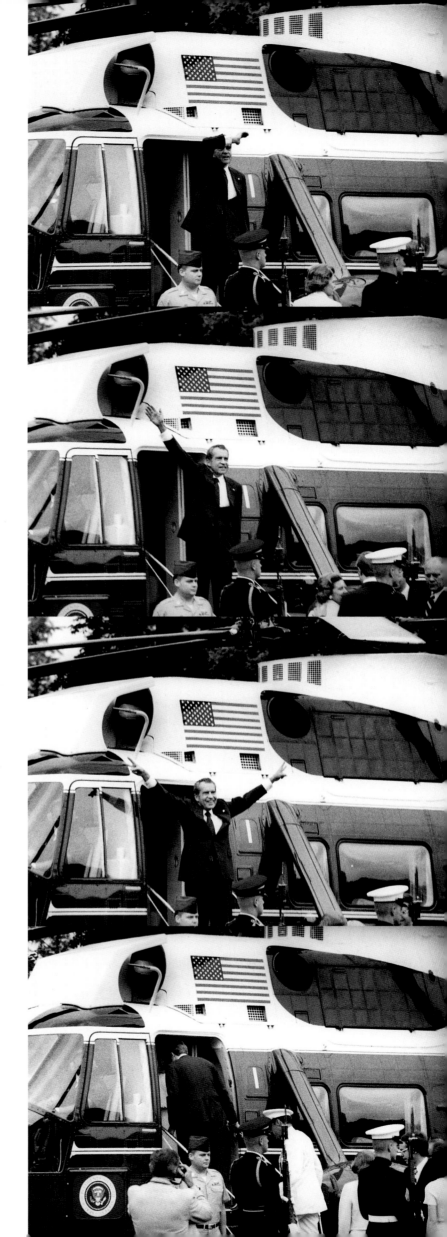

PRESIDENT RICHARD M. NIXON RESIGNS / WASHINGTON, D.C. / AUGUST 1974 — Nixon resigned the presidency on August 9, saying farewell to his Cabinet and White House staff with his family by his side. As Nixon left the White House in a helicopter to Andrews Air Force Base for the trip home to San Clemente, California, he turned and gave his trademark wave to the crowd that had gathered to see him off.

RECONCILIATION / HANOI / 1988 – Vietnam veteran Bill Fero met his North Vietnamese counterpart at a rehabilitation hospital in the North not far from where he himself was wounded during the war. Bill wanted to return to where he had been shot. There seemed to be an unspoken bond between the two. Each had been wounded for his own country. The Vietnamese soldier told us how he used to creep up near the American camps late at night, not to kill, but to listen to the American music. He said that although they were fighting the Americans, it was only the Russians they hated.

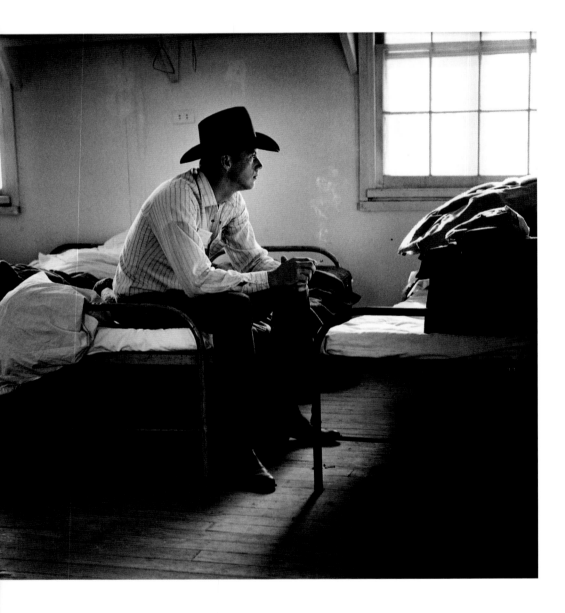

PHILIP ROGERS / CAMP ATTERBURY, INDIANA / OCTOBER 1974 – A twenty-two year old infantryman in Vietnam for over two years when he deserted, Rogers went home to Freer, Texas, when his mother became ill. "Everybody knew I was AWOL, but they figured I had good reason," he said. He turned himself in along with others who had fled to Canada when President Gerald Ford began an amnesty program, and was sentenced to eleven months alternative service. His face had a haunted look, but it was a good, strong face. A lot of these soldiers left Vietnam because they said they couldn't take it anymore.

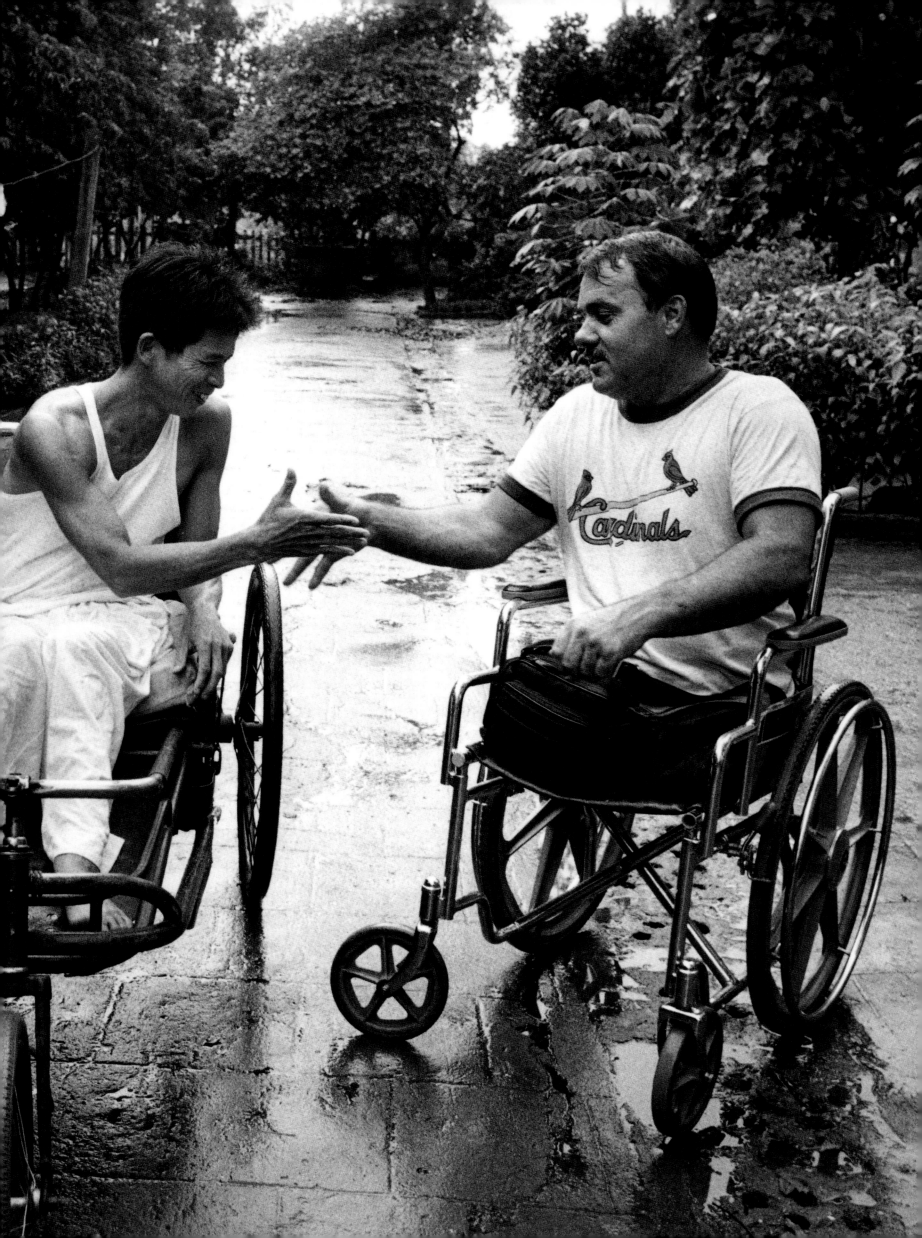

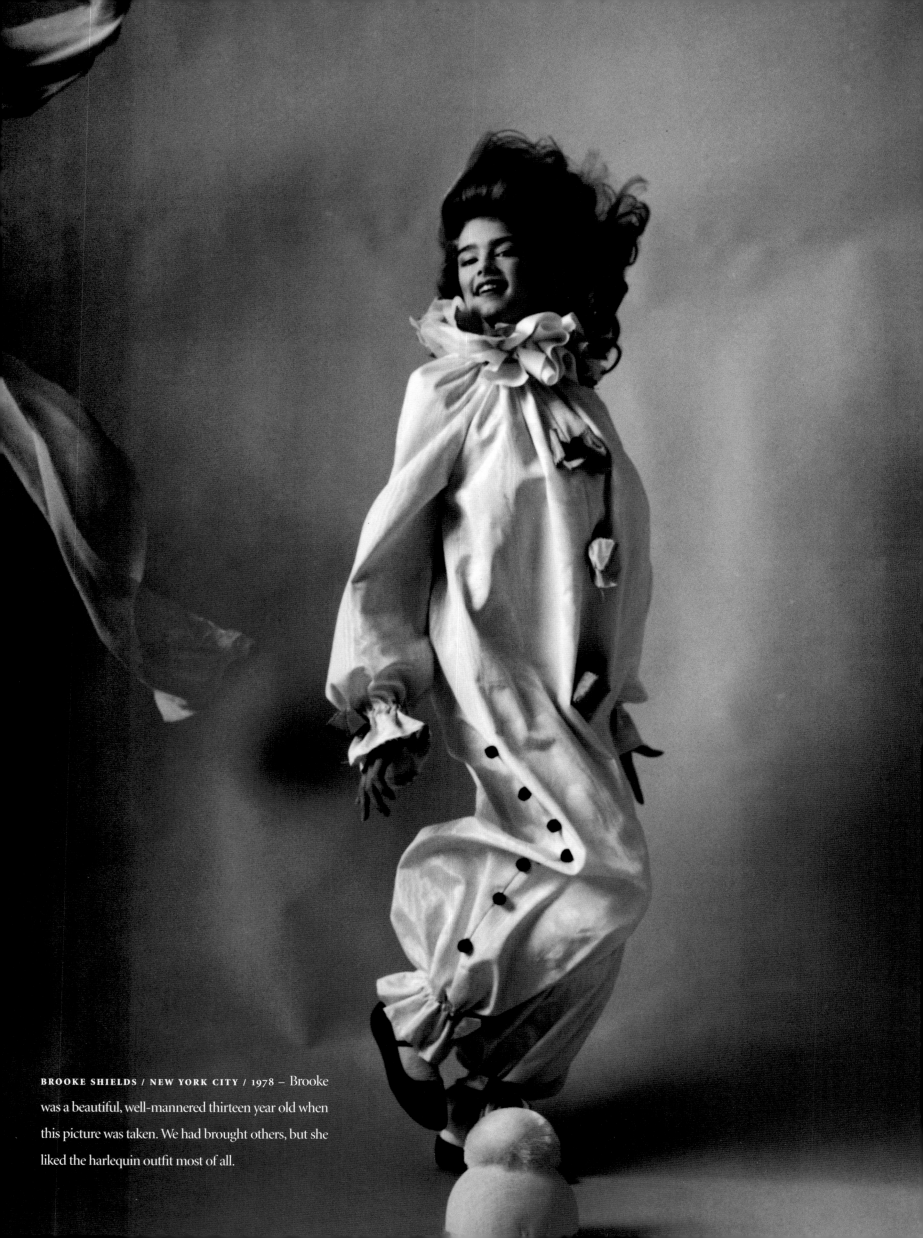

BROOKE SHIELDS / **NEW YORK CITY** / *1978* – Brooke was a beautiful, well-mannered thirteen year old when this picture was taken. We had brought others, but she liked the harlequin outfit most of all.

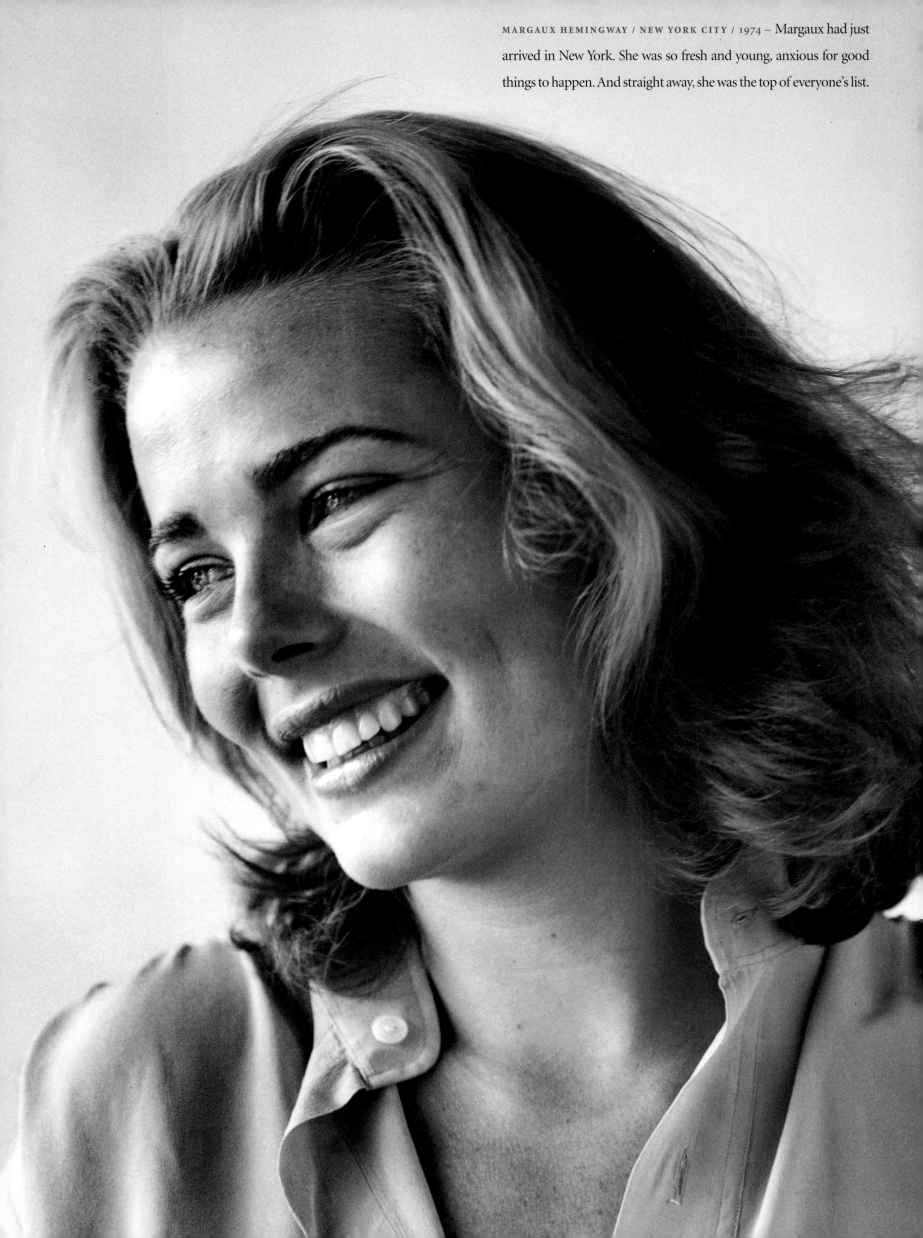

GRETA GARBO / ANTIGUA / 1976 – How could you not take a photograph of film legend Greta Garbo if she swam right in front of your camera? She didn't even know I was there. In other words, I was being what some would call a paparazzo.

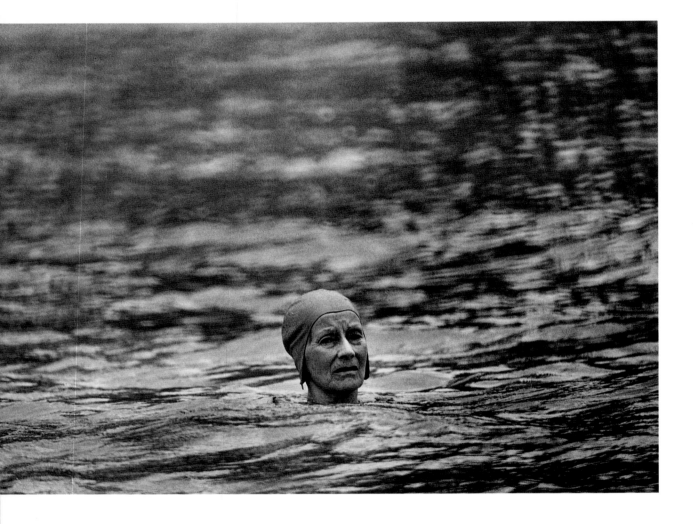

GRETA GARBO / ANTIGUA / 1976 – As Garbo left the beach, it was clear she had lost none of the style that had made her a legend.

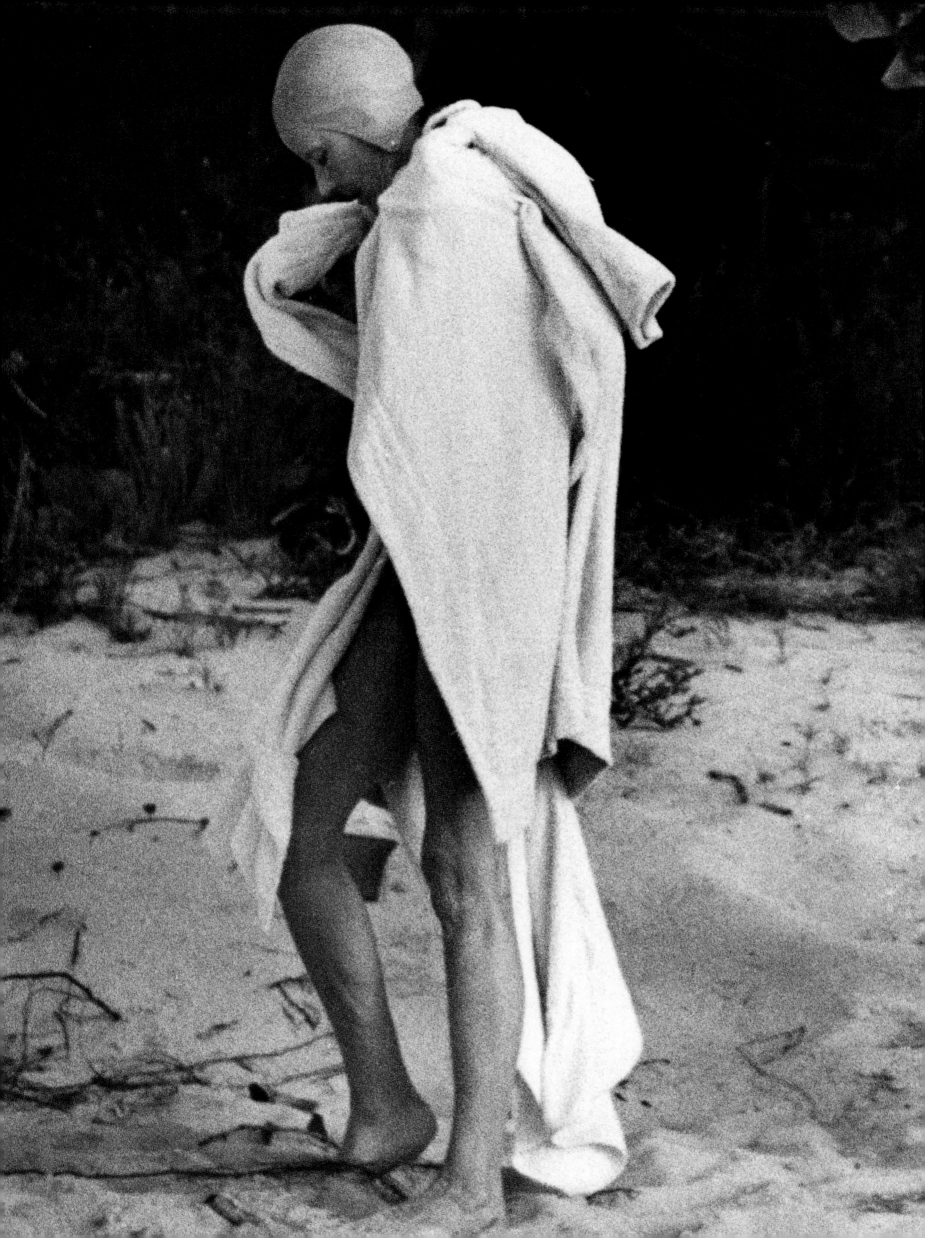

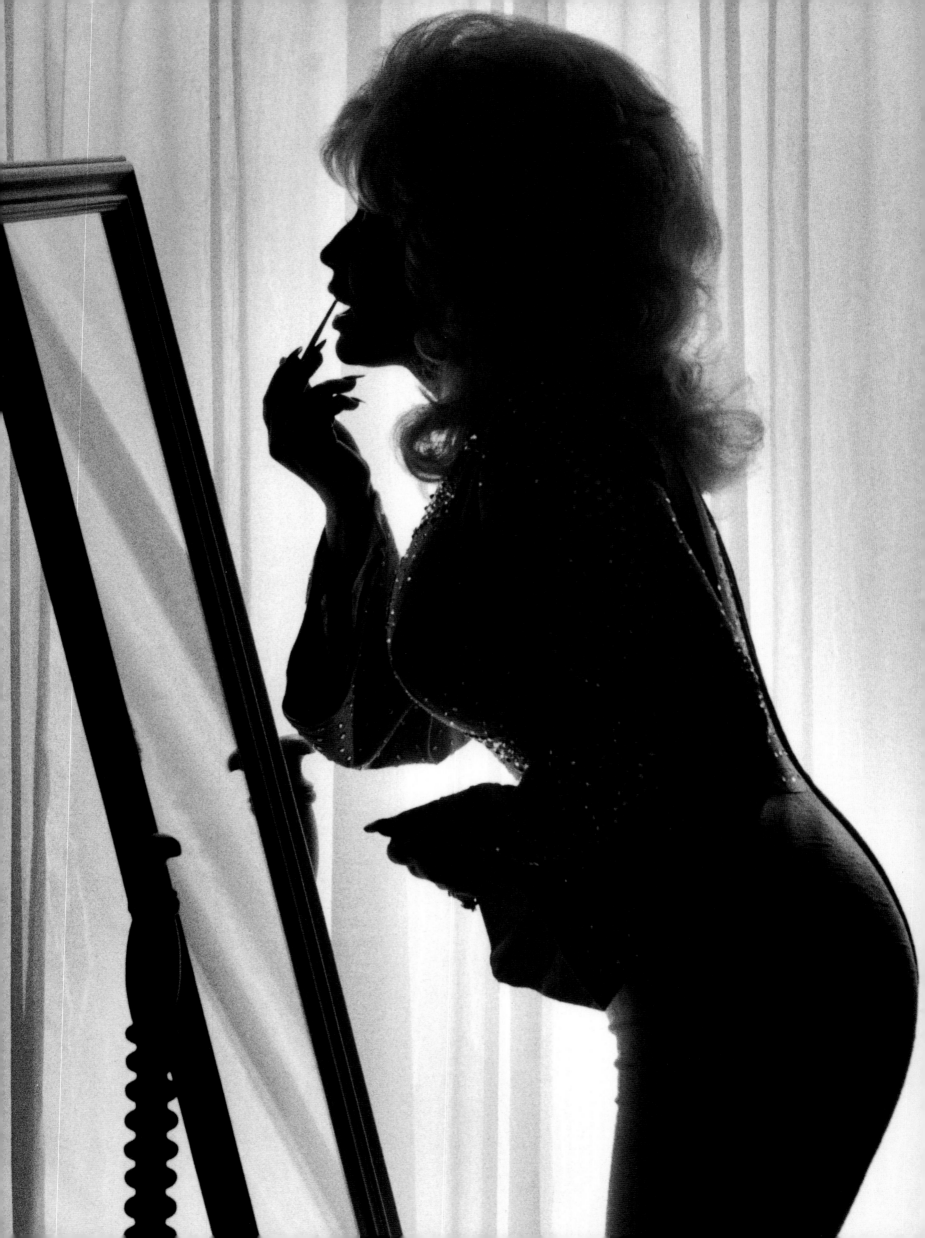

hustle

I became aware of Harry's talent, keen editorial instincts, and hustle while I was an assistant managing editor at the weekly *Life,* so I wanted to use him on the newly-launched *People,* where I was the newly-appointed managing editor. Harry was our early star, coming back with amazingly intimate takes on both famous and ordinary newsmakers. I remember one assignment in particular. He and a *People* correspondent were sent to Denver to get a story on the conservative patriarch of the Coors beer family, name of Adolph. He lived on a hilltop enclave, heavily guarded, in nearby Golden, Colorado. Harry and the reporter drove up the hill and walked around the house, whereupon they introduced themselves and greeted old man Coors at his pool, as I recall. He was surprised, but in the end agreed to pictures and an interview. It was Harry at his enterprising best. ¶ He could get annoyed, however—never at the source, he was too diplomatic for that, but at the accompanying reporter. In one famous incident at *Picture Week,* an experimental magazine that was tested for six months in 1985–86, Harry was so irritated by a reporter's apparently faulty directions in Pennsylvania that he stopped at a gas station, commanded the reporter to go inside and get proper directions, then drove off stranding the reporter. She ran down the highway after him, and Harry finally stopped to pick her up. —Dick Stolley, managing editor, *People* magazine, 1974–81

DOLLY PARTON / NASHVILLE / 1976 – Dolly Parton makes everyone feel right at home with her big smile and down home welcome when she meets you. She was getting ready for me to photograph her when I said, "Just keep doing what you're doing." It was a completely natural picture, no lights were set up, yet it was the one I liked best from that day.

WILLIE NELSON / NEAR AUSTIN, TEXAS /AUGUST 1983 – Over the years I have photographed legendary country western singer-composer Willie Nelson many times and have always found him very easy going. He is the favorite of my wife, Gigi, who like Willie is a Texan.

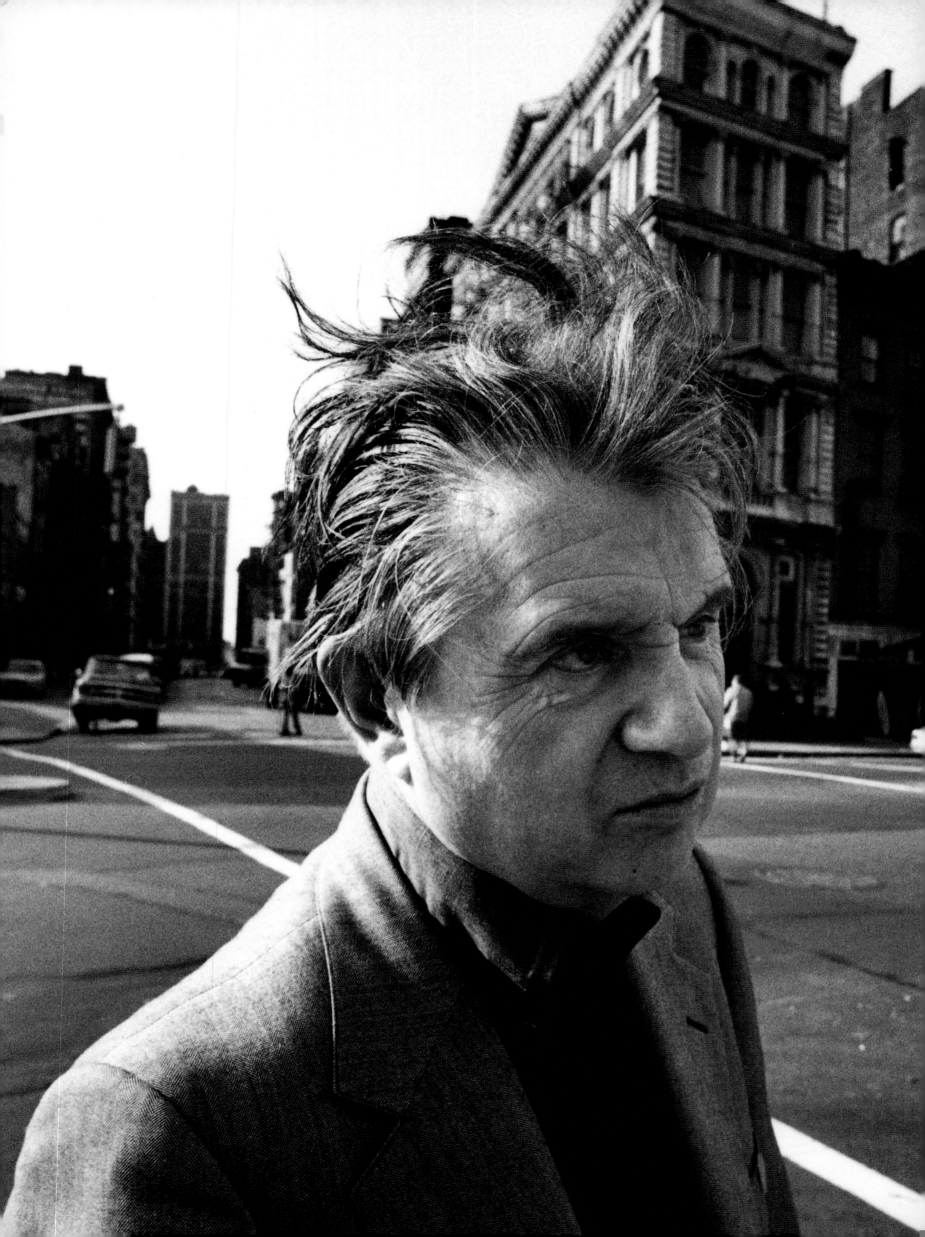

FRANCIS BACON / NEW YORK CITY / 1975 – Formidable British artist Francis Bacon was in New York for the installation of his exhibition at the Metropolitan Museum of Art. We jumped into a cab and headed for skid row on the Bowery in Lower Manhattan. He said he felt more comfortable there. We went into bars where he joked and visited with old and new friends alike, and walked the streets looking for winos and street people to talk to. He said part of his inspiration came from these downtown journeys.

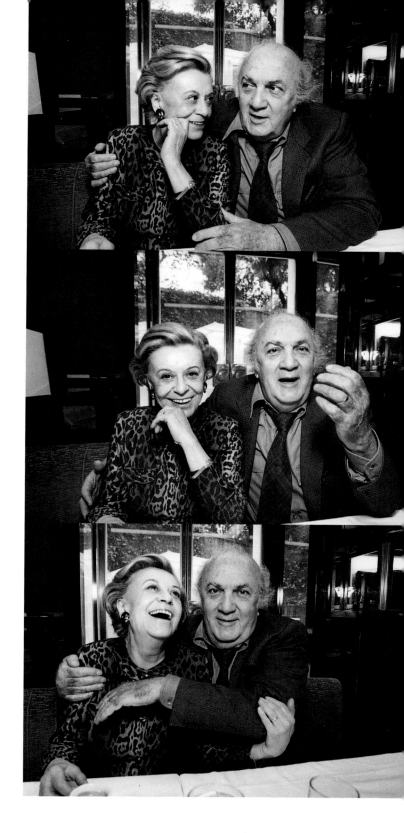

FEDERICO FELLINI AND GIULIETTA MASINA / ROME / 1992 – In Rome to photograph director Federico Fellini and his wife and muse Giulietta Masina, I joined them at a wonderful little restaurant for lunch. It was obvious that Fellini was the king. He was humble and slightly self-deprecating, like many talented people who know they're good and don't have to show off.

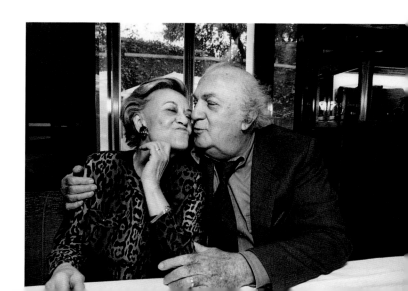

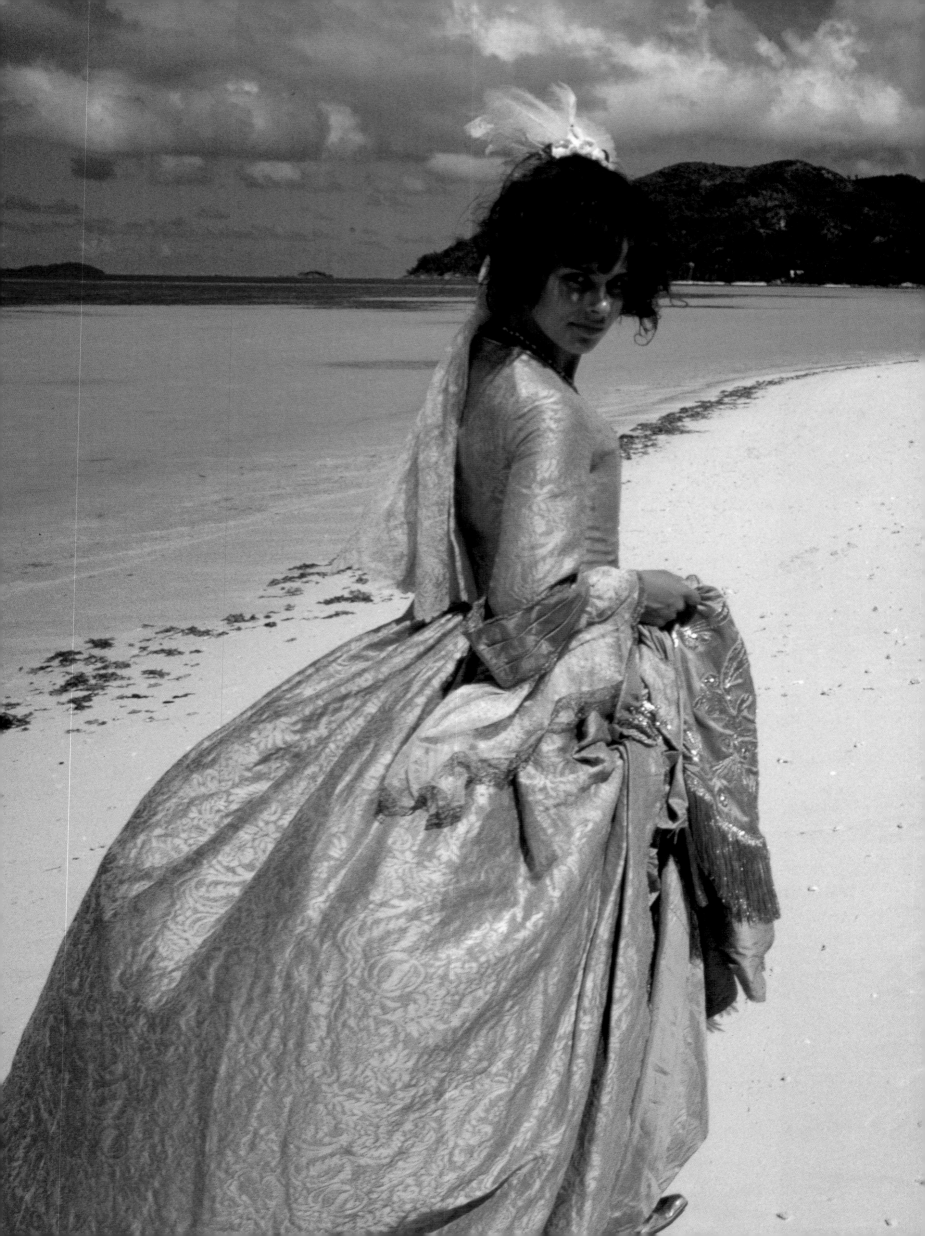

NASTASSJA KINSKI AND ROMAN POLANSKI / SEYCHELLES ISLANDS / 1976 —
Nastassja was only fifteen when she went on location for the pirates issue of French *Vogue.* I liked the way her dress picked up the wind as she walked. The last time I heard, the clothes were all damp and sandy and stuck in customs somewhere.

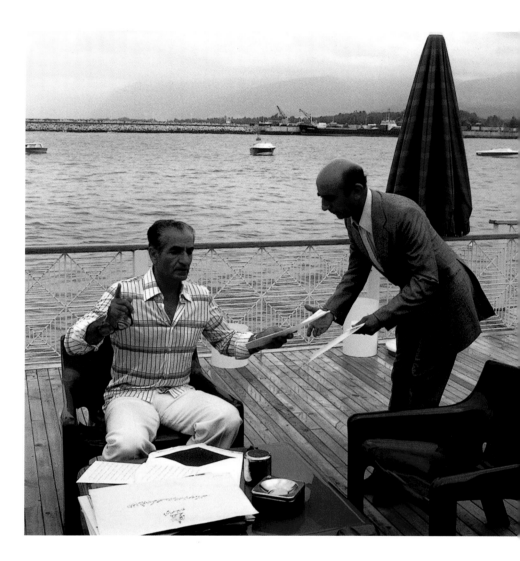

MOHAMMED REZA PAHLAVI, SHAH OF IRAN / NOSHAHR, IRAN / 1978 — Just before his world crumbled, the Shah and his family vacationed at their villa on the Caspian Sea. You could see in his eyes that he was worried about the situation in his country and the disruption being caused by the Ayatollah. The Shah spent part of each day with his aides going over dispatches from his office then went water skiing with his family to relax.

HALSTON / NEW YORK CITY / 1978 – At the height of his career, fashion designer Halston's lifestyle was as glamorous as the women he designed for. Photographing him in his starkly handsome Manhattan townhouse, I found it hard to imagine it would not last forever.

STUDIO 54 / NEW YORK CITY / 1978 – There was the strangest mix of socialites, beautiful people, and low lifes at Studio 54. The celebrities entered either through a private door or they marched right up as the velvet ropes were parted for their grand entrance. Behind a curtain at the back, in a private area up high behind the half-moon blinking sign, sat Halston with Lorna Luft, Steve Rubel, Victor Hugo, and Pat Ast. Halston told me he went there almost every night for the best show in town.

DIANA VREELAND / NEW YORK CITY / 1983 – After leaving her post as editor of *Vogue*, Diana Vreeland headed the Costume Institute of the Metropolitan Museum of Art in New York. I found her preparing an exhibition that was about to open. "By the time I'm finished these dear girls will look ravishing," she told me, as she laughingly sat among her mannequins. She had such a great sense of style and drama.

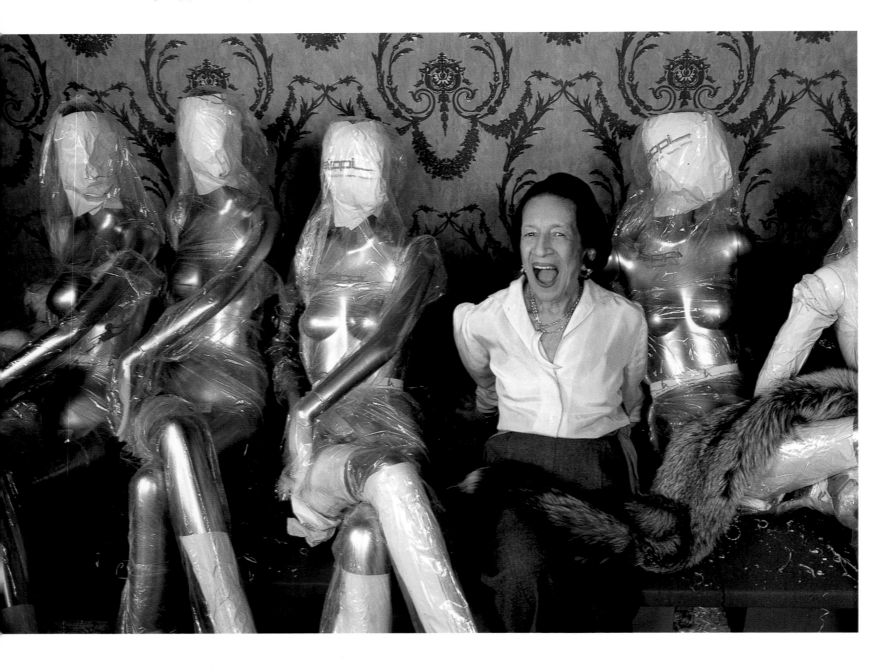

YVES ST. LAURENT / PARIS / JANUARY 1978 – It was all business backstage at the St. Laurent collection. He was completely engrossed, adjusting a sleeve, rewrapping a turban, as each model stepped onto the runway.

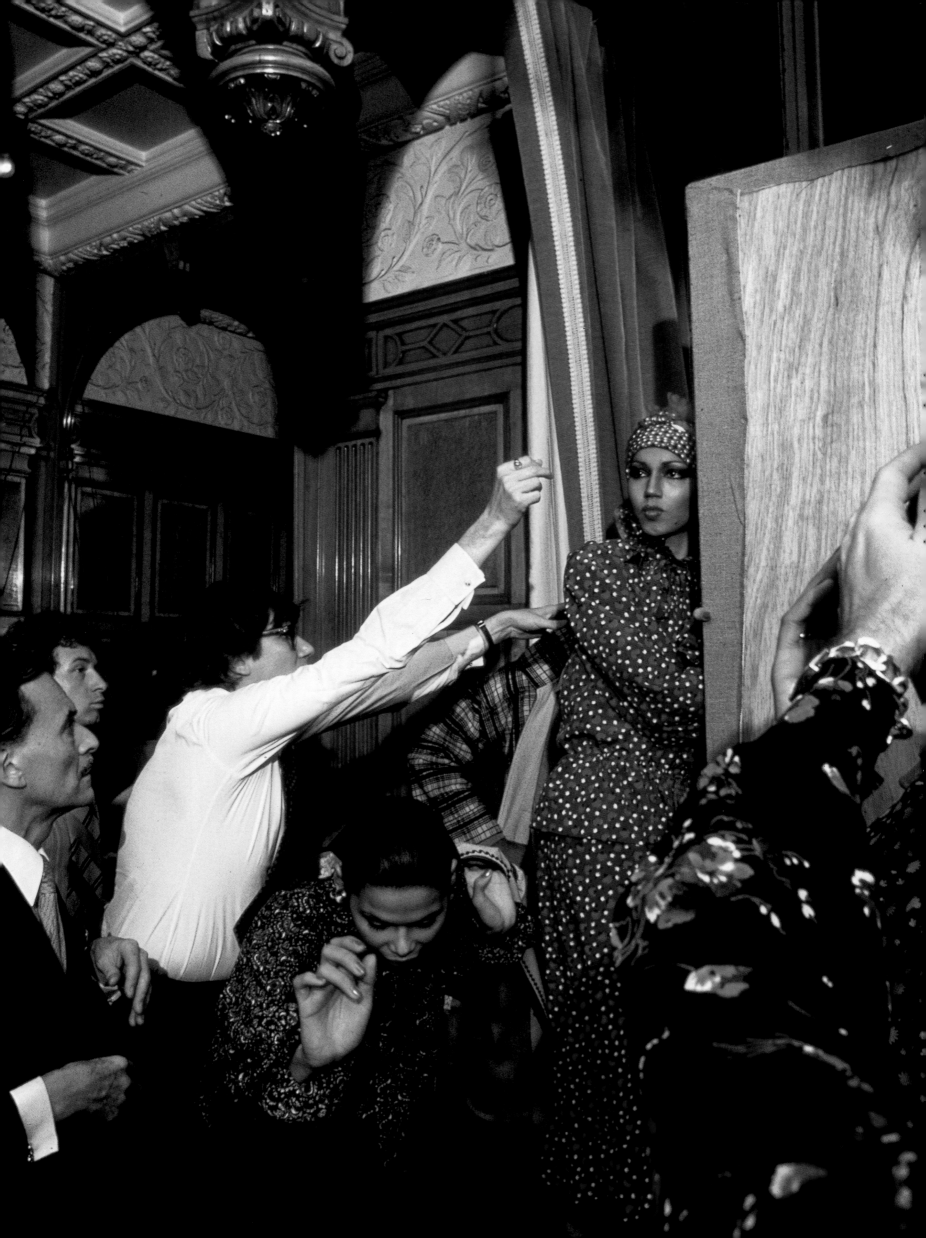

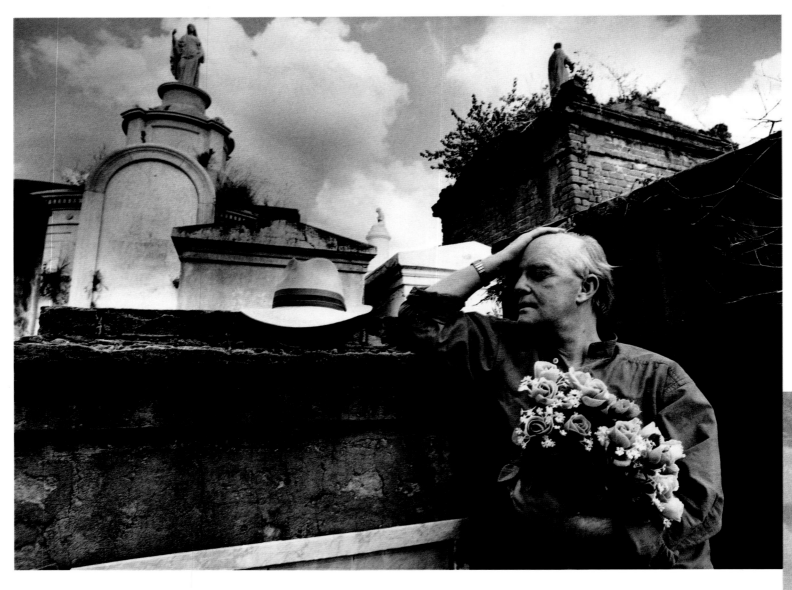

TRUMAN CAPOTE / NEW ORLEANS / 1980 – Truman Capote comes from the South. In New Orleans, I suggested an antebellum house as a backdrop, but he said, "forget about antebellum, where I belong is on Bourbon Street." As we walked along, he pointed out a transvestite club, and stopping to see the show, he joined the performers on stage and had a good laugh. Later we went to what Capote called the most fantastic cemetery ever. In the bathroom in his hotel room I saw an open Bible, with the center cut out and full of cocaine.

TRUMAN CAPOTE / LONG ISLAND, NEW YORK / 1984 – Capote ran barefoot on the beach near his summer home in Wainscot. Later, at a bar in nearby Southampton, he asked the bartender for "the usual" and I said I'd have the same. He warned me that I would be sorry. I couldn't tell you what it tasted like—a mixture of gin, vodka, whiskey, and brandy—but I imagine the closest approximation would be gasoline. He remarked, "I told you, Harry, not to order a man's drink."

preparedness

Harry is a scrapper. He looks at every assignment, every day, as the main event—a boxing match with history's high and mighty, a chance to be at the white-hot center of events, an opportunity to deliver a crushing blow to competing photographers. If a great picture is to be made within a ten-block radius of his Kelly-green pocket square, Harry's journalistic antennae suddenly twitch. He senses a photograph developing, somewhere out in the great gray distance. And, like Clark Kent or Bruce Wayne, he's suddenly transformed: cloaked in concentration, ready for battle, beckoned to the scene. I remember one snowy evening in Vermont. The next morning, Harry and I were to meet Aleksandr Solzhenitsyn, the famous Russian writer and dissident, then living in nearby Cavendish. Ours was to be the first-ever "at-home take" with the exiled author since he fled the Soviet Union almost a decade before. Harry and I took a walk after dinner to ease our anxieties about the next day's shoot. We followed the curve of a country lane, walking slowly in the dark winter chill. We passed a low fence, a horse pasture, a streetlamp. I looked over at Harry. And I noticed that he had fallen several paces back. I saw that he was shadowboxing in the lamplight, soft snow swirling around him. He kept walking, head slightly bowed, punching at the darkness in front of him. He was mumbling a little, or making little pumph-pumph sounds under his breath. "What the hell are you doing?" I asked him. "You only get one chance, David," he remarked. "I've gotta be ready tomorrow." ¶

—David Friend, staff reporter, *Life* magazine, 1978–85

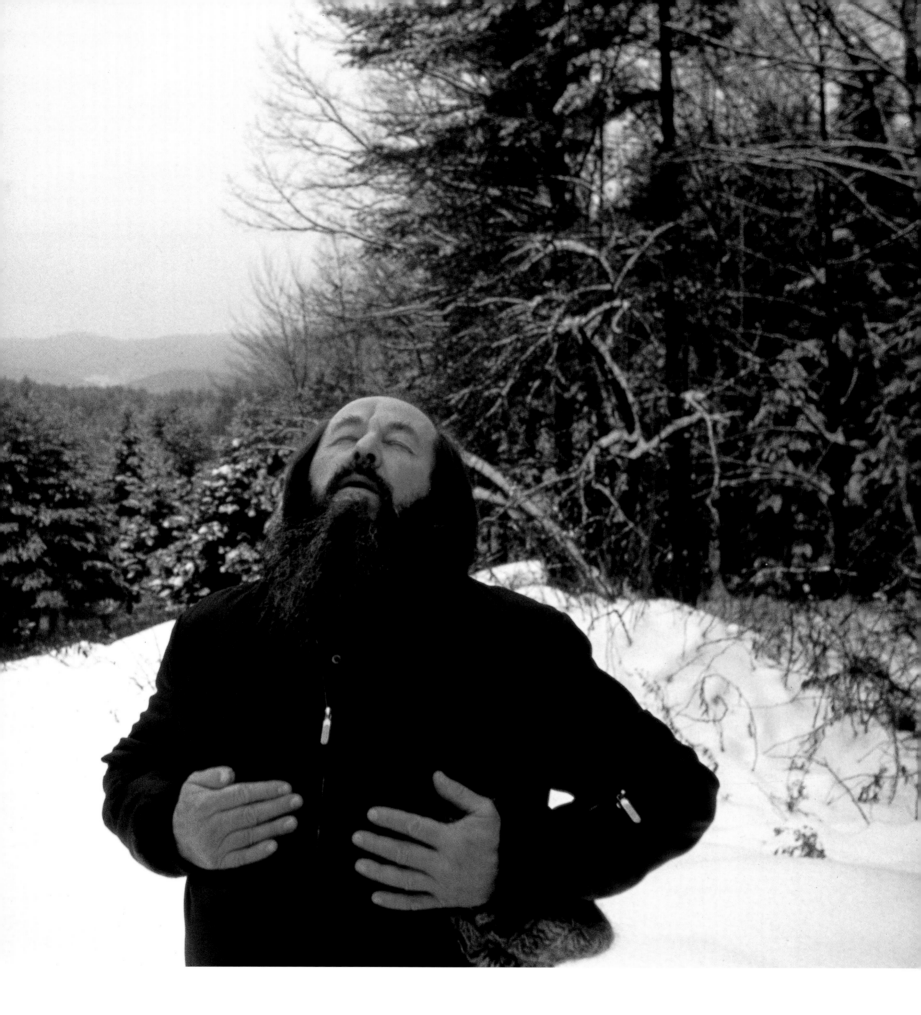

ALEKSANDR SOLZHENITSYN / *CAVENDISH, VERMONT / 1981* – After eight years of exile from his beloved Russia, the reclusive Nobel-prize winning author and historian told me the air was free in America when I asked him what he liked about his adopted country.

FRED ASTAIRE AND HIS WIFE, ROBYN SMITH / LOS ANGELES / 1981 — Astaire was a gracious host, a gentleman in every sense of the word. He told me he learned his sense of style from watching the Duke of Windsor. I asked the eighty-one year old star to dance for me, but he hesitated when his wife said no. Then she said yes and he said no. Crossing his feet was the closest I got to the dancing, elegant Astaire.

→ 6 → 5 → 4 → 3 → 2 → 1

BOB FOSSE / NEW YORK CITY / 1979 — Fosse's autobiographical film *All that Jazz* had just been released and it took several calls back and forth to arrange the shoot. Although he was reticent to be photographed, he was fine when I got to his small apartment. He didn't look like a dancer to me, but when I started taking photographs, he really came to life.

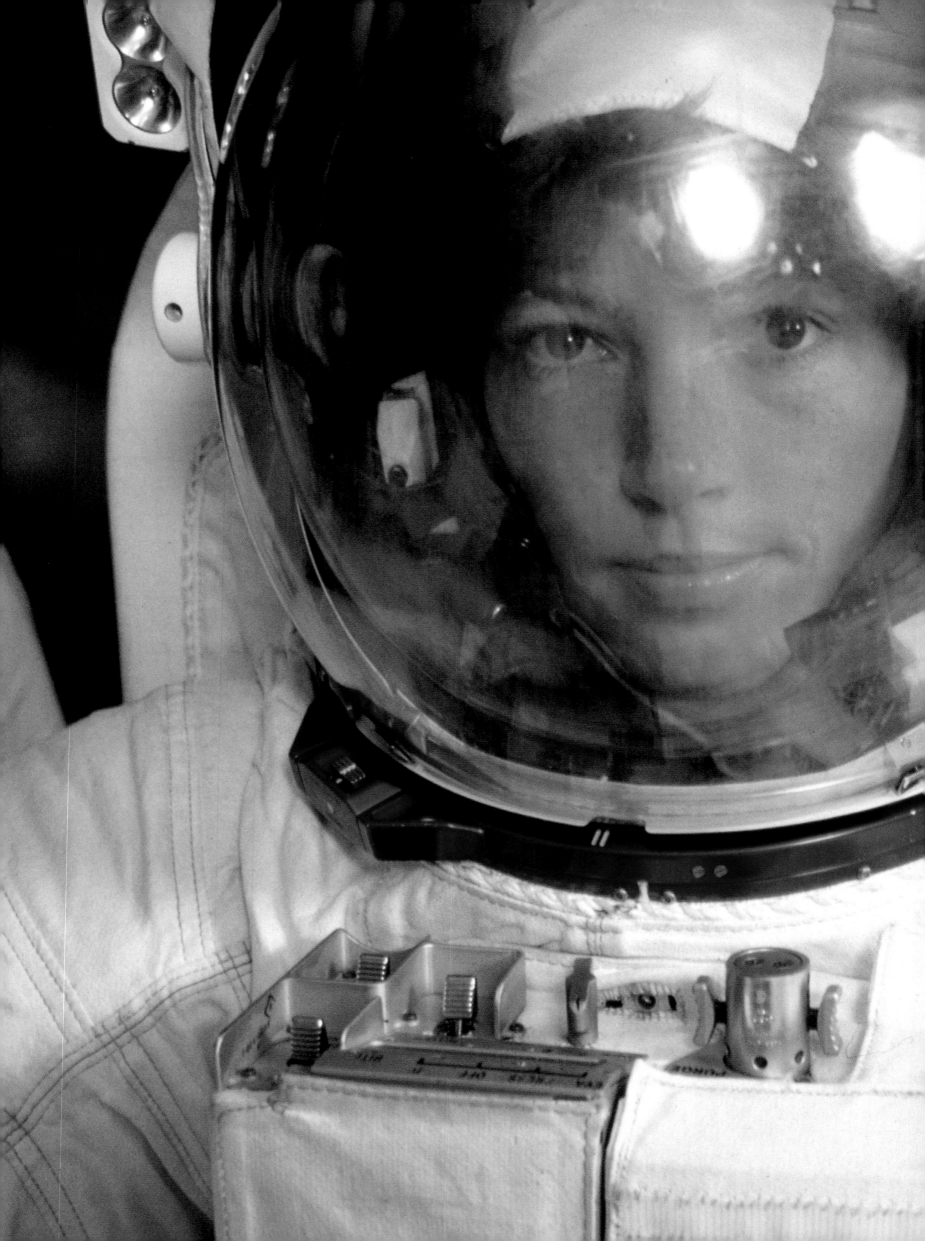

ASTRONAUT ANNA L. FISHER / JOHNSON SPACE CENTER, HOUSTON / 1982 – Anna and William Fisher were the first husband and wife astronaut team, although they did not go up together on the same mission. She was to become, in November 1984, the second American woman in space (Sally K. Ride was the first).

TINA BROWN AND HAROLD EVANS / LONDON / 1982 – When I photographed them at their home near Victoria Station, Harry was the editor of the London *Times* and Tina was the editor of *Tattler*. They later moved to New York, where she edited *Vanity Fair, The New Yorker,* and started *Talk* magazine, and he founded *Condé Nast Traveler* and became editor-in-chief of Random House.

FORMER PRESIDENT RICHARD M. NIXON AND DIANE SAWYER / WASHINGTON, D.C. / 1978 – Broadcast journalist Sawyer had worked for Nixon's White House press office and later in his press office at San Clemente. During a reception in his honor given by his former White House staff, he asked if she still had that long blond hair. She obliged by turning around and showing him.

UNIVERSITY OF MARYLAND HOSPITAL SHOCK-TRAUMA UNIT / BALTIMORE / 1980 —
I wanted to show the tension of a hospital shock-trauma unit and one weekend followed
victims from accident to helicopter to emergency and operating rooms where doctors
worked with urgency and precision to save lives. What surprised me was the amount of
blood that spills on the floor during an operation.

SHOOTING GALLERY / NEW YORK CITY / 1980 – On a story for *Life* about teenage drug abuse, I was in a "shooting gallery," an abandoned building where addicts go to shoot up heroin. When the police unexpectedly raided the place with guns drawn, they were as surprised to see me as I was to see them.

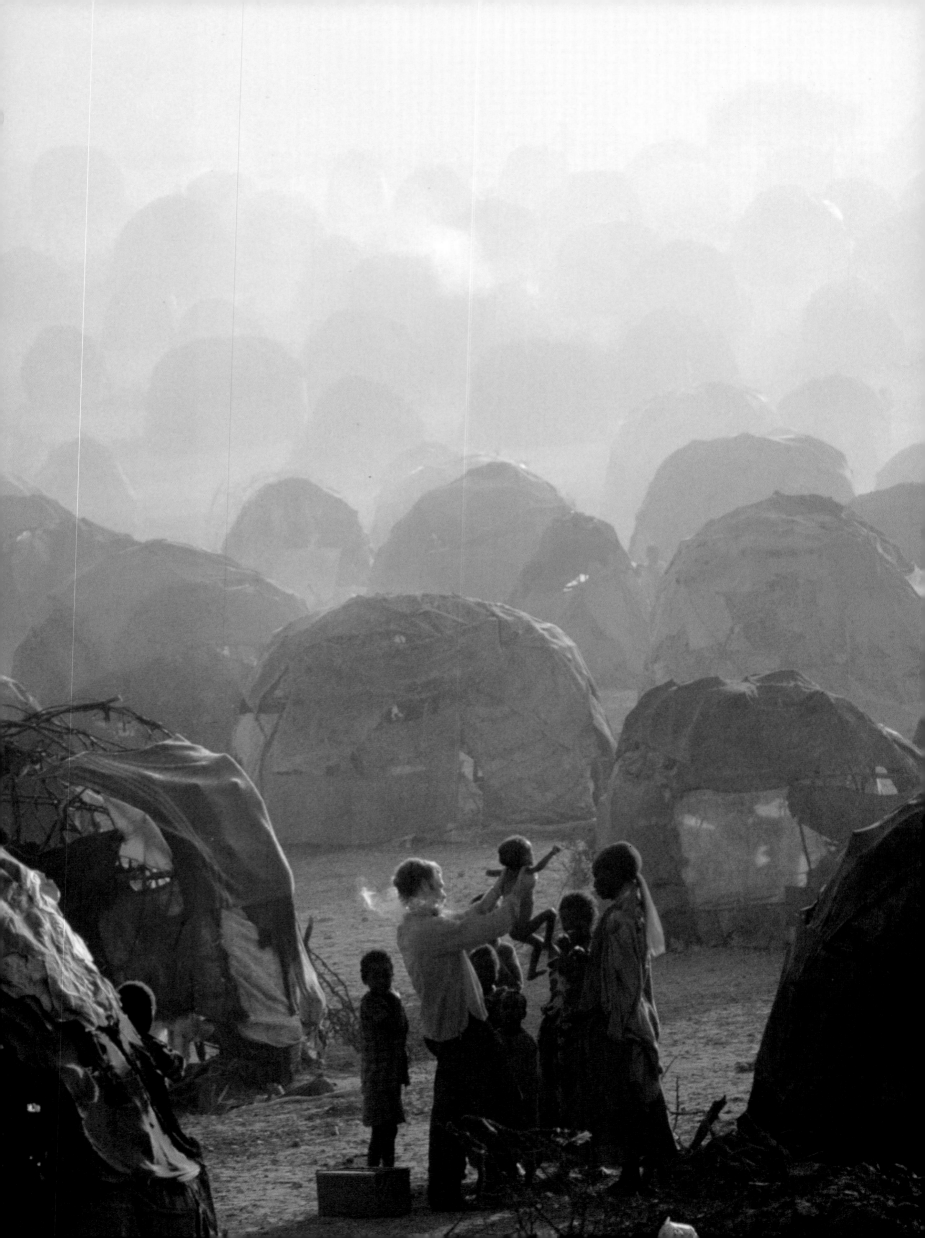

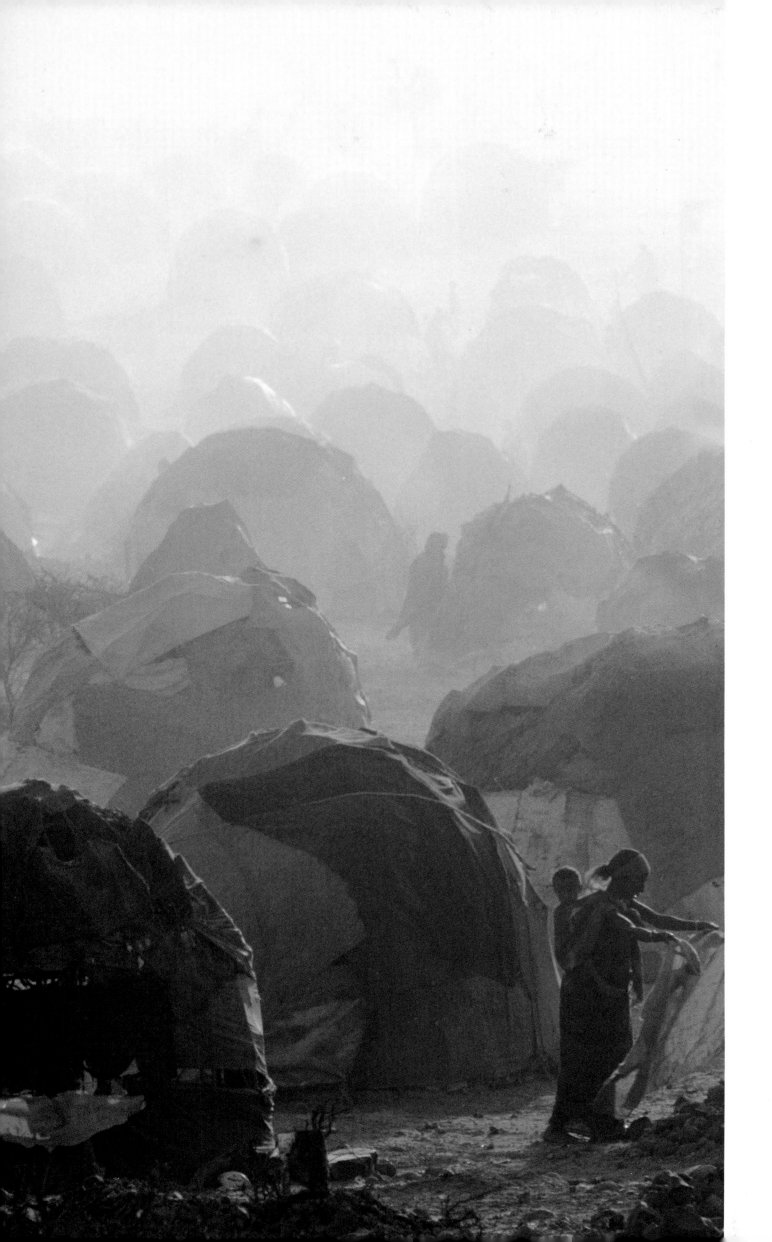

REFUGEE CAMP / LAS DHURE, SOMALIA / 1981 — It was very early in the morning with a mist in the air and Dr. Eric Avery was already treating young and old suffering from dysentery, yellow fever, and starvation. The camp had been set up to house the thousands of refugees that arrived daily from war-torn Ethiopia, walking for miles with whatever possessions they could carry to get there. The chanting, the moaning, and the dying never stopped.

133

behind enemy lines

One evening in October 1983, shortly after the Soviets invaded Afghanistan, Harry and I were strategizing in his hotel room in Peshawar,

Pakistan, on assignment for *Life*. The next morning we were to be spirited across the border by representatives of a militant Islamic fac-

tion that was holding several Russian prisoners of war. Our intention was to be the first Western journalist team to photograph and inter-

view Soviet combatants being held in Afghanistan by the Mujahideen. Other reporters had talked with P.O.W.s at rebel hideouts in

Pakistan. But we needed to penetrate the war zone—to travel into Afghanistan—to secure a true exclusive. Several days before, we had

acquired invaluable gear for the trip: loose-fitting tunics and headgear so that we could pass, undetected, through numerous checkpoints

on our way into the mountains. And, in preparation, we had been blindfolded and taken to safe-houses in Pakistan to meet a handful of

other Russian soldiers. Tomorrow, insha'allah, we would meet their compatriots in Afghanistan. That night, as we readied for our sojourn,

the telephone rang. "Don't answer it," Harry warned, holding up a hand. "If you do, you'll be on the next plane back to New York." He took

the call. And, naturally, it was New York on the line. Coming up against a looming deadline, our editors were getting nervous. They won-

dered if Harry could hand me the film he'd already shot so that I could return home immediately. At least this would give them a sense of

how the piece was shaping up and would allay their fears; Harry could finish the story himself. "I'd love to do that, Steve," Harry lied. "But

David's already about five hours from here. Somewhere I can't tell you about on the phone. Dressed like an idiot." "Don't worry," he went

on. "We'll be home with the story in time for the close." Harry smiled as he cradled the receiver. "If you'd've picked up that phone, you'd

have traveled half-way around the world just to be a messenger boy. You'd never have set foot in Afghanistan." We got our exclusive over

the course of the next three days, passing within fourteen miles of the Russian front. And we did it together, thanks to Harry. ¶

—David Friend, staff reporter, *Life* magazine, 1978–85

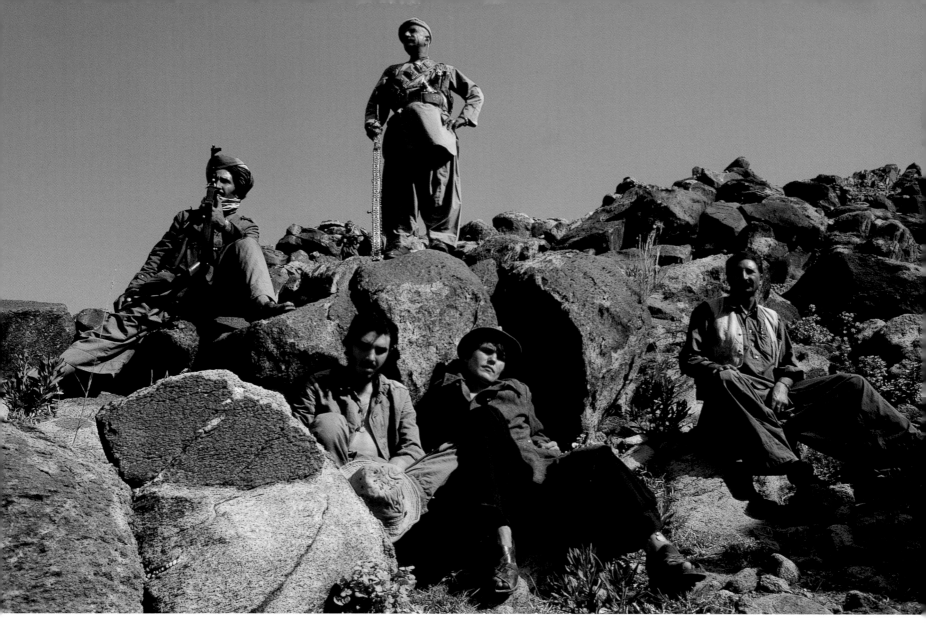

MUJAHIDEEN GUERILLAS AND RUSSIAN PRISONERS / BORDER OF PAKISTAN AND AFGHANISTAN / 1983 —
Wearing native Pakistani clothes as a disguise, David Friend and I drove for two days in a beat-up jeep to rendezvous with Mujahideen guerrillas and their Russian prisoners of war. The prisoners were so young, teenagers mostly. One of them refused to be photographed. Our interpreter started speaking to me in Russian, which I couldn't understand. She was doing it for his benefit, saying that the best thing he could do would be to be photographed for *Life* magazine, insuring the Swiss Red Cross would see him and he could be saved.

WAR VICTIM / AFGHANISTAN / 1983 — The editors at *Life* thought my photographs of children with their legs blown off by mines—casualties of the war between Russia and Afghanistan—were too graphic to use. They felt the same about my photographs of men with one eye gouged out . . . an eye for an eye being a punishment as old as the Bible. It was something I thought people should know about.

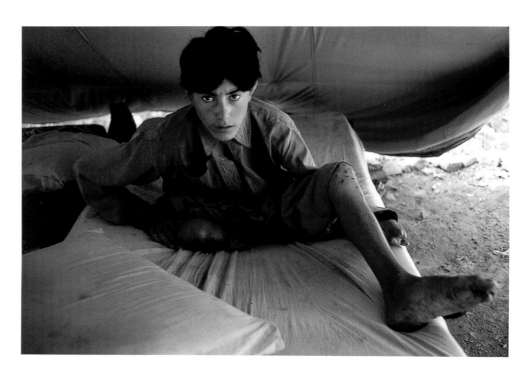

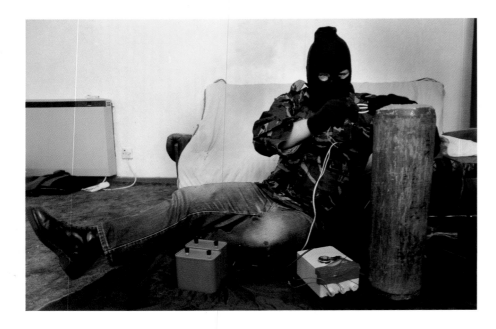

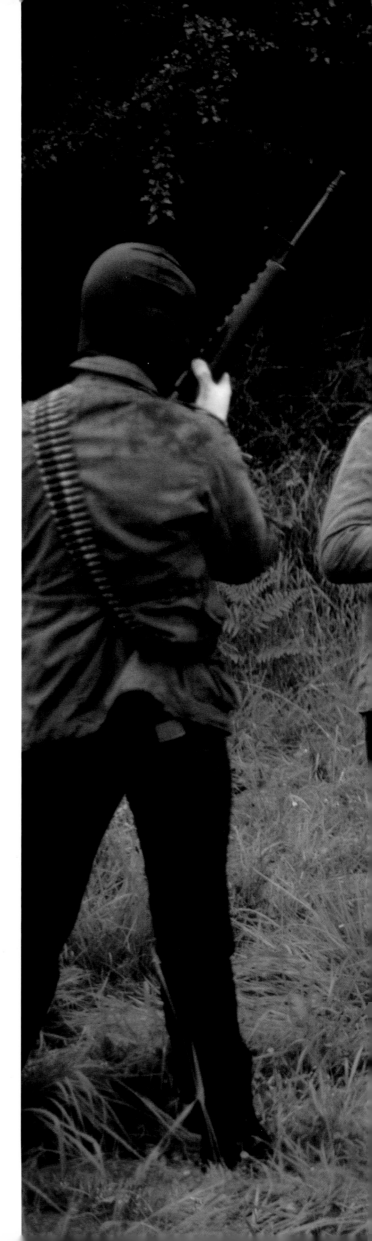

IRA BOMB MAKER / BELFAST / 1985 – On assignment for *Life* magazine, I managed to gain the confidence of the Irish Republican Army and go on maneuvers with them. I was blindfolded and taken to a safe house, where the IRA soldier was actually making a bomb. When I came into the room and they took off my blindfold, the bombmaker stood up and shook hands. He was a small man. At his feet was a canister about two feet high and one foot wide filled with explosives. I thought about all the devastation and death that might have been caused by this man's handiwork. There was an acrid smell of explosives even outside the house, which made me wonder why a British patrol with police dogs never discovered it. What I found astonishing was that we were in the heart of Belfast and the only security was the drawn blinds.

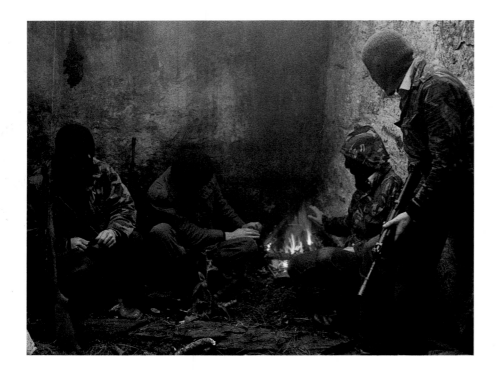

IRA SOLDIERS / ULSTER, NORTHERN IRELAND / 1985 – In an abandoned stone hut late at night, we built a small fire to combat the freezing cold. My hosts were confident we wouldn't be discovered.

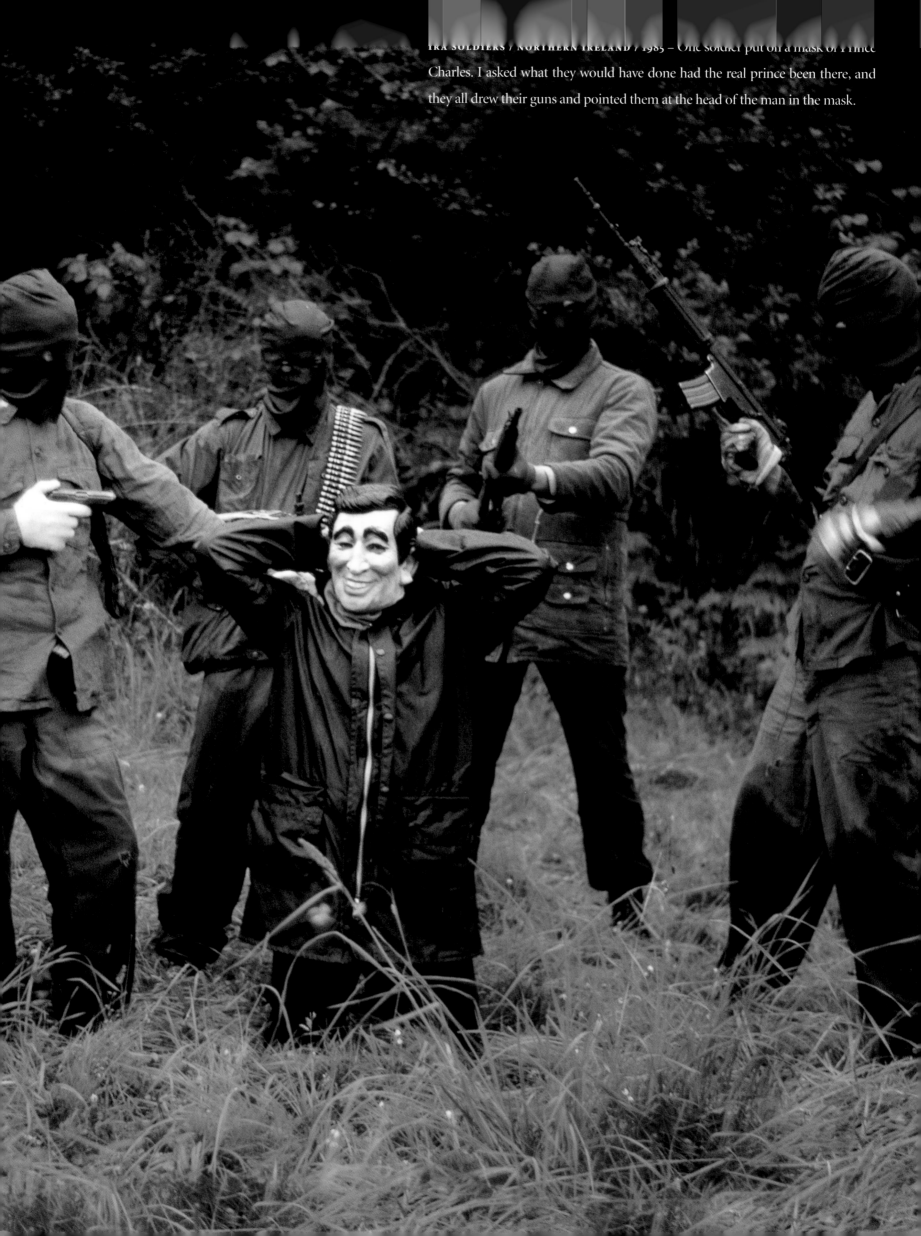

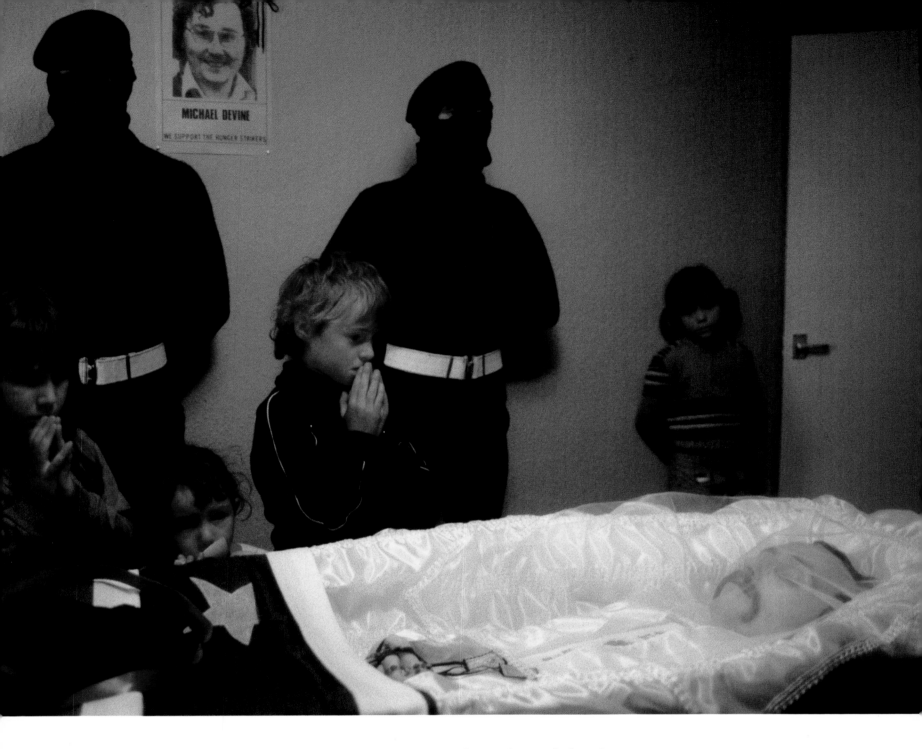

MICKEY DEVINE'S WAKE / LONDONDERRY, NORTHERN IRELAND / 1981 – Mickey Devine was the last of ten IRA hunger strikers to die in the Maze, known as "Long Kesh," a British prison outside Belfast. It is a terrible death. In the room adjacent to where his body lay, mourners gathered for tea and sandwiches. Masked Irish Republican Army soldiers stood guard, while two hundred yards down the road were British army patrols.

GRAVESITE / CAMLOUGH, NORTHERN IRELAND / 1981 – At his gravesite on a hill-
top in their village of Camlough, Raymond McCreesh's parents pray for him.
Their son died on a hunger strike to gain world attention for the IRA cause.

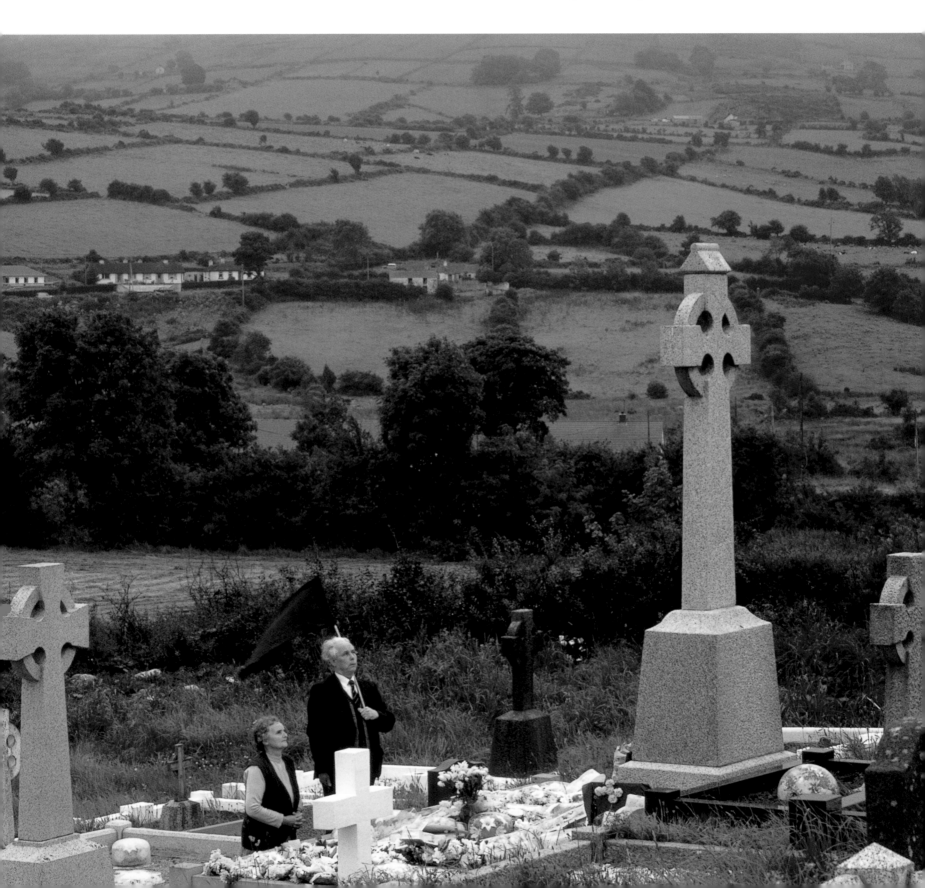

fast work

The photograph of the Reagans dancing, which was used for the cover of *Vanity Fair* in June 1985, was taken in the map room of the White House. When the White House press people put us in the room and left, I turned it into a studio. I rolled out white seamless paper, put on a tape of Frank Sinatra singing "Nancy with the Laughing Face," and waited. When the President and Mrs. Reagan stopped by, on their way to a state dinner, I could see the faces of the press officers fall. I hadn't told them what I was going to do. What are they going to say at this point? They can't run up to the President and say they didn't know this was happening. They would look stupid. Anyway, Nancy loved it and started dancing with the President. As they were leaving, I asked for a Hollywood ending—a close-up of the couple kissing. I got the pictures and they were off to their dinner. All in five minutes.

PRESIDENT AND MRS. RONALD REAGAN / THE WHITE HOUSE, WASHINGTON, D. C. / 1985

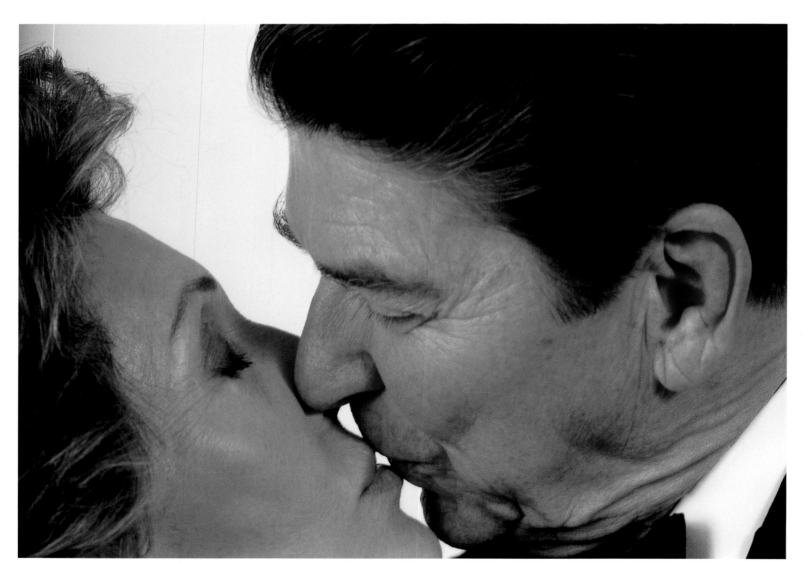

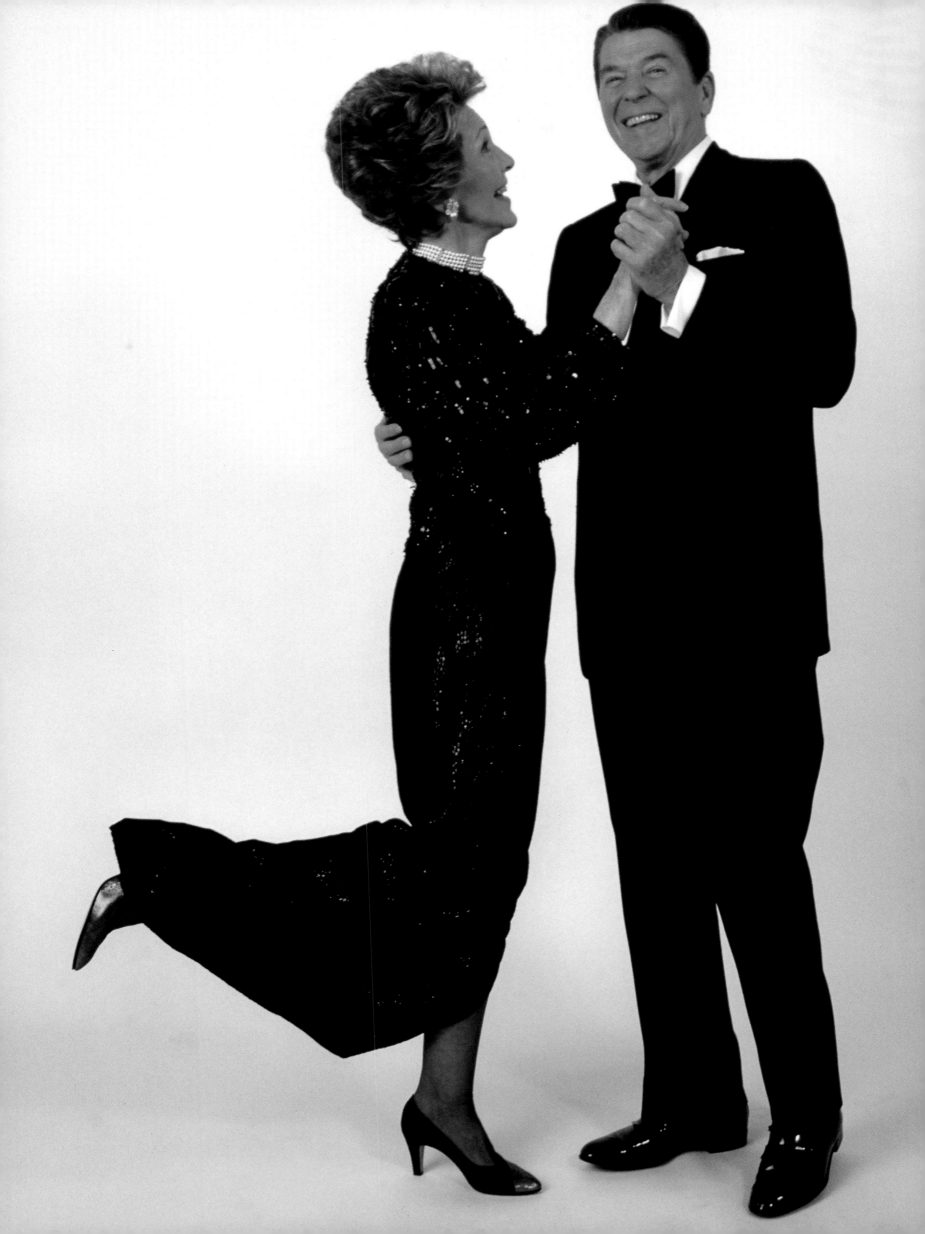

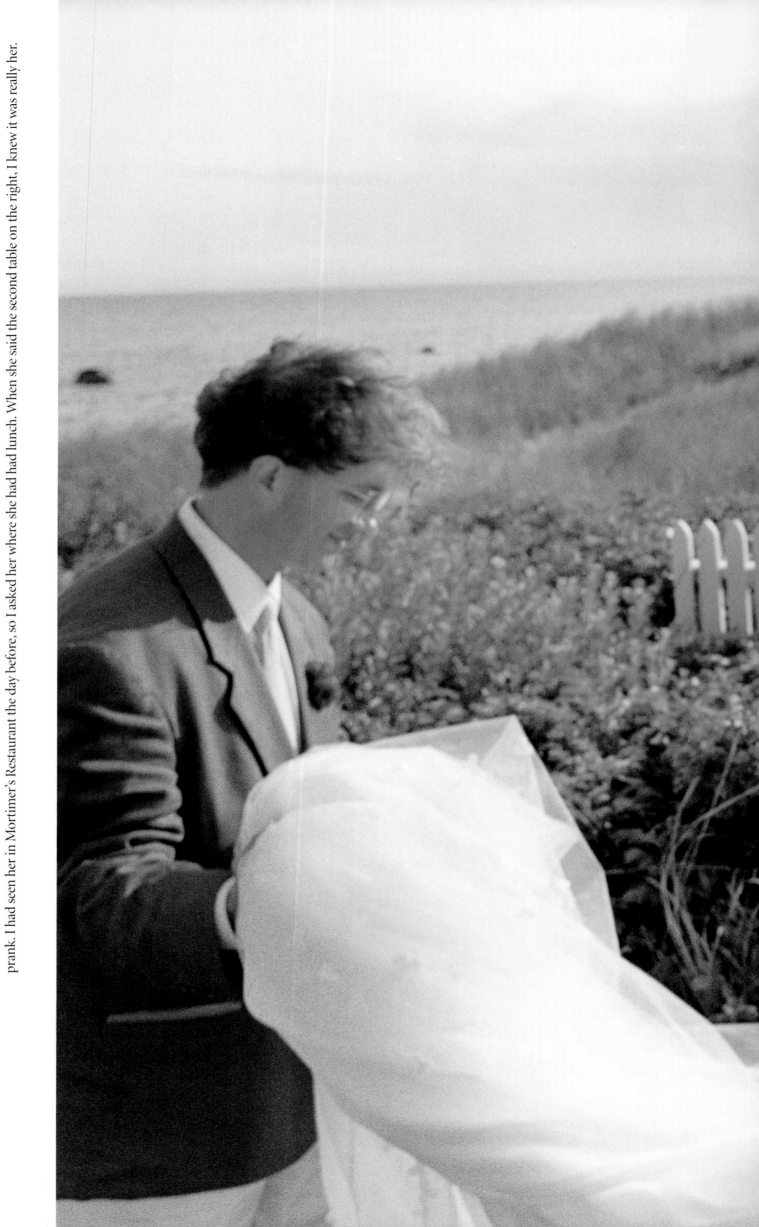

CAROLINE KENNEDY / HYANNIS, MASSACHUSETTS / JULY 1986 — Caroline Kennedy wanted me to photograph her wedding because I had taken the cover photo of her with her brother John for *Life* magazine. Her mother called to ask. I didn't believe her when she said, "This is Jacqueline Onassis." I thought it was some friend of mine playing a prank. I had seen her in Mortimer's Restaurant the day before, so I asked her where she had had lunch. When she said the second table on the right, I knew it was really her.

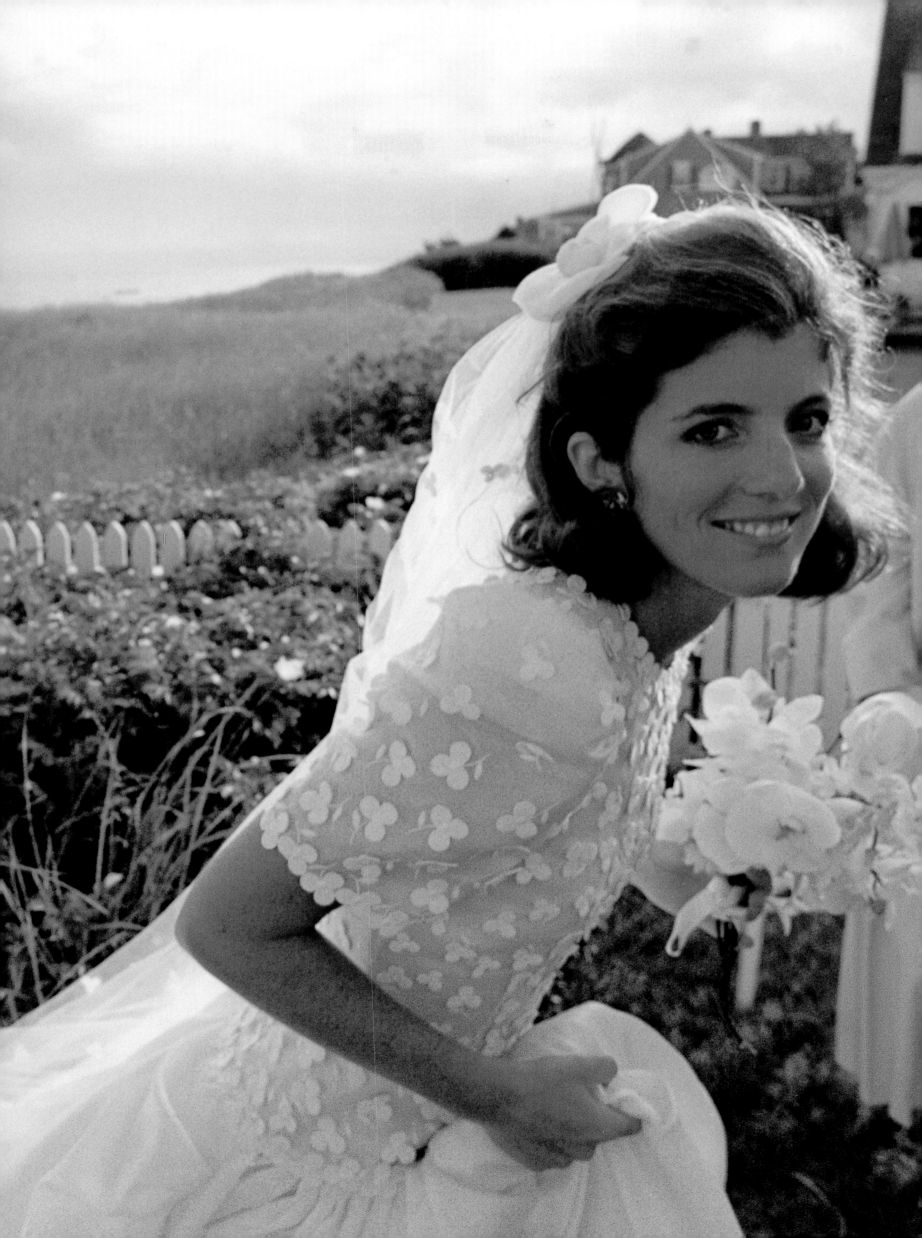

PRINCESS GRACE OF MONACO / PARIS / 1982 – In one of the last photographs taken of her, Princess Grace sat waiting in her Paris apartment for her daughter, Princess Stephanie, to arrive home from school. Princess Caroline arrived instead.

PRINCESS CAROLINE OF MONACO / MONTE CARLO / 1986 – As a patron of the Royal Ballet of Monaco, her mother's favorite, Princess Caroline visits from time to time to meet the students and lead a class. She wasn't what I expected. She was serious, hard-working, and could speak five languages fluently. She had taken up many of the duties that Princess Grace had when she was alive.

confidence man

MARK DAVID CHAPMAN / ATTICA, NEW YORK / 1987 – Chapman took me aside and we sat down. He said, "I want to apologize to you for killing your friend, John."

Harry is one of a kind. We did lots of stories together, and I've seen him do some amazing things, but the most amazing job we ever did together was the story of Mark David Chapman, the man who killed John Lennon. Winning the confidence of a murderer is always, of course, a little unsavory, and for better or worse I had got Chapman's. When our story appeared, Chapman had not been interviewed or photographed by anyone else in the eight years that had then passed since Lennon's murder. I had interviewed him for more than a hundred hours before Harry came up to Attica one day for the photo shoot. Chapman was well aware of Harry's history with the Beatles and of course Harry knew that Chapman knew, so as his assistant Jon Delano was setting up the cameras and lights in the dingy little room we had been given—awful prison-green walls and just one small barred window—Harry sat down with Chapman to put him at ease with a little conversation. Of course they talked about the Beatles (as I said, gaining the confidence of a murderer is always a little unsavory). At one point Chapman apologized to Harry for killing his friend, and I heard Harry saying, "Mark, I think John went just the way he wanted to go." Chapman lit up: "Do you really think so?" And Harry had his subject—his "victim," as he puts it—right where he wanted him. For a while. Chap-

man had done only a few pictures when Harry asked him to kneel in a prayerful position under the light of the window, and he balked. After

a little back and forth Harry told Jon to pack up the equipment and told Mark he thought he had enough pictures anyway and that they

were done. To say I was concerned would be putting it mildly. I was negotiating for a three-part series in *People*, which would require more

than thirty pages in the magazine. Somehow, those pages had to be covered by photography, and this would be all there was. But Harry knew

exactly what he was doing. Since Chapman hadn't had many visitors in quite some time and was facing the prospect of losing this moment

of fame (which, of course, is why he became a murderer in the first place), he started mugging—he struck a muscleman pose, he put his t-

shirt over his mouth and nose like a mask—after Harry's bluff, he acted out all of the pictures that accompanied the three-part series that

would eventually appear in *People.* Out of that dreary little room, Harry took at least eight pictures worthy of double-truck layouts, no two

of them alike. It was a work of genius as much in the field of deviant psychology as photography, and I'll never forget it.

—Jim Gaines, managing editor, *People* magazine, 1987-89

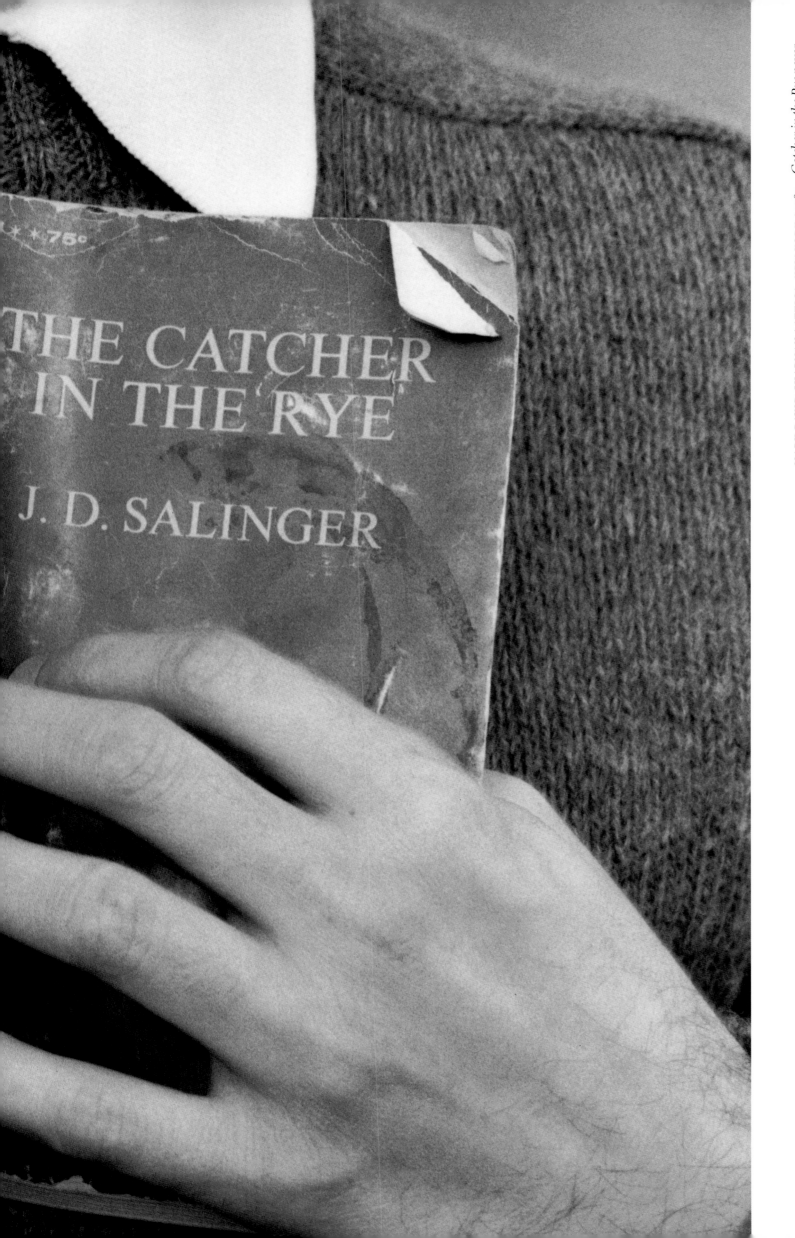

MARK DAVID CHAPMAN / ATTICA, NEW YORK / 1987 — *Catcher in the Rye* never left Chapman's side. He had this copy with him the night he murdered John.

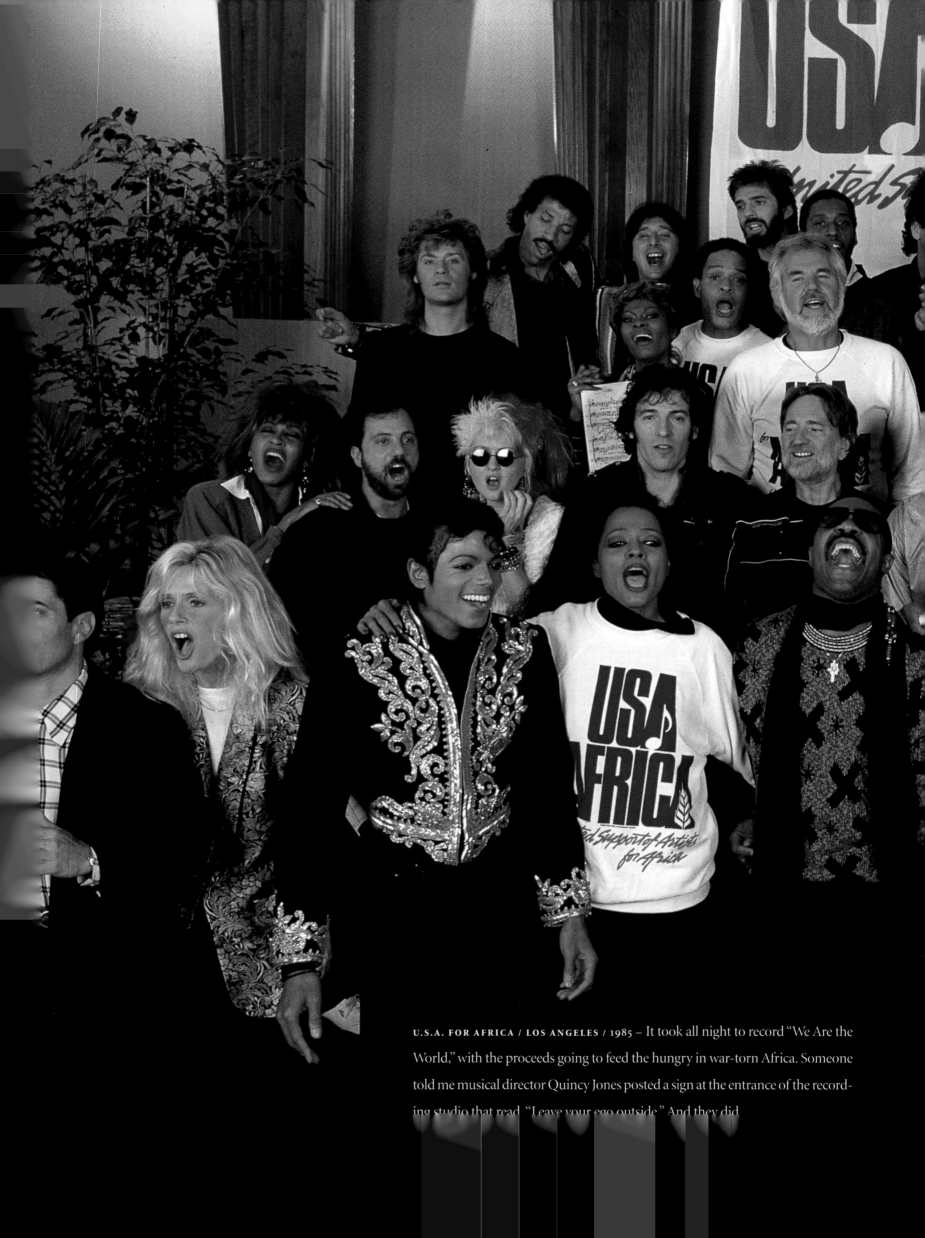

U.S.A. FOR AFRICA / LOS ANGELES / 1985 – It took all night to record "We Are the World," with the proceeds going to feed the hungry in war-torn Africa. Someone told me musical director Quincy Jones posted a sign at the entrance of the recording studio that read, "Leave your ego outside." And they did.

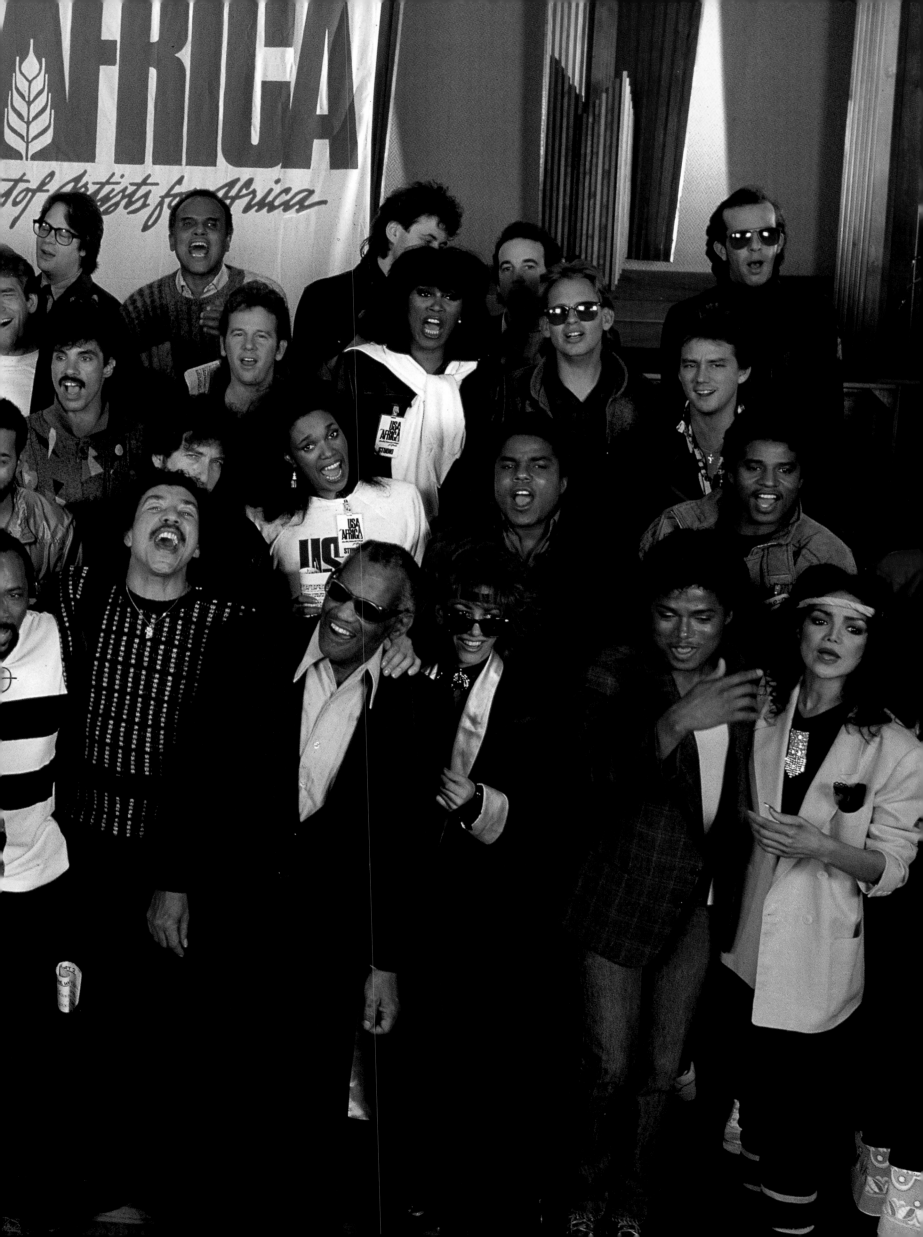

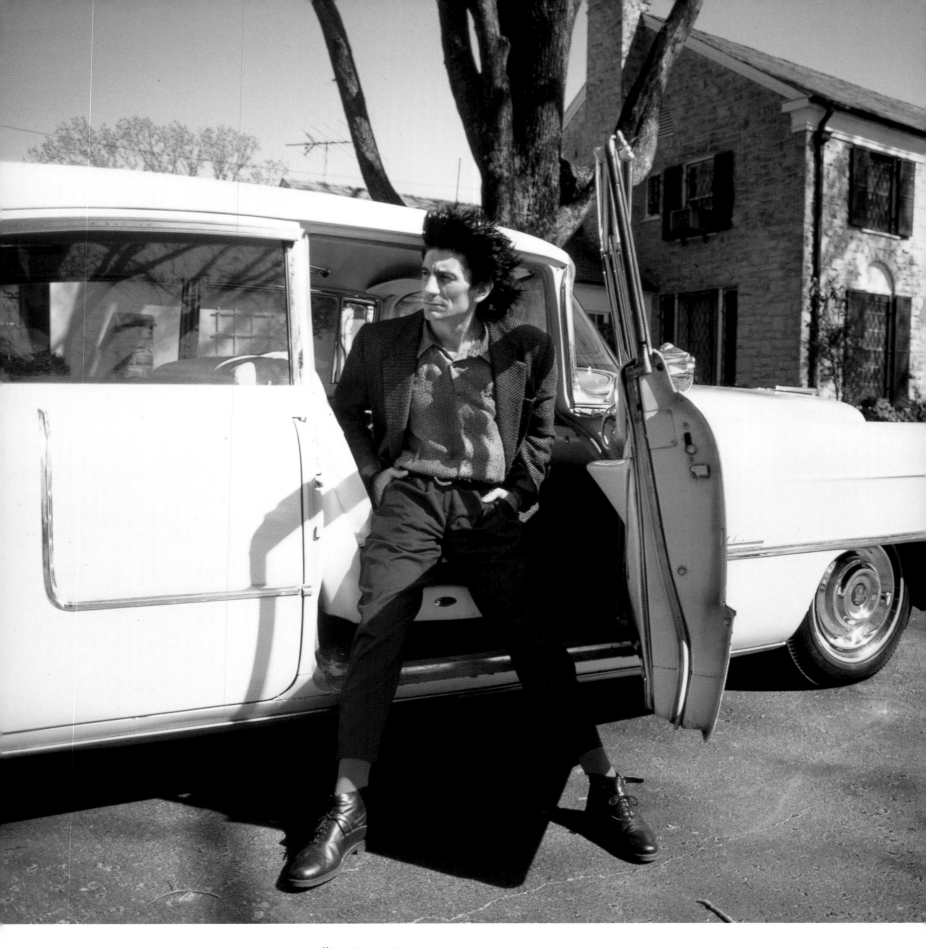

RON WOOD / MEMPHIS, TENNESSEE / 1987 – Rolling Stone Ron Wood was at Graceland for a tribute to Elvis. Sitting in the pink Cadillac Elvis gave his mother, Wood said, "We all owe Elvis a lot."

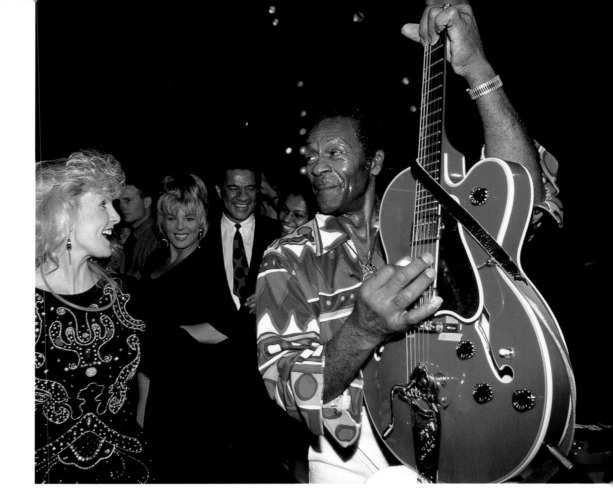

CHUCK BERRY / RENO, NEVADA / 1992 – Acknowledged as one of the first great rock and rollers, Berry is remembered for his classic hits including "Johnny B. Goode" and "Sweet Little Sixteen." When the '50s rock and roller jumped off the stage doing his famous duck walk during a spirited performance, the fans joined in the revelry.

BUDDY GUY / NEW YORK CITY / 1992 – I found Guy, a king of the electric blues guitar and normally a denizen of Chicago, in a bar in downtown New York.

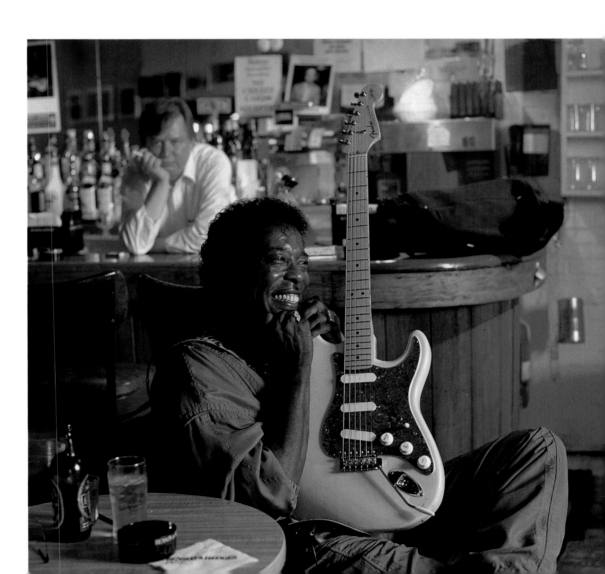

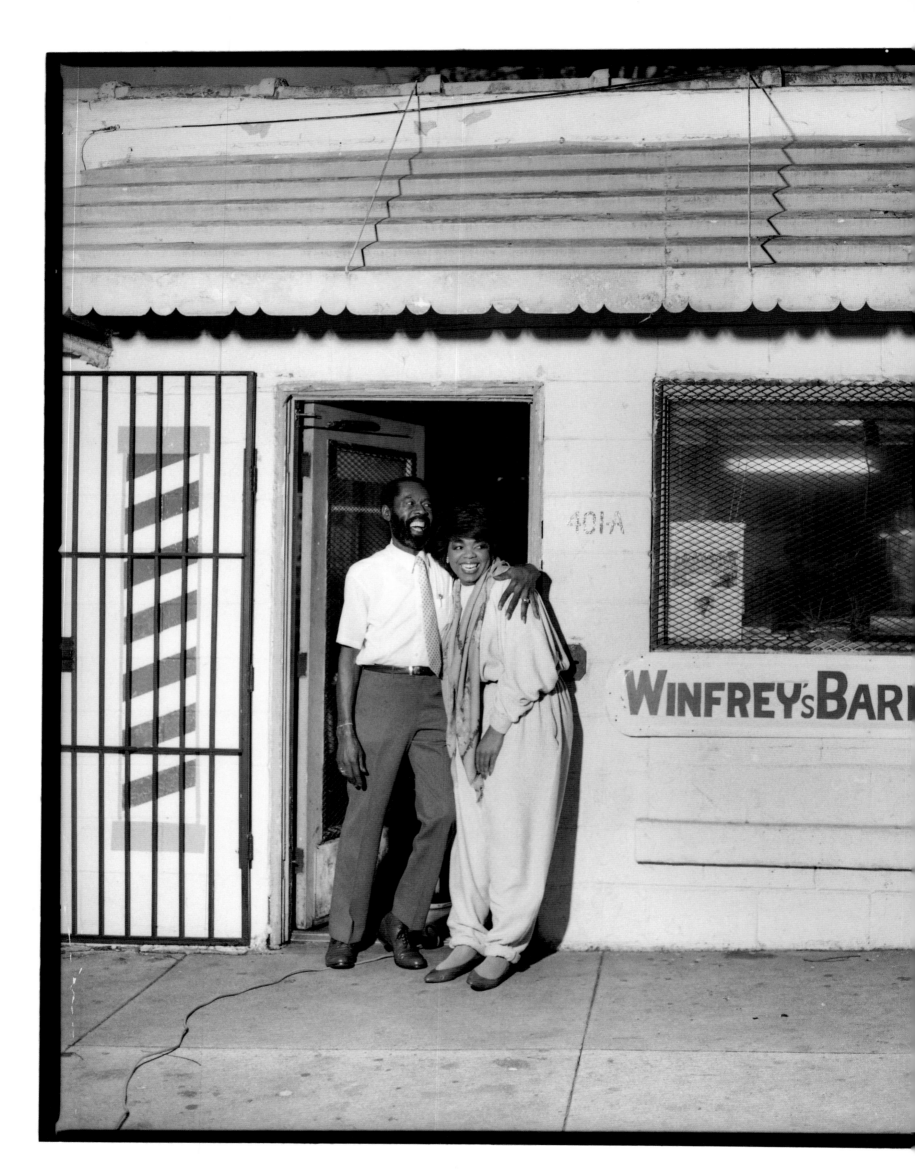

LIZ SMITH AND TRACI LORDS / LOS ANGELES / 1996 – We were at the same table at an L.A. benefit. Traci was cutting up in the middle of the party and decided that Liz needed a different shade of lipstick.

OPRAH WINFREY AND HER FATHER VERNON / NASHVILLE / 1986 – Oprah's dad, a Baptist deacon and Nashville barber, was also a part-time city councilman when this photograph was taken. He said he used to discipline Oprah as a child by lowering his chin to his chest and just looking at her like his father had looked at him. He was very proud of his daughter's success.

TRACY ULLMAN / LOS ANGELES / 1987 – Brilliantly talented comedienne that she is, Tracy Ullman could not have orchestrated this photograph. A very funny lady, she held the pose until I snapped the photo. Having worked in Glasgow, she was familiar with the Glasgow brand of humor, which I thought was funny only to Glaswegians, but Tracy found it hilarious as well.

GEORGE BURNS / LOS ANGELES / 1988 – I was packing my cameras to leave George Burns's home, when he mentioned he was going to see his wife, Gracie. I asked if I could come along and he agreed.

He talked to her, telling her what he did that week, and, standing on tiptoe, he kissed her vault before he left. He told me she was in good company, with Jeanette McDonald and Ramon Navarro nearby.

BERLIN WALL / 1961 – On the day the wall started to go up, I got on the first flight from London to Berlin. On the plane coincidentally—and coincidence plays a large part in a photojournalist's life—was reporter Donald Edgar, who spoke perfect German. We managed to get to distraught West German mayor Willy Brant and ride with him to see firsthand the East German tanks and troops circling the city, while workmen put up barbed wire barricades and began laying the wall that came to symbolize the Cold War.

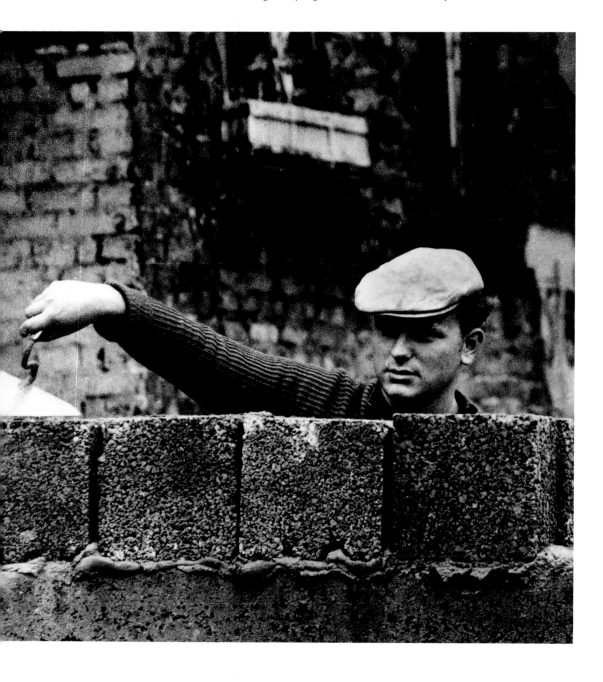

BERLIN WALL / 1989 – I happened to be in London on a completely different story when it was rumored that the Russians were going to take the wall down and make Berlin an open city, so I got on a plane. Upon arrival I could see there was a lot of unrest in the city. Young and old alike, Berliners started banging away at the wall. The police didn't try very hard to stop them. The woman in the photograph told me she had lived with the wall all her life and hated it. "I hate it, I hate it," she kept repeating as she beat it with a stone.

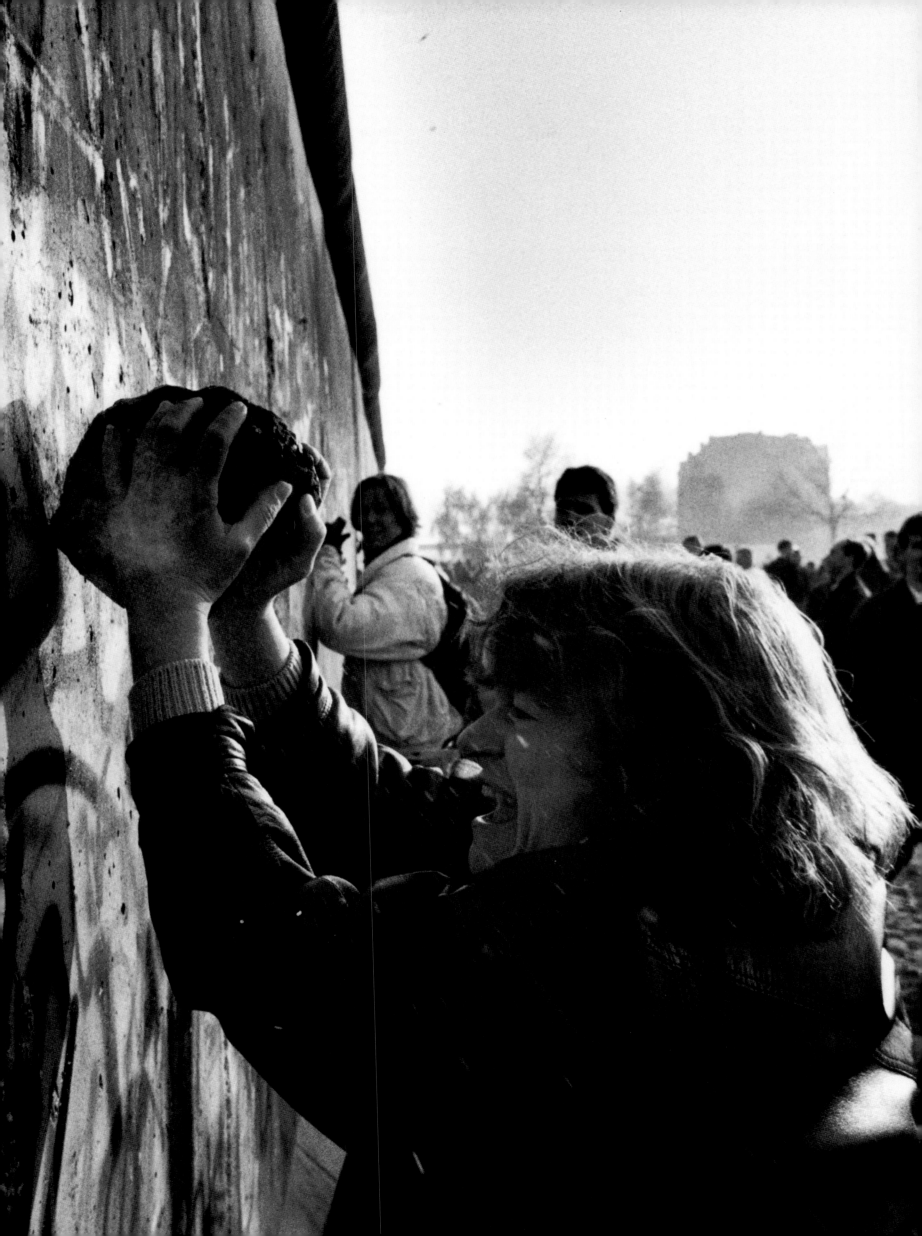

MARINE LT. COL. OLIVER NORTH / WASHINGTON, D.C. / 1987 – During the investigation into the Iran-Contra Affair, when the U.S. sold arms to Iran and used the money to aid the Nicaraguan Contras, 55 million Americans watched on television as North explained his role in the dealings. He arrived at his lawyer's office, where I had set up a makeshift studio, with his uniform neatly pressed. Jonathan Delano, who would help me on the shoot, drove from New York to Washington in a heavy snow storm because the backdrop I wanted to use was so large the airline refused to have it checked with the luggage.

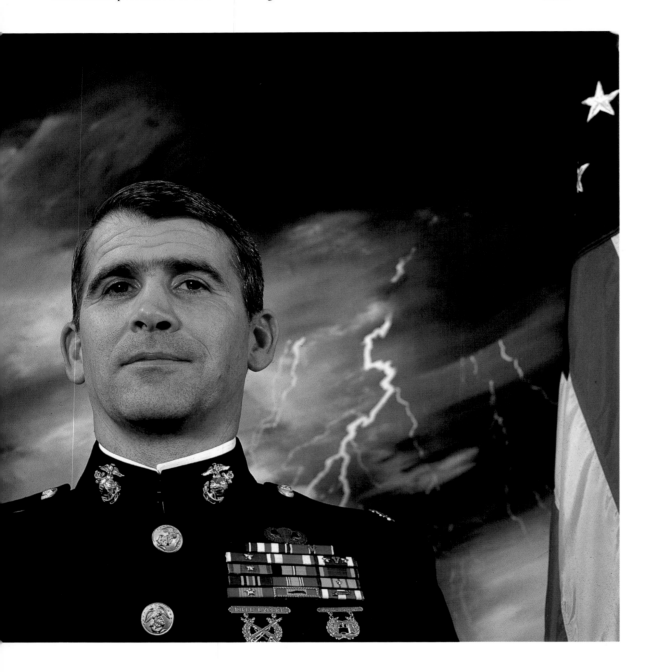

SUPREME COURT JUSTICE CLARENCE THOMAS / WASHINGTON, D.C. / 1991 – After a grueling confirmation hearing, Thomas had just been confirmed to the Supreme Court. He seemed relieved that the hearings were over.

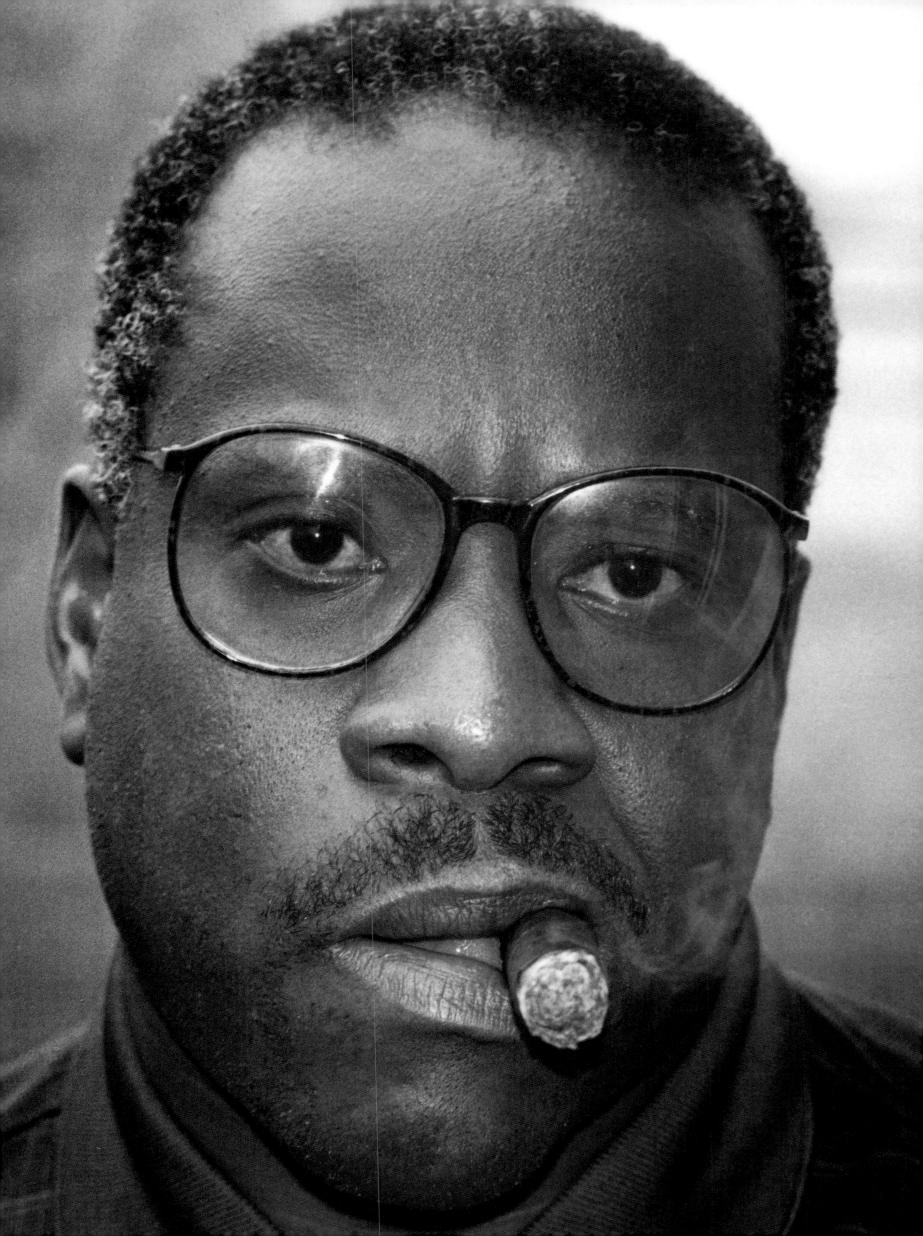

GENERAL HENRY H. SHELTON AND GENERAL WESLEY K. CLARK / KOSOVO / 1999 – I had gone with Shelton, the chairman of the Joint Chiefs of Staff, on the U.S. invasion of Haiti in 1994 and now joined him on a very quick twenty-four hour round trip from Washington to Kosovo and Macedonia to inspect the troops. Clark was the Supreme Allied Commander Europe, who was in Kosovo to supervise a N.A.T.O. air campaign against Slobodan Milosevic's Serbia. It resulted in Kosovo being returned to the ethnic Albanians.

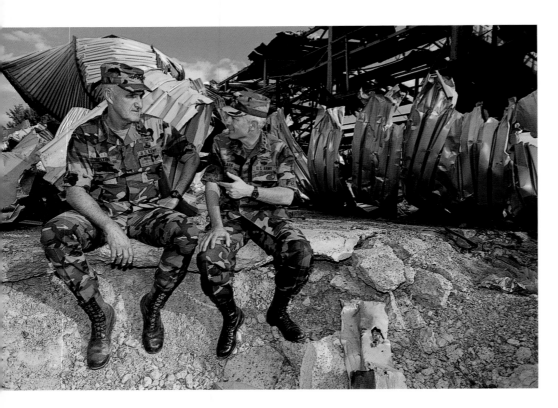

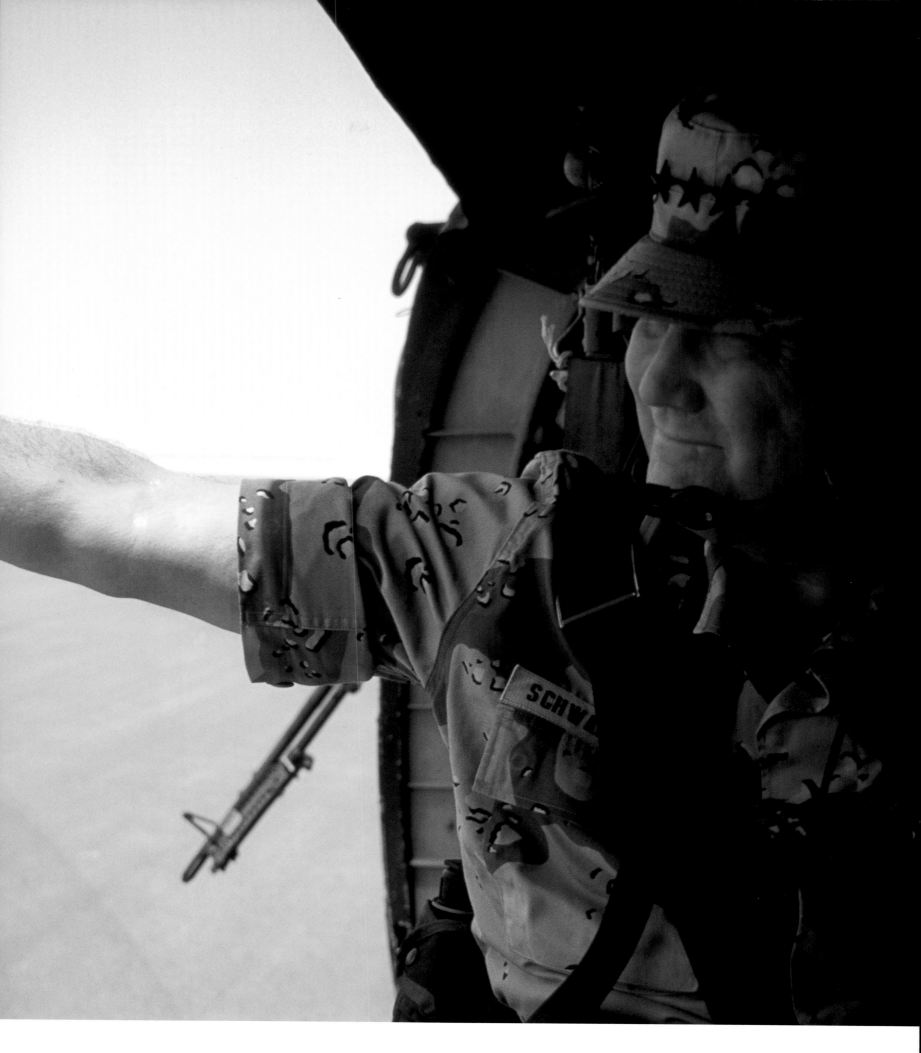

GENERAL NORMAN SCHWARZKOPF / SAUDI ARABIA / 1990 – A soldier shouted up to us as we took off. The general had just won the Gulf War and he gave the shouting soldiers the thumbs up. We were headed to Barhrain to meet the prisoners of war who had just been released by Iraq.

KING JUAN CARLOS OF SPAIN / ZARZUELA PALACE, NEAR MADRID / 1985 – As I was leaving the palace, I saw the king lift his retriever pups, Ajax and Atlas, by the scruff of the neck and return them to their pen. I thought about what a good picture I had missed. Ambling over to say goodbye, I casually reopened the gate. When the dogs ran out, the King looked at me like I was daft and had to retrieve them once again.

PRINCESS DIANA / GLASGOW / 1992 – I was standing with a group of photographers, and one said to me, "Save your film. Don't bother taking any pictures until she gets to the little girl. I guarantee she'll kneel down and we'll get a picture." That's just what happened. Another Fleet Street photographer who was there told me a story. To get a good position at an event she would be attending, he had camped out overnight in the cold. The next evening when she walked by, his flash didn't go off. She walked past, turned, and stood there until he got his picture. "That's why we all love Diana," he said.

HRH PRINCESS MICHAEL OF KENT WITH HER SON LORD FREDERICK / NETHER LYPIATT MANOR, GLOUCESTER, ENGLAND / 1986 – Princess Michael stands with her seven year old son at their thirty-acre retreat in the West Country. An author and lecturer, the Czecho-slovakian-born princess is married to Queen Elizabeth II's cousin.

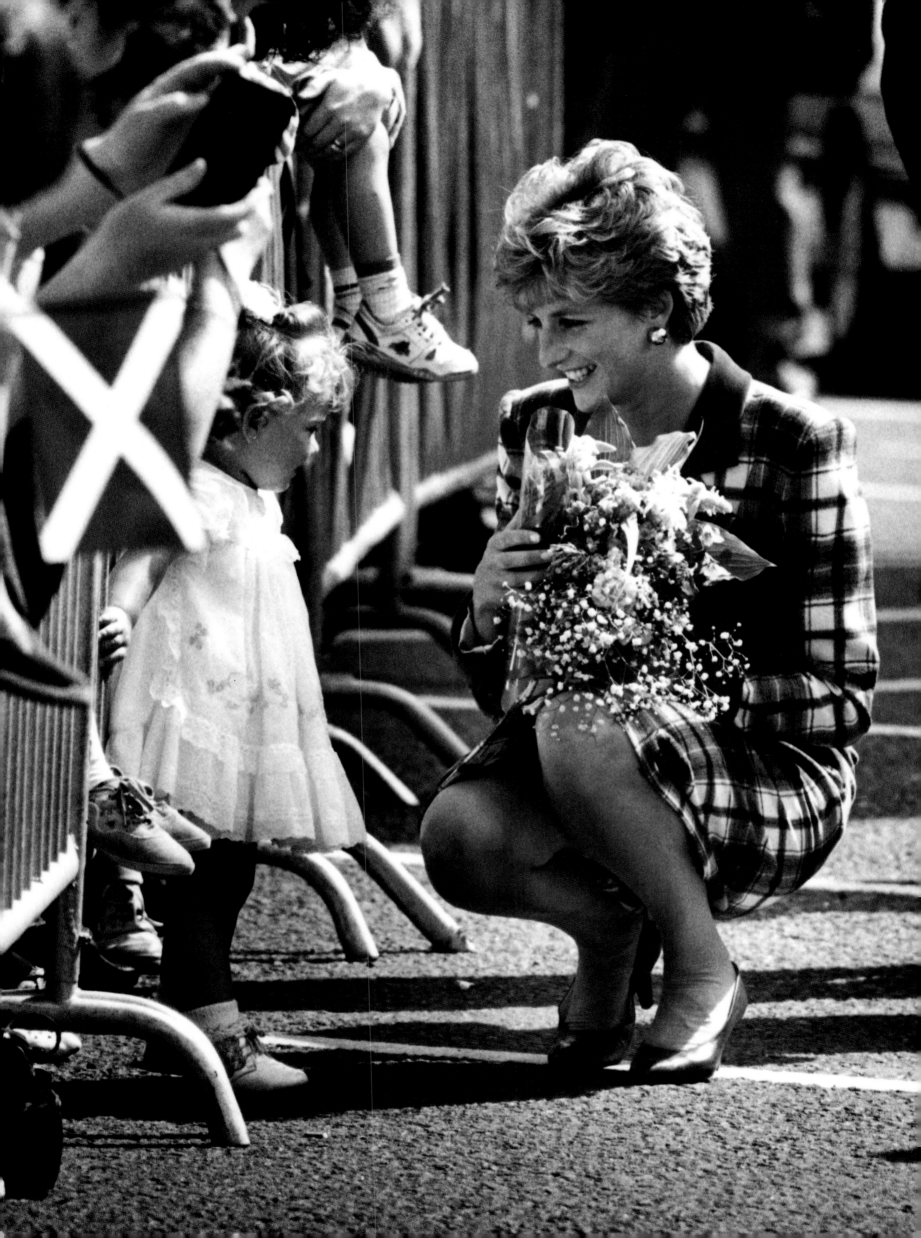

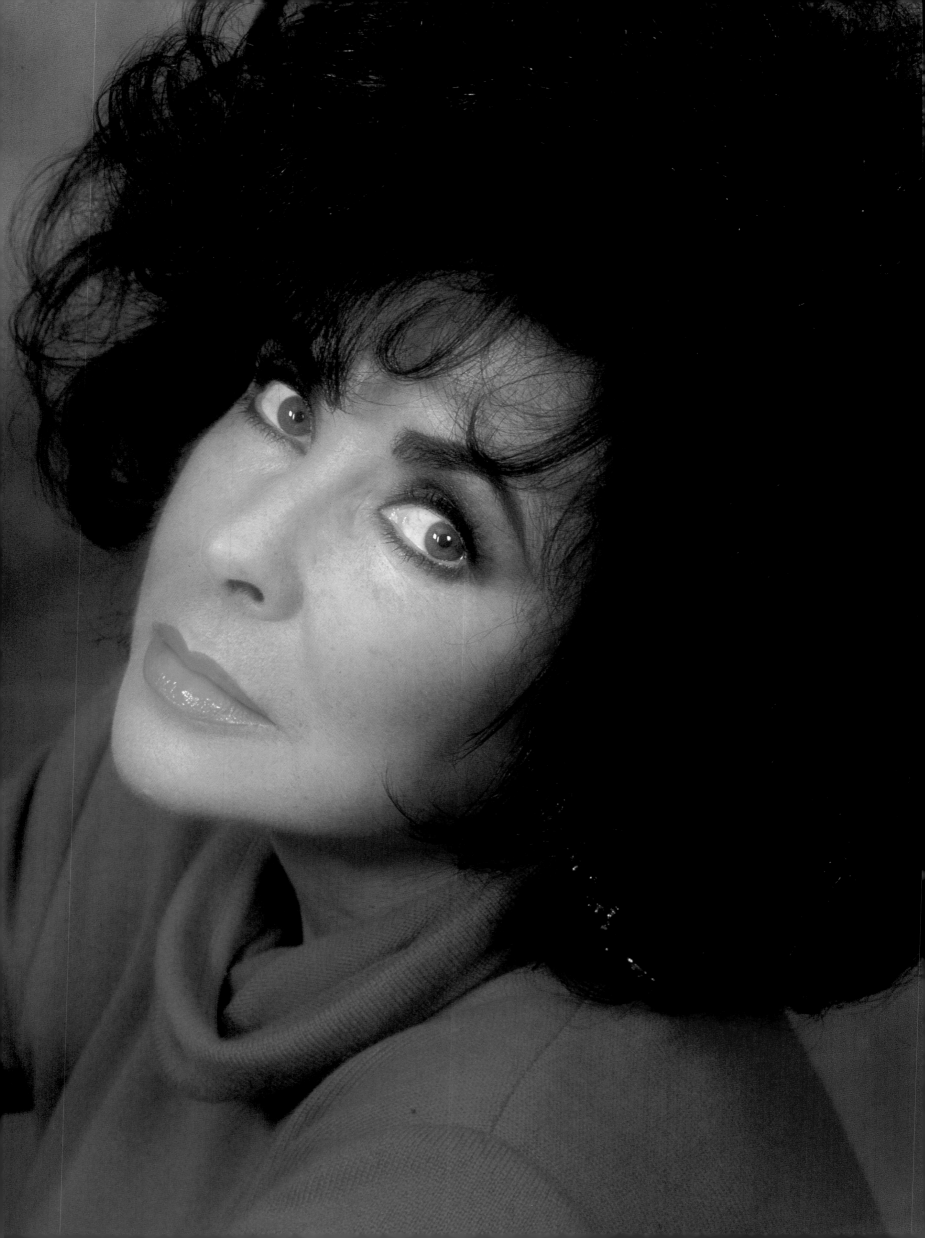

ELIZABETH TAYLOR / BEL AIR, CALIFORNIA / 1992 – When my sixtieth birthday photo of Elizabeth Taylor appeared on the cover of *Life* magazine, the telephone started ringing. Friends were curious to know if I had retouched the photograph. The answer is no. That's how she actually looked. I first photographed her in 1961 on the set of *Cleopatra* at Pinewood studios, London. I slipped onto the set at 4 A.M. and hid in a palm tree for hours, waiting for her to appear. How could they have thought of making a Roman epic in London in February? She caught pneumonia and they finally moved the production to Rome.

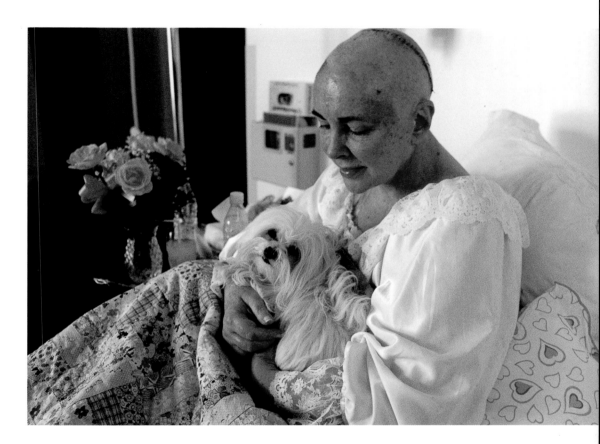

ELIZABETH TAYLOR / CEDARS SINAI HOSPITAL, LOS ANGELES / 1997 – When reporter Brad Darrach and I heard she was to have a tumor removed from her brain, I called Taylor's publicists at the time to request a photo session. They said don't be ridiculous. I said, "Just ask Elizabeth, she marches to her own drum." Within two hours, word came back that I could be there before, during, and after the operation. When I saw her in her hospital bed, holding her favorite dog, she asked what she looked like, and I told her Sinead O'Connor. She howled. I photographed an X-ray of her brain as well—perhaps a first in celebrity photography.

SAMMY DAVIS, JR. / LOS ANGELES / 1990 – Shortly after his throat cancer operation, I asked Davis if he had it to do over again would he smoke. The answer was yes. He said it was something to do with his hands while he was on stage. I had first photographed him in London in 1959 at the Pigalle nightclub and have never, before or since, seen such a tremendous performance. I also remember him at Martin Luther King, Jr.'s funeral. Medger Evers, Jr.'s brother told me that Sammy was the best of all the celebrities who professed to be liberals. Sammy was the one who would really be there when you needed him.

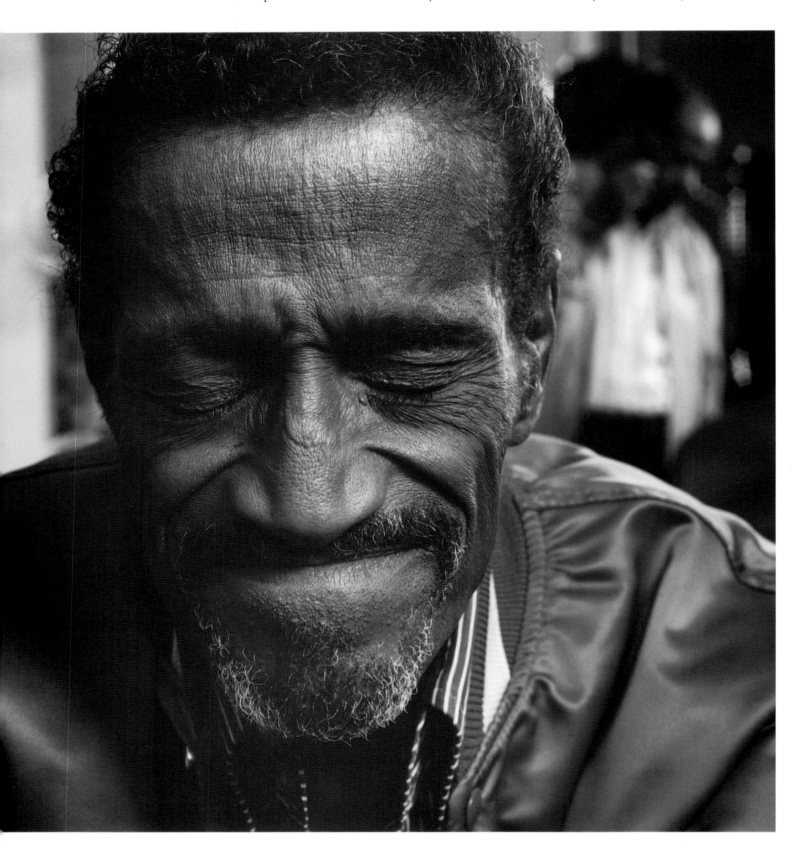

JAMES STEWART / BEVERLY HILLS / 1991 – One of the few actors who actually went on bombing missions over Germany during WWII, Stewart showed me his old Air Force uniform. He was very proud of it. When I asked him to try it on, he laughingly said it wouldn't fit anymore. After his photograph appeared in *Life,* he wrote me a letter saying it was his favorite photograph ever taken of him.

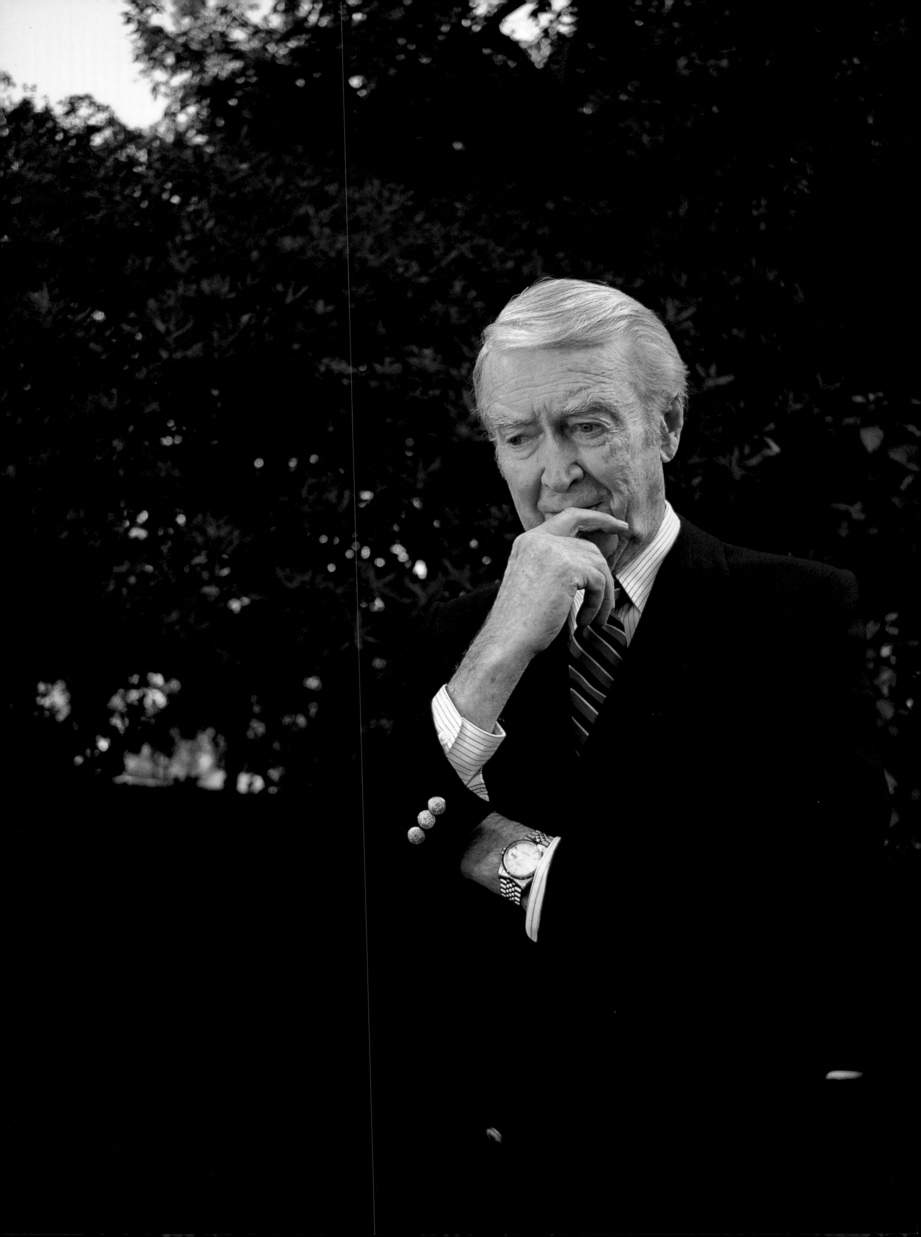

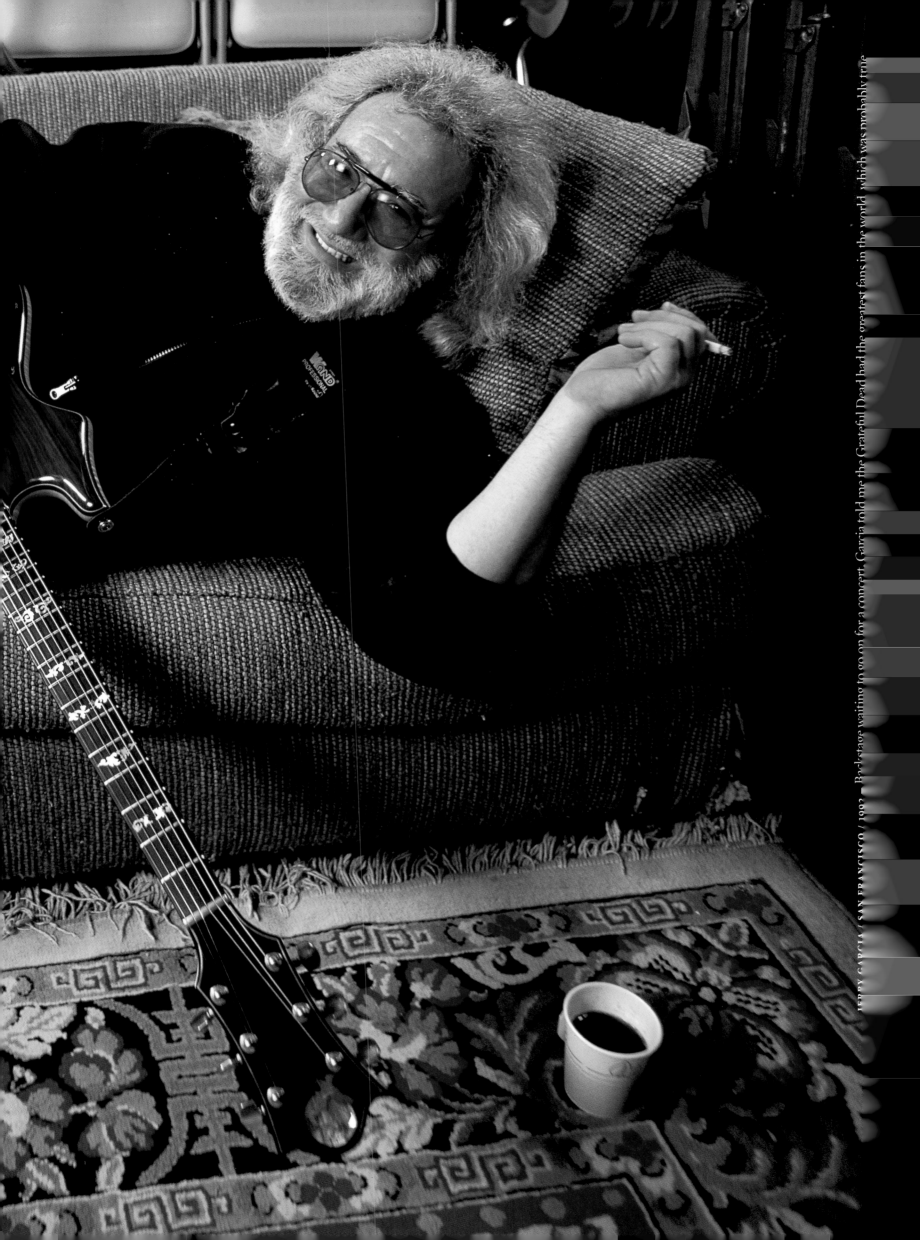

JERRY GARCIA / SAN FRANCISCO / 1992 · Backstage waiting to go on for a concert, Garcia told me the Grateful Dead had the greatest fans in the world, which was probably true

TIM BURTON / SANTA MONICA, CALIFORNIA / 1994 – At the Santa Monica pier, I casually suggested that the film director get in the outdoor shower with all his clothes on. Surprisingly, before I finished the sentence, he had drenched himself.

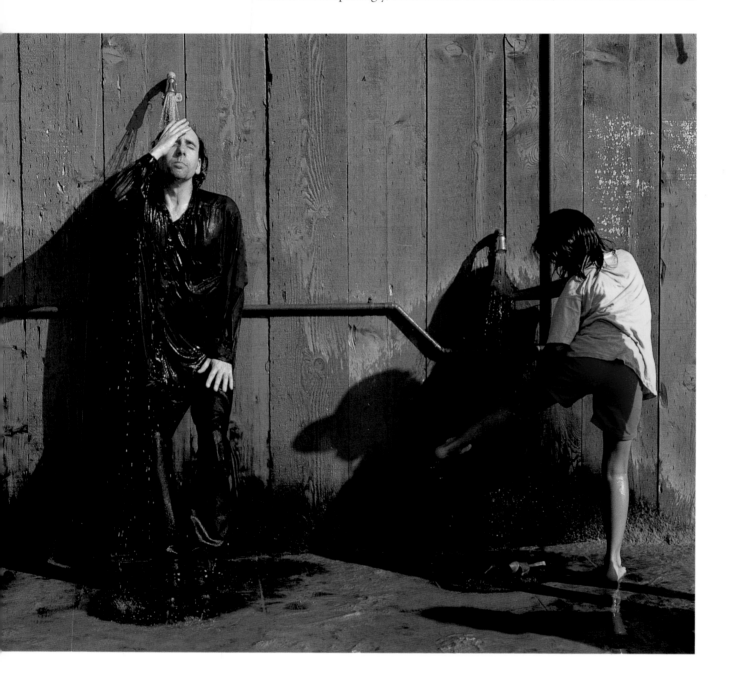

JACK NICHOLSON / ASPEN, COLORADO / 1990 – Nicholson had agreed to be photographed for *Life* while starring in and directing *The Two Jakes,* the sequel to *Chinatown.* I waited four days for him to finally come out, but when he did I had two hours well spent.

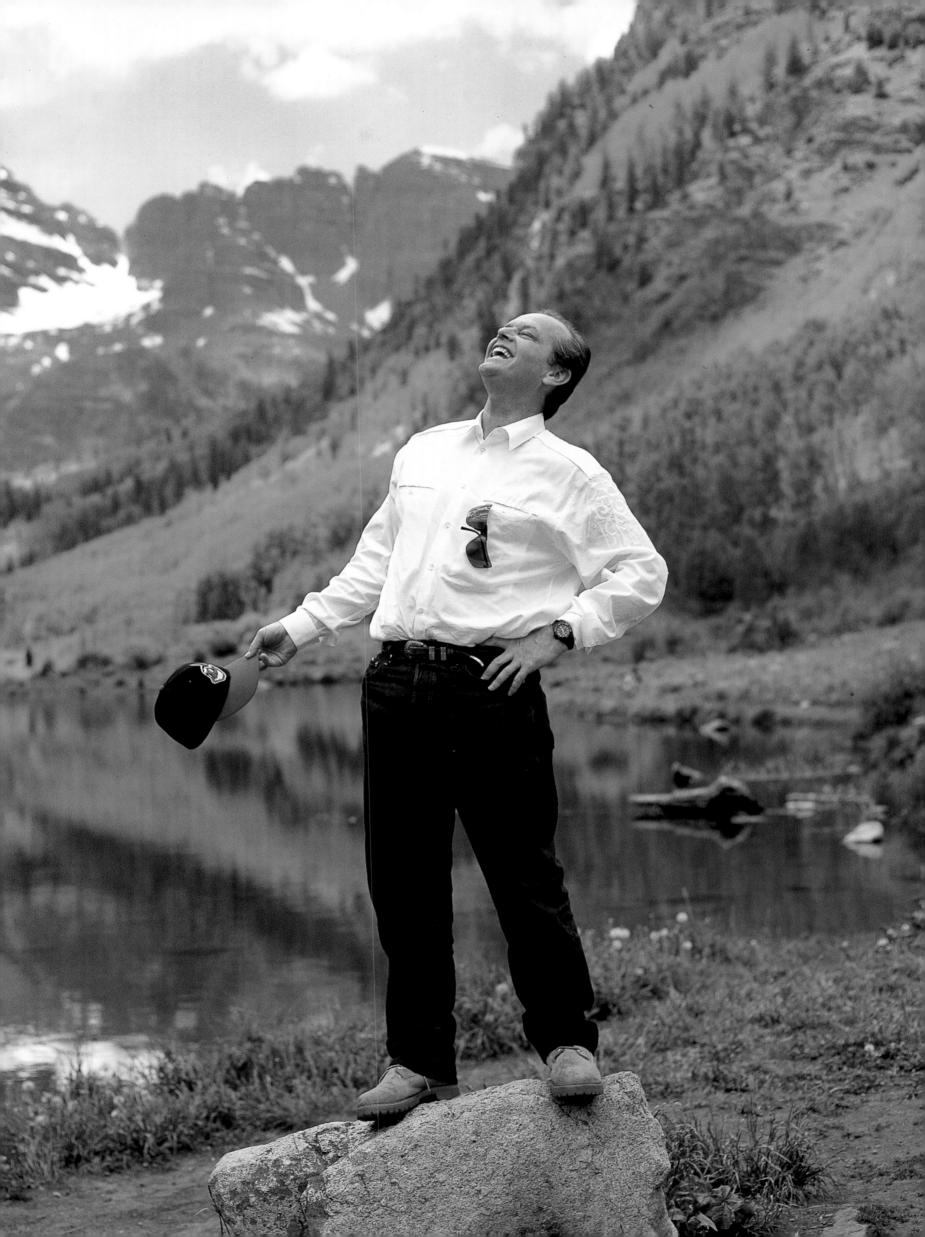

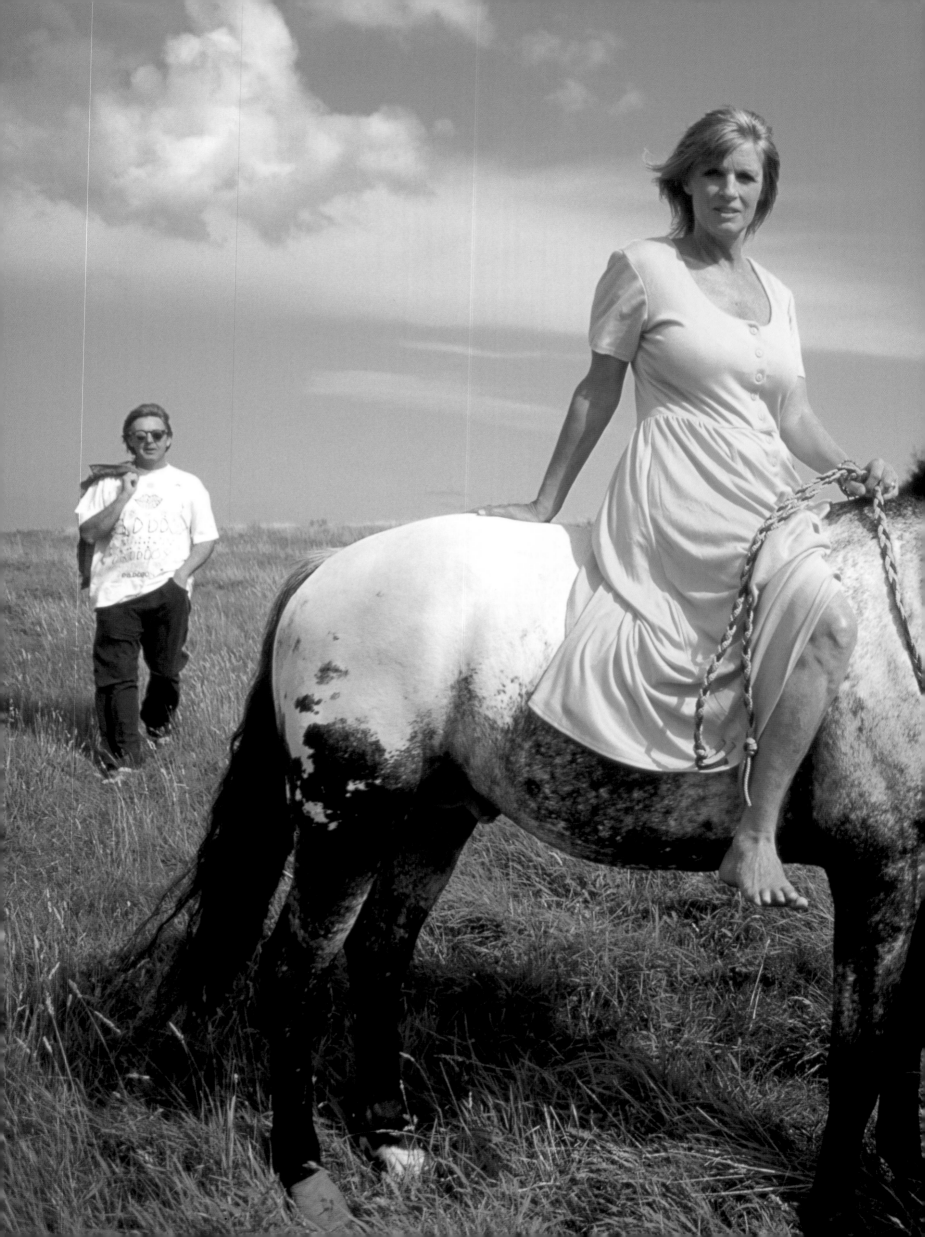

PAUL AND LINDA MCCARTNEY / EAST SUSSEX, ENGLAND / 1992 – The last time I photographed Paul and Linda together was at their farm in Peasmarsh in East Sussex. Linda was riding her favorite appaloosa and Paul came over to join us. He had given her the horse after they had seen it in a field one day while out for a drive. It was easy to see Paul and Linda were a team, completely natural and at ease with each other.

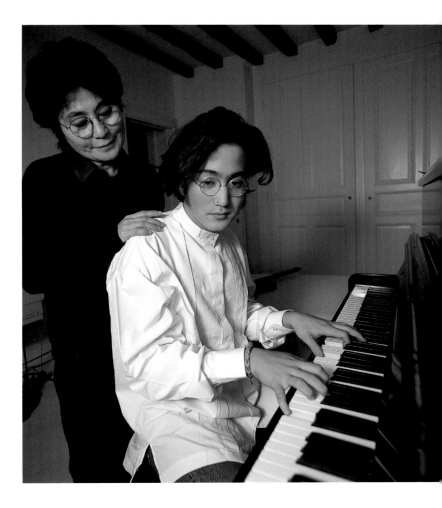

YOKO ONO AND SEAN LENNON / SWITZERLAND / 1990 – At their home in Switzerland approaching the tenth anniversary of his death, Yoko Ono asked me to talk with Sean about what it was like being with his father in the early years of his fame. I realized what John saw in her. She was intelligent and intuitive. She wanted for Sean as normal a childhood as he could possibly have.

WALTER AND CAROL MATTHAU / PACIFIC PALISADES, CALIFORNIA / 1992 – It is said that Truman Capote based his character Holly Golightly on Carol before she married actor Walter Matthau. Amused by her primping while he sat in her dressing room, he exclaimed, "She can do no wrong."

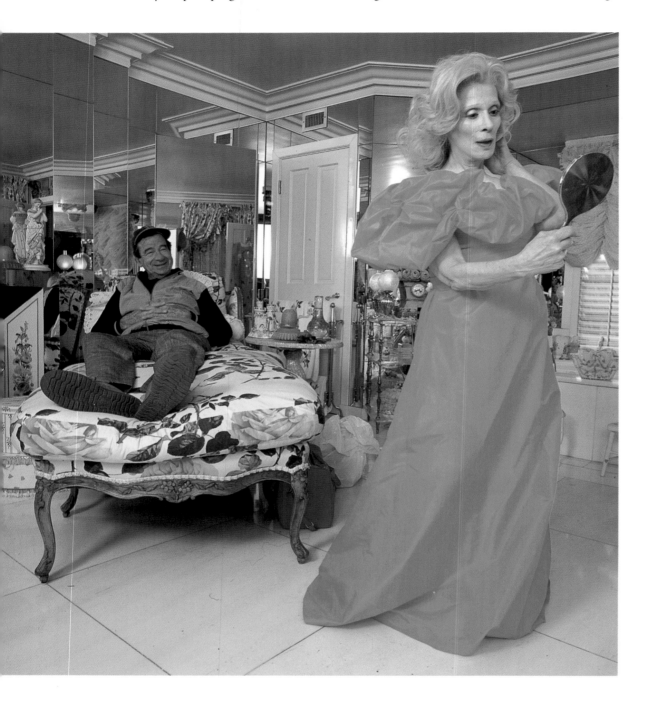

MERV GRIFFIN / PALM SPRINGS / 1998 – Former talk-show host and creator of television game shows including "Jeopardy," multimillionaire Merv Griffin poses with his dogs, Lobo and Patrick, at his 240-acre La Quinta Ranch in the Coachella Valley near Palm Springs. His fifty-two racehorses are trained here on his own racetrack.

presidential mission

When photographing the President of the United States, I want people to feel that I am doing more than participating in a photo opportunity—a five-minute window orchestrated by the press office—but rather that I have been alone with him and his family in a private setting. To take such pictures, hopefully ones you will want to look at, to get in and out as quickly as possible, to close in on what is really happening, that is my job. There is usually one moment in a sitting where I can nail it. It goes along in a steady way and then it happens, like with the Clintons on the hammock—I know this is a moment and it's not going to last. No matter what story I do there is always a moment when it will soften in my favor. Bang, I've got it. It goes by quickly. Opportunity comes along in photography like an express train and you've got to catch it. You've got to be paying attention. I don't take my eyes off the subject. I'm watching for the moment, yet I'm not being offensive. Not some brittle nervous wreck. Sometimes I've been with a reporter who starts talking about his or her children with the President, wasting time when we've only got fifteen minutes tops. All it's done is take away valuable time needed for questions or pictures. The President doesn't really care about the reporter's children and no one is going to become friends with the President on the spot. That's not going to happen. I've got to live in reality. I'm there to do a job.

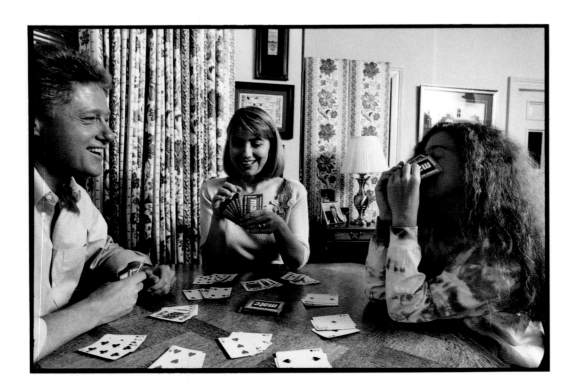

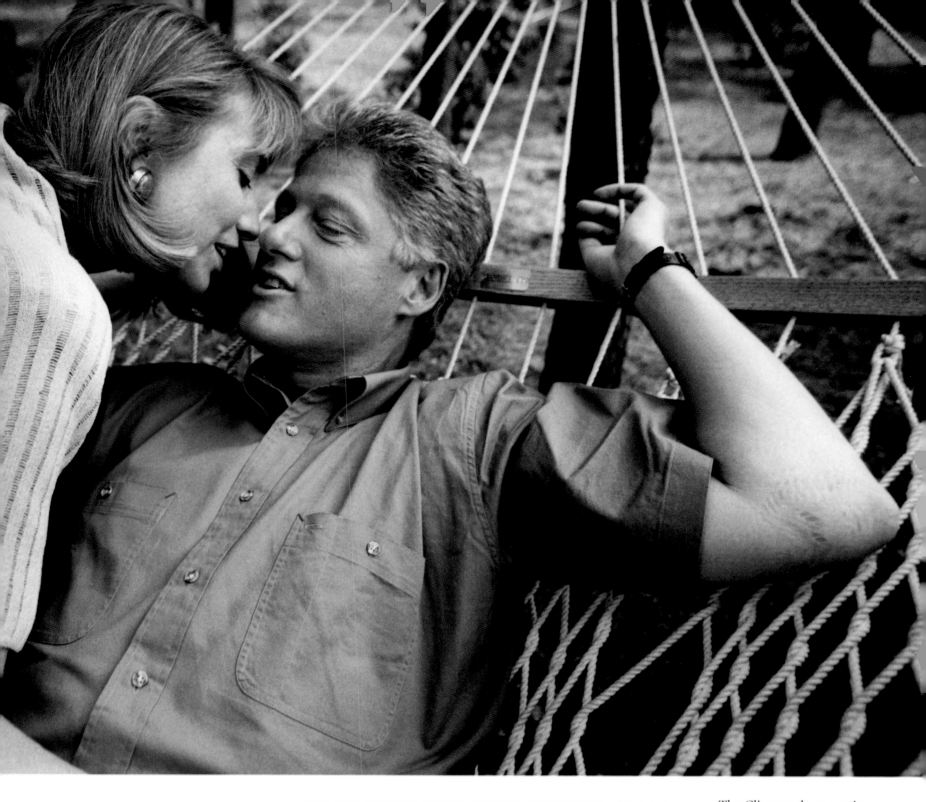

BILL AND HILLARY RODHAM CLINTON / LITTLE ROCK, ARKANSAS / 1992 – The Clintons share a quiet moment in the backyard of the Governor's Mansion before their hectic campaign schedule began.

THE CLINTONS / LITTLE ROCK, ARKANSAS / 1992 – Playing hearts at the governor's mansion, a card game the presidential candidate's mother, Virginia Kelly, had taught her son as a child, Chelsea made a tactical error and wanted to take it back, but her parents wouldn't let her. When I showed Clinton a photograph I had taken of his mother holding a picture of him as a child, his eyes filled with tears.

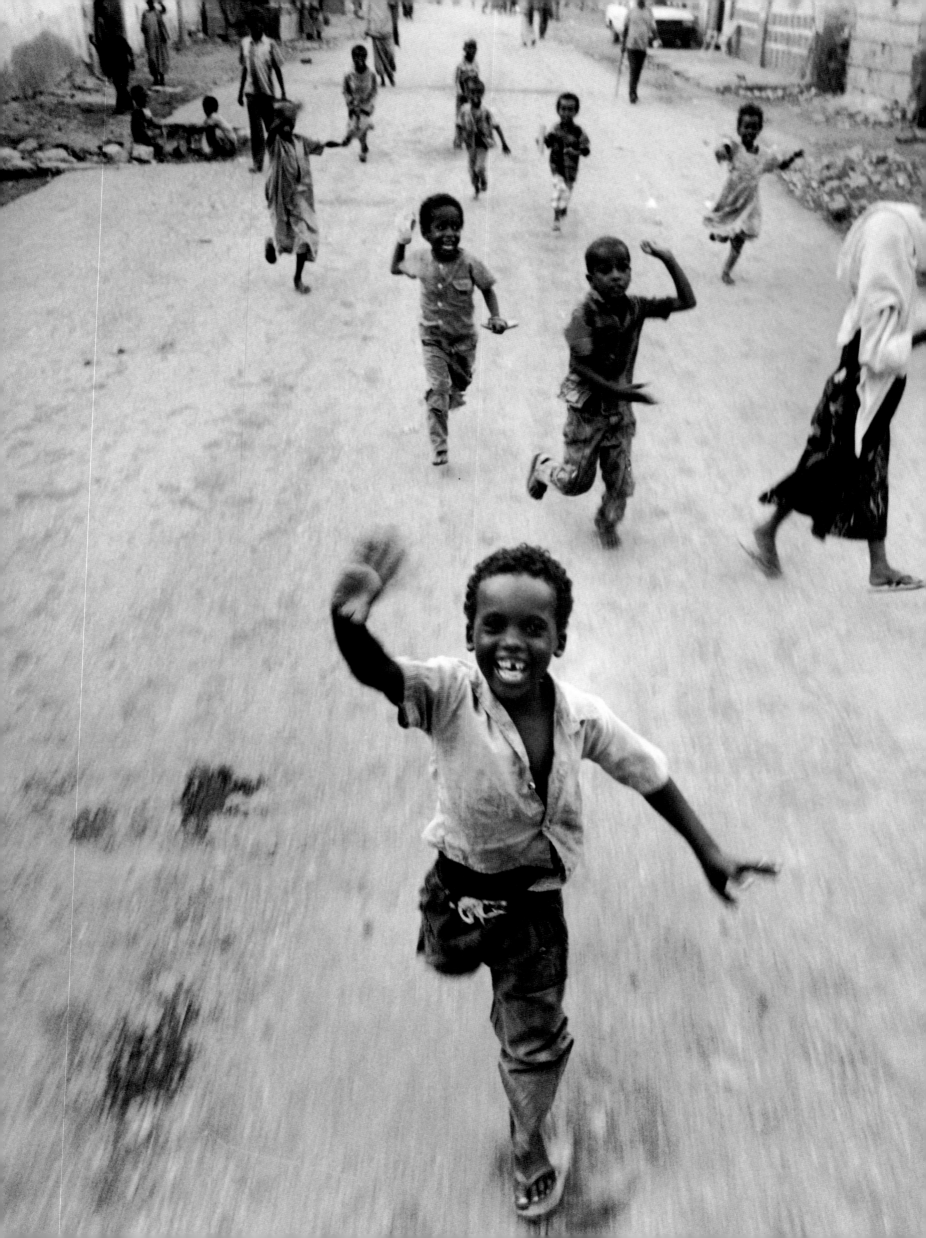

CHILDREN / BAIDOA, SOMALIA / JANUARY 1993 – Young children, eager for chewing gum, candy, or cigarettes, followed the U.S. Marines' patrol vehicles along the rubble-strewn streets of Baidoa. There to distribute food to the starving children, the Marines were friendly, but if anyone in the streets was suspected of carrying arms, they were quickly surrounded, searched, and disarmed if necessary.

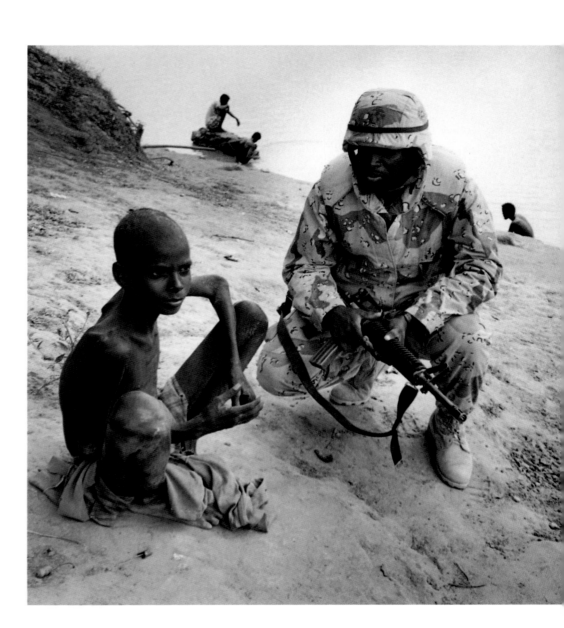

BAIDOA, SOMALIA / JANUARY 1993 – A U.S. Marine stops to talk quietly with a child for a few moments.

UNITED STATES MARINES / BAIDOA, SOMALIA / JANUARY 1993 – Sent to Somalia to restore order, aid the thousands of victims of famine, and guard the airstrip in Baidoa, the soldiers of the 7th Marine Regiment stopped to pose for a group photo. They were happy knowing they were there to help people, although later the situation got nasty.

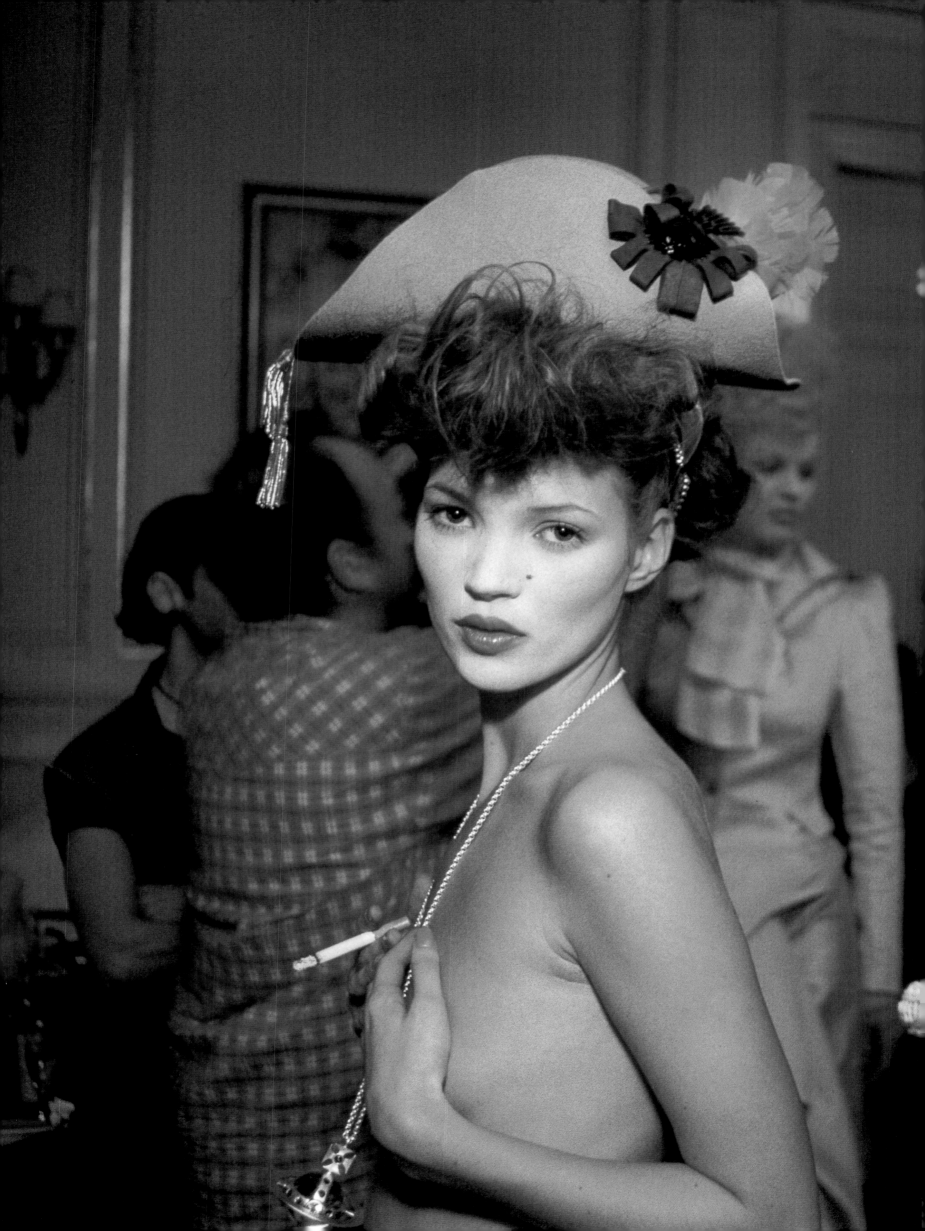

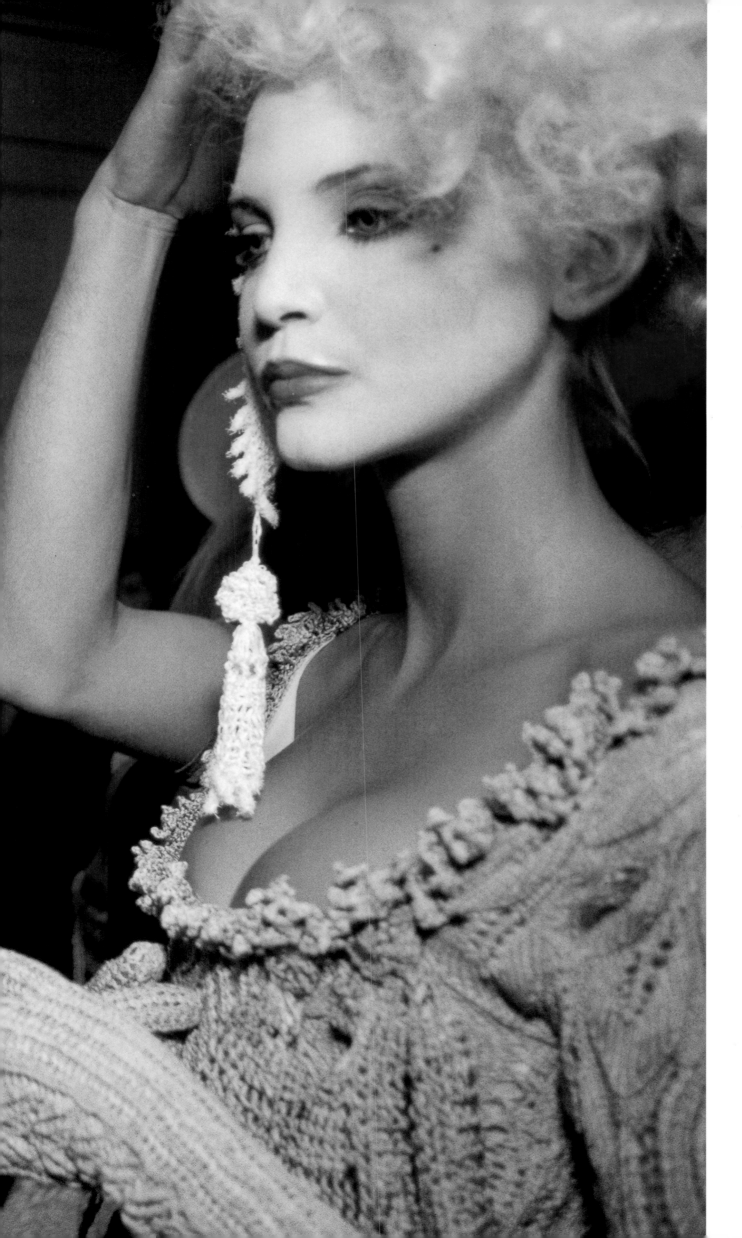

KATE MOSS / PARIS / 1994 — Backstage at British designer Vivienne Westwood's fashion show in Paris, model Kate Moss was waiting her turn to go out. When she walked out topless, she threw her arms in the air. The models had fun at the show. Always theatrical, Westwood's clothes appear to me as if they were designed for little girls playing dress up.

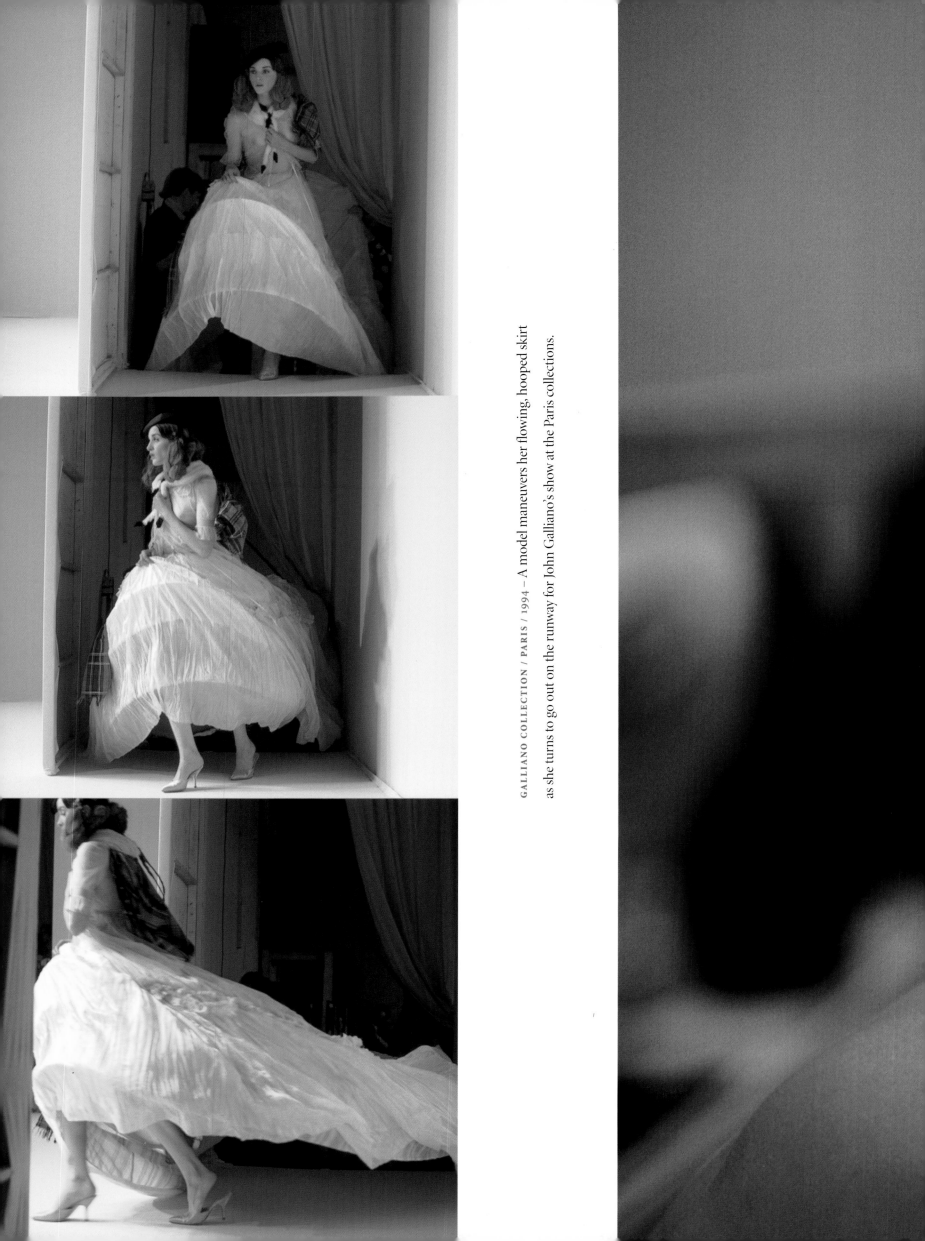

GALLIANO COLLECTION / PARIS / 1994 – A model maneuvers her flowing, hooped skirt as she turns to go out on the runway for John Galliano's show at the Paris collections.

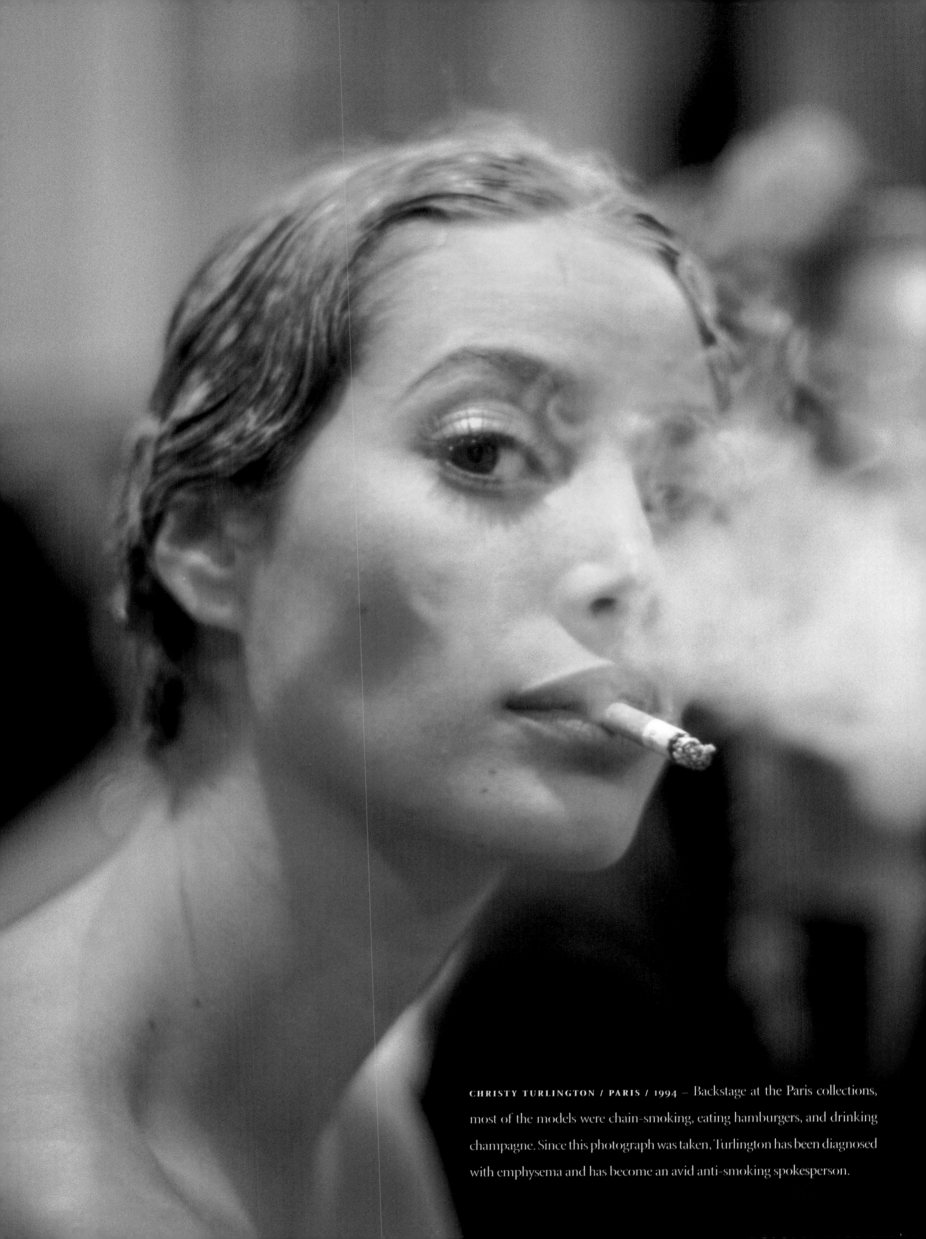

CHRISTY TURLINGTON / PARIS / 1994 – Backstage at the Paris collections, most of the models were chain-smoking, eating hamburgers, and drinking champagne. Since this photograph was taken, Turlington has been diagnosed with emphysema and has become an avid anti-smoking spokesperson.

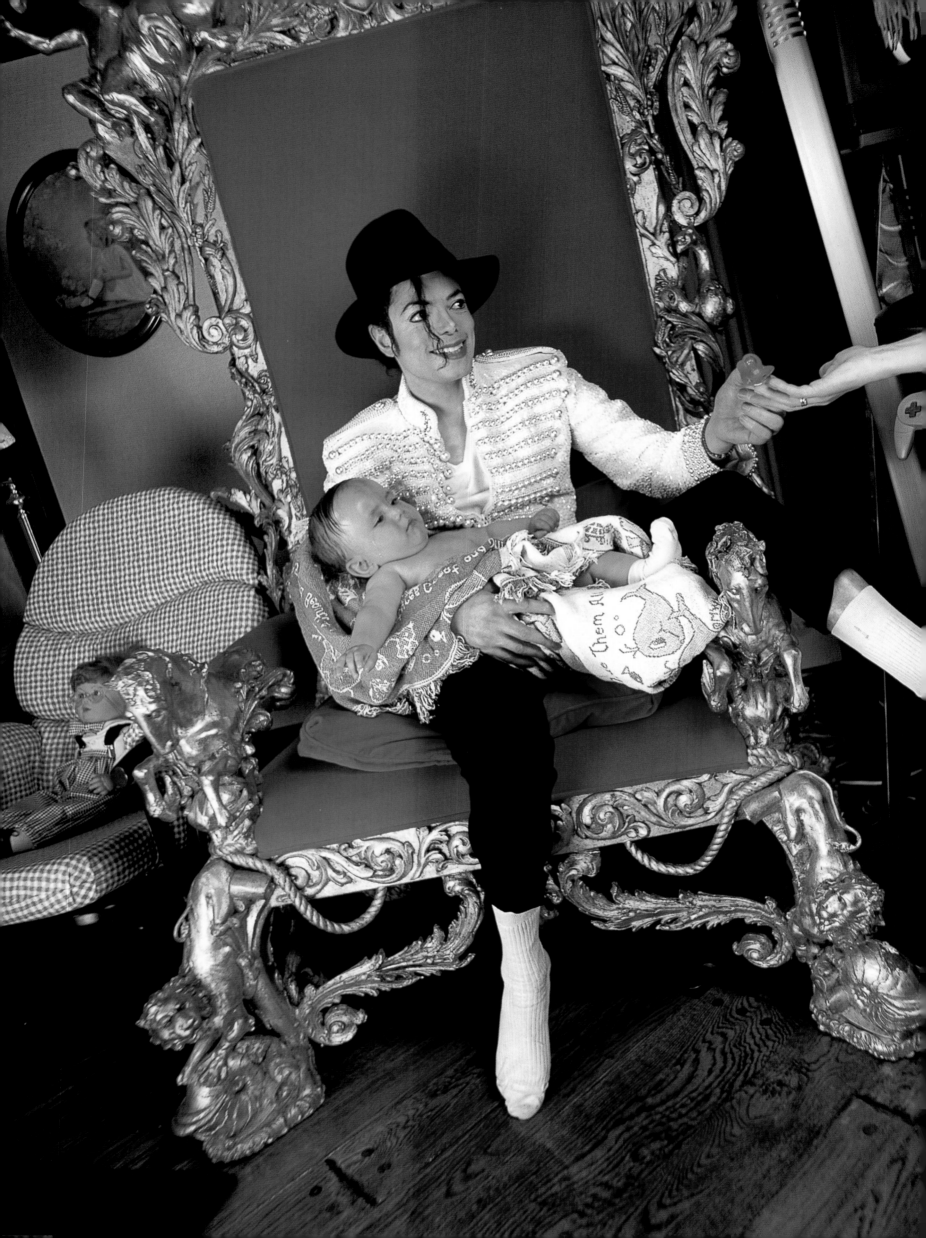

MICHAEL JACKSON AND MICHAEL JOSEPH JACKSON, JR. / NEAR SANTA BARBARA, CALIFORNIA / 1997 – A proud father holds his nine-month-old firstborn son Prince on his lap in the bedroom of Neverland, his home in California. A small railroad train circles the property, which includes a zoo and an amusement park.

LISA MARIE PRESLEY AND MICHAEL JACKSON / NEAR ASPEN, COLORADO / 1995 – When Michael married Elvis's only daughter, the world took note. After their divorce, he married the woman who was to bear his two children.

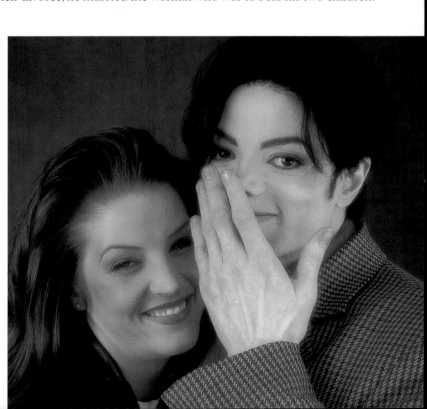

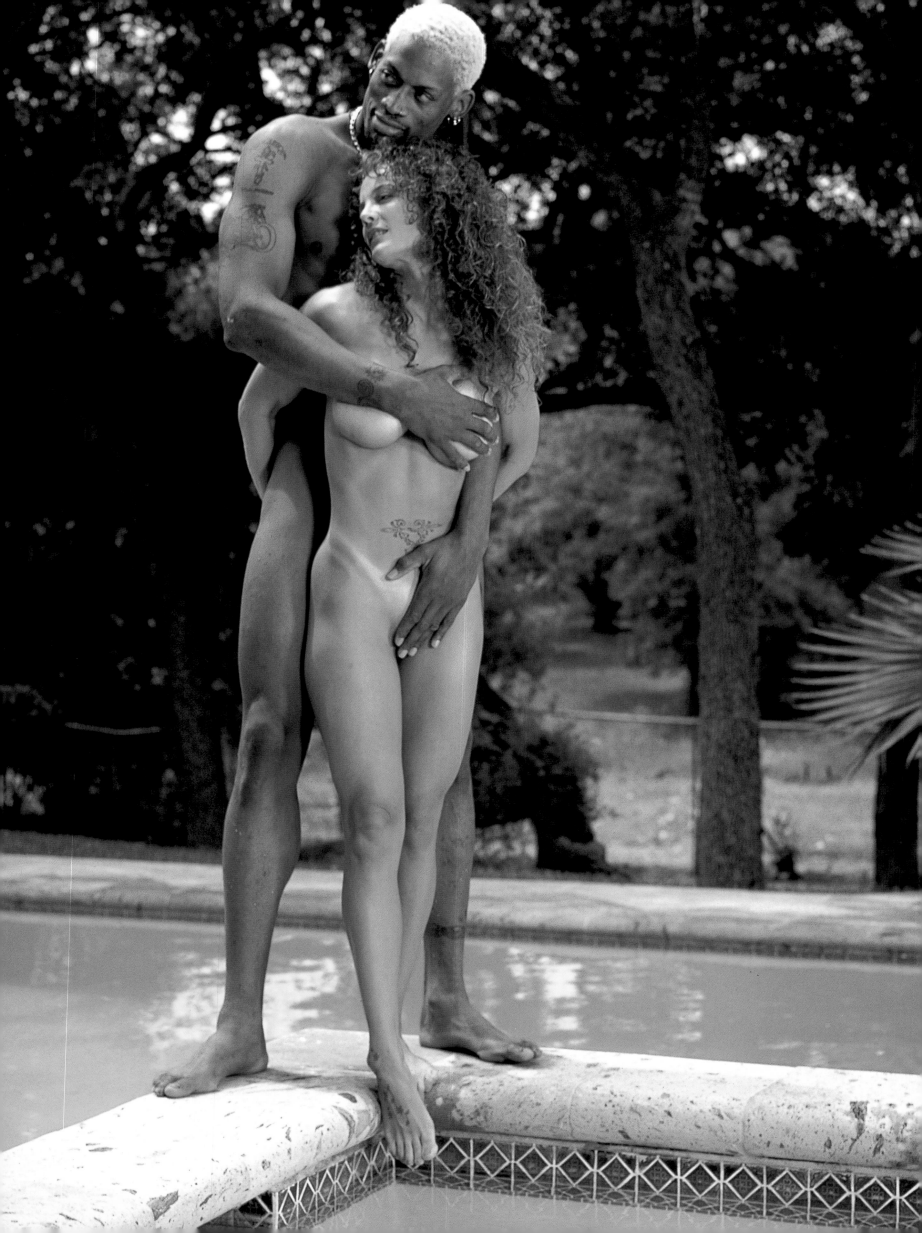

DENNIS RODMAN AND STACEY YARBOROUGH / SAN ANTONIO, TEXAS / 1995 – At Rodman's home while he still played basketball for the San Antonio Spurs, he was quick to undress and have some fun, posing with his girlfriend at the time. Yet he was concerned that the neighbors would peek over the garden fence to see what was going on.

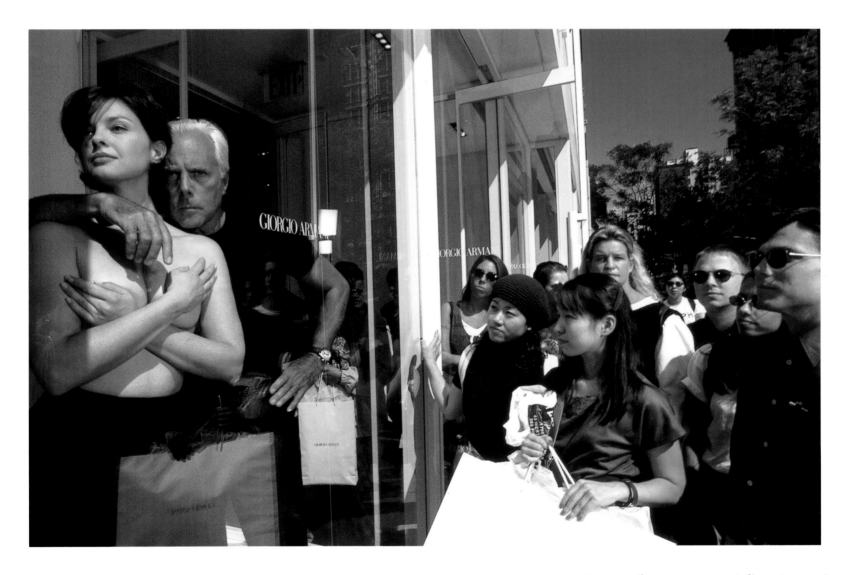

GIORGIO ARMANI AND ASHLEY JUDD / NEW YORK CITY / 1996 – At Armani's new store on Madison Avenue, I tried to think of something amusing for him to do with Ashley Judd. Half jokingly, I suggested they pose in the store window, her with her top off, and him with his arms around her. To my surprise, they were willing. A small crowd that became a large crowd gathered, partially blocking Madison Avenue and holding up traffic. My one concern was if the police had arrived, there might have been more than one police car headed for the precinct.

JOHN WAYNE BOBBIT / LAS VEGAS / 1994 – Bobbit became a kind of folk legend in 1993 when his wife Lorena sliced off the end of his penis. Looking for a cowboy hat in a casino shop, I had an idea for his picture and it worked. I wanted to take the photo on the Vegas strip, but because we might have been arrested, we drove to the desert. He took off one piece of clothing, then another, until he was wearing only his boots and the hat.

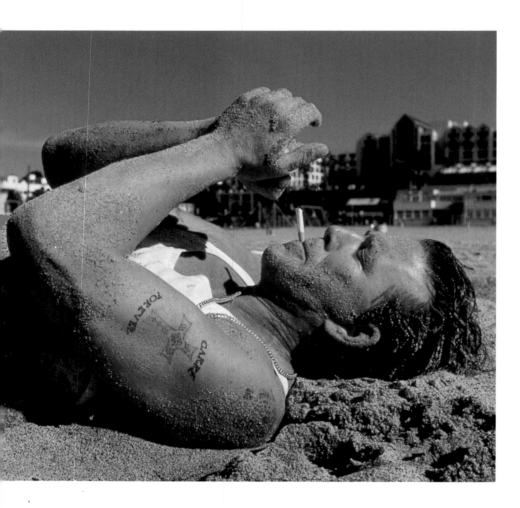

MICKEY ROURKE / VENICE BEACH, CALIFORNIA / 1995 – Mickey was a good sport to get sopping wet and roll around in the sand for me. As he stood near the shoreline, the waves knocked him down. He just laughed.

ANDREW WYETH / CHADDS FORD, PENNSYLVANIA / 1996 – I spent a day with Wyeth and his wife, Betsy, at their home in Pennsylvania. She made a delicious meal for us. They had a great time, joking with each other and laughing. You could see he wanted to keep his life as it had always been—to hold on to a part of America that was changing.

HANDS AND PAINTING / BENNER ISLAND, MAINE / 1996 – Wyeth's *Air Raid*, with gull and crow feathers scattered over the landscape, is set on Benner Island.

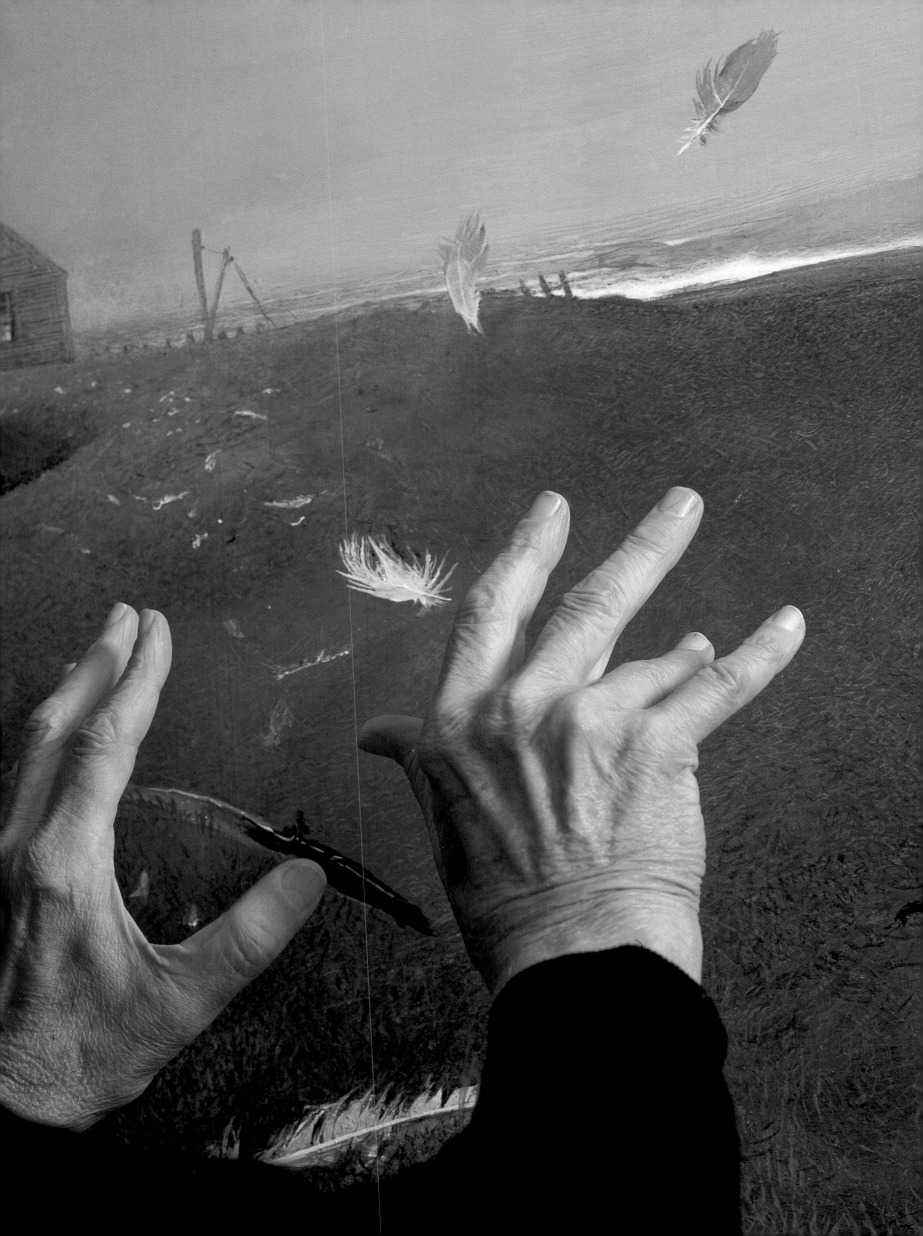

ANDREW WYETH / BENNER ISLAND, MAINE / 1996 — At his summer retreat on an island off the coast of Maine, the great American artist went out to sketch by the water's edge. He carried his sketch pad the way a photographer carries his camera—hoping to see something that will catch his eye. He would stop and sketch a tree here, a river there, tearing up sketches he didn't like.

NUDE PARK / BERLIN / 1996 – In the middle of what used to be West Berlin, I wandered around a park where nudity is the norm in summer. No one minded having their picture taken.

KIT KAT CLUB / BERLIN / 1996 – I found the Kit Kat Club the most outrageous cabaret open in East Berlin after the wall came down. It evoked visions of Sally Bowles in Christopher Isherwood's "I Am a Camera." It was very dark and full of all kinds of people, from businessmen to bikers. The girl with the knife didn't see me. I don't know if it would have made any difference anyway.

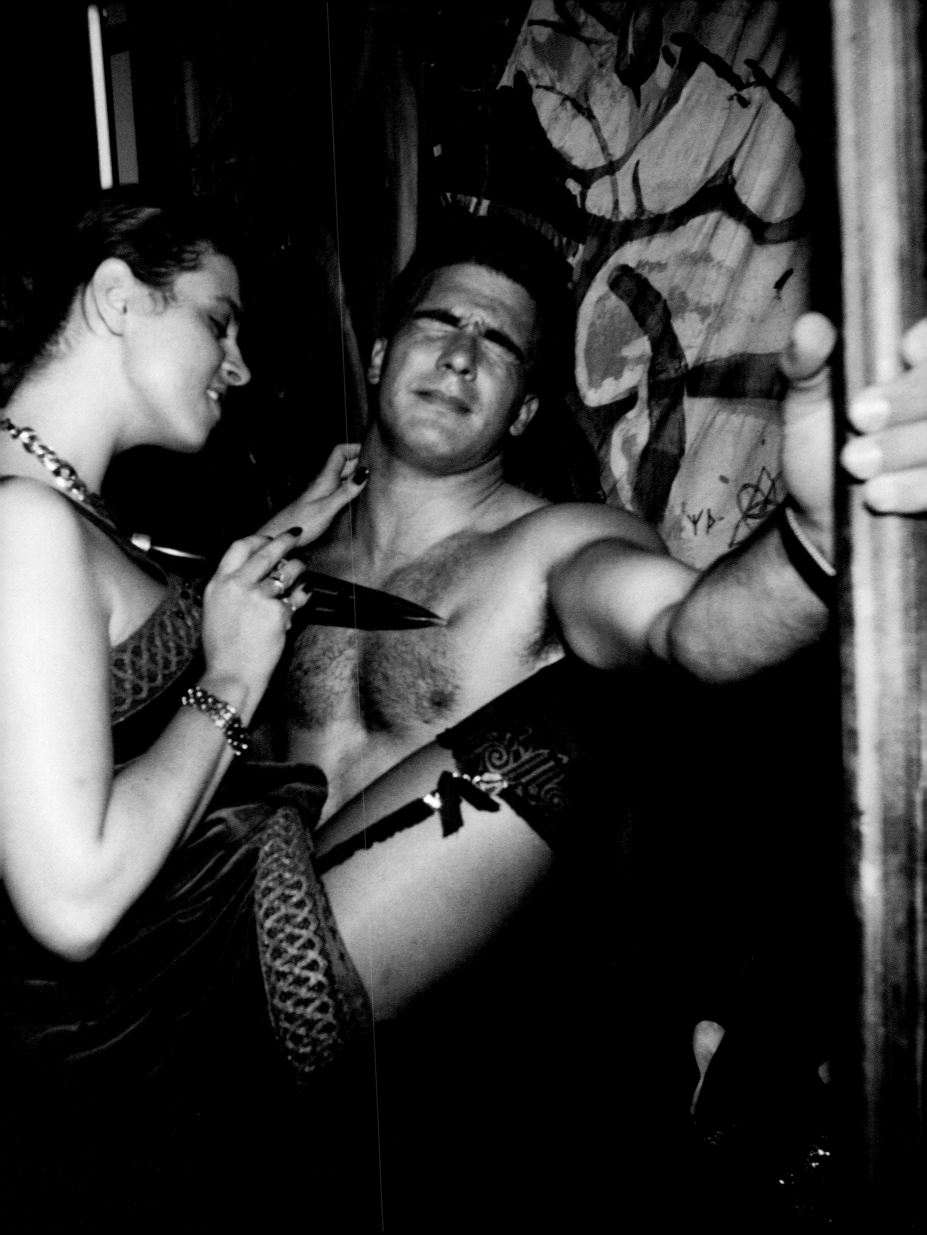

ANNABELLE'S CLUB / BERLIN / 1996 – Friday night at Annabelle's in what used to be East Berlin.

BERLIN KISS / BERLIN / 1996 – It was about 3:00 A.M. and I was at the bar at Annabelle's Club when I happened to see this couple who were totally oblivious to their surroundings.

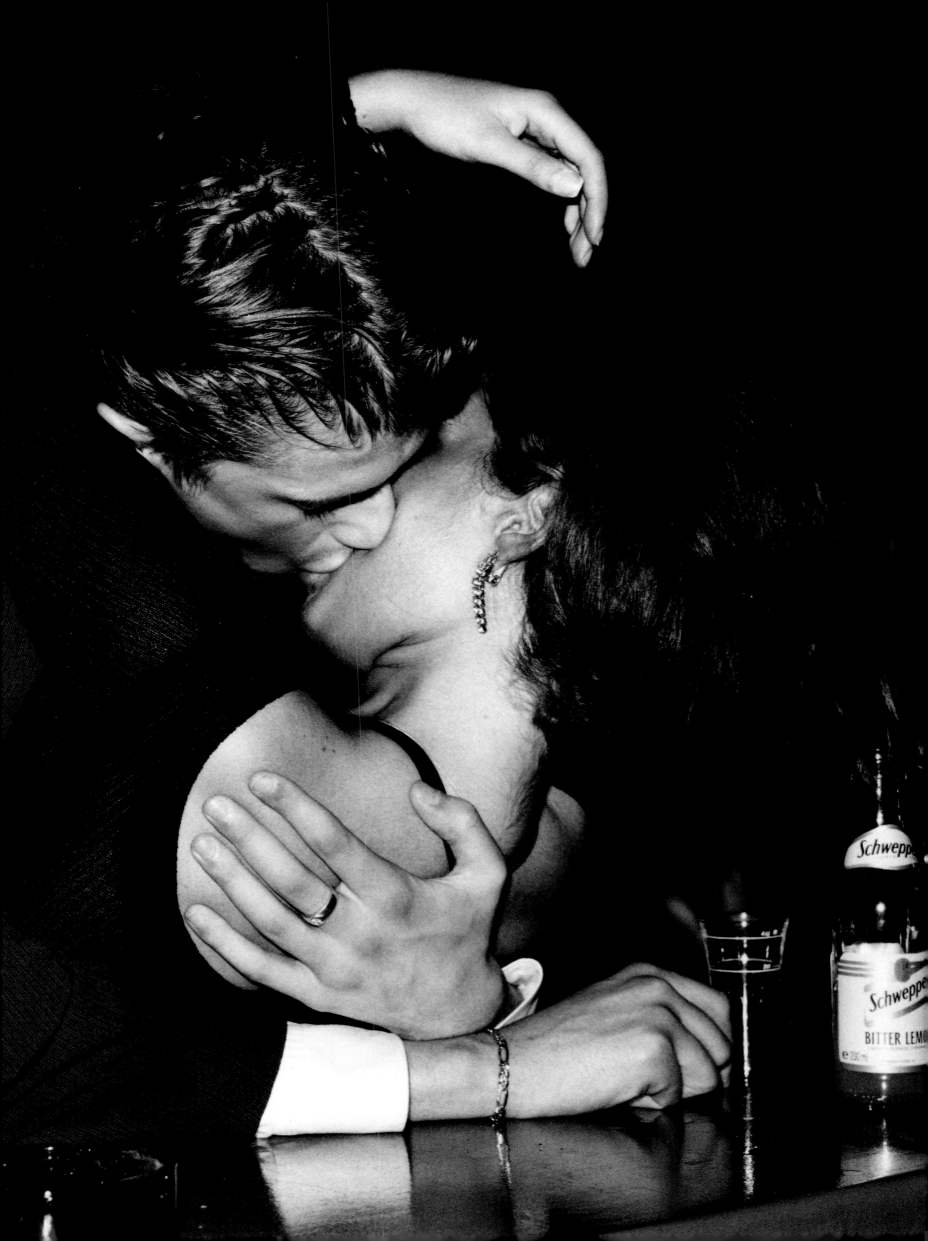

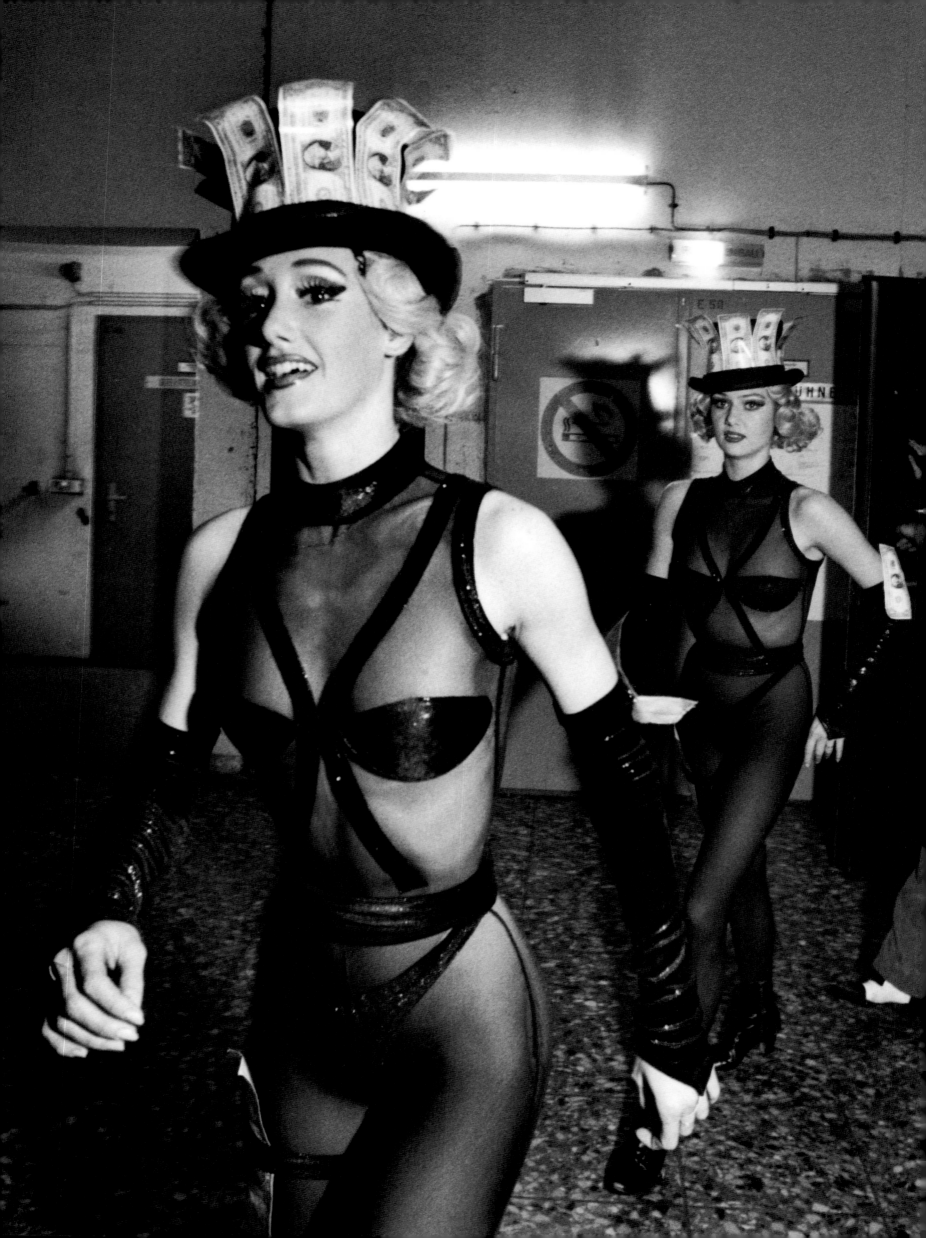

DANCERS / BERLIN / 1996 – Coming off the stage after their opening number in a cabaret in the former Russian zone, these dancers were rushing to change costumes for the next number. The choreographer was shouting orders to hurry up. It was a very professional show and I wasn't surprised when I learned that the women are classically trained ballet dancers.

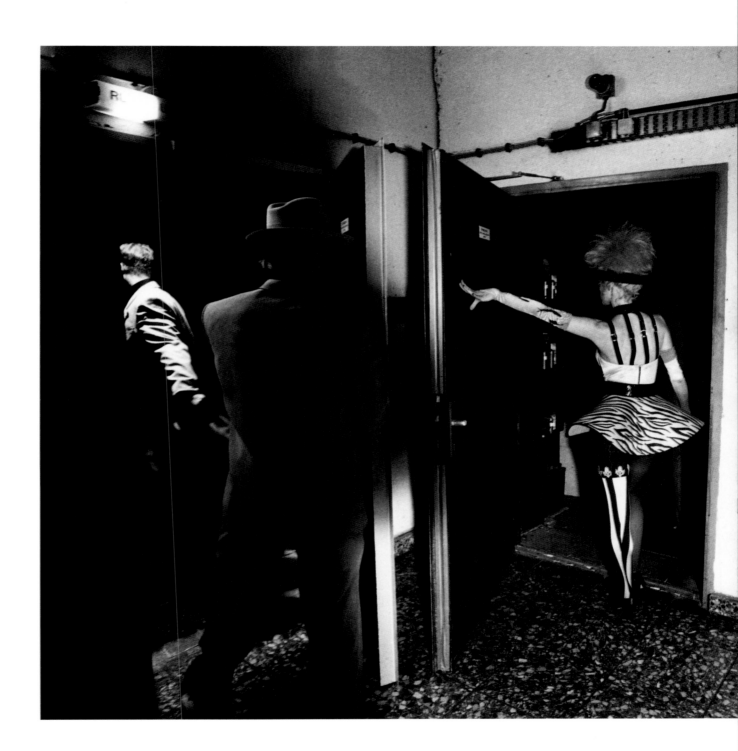

DANCERS / BERLIN / 1996 – After a quick costume change the performers went back onstage.

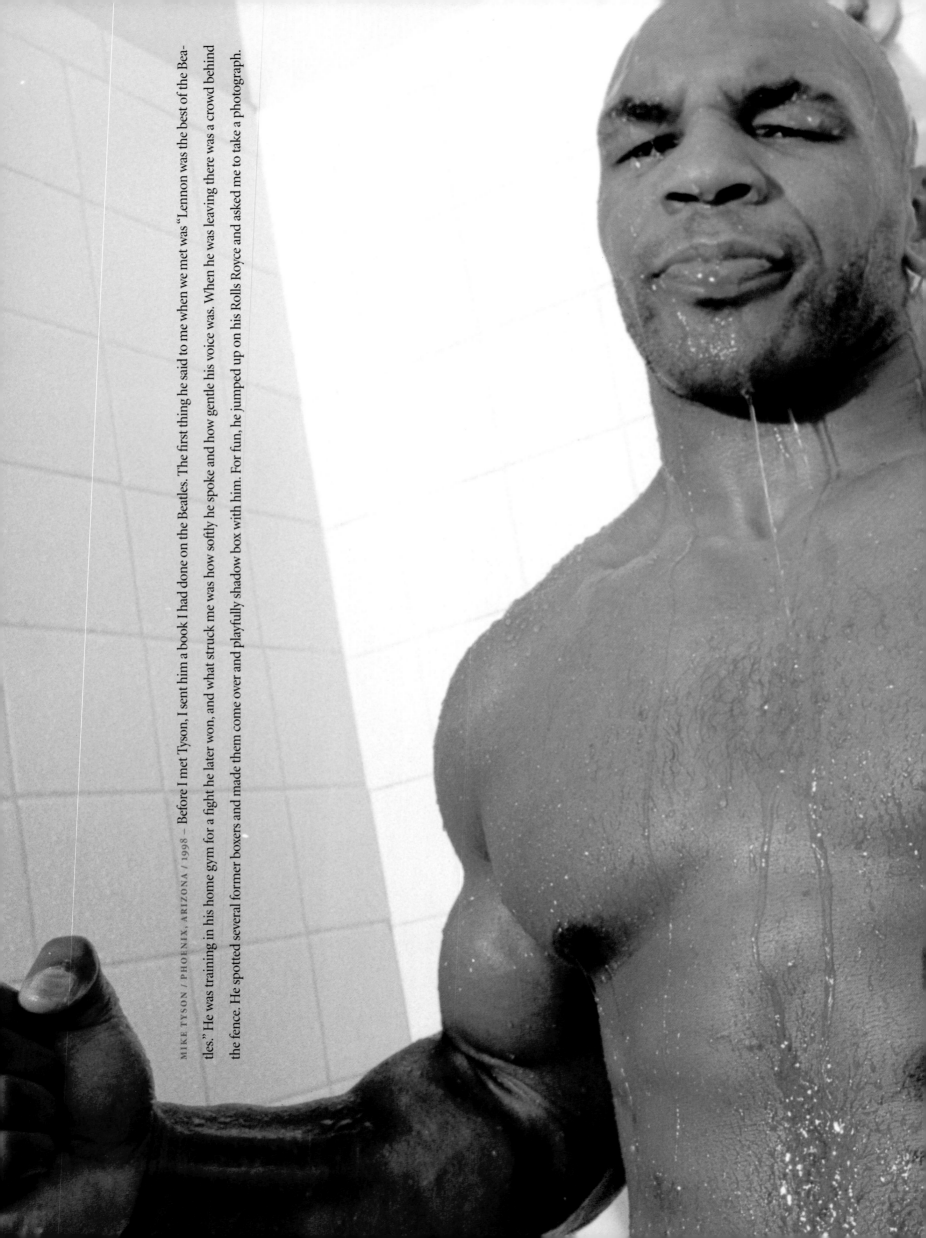

MIKE TYSON / PHOENIX, ARIZONA / 1998 – Before I met Tyson, I sent him a book I had done on the Beatles. The first thing he said to me when we met was "Lennon was the best of the Beatles." He was training in his home gym for a fight he later won, and what struck me was how softly he spoke and how gentle his voice was. When he was leaving there was a crowd behind the fence. He spotted several former boxers and made them come over and playfully shadow box with him. For fun, he jumped up on his Rolls Royce and asked me to take a photograph.

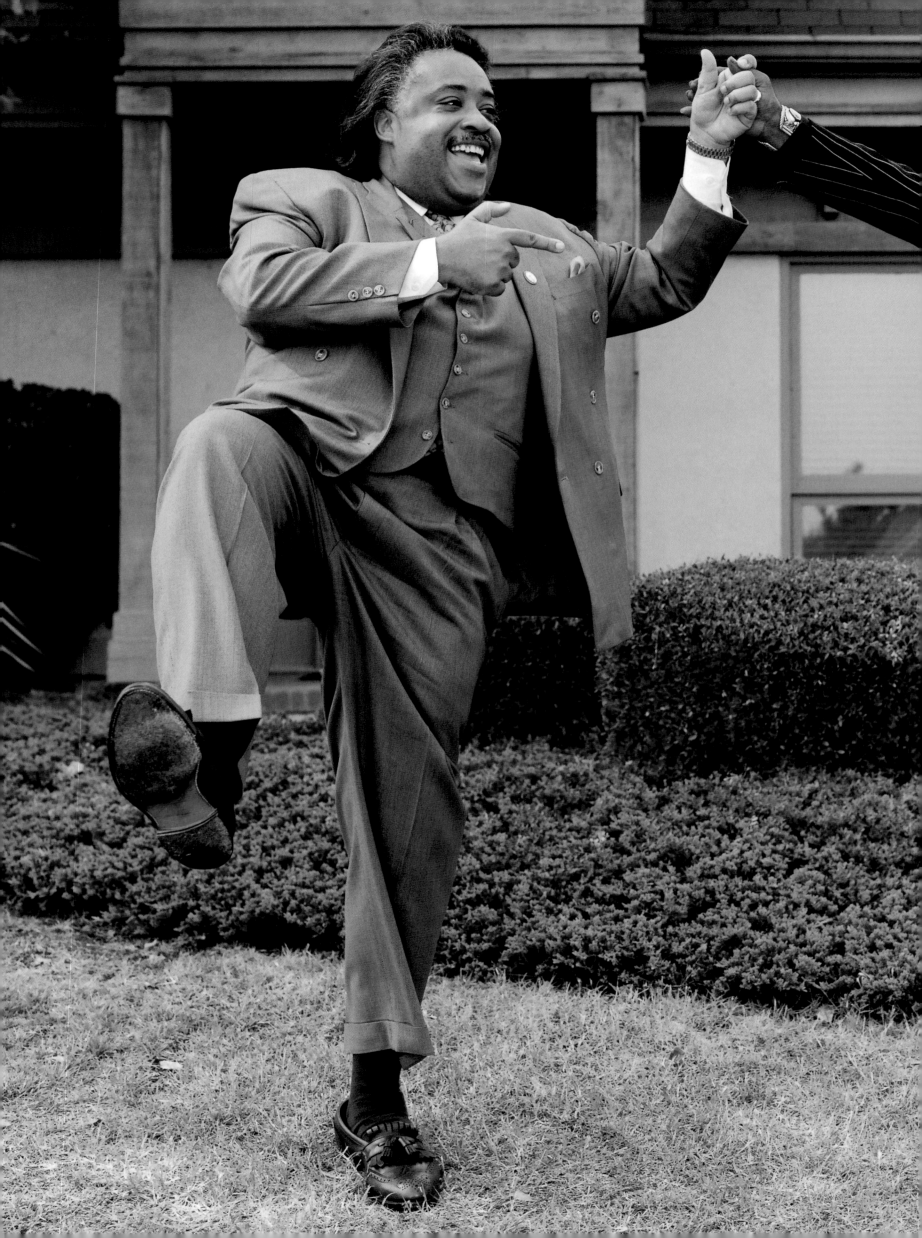

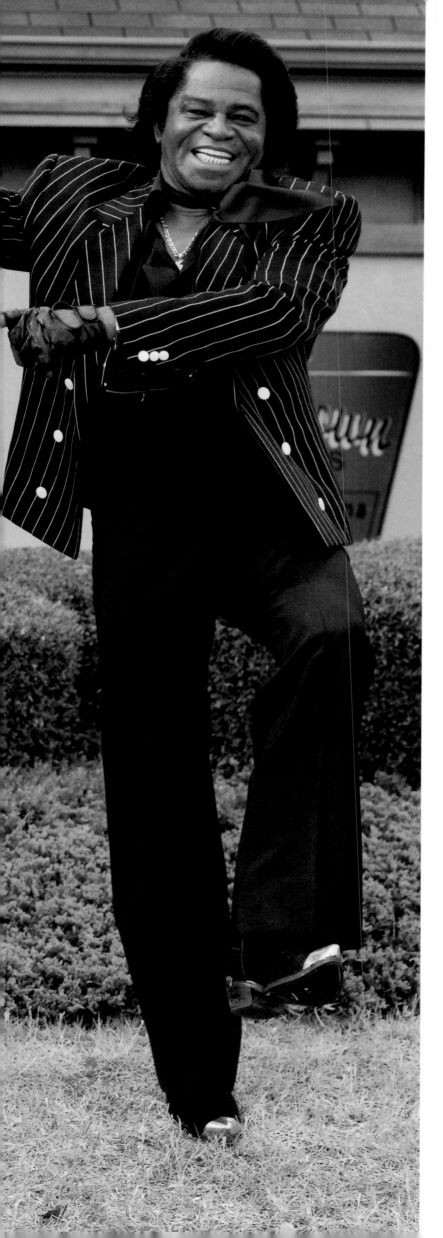

AL SHARPTON AND JAMES BROWN / ATLANTA / 1999 – Minister and activist Al Sharpton had chosen rhythm and blues legend James Brown as his hero for a story I was doing for *Esquire* magazine. In front of Brown's office in Atlanta, they laughed and talked about their hair.

THE REVEREND BILLY GRAHAM AND HIS WIFE, RUTH / MONTREAT, NORTH CAROLINA / 1993 – With his gracious wife, Ruth, always at his side, Graham was very comfortable to be around, with a warm smile and a sense of humor that put you completely at ease. What impressed me most was that he could name parts of my hometown, Glasgow, that I thought only the natives knew about.

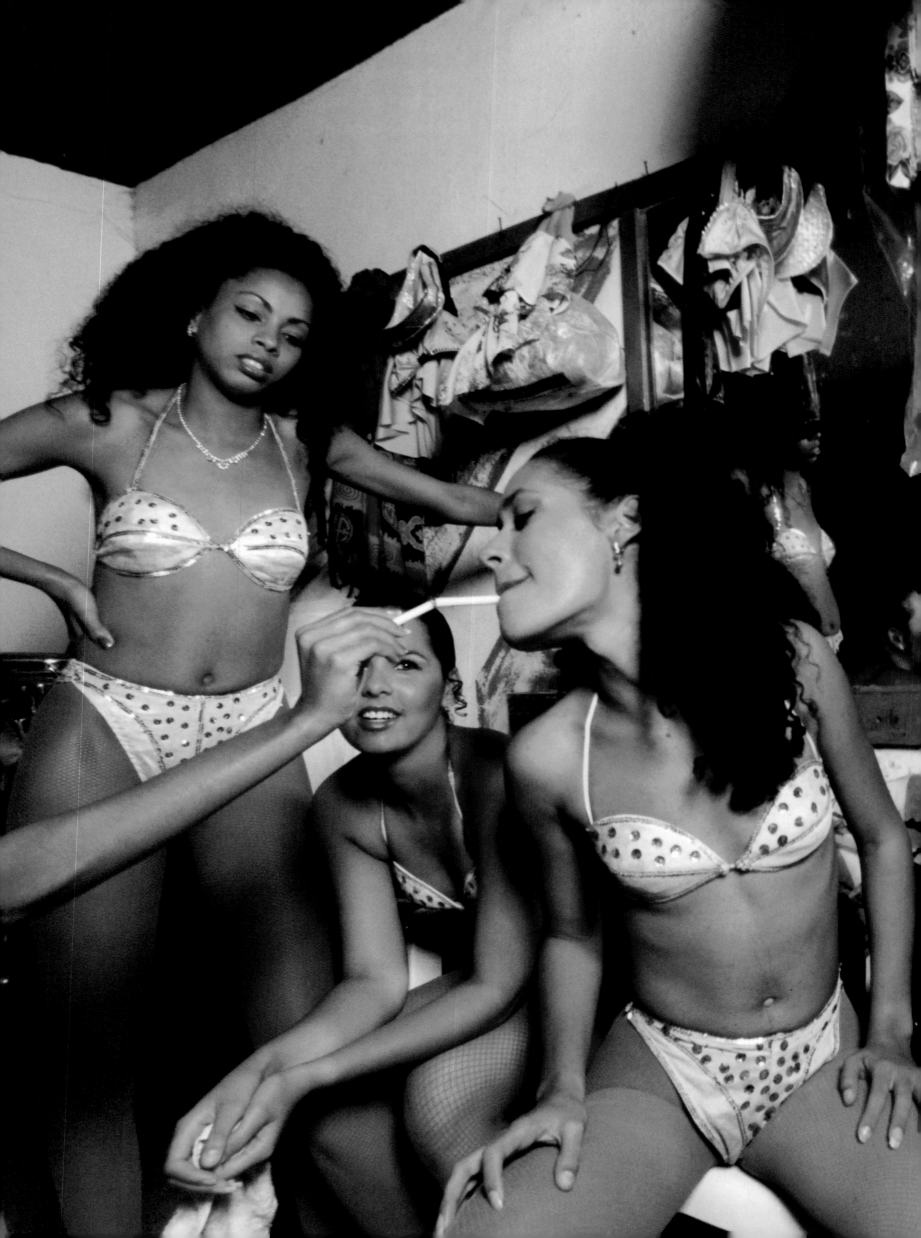

SHOWGIRLS / HAVANA / 1999 — Backstage at a nightclub in Cuba, the dancers are waiting to go on. These girls have fun and are considered the lucky ones in a city where there are few good jobs to be had. Havana hadn't changed much since I was last there twelve years before. American cars from the fifties still lined the streets of the once beautiful city.

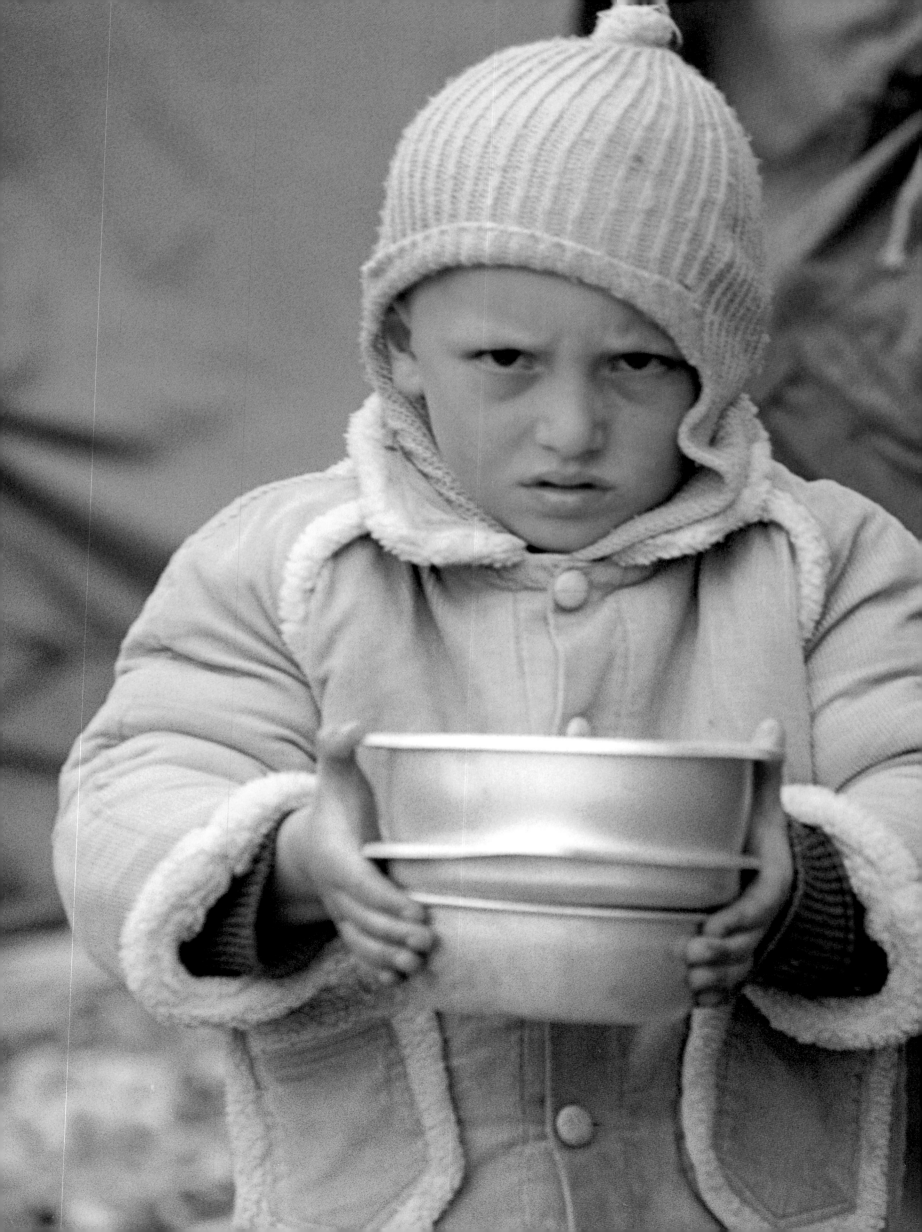

REFUGEE CHILD / MACEDONIA/KOSOVO BORDER / 1999 – Families had been uprooted by the Kosovo-Serbian war in the former Yugoslavia. The humanitarian organization Doctors Without Borders was giving out soup to the refugees. This little boy was standing in line waiting his turn.

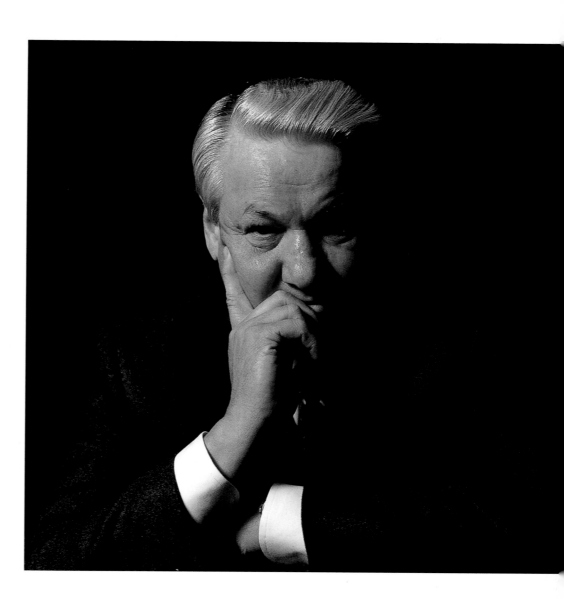

PRESIDENT BORIS YELTSIN / MOSCOW / 1991 – As Russian President Yeltsin was giving a speech to the parliament, I was told to set up in a room directly behind the auditorium. One of his aides said, "He'll never go in there. The only way you will get a photo is by setting up in the corridor of the doorway that he must use to leave." I stood in his path as he left and asked to take his photograph. He stood still for five frames, then went on his way.

FIRST SERGEANT SHIRLEY GAULDEN / BOSNIA (CROATIA) / JANUARY 1996 – As part of the peacekeeping 127th Military Police stationed in Bosnia, thirty-five-year-old career soldier Gaulden was in charge of logistics for her company. Standing outside her tent, she said she worried about the two young sons she left in Germany with her husband. She is one of only a few women to rise to the rank of first sergeant in the U.S. military police.

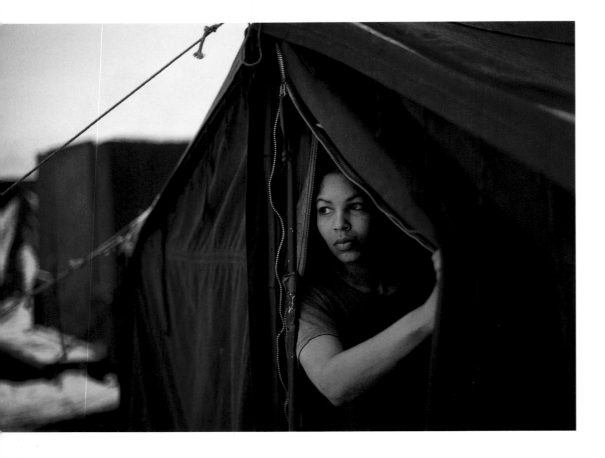

U.S. SOLDIERS / BOSNIA (CROATIA) / JANUARY 1996 – U.S. soldiers were part of the United Nations peacekeeping forces in Bosnia. The cold was unbearable. These soldiers are looking for mines. When pouring rain melted the snow, we discovered a landmine right outside the tent I was sleeping in. The soldiers moaned about the hardships and liked trading rations with the French. No one wanted to trade food packets with the British.

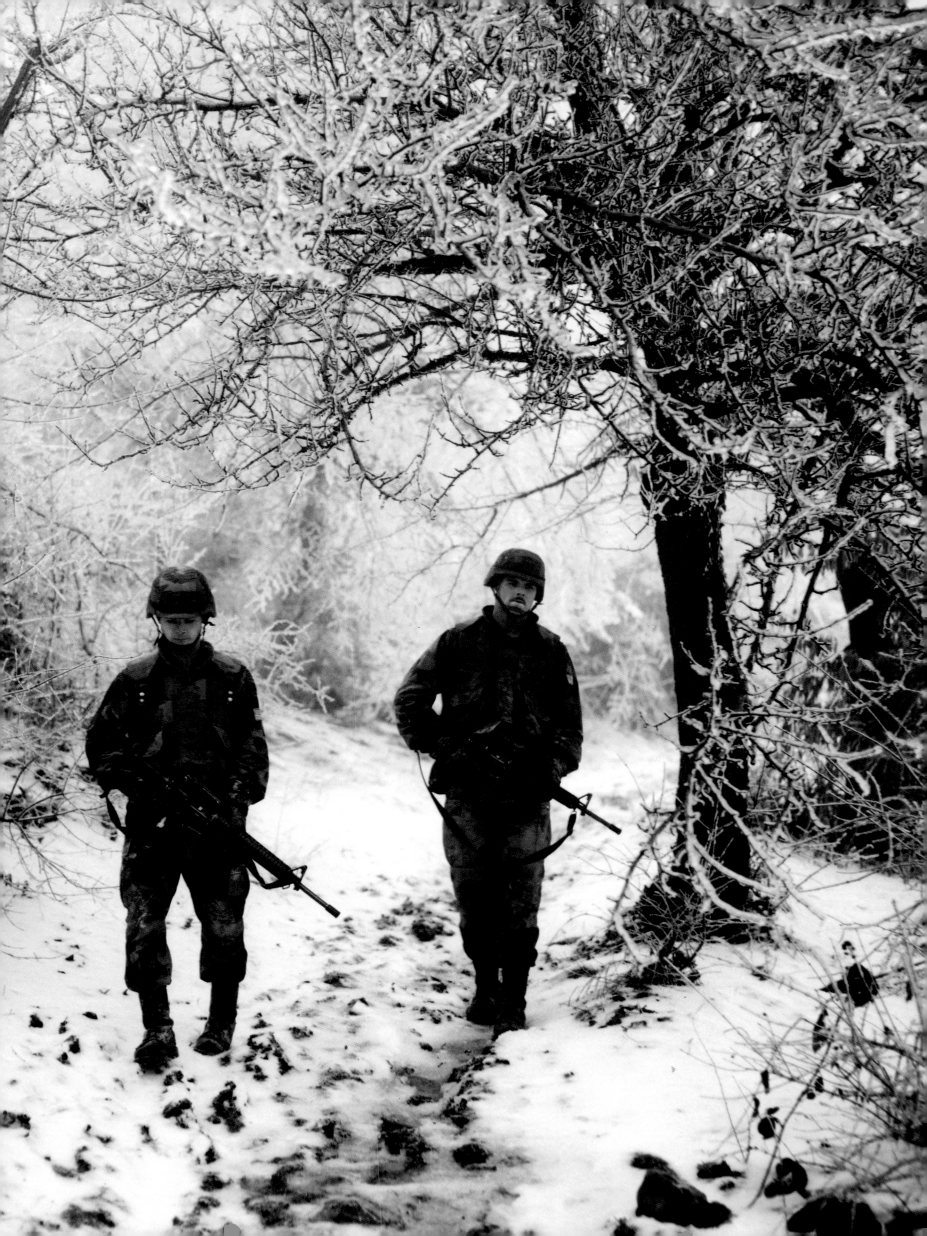

U.S. SOLDIER CHRIS COTTINGHAM / TUZLA, BOSNIA (CROATIA) / JANUARY 1996 – Californian Chris Cottingham, gunner specialist, sits on a Humvee with his .50-caliber M2 machine gun. Perhaps it is the bottle of Coca Cola, but somehow the solitary soldier on lookout behind his gun reminded me of the photographs I had seen of American soldiers in World War II.

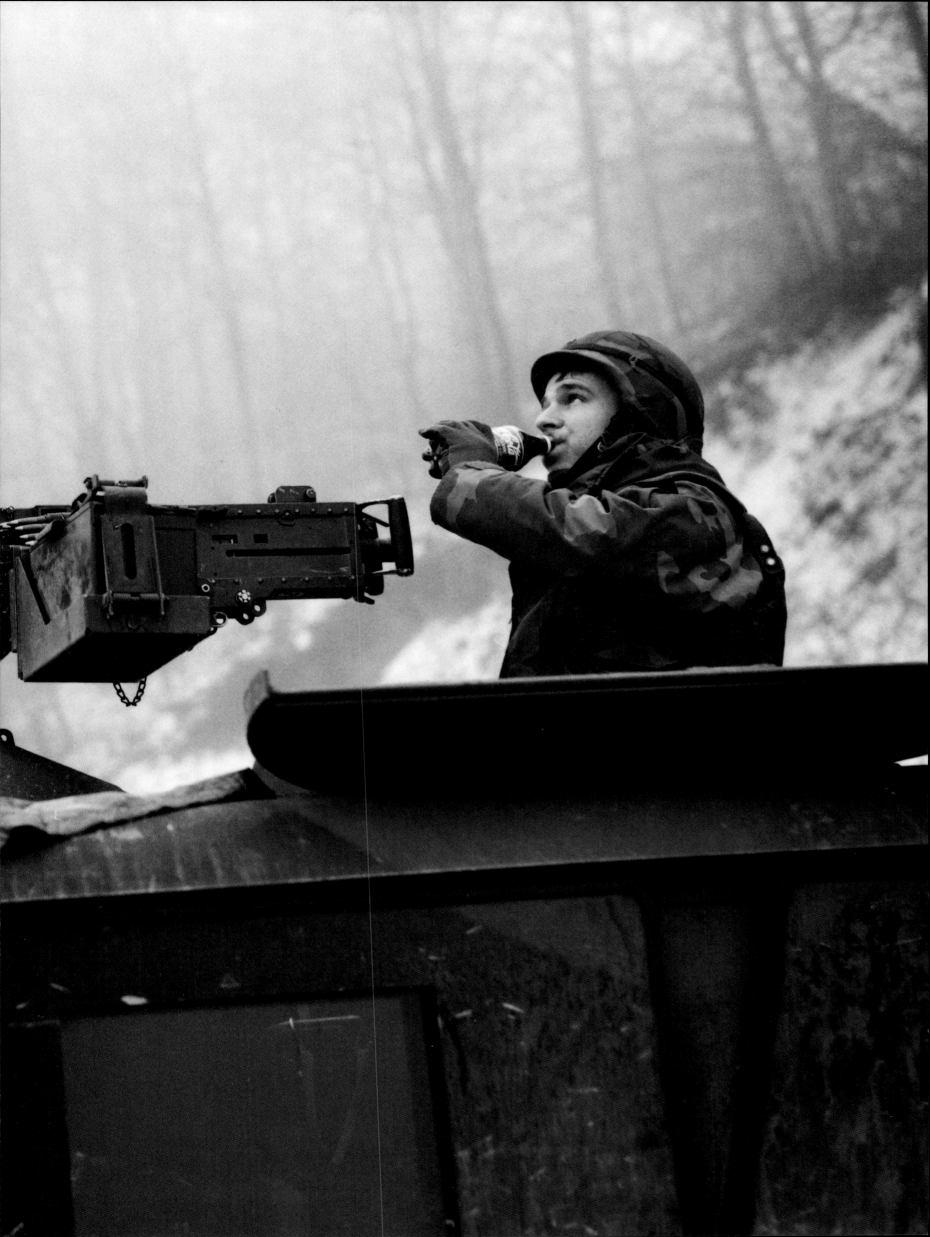

GOVERNOR GEORGE W. BUSH / AUSTIN, TEXAS / 2000 – Governor Bush looked at you the way a boxer does – by not quite looking at you. The first time we met, he asked if I was from Scotland. I answered yes, but told him my wife was from Seguin, Texas. That surprised him. Before he was elected president, I photographed him holding an antique wooden golf club at the Governor's Mansion. He said his grandfather used to play with wooden clubs. Asked what I had been doing since we last met, I told him I had become an American citizen. He pointed the club at me and said, "I'm asking for your vote." I laughingly told him we'd see how the photo session went that day.

VICE-PRESIDENT AL GORE WITH HIS WIFE, TIPPER, AND DAUGHTER
KARENNA / NORTH CAROLINA / 2000 – At a vacation cottage on an island
off the coast of North Carolina, the Gore family relaxed for a weekend
during his presidential campaign against George W. Bush.

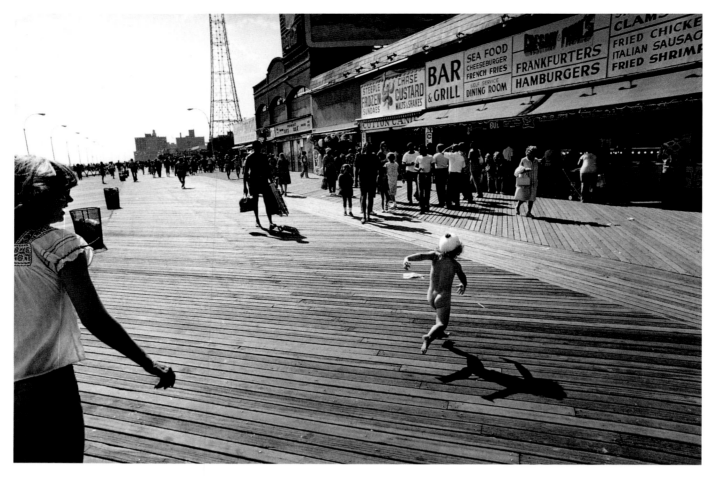

WENDY BENSON / CONEY ISLAND, NEW YORK CITY / 1975 – My wife, Gigi, tries to catch Wendy as she runs away on the Boardwalk at Coney Island.

TESSA BENSON AND OUR DACHSHUND, CARLO / NEW YORK CITY / APRIL 1983 – For a *New York* magazine special issue, "A Day in the Life of New York," I started an eighteen-hour assignment by photographing my daughter Tessa asleep in her bed. I told Carlo to shut his eyes and he obliged.

selected exhibitions

1982

Soho International Art Center, New York, New York. *Harry Benson On Photojournalism.*
May 6–June 15.

Traveled to: **Southwest Craft Center**, San Antonio, Texas. *Harry Benson On Photojournalism.* September 9– October 1; **Western States Museum of Photography, Brooks Institute**, Santa Barbara, California. *Harry Benson On Photojournalism.*
November 7, 1983–January 6, 1984.

1983

Art Center College of Design, Pasadena, California. *Harry Benson: A Retrospective.*
June 19–July 9.

Tucson Museum of Art, Tucson, Arizona. *Harry Benson On Photography.*
August 20–September 28.

1985

National Portrait Gallery, Smithsonian Institution, Washington, D.C. *White House Families.* February 15. Permanent collection.

National Museum of Photography, Bradford, England. *Harry Benson: Photojournalist.*
June 25–August 18.

1990

Christie's, Glasgow, Scotland. *Harry Benson's People.* July 16–August 3.

Traveled to: **Christie's**, London, England. November 7–16; **Christie's**, New York.
December 1991; **Soho International Art Center**, New York, New York.
September 13–October 26, 1991.

1992

Academy of Motion Picture Arts and Sciences, Los Angeles, California. *Harry Benson Photographs.* July–August.

1997

G. Ray Hawkins Gallery, Santa Monica, California. *Harry Benson: A Retrospective, 1956–1997.* May 9–June 3.

Abbaye de Montmajour, Festival of Photography, Arles, France. *First Families from the Kennedys to the Clintons.* July–August.

Newseum, Arlington, Virginia. *First Families: From the Kennedys to the Clintons.*
July 23–October 12.

Traveled to: **Newseum**, New York, New York, November 6, 1997–February 7, 1998;
The Richard Nixon Library and Birthplace, Yorba Linda, California, January 31–March
31, 1998; **Pacific Coast Center**, San Francisco, California, March 5–April 25, 1998;
Hoover Presidential Library and Museum, West Branch, Iowa, May 24–October 31,
1998; **Gerald Ford Library and Museum**, Grand Rapids, Michigan, November 22,
1998–January 30, 1999; **Ronald Reagan Library and Museum**, Simi Valley, California,
May 23–July 31, 1999; **George Bush Library and Museum**, College Station, Texas, August
22–October 30, 1999; **Harry S. Truman Library and Museum**, Independence, Missouri,
February 20–April 29, 2000; **Jimmy Carter Library and Museum**, Atlanta, Georgia, May
19–July 29, 2000; **Southwest School of Art and Craft**, San Antonio, Texas, August
24–October 28, 2000.

1998

Carla Sozzana Gallery, Milan, Italy. *The Beatles Now and Then.* November.

Govinda Gallery, Washington, D.C. *The Beatles.* December 11–January 23, 1999.

Traveled to: **Magidson Fine Art**, New York, New York, February 18–March 18, 1999;
A Gallery for Fine Photography, New Orleans, Louisiana, April 15–July 15, 1999.

1999

Newseum, Arlington, Virginia. *The Beatles Now and Then.* January 20–May 16.

Traveled to: **Newseum New York**, June 18–September 25, 1999; **Pacific Coast Center**, San
Francisco, California, September 29–November 19, 1999; **Chicago Historical Society**,
Chicago, Illinois, July 2–August 15, 2000; **Historical Society of Western Pennsylvania**,
Pittsburgh, December 10, 2000–June 16, 2001.

New Alchemy Gallery of Fine Art, Los Angeles, California. *Harry Benson.* June 5–July 2.

2000

Liss Gallery, Toronto, Canada. *Harry Benson.* June 8–July 1.

awards

**National Press Photographers Association (N.P.P.A.)
and University of Missouri "Pictures of the Year" Awards**

1995	Second Place, Portraits: *John Wayne Bobbit*
1987	Third Place, Portraits: *Tammy and Jim Baker*
1985	"Magazine Photographer of the Year"
1982	First Place, Portraits: *Native Americans*
1982	Runner-Up, "Magazine Photographer of the Year"
1981	"Magazine Photographer of the Year"
1979	First Place, Portraits: *Regine*
1976	Third Place, Portraits: *Truman Capote*
1974	First Place, News: *John Mitchell Celebrates*
1974	Second Place, News: *Nixon Resigns*
1968	Honorable Mention, News: *R.F.K. Assassination*

British Photographer of the Year Awards

1968	First Place, R.F.K. Assassination Photos
1966	Honorable Mention, Royal Family Photos
1959	Second Place, Feature Photos
1958	Second Place, "Photographer of the Year"

Other Awards

1996	"Photographer of the Year," Photographic Manufacturers of America Award
1989	People Magazine Hall of Fame Award
1988	Overseas Press Club Madeline Dane Ross Award
1985	Third Place, World Press Photos
1984	Leica Medal of Excellence
1983	Leica Medal of Excellence
1982	Overseas Press Club Citation of Excellence
1981	Overseas Press Club Citation of Excellence

books by harry benson

Harry Benson On Photojournalism. Text by Gigi and Harry Benson.
New York: Harmony Books, 1982.

Harry Benson's People. Text by Harry Benson. Foreword by Richard B. Stolley.
Design by Wide Art, Edinburgh, and Gigi Benson, New York. Great Britain:
Mainstream Publishing, 1990.

People: Harry Benson. Foreword by James L. Brooks.
Text by Harry Benson. San Francisco: Chronicle Books, 1991.

The Beatles in the Beginning. Text by Harry Benson.
New York: Universe Publishing, 1993.

First Families: An Intimate Portrait from the Kennedys to the Clintons.
Forewords by Rosalynn Carter, Nancy Reagan, and Barbara Bush.
Edited by David Friend and Gigi Benson.
New York/Boston: Bullfinch Press, 1997.

The Beatles Now and Then. Text by Harry Benson. Edited by Gigi Benson.
New York/Universe Publishing, 1998.

Allen, Casey. "The Predator." *Studio Photography*, September 1995, 10, 13, 57.

American Photo, editors. "Photo Survivor." *American Photo*, January/February 2001, 32.

American Photo, editors. "Photography's Top 100, 1994." *American Photo*, January/February 1994, 68.

American Photo, editors. "The 100 Most Important People in Photography 1998." *American Photo*, May/June 1998, 54.

Archerd, Army. "Right Now." *Daily Variety*, July 3, 1999.

Baily, Ronald H. "Raging Scot: How Magazine Photographer of the Year Harry Benson Fought his Way to the Top." *American Photographer*, May 1982, cover story, 42–59.

Balian, Edward Sarkis. "The Portrait King." *Shutterbug*, August 1994, 21–24.

Bausmith, Wes. "Presidential Image." *Orange County Register* [California], February 1998.

Bendoris, Matt. "Harry's People: Exile Is The No.1 Choice For Stars Hall of Photo Fame." *The Sun* [London], February 2, 1998, 21–23.

Bennett, Elizabeth. "Harry Benson, Tough Guy Behind The Camera." *Houston Post*, April 7, 1985, 61.

Benson, Harry. "Echos of Evil 20 Years Later." *Newsday*, October 9, 1991, 3–5.

Bizio, Silvia de. "Click: The Scoop!" *L'Espresso*. January 12, 1992, 163.

Blyth, Jeffrey. "Dateline America." *Press Gazette* [U.K.], July 7, 1986.

Brodie, Ian. "Presidents Pay Lip Service To The Lens." *The Times* [London], August 11, 1997, 10.

Burton, Tom. "Retrospectives Are Portraits of Photographic Mastery." *The Orlando Sentinel* [Florida], December 8, 1991, D17.

Carlock, Judy. "History According To Harry." *Tucson Citizen*, August 23, 1983, B1.

Carlson, Peter. "Posing The Imposing." *The Washington Post*, July 29, 1997, E1, E3.

Chandler, Chuck. "Photographer Preserves Historic Times, People." *The Advertiser*, December 11, 1984.

Cirone, Bettina. "Harry Benson Tells It Like It Is." *Photo District News*, July/August 1984, 8, 38–39.

Coleman, A.D. "Harry Benson At Christies: Up From Fleet Street." *The New York Observer*, December 23, 1991.

Collins, Amy Fine. "Wild About Harry." *Vanity Fair*, September 1991, 159.

Corning, Blair. "Harry Benson's People." *San Antonio Express-News*, September 8, 1991, 1J, 5J.

Day, Lori. "Photographs of the Times: Facing Celebrity." *Twin Cities Reader*, January 28, 1987, 23.

Delano, Anthony. "Slip Up." *Quadrangle*/The New York Times Book Co., 1975, 138–139.

Della Femina, Donna. "Marriage and Photography: A Good Mix?" *Photo District News*, October 1983, 52, 86.

Docherty, Gavin. "Man Who Filmed While Bobby Died." *Times* [Scotland], November 13, 1984, 13.

Donald, Marian. "Why Priscilla Stuck Out Her Tongue At The Lad From Glasgow." *Sunday Mail* [London], November 4, 1990, 24–25.

Edwards, Robert. *Goodbye Fleet Street*. London: Jonathan Cape, 1988, 148–149.

Fennessy, Steve. "Photography Icon Says His Secret Is Getting Private Doors To Open." *Democrat and Chronicle*, April 23, 1999, C1, C4.

Filler, Martin. "Photography." *House and Garden*, May 1982, 12.

Fotheringham, Ann. "When Harry Met Ann." *East Kilbride News*, July 26, 1985.

Fox, David. "Photojournalist At Work: Harry Benson." *Studio Photography*, July 1982, 22–25.

Friend, David. "Eyes To The Action." *The Sunday Times Magazine* [London], July 21, 1990, 30–34.

Gett, Trevor. "Foul Play." *Amateur Photographer* [U.K.], November 15, 1997, 18–19.

Gett, Trevor. "Photography Should Be Fun." *Australian Photography*, June 1991, 50–52.

Gett, Trevor. "Photography Should Be Fun." *Female*, November 1990, 88–92.

Goddard, Dan R. "FotoSeptiembre 2000." *The San Antonio Express-News*, August 25, 2000, Life section, F3.

Grundberg, Andy. "Photography View. Photojournalism: A Blend of Artifice and Actuality." *The Sunday New York Times*, January 10, 1988, 33.

Guten, Keri. "Benson's Eye Is Always At Center of The Action." *San Antonio Light*, September 10, 1982, 11E.

Harris, Joyce Saenz. "Harry Benson, Every Picture Tells A Story." *Dallas Morning News*, November 10, 1991, 6E.

Harris, Ron. "They're All Wild About Harry!" *Hamilton Advertiser*, November 9, 1984, 28.

Hart, Russell. "Harry Benson." *American Photo*, January/February 1987, 58–59.

Hood, Jennifer. "Wild About Harry." *Night Light Magazine*, November 23, 1983, 1, 7.

Huhn, Mary, "Hobbled by Bobbit?" *Mediaweek*, February 20, 1995, 12.

Hunter, William. "After A Pillow Fight Things Just Clicked." *Glasgow Herald*, November 6, 1982.

Kelly, Keith J. "Conde Nast Editors Gang Hire Lensman." *New York Post*, February 24, 1999, 35.

Klock, Renee. "Capturing Their Souls, The Photographs of Harry Benson." *Hamptons Magazine*, July 4, 1992, 36–37.

Lasala, Anthony. "Self-Portrait, Harry Benson." *Photo District News*, January 1998.

Lawlor, Eric. "Benson's Photos So Revealing Because He Kept His Distance." *The Houston Chronicle*, June 9, 1995, 5.

LeFave, Kenneth. "Despite Protests, Benson's Camera Is An Artist's Brush." *The Arizona Daily Star*, August 23, 1983, B1.

Life Magazine. "Camera at Work: Harry Benson." *Life Magazine*, October 1993, 20–24.

M Magazine. "Dream Jobs: One Feisty Photojournalist doing Combat with a Camera." March 1988, 80–81.

MacAskill, Eilidh. "The Man Who Shot The President." *Scotland On Sunday*, Spectrum, May 10, 1997, 16–19.

MacCash, Douglas. "Picture Yourself: Beatles Blossom an Un-candid Camera." *Picayune Times* [New Orleans], July 1999, 14–15.

Madlin, Nancy. "In Print: Harry Benson's People." *Photo District News*, October 1992.

Maier, Thomas. "Dancing With Tina." *Newsday*, October 19, 1994, B3, 25.

Maier, Thomas. *Newhouse.* New York: St. Martin's Press, 1994, 226–28, 230.

Martin, Courtenay. "Intimate Portraits: Harry Benson Captures The Humanity of The First Families." *The Sunday San Antonio Express-News*, August 20, 2000, Life section H, 7, 8.

McCarthy, Robert. "Making It In The Colonies." *Photo District News,* July 1985, 14.

McGee, Kathy. "Pro Profiles: Harry Benson." *Petersen's Photographic,* May 1994, 52.

McKay, Ron. "Beatles About." *Scotland On Sunday,* Spectrum, October 10, 1983, 3.

McMahon, Barbara. "Flash Harry: The Harry Benson Story." *Evening Times* [Glasgow], February 1986, 4–5.

Mead, Rebecca. "I Want To Hold Your Camera." *New York,* October 25, 1993, 25.

Minolta Mirror. "Harry Benson's People II." *Minolta Mirror,* 1987, 120–33.

Murashko, Alex. "Stars Become Real People For Harry Benson." *San Juan Capistrano,* May 1984, 7.

Newsday Magazine, The. "The Greatest Pictures Ever Told." November 1, 1987, 24.

Newsweek Magazine. "A Kiss is Still a Kiss." Newsmakers, June 10, 1985, 61.

Newsweek Magazine. "Power Portraits: First Couples Captured." Newsmakers, August 11, 1997, 52.

Ott, Terry. "Act Naturally." *The Sunday National Post* [Canada], April 6, 1999, B10, 11.

Paton, Morris. "Point and Shoot." *Sunday Herald Magazine* [U.K.]. April 4, 1999, 18–21.

People Magazine. "Gallery: A Canny Eye." December 9, 1991, 73–76.

Peppard, Alan. "Rodman Bares All for Benson." *The Dallas Morning News,* December, 1984.

Pierce, Rebecca. "About Faces." *Spirit Magazine,* September 1991, 91.

Polanski, Roman. *Roman.* New York: William Morrow & Co., 1984, 378.

Popular Photography. "Intimate Portrait." January 1998, 8.

Rafferty, Stephen. "Snap Happy." *The Glaswegian,* July 21, 1990, 12.

Renalls, Candace. "Harry Benson: Pictures From the Past Live On." *Minneapolis Skyway News,* February 10, 1987, 1, 24.

Rico, Diana. "Photographer Captures the Twentieth Century." *Los Angeles Daily News,* Life section, April 15, 1984, 19.

Rose, Lloyd. "Harry Benson's Early Photos." *The Washington Post,* Arts section, January 10, 1999.

Rose, Lloyd. "The Beatles Blue Album: Harry Benson's Early Photos Are Tinged With Mystery and Melancholy." *The Washington Post,* January 10, 1999, G4.

Rush & Malloy. "Beatlemania." *New York Daily News,* February 15, 1999, 14.

Sammon, Rick. "The 35mm World of Harry Benson." *Studio Photography,* July 1980, cover, 36–43.

Schaub, George. "Conversation with Harry Benson." *Photographer's Forum,* May 1986, 42–49.

Schurman, Dewey. "Photographer Harry Benson Still Brings His Lens to Life." Santa Barbara, California, *News-Press.* November 13, 1983, D1.

Schweit, Ernest J. "He Saw Them Standing There." *Daily Herald* [Chicago], section 3, 1, 4.

Sealfon, Peggy. "Meet the Masters: Harry Benson." *Petersen's Photographic,* February 1984, 66–69.

Seidel, Mitchell. "Fleet Street Lensman Shares Images of the Beatles' Rise to Fame." *The Sunday Star-Ledger* [New Jersey], June 20, 1999, Section 4, 3.

Shown, John. "Top Photographer Captures Essence of Famous Faces." *The Sunday San Antonio Express-News,* September 19, 1982, 8T.

Silverman, Stephen M. "On the Long and Winding Road with the Beatles, part five: Ace Photographer had the Fab Four in Focus." *New York Post,* February 10, 1984, 35.

Skinner, Peter. "People: Photographs by Harry Benson." *A.S.M.P. Bulletin,* March 1992, 10.

Smith, Liz. "A Buried Tale of R.F.K. Pix." (entire column). *The New York Post,* syndicated, October 9, 1991.

Smith, Nancy. "Images Stay with Photographer after the Picture." *Dallas Times Herald,* November 16, 1991.

Stein, Ruth. "An Award-Winner Who Still Fears Failure." *San Francisco Chronicle,* June 28, 1982, 15.

Sullivan, Catey. "Both Sides Now." *Press Publications* [Chicago], July 28–August 3, 2000, Spotlight, 7, 11.

Sunday Mirror Magazine, The [London]. "Harry Benson: The Best of the Best." Oct. 14, 1990, 10–12.

Sunday Mirror Magazine, The [London]. "Harry Benson: The Rest of the Best." Oct. 21, 1990, 16–17.

Szilagyi, Pete. "Celebrities Demystified." *Austin American Statesman,* February 10, 1992.

Texas Monthly. "State of the Art: Bunker Hunt." *Texas Monthly,* September 1991.

Thornton, Gene. "Photographic View: Glamour–A New Kind of Public Art." *The Sunday New York Times,* Arts and Leisure, June 6, 1982.

Thorsen, Karen. "Harry Benson." *Zoom,* Summer 1982, 36–43.

Thym, Jolene. "Focusng on First Families." *The Oakland Tribune,* March 12, 1998, C1, C5.

Walker, Liz. "Man of the People." *Amateur Photographer* [U.K.], January 12, 1991, 41–43.

Webster, Jack. "The Life and Times of Harry Benson." *Glasgow Herald Weekender,* July 7, 1990, 1.

Whiting, Sam. "Catching Celebrities Off Guard." *San Francisco Chronicle,* November 4, 1991, D3–D4.

Williams, Jeannie. "The Kiss: A Fox Trot and Three Takes, Then Benson's Camera Clicks." *U.S.A. Today,* Life section, May 28, 1985, D1.

Wong, Herman. "Benson's Photo Exhibit Frames Recent History." *The Los Angeles Times* calendar, March 22, 1984, 1, 5.

Woulfe, Molly. "Up Close & Personal with Harry Benson." *Sunday Chicago Times,* July 9, 2000, section E, 1, 2.

Wrey, Mark and Adam Hogg. "Harry Benson's People." *Christie's International Magazine,* vol. VII, No. 6, June 1990.

Yerkes, Susan. "Devil or Darling? You Make the Call." *The San Antonio Express-News,* January 22, 1995.

contributors

SEAN CALLAHAN (pages 92–93) began his career as a correspondent for *Time* magazine in 1968. He moved to *Life* two years later as reporter and then picture editor before founding *American Photographer* magazine, which he edited for ten years. He has written or edited twelve books about photography that range from the works of Elliott Erwitt to those of Margaret Bourke-White. He is currently director of broadband programming for Time Warner Cable.

London-born IVOR DAVIS (page 40) became a foreign correspondent in America when the *Daily Express* sent him to cover the Beatles in 1964. He continued as West Coast chief correspondent until 1977. He was American correspondent for the *Times* of London for more than ten years and for sixteen years was editor at large for *Los Angeles* magazine. He writes an entertainment column for the *New York Times Syndicate* and covered the last two World Cup soccer tournaments for CBS and Los Angeles KNX Radio. He lives with his writer wife Sally Ogle Davis in southern California.

VICTOR DAVIS (page 58) was the *Daily Express* roving American correspondent in the 1960s. Thereafter he returned to London where he became a leading celebrity interviewer traveling the world for the *Daily Express* and later for *The Mail On Sunday*. He is also an author, now on his fourth novel. He lives in Kensington, London, hiding from combat photographers who want to know if they can interest him in a nice little war in the Balkans/West Africa/the Levant/South Central L.A.

DAVID FRIEND (pages 120 and 134) is the editor of creative development at *Vanity Fair* magazine. An award-winning editor and curator, he was the director of photography at *Life* magazine from 1992 until 1998 and edited *The Meaning of Life* book series. With Graydon Carter, he edited *Vanity Fair's Hollywood* and with Gigi Benson he edited *First Families*. As a correspondent, he and Harry have covered stories in Afghanistan, Great Britain, Israel, Kuwait, Oman, Pakistan, and Poland, and they have collaborated on numerous profiles of personalities from Michael Jackson to Bill Clinton.

ANDREW FYALL (pages 44–45) was a foreign correspondent and U.S. correspondent in the 1960's for the *Daily Express* newspaper. He is a lifelong friend of Harry Benson, with whom he has covered a myriad of assignments in many parts of the world. He became director of public relations and tourism for the City of Edinburgh and headed the Edinburgh bureau of Scottish Television. He now lives in happy retirement with his wife, Betty, and is writing his memoirs and getting his golf handicap down.

JAMES R. GAINES (pages 146–147), the former editor of *Time*, *Life* and *People* magazines, is writing a book about learning to fly. He lives with his wife, Karen, and their three children in Boulder, Colorado.

JOHN LOENGARD (pages 98–99) joined *Life* magazine as a staff photographer in 1961 and was called *Life*'s most influential photographer of the 1960s by *American Photographer* magazine. When *Life* ceased weekly publication in 1972, he became the picture editor of *Life Special Reports* and was also picture editor of *People* magazine during the planning stages and early issues in 1974. Instrumental in the rebirth of *Life* as a monthly in 1978, he was picture editor from 1973 until 1987. He received the Lifetime Achievement Award from Photographic Administrators, Inc. He is the author of six books including *Georgia O'Keeffe at Ghost Ranch*, *Life Photographers: What They Saw*, and *Celebrating the Negative*.

RICHARD B. STOLLEY (page 109) is senior editorial advisor of Time, Inc. A professional journalist since the age of fifteen, he worked on three newspapers, was a correspondent for the weekly *Life* for fourteen years and later edited the monthly *Life*. He was the founding editor of *People* magazine and served as editorial director of all Time, Inc. magazines.

index of names

acknowledgments

My sincere thanks to my editor, Eric Himmel; my art director, Michael Walsh; and my wife, Gigi, for their invaluable help in putting the book together. I must thank my friends, colleagues, and editors who over the years have played a part in my career: Charlie McBain, Jean-Jacques Naudet, Lord Beaverbrook, Sir Max Aitken, Dick Stolley, John Loengard, Jim Gaines, David Friend, Sean Callahan, M.C. Marden, Mary Dunn, Graydon Carter, Lanny Jones, Dan Okrent, David Breul, Jay Lovinger, Ralph and Eleanore Graves, Ed Kosner, Art Cooper, David Schonauer, David Granger, Freddy Wackett, Jeremy Banks, Frank Spooner, Vic Davis, Harold Keeble, Derek Marks, Derek Lambert, Ivor Davis, Sir Ted Pickering, Bob Edwards, Peter Baker, Ronnie Burns, Roger Wood, Tom Murray, Sir David English, Andrew Robb, Herbert Gunn, Len Franklin, Alex Thomson, Michael Rand, Francine Crescent, Roman Polanski, Roberta Doyle, Val Atkinson, Jimmy Walsh, Sam Kusumoto, Michael Coady, Clay Felker, Tina Brown, Stef Heckscher, Margot Dougherty, Chris Whipple, Ron Bailey, Susan White, David Harris, Elizabeth Biondi, Michele Stephenson, Karen Mullarkey, Mel Scott, Karen Frank, James Danziger, Judy Fayard, Lisa Berman, David Sherman, Tala Skari, Mary Kay Baumann, MaryAnne Golon, Steve Robinson, Edward Barnes, Kristen McMurran, Phil Seltzer, Marie Schumann, and Justin McGuirk. I must also thank photographers Jonathan Delano, David Cairns, Alfred Eisenstadt, Tommy Fitzpatrick, and Ralph Morse who gave me my first assignment at *Life*. Many thanks to Benjamina Baron, Mike Newler, Lou Desiderio, Kenneth and Richard Troiano, Zee Morin, Igor Bakht, and to Stanley Benson, Dan Daniels, Carlo Pediani, H.A. and Mimi Daniels, and lastly to my parents, S.H. and Mary Cunningham Benson for giving me my first camera. ¶

EDITOR: *Eric Himmel*
DESIGNER: *Michael J. Walsh*

Library of Congress Cataloging-in-Publication Data
Benson, Harry.
 Harry Benson: fifty years in pictures / by Harry Benson.
 p. cm.
 Includes index.
 ISBN 0–8109–4171–6
 1. Photojournalism. 2. Benson, Harry. I. Title: Fifty years in pictures. II. Title.
 TR820 .B423 2001
 779'.092—DC21
 2001002512

Harry N. Abrams, Inc.
100 Fifth Avenue
New York, N.Y. 10011
www.abramsbooks.com